american abstraction at midcentury

MODERN MASTERS

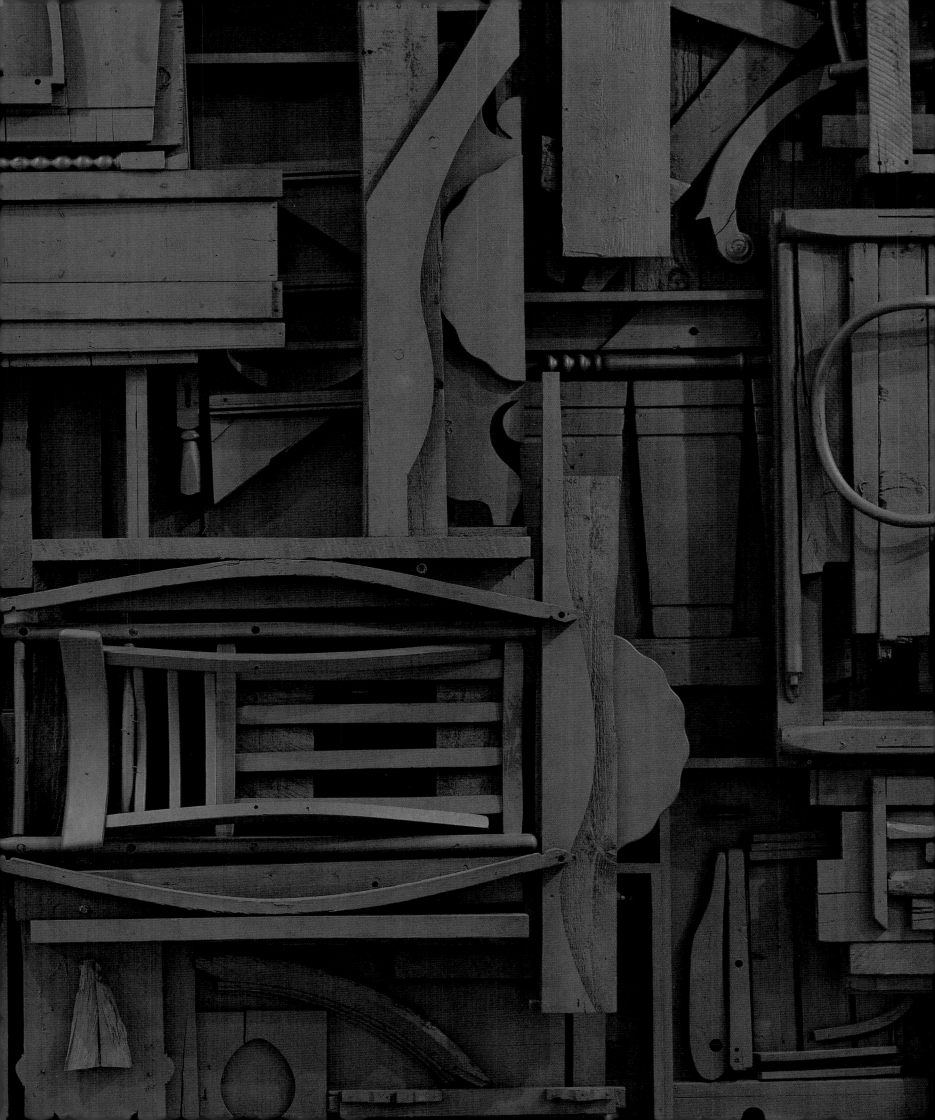

VIRGINIA M. MECKLENBURG

with contributions by TIFFANY D. FARRELL

american abstraction at midcentury

MODERN MASTERS

SMITHSONIAN AMERICAN ART MUSEUM, WASHINGTON, DC
IN ASSOCIATION WITH D GILES LIMITED, LONDON

Modern Masters: American Abstraction at Midcentury

Chief of Publications: Theresa J. Slowik
Editor: Tiffany D. Farrell
Designer: Jessica L. Hawkins
Photo Researcher: Deborah A. Earle

 Smithsonian American Art Museum

The Smithsonian American Art Museum is home to one of the largest collections of American art in the world. Its holdings—more than 41,000 works—tell the story of America through the visual arts and represent the most inclusive collection of American art in any museum today. It is the nation's first federal art collection, predating the 1846 founding of the Smithsonian Institution. The museum celebrates the exceptional creativity of the nation's artists whose insights into history, society, and the individual reveal the essence of the American experience.

For more information or a catalogue of publications, write:
Office of Publications, Smithsonian American Art Museum,
MRC 970, PO Box 37012, Washington, DC 20013-7012

Visit the museum's Web site at AmericanArt.si.edu.

Cover: Hans Hofmann, *Fermented Soil* (detail); see page 152

Frontispiece: Louise Nevelson, *Sky Cathedral* (detail); see pages 96–97
© 2008 Estate of Louise Nevelson/Artists Rights Society (ARS), New York

Frontispiece to Contents: Franz Kline, *Blueberry Eyes* (detail); see page 162

Frontispiece to Acknowledgments: Robert Motherwell, *Collage No. 2* (detail);
see page 176

Back cover: David Park, *Beach Profile*; see page 234

Library of Congress
Cataloging-in-Publication Data

Smithsonian American Art Museum.
Modern masters : American abstraction at midcentury / Virginia M. Mecklenburg ;
with contributions by Tiffany D. Farrell.
 p. cm.
Exhibition catalog.

Includes bibliographical references and index.

ISBN 978-1-904832-59-1 (hardcover : alk. paper)
ISBN 978-0-9790678-2-2 (softcover : alk. paper)

1. Art, Abstract—United States—Exhibitions. 2. Art, American—20th century—
Exhibitions. 3. Art—Washington (D.C.)—Exhibitions. 4. Smithsonian American Art
Museum—Exhibitions. I. Mecklenburg, Virginia M. (Virginia McCord), 1946– II. Farrell,
Tiffany D. III. Title.

N6512.5.A2S65 2008
709.04'052—dc22

 2008026102

First published in 2008 by GILES, an imprint of D Giles Limited, in association with the Smithsonian American Art Museum.

D Giles Limited
2nd Floor
162–164 Upper Richmond Road
London, SW15 2SL UK
www.gilesltd.com

Published in conjunction with the exhibition
Modern Masters from the Smithsonian American Art Museum,
which tours the United States from 2008 through 2011.

The Patricia and Phillip Frost Art Museum
Florida International University, Miami
November 29, 2008 – March 1, 2009

Westmoreland Museum of American Art
Greensburg, Pennsylvania
June 14 – September 6, 2009

Dayton Art Institute
Dayton, Ohio
October 10, 2009 – January 2, 2010

Telfair Museum of Art
Savannah, Georgia
November 13, 2010 – February 5, 2011

Cheekwood Botanical Garden and Museum of Art
Nashville, Tennessee
March 19 – June 19, 2011

Reynolda House Museum of American Art
Winston-Salem, North Carolina
October 7, 2011 – January 1, 2012

For tour updates visit
AmericanArt.si.edu/collections/exhibitions.cfml#traveling

The Smithsonian American Art Museum is grateful to our generous contributors for their support of this exhibition and catalogue.

The William R. Kenan Jr. Endowment Fund provided support for the publication of this catalogue.

The C. F. Foundation in Atlanta supports the museum's traveling exhibition program *Treasures to Go*.

Members of the Smithsonian Council for American Art contribute to the museum's national programs. These leaders from across America serve as advocates for the museum in their communities.

Mr. and Mrs. Gary Abramson
Potomac, Maryland

Mr. Jae Kyoung Ahn
Falls Church, Virginia

Mr. and Mrs. Charles Akre
Hume, Virginia

Mrs. Dolores S. An
Tuxedo, New York

Mr. A. Scott Anderson
Salt Lake City, Utah

Mr. Kim C. Anderson
Vero Beach, Florida

Mr. and Mrs. E. Bertram Berkley
Shawnee Mission, Kansas

Mr. Don Bivens and
Ms. Patricia L. Refo
Paradise Valley, Arizona

Ms. Janet Blocker
New Orleans, Louisiana

Mr. and Mrs. Joseph Boulos
Falmouth, Maine

Ms. Jacqueline Bradley
Windermere, Florida

The Honorable Nancy G. Brinker
Washington, District of Columbia

Mr. Mark Buell
San Francisco, California

Mrs. Mary Ann Casey
Hobe Sound, Florida

Ms. Terresa Christenson
and Mr. David Zimmerman
Hermosa Beach, California

Mr. Hersh Cohen
Sands Point, New York

Mr. Thomas B. Coleman
New Orleans, Louisiana

Mr. I. Michael Coslov
Haverford, Pennsylvania

Mr. and Mrs. James G. Coulter
San Francisco, California

Ms. Gabrielle Sheshunoff de
Kuyper
Austin, Texas

Ms. Margaret H. Demant
Huntington Woods, Michigan

Mr. James F. Dicke II
New Bremen, Ohio

Mr. and Mrs. J. Robert Duncan
Lincoln, Nebraska

Mrs. Nancy McElroy Folger
Washington, District of Columbia

Mr. Christopher Forbes
Far Hills, New Jersey

Mrs. Caroline Forgason
San Antonio, Texas

Mr. Jaime Frankfurt
Los Angeles, California

Mrs. Patricia Frost
Miami Beach, Florida

Mr. Ralph Gifford
Ankara, Turkey

Mr. Dan Glickman
Washington, District of Columbia

Ms. Dorothy Tapper Goldman
New York, New York

Mr. and Mrs. Barry Goldy
Westborough, Massachusetts

Mr. and Mrs. James Goodnight
Cary, North Carolina

Mr. Michael D. Greenbaum
Paradise Valley, Arizona

Mr. Joseph Hardy
Eighty Four, Pennsylvania

Mr. and Mrs. R. Earl Holding
Salt Lake City, Utah

Mr. Larry Irving
Washington, District of Columbia

Dr. Sheila Crump Johnson
The Plains, Virginia

Mr. and Mrs. Maurice H. Katz
Los Angeles, California

Mr. Donald R. Keough
Atlanta, Georgia

Ms. Kavar Kerr
Wilson, Wyoming

Mr. and Mrs. Carl W. Knobloch Jr.
Wilson, Wyoming

The Honorable
and Mrs. Philip Lader
Charleston, South Carolina

Mr. and Mrs. Jerry Lauren
New York, New York

Mr. Edward Lenkin
Bethesda, Maryland

Mr. and Mrs. Mark D. Lerner
Washington, District of Columbia

Mr. William Louis-Dreyfus
New York, New York

Mr. Steven Lunder and
Dr. Elissa Lunder
Weston, Massachusetts

Mr. Jed Lyons
Lanham, Maryland

Mr. James P. MacGuire
New York, New York

Mrs. Adair Margo
El Paso, Texas

Mr. Gilbert C. Maurer
New York, New York

Ms. Marcia V. Mayo
Washington, District of Columbia

Mr. Nion T. McEvoy
San Francisco, California

Ms. Coral J. McGhee and
Mr. Oliver Kellman
Washington, District of Columbia

Mr. Lewis E. Nerman
Leawood, Kansas

Mr. Washburn Oberwager
Rosemont, Pennsylvania

Mrs. Barbara R. Palmer
State College, Pennsylvania

Ms. Rachel Pearson
Washington, District of Columbia

Ms. Edna Bennett Pierce
Centerville, Delaware

Mr. and Mrs. Lawrence Pugh
Naples, Florida

Mr. Thomas L. Pulling
Oyster Bay, New York

Dr. Jonathan Pynoos and
Ms. Elyse Salend
Beverly Hills, California

Mr. Robert S. Pynoos, M.D. and
Ms. Marion Lefèbre
Beverly Hills, California

Mr. David Rumsey
San Francisco, California

Mr. and Mrs. John Safer
McLean, Virginia

Ms. Conchita Sarnoff
Washington, District of Columbia

Mr. and Mrs. Lloyd G. Schermer
Aspen, Colorado

Mr. Walter Scott Jr.
Omaha, Nebraska

The Honorable and
Mrs. Alan K. Simpson
Cody, Wyoming

Ms. Michelle Smith
Washington, District of Columbia

Mr. Dan Solomon
Monarch Beach, California

Mrs. Diane Stewart
Salt Lake City, Utah

Mr. Eric Streiner
New York, New York

Ms. Kitty Sununu
McLean, Virginia

Mrs. Roselyne C. Swig
San Francisco, California

Ms. Anne O'Hanian Szostak
Providence, Rhode Island

Ms. Sanem Tatlidil
New York, New York

Ms. Mary Ann Tighe
New York, New York

Mr. Paul D. Van Cura
New York, New York

Mr. Robert Wilder
Washington, District of Columbia

Mr. R. James Woolsey
McLean, Virginia

Dr. Tomás Ybarra-Frausto
New York, New York

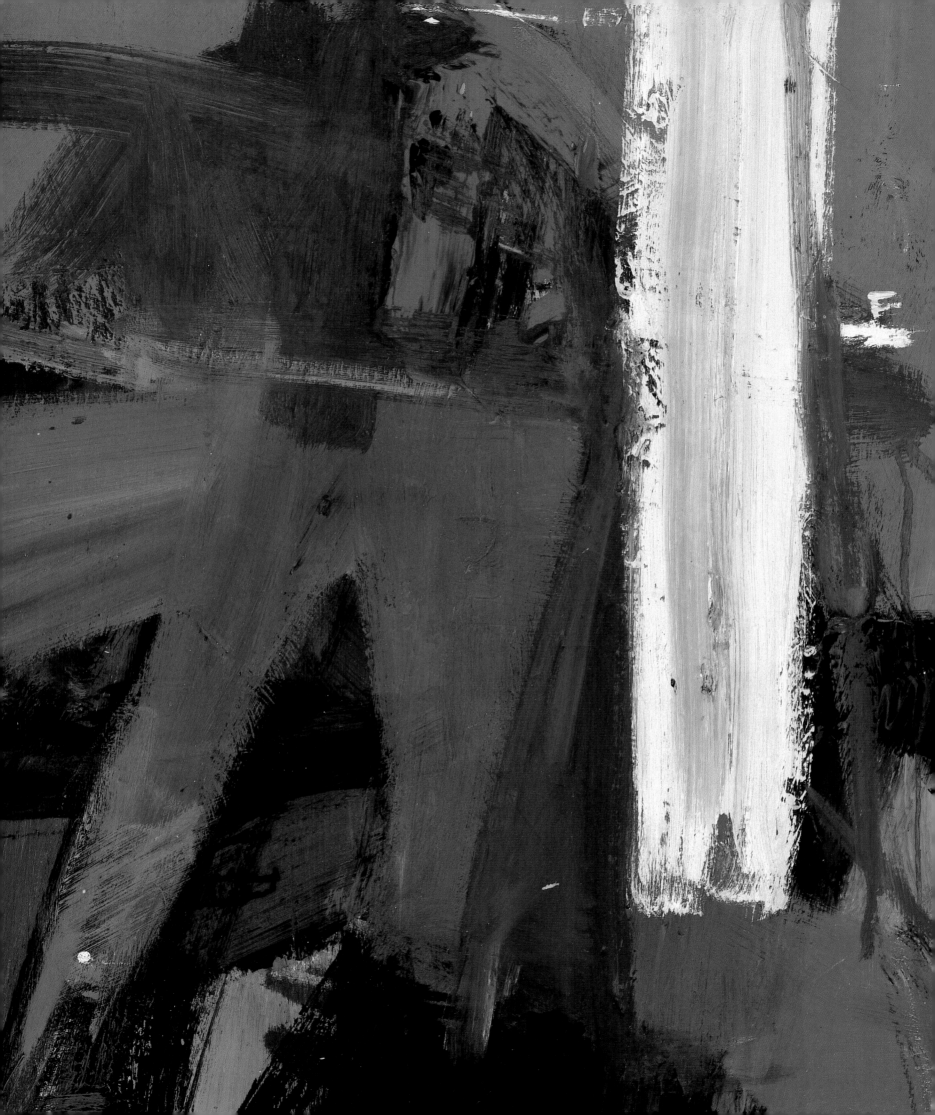

CONTENTS

FOREWORD

Modern Masters features seventy-three significant artworks by thirty-one mid-twentieth century artists. The artworks were chosen in part because they are longtime favorites from SAAM's collection, and also because they restore some of the complexity of this incredibly rich period of American art. Critics and scholars have done their work over the past fifty years, streamlining and distilling a really good story about how abstract artists—who happened to be male, white, and from New York—triumphed over native regionalism and French influences in the 1940s and 1950s to create our first great international school. That storyline, in its first telling, is true; but like any heroic epic, it relies on expert editors to select and combine historical facts to make a simple tale with mounting impact. It's far from being the only story that can be told from these fertile midcentury decades. The artworks in this book will help inspire the next narratives.

The artists of this crucial generation lived through and participated in massive political and social upheavals, and their art reflects this tremendous change. An alternate story to be told is how these postwar artists were themselves affected by the war that reshaped their world. Nine served in the Army or Army Air Corps or Marines (Bearden, Bolotowsky, Diebenkorn, Francis, Goldberg, Lassaw, McLaughlin, Rivers, Wonner). Military service affected a few in obvious ways, for instance Sam Francis, whose training plane crashed, leading to years of hospitalization and chronic pain. For others, the impact of the war is read between the lines; John McLaughlin internalized habits of secrecy as an intelligence officer, and later said, "I have gone to considerable pains to eliminate from my work any trace of my own identity." Anne Truitt, while not enlisting in the armed forces, served as a psychological researcher at Massachusetts General Hospital during the war, providing a special kind of insight into the war experience. How did these artists' experiences as part of the Greatest Generation help set the stage for the advances of the 1960s and 1970s, including the civil rights movement, the aggressive antiwar response to the Vietnam War, and the nuclear debate?

About one-third of these artists were immigrants, all arriving before the outbreak of World War II. Bolotowsky, Golubov, Nevelson, and Roszak came early in the century from Russia or Poland, their families urged out by the wars raging there. Three immigrated for various reasons in the 1910s and 1920s—Vicente from Spain, Guston from Canada, Lassaw from Egypt. The last to arrive were Albers and Hofmann, who left Germany in the early 1930s as the Nazi ascendence began. America absorbed these newcomers as it had assimilated their predecessors for three centuries before, somewhat grudgingly at first, but eventually incorporating them as major factors in the larger whole. Their contributions expanded understanding in the United States with new perspectives from a world already globalized by strife (as well as opportunity), in a new universe of shifting borders and national interests. Interestingly, all nine immigrants worked mostly in a reductive abstract style, as if the specific details needed for figurative representation were too painful or too buried in the subterranean parts of their minds to sustain repre-

sentational realism in their art. There's a case to be made that abstraction—especially the hard-edged or geometric kind favored by Albers, Bolotowsky, Golubov, Nevelson, and Roszak—helps re-establish structure in the face of disorienting and chaotic experience. The exception is Guston, who abandoned abstraction for a disturbing form of figuration later in his career.

The mythology of the swaggering masculine abstract expressionist in New York deserves, and receives, a welcome complication and expansion in *Modern Masters*. Five women make their mark on this show, as they did in the art world. Frankenthaler, Hartigan, and Truitt struggled to balance ambitious career goals and marriages, even as postwar stereo-types sent women from factory back to kitchen. Mitchell avoided some American social tensions but encountered other problems by living as an expatriate in France. Nevelson simply rejected the pressure out of hand. Not allowing the role of wife to deflect her attention, she divorced her husband early in her career and pursued her goals without compromise.

Several Californians remind us that not all the action was in New York. Diebenkorn, Francis, McLaughlin, Oliveira, Park, and Wonner anchor the left side of the map with significant independent approaches. Interestingly, none were immigrants, and Diebenkorn, Oliveira, Park, and Wonner departed from the prevailing abstraction to return to a figurative art in a bold declaration of independence from New York, though Diebenkorn worked comfortably in both manners. While the East and West Coasts are represented in *Modern Masters*, the rest of the country is notably absent from this book. Future exhibitions will further enrich these decades with midwesterners and southerners, among others yet awaiting their integration into newly expanded narratives.

Finally, three African Americans (Bearden, Cruz, and Driskell) and two Hispanics (Oliveira and Vicente) are here where they should be by right, though they have too often been left out of earlier, streamlined epic accounts. All have roots in family, community, and spiritu-ality that speak to significant, personal points

of view. Their artworks are not marginalized echoes from the periphery of a master narrative, but a new locus that shifts the whole story off-center. Including their distinctive voices helps us reclaim the richness of a still-confusing but intriguing time in American life.

Those who are considered card-carrying abstract expressionists—Goldberg, Gottlieb, Kline, Motherwell, Reinhardt, and Stamos—hold their own in this varied company, their accomplishments strong and inspiring, even if their cohort appears less dominant on this reclaimed landscape, which is expanded in this book and still open to discovery. One could argue that adding Pollock and de Kooning would tip the balance in their favor, but it seems sure that any twenty-first-century story of this period will be more richly textured and delightfully varied than that which came before. This exhibition attempts no definitive narrative, as the museum's collections are not sufficiently comprehensive for that great enterprise, but it offers an enlarged cast of characters for the future stories, which will be written in years to come.

Elizabeth Broun
The Margaret and Terry Stent Director
Smithsonian American Art Museum

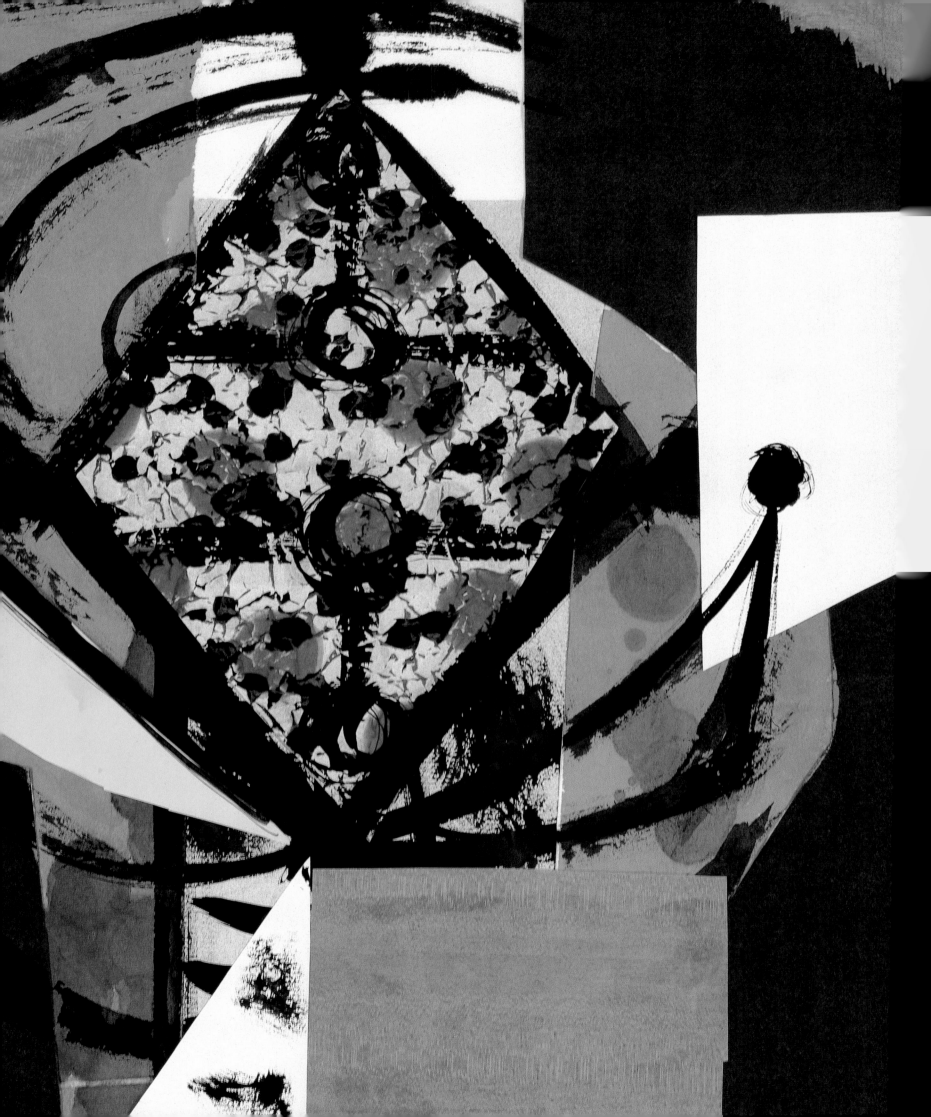

ACKNOWLEDGMENTS

The idea of organizing a show of midcentury abstraction came up in 2006 during a visit to the construction site for the Frost Art Museum at Florida International University in Miami. Strolling through the soaring spaces of unfinished galleries, intimate rooms for showing prints and drawings, beautiful prep rooms, and spacious loading dock and storage areas prompted memories of the opening of *The Patricia and Phillip Frost Collection: American Abstraction, 1930–1945* at the Smithsonian American Art Museum in 1989. In the twenty years since the Frost Collection exhibition opened, Patricia and Phillip Frost have become special friends and patrons, not only of the Smithsonian American Art Museum (SAAM), but of the entire Smithsonian Institution. After chairing SAAM's Board of Commissioners, Patricia was tapped by the Institution to chair its national board. In January 2007, Phillip was appointed by the Chief Justice of the United States to become a regent of the Smithsonian. In the intervening years, the Florida museum that bears their name has become an active Smithsonian affiliate and has hosted three of SAAM's traveling shows.

The Frosts' passion for art initially focused on abstraction of the 1930s and 1940s. What better way to celebrate the opening of the new Frost Art Museum building than with an exhibition drawn from SAAM's collection that would feature America's next wave of abstract art and tour to museums around the country? The Frosts' long-standing commitment to research in the field of abstract art and their desire to celebrate Smithsonian collections prompted this presentation of paintings and sculpture created in the years following World War II. It has been a joy to work again with Patricia and Phillip Frost, and a great pleasure to collaborate with Carol Damian, acting director of the Frost Art Museum, and with her predecessors Stacey de la Grana and Marta de la Torre in bringing the exhibition to Miami.

Modern Masters: American Abstraction at Midcentury brings together the work of artists whose ideas were forged during the difficult years of the Great Depression and World War II and who came to their signature styles soon after. These artists transformed American art, not simply in terms of style, but in acknowledging the power of abstraction to express the thoughts, feelings, and moods of a nation. The painters and sculptors featured here were not the only ones—many others contributed to what was later called the "triumph" of American painting—but they were key to this period. They are represented in SAAM's collection by works of compelling power, thanks to the generosity of S. C. Johnson & Son, Inc., which donated its collection, *Art USA Now*, in the late 1960s; David K. Anderson, who presented the Martha Jackson Memorial Collection in the early 1980s; and Patricia and Phillip Frost, whose 1986 gift established SAAM as one of the country's leading venues for the research and exhibition of abstract art.

The William R. Kenan Jr. Charitable Trust and especially Executive Director Dr. Richard M. Krasno deserve special thanks for encouraging the project from the outset and for supporting this catalogue. The C. F. Foundation of Atlanta, which underwrites the museum's traveling exhibition program, has helped make the tour possible. Thanks, too, to the members of the Smithsonian Council for American Art for ongoing support of the museum's national programs.

I am very grateful to the *Modern Masters* project team for a wonderful collaborative experience. Tiffany Farrell wrote the discussions of Richard Diebenkorn, Helen Frankenthaler, Louise Nevelson, Nathan Oliveira, David Park, and Paul Wonner. Her sensitive eye and agile pen illuminate the paintings and lives of these remarkable artists. Her deft editing ensured coherent language and smooth transitions throughout the text, and her probing questions helped me clarify ideas and sequences. Administrator extraordinaire Debbie Earle identified photographs of artists and managed the complicated logistics of securing images and obtaining the rights to reproduce them. Through her efforts we are able to feature photographs of each of the artists. Jessica Hawkins's elegant catalogue design is not only a testament to her artistic skills, but a fitting tribute to the artists' work. Theresa Slowik, head of SAAM's publications department, has worked tirelessly to ensure that the publication measures up to the potential of the content. I am grateful for her constant support and enthusiasm and to Theresa Blackinton,

who joined the team to ensure that notes and bibliography are accurate and informative.

After searching through archives, we turned to Daphne Coles, Michael Golubov, Denise Lassaw, Joe Oliveira, Sara Roszak, and Alexandra Truitt, who generously provided images of their illustrious parents, and to Marsha Mateyka, whose Washington, D.C., gallery represents Nathan Oliveira. Peter Namuth permitted us to reproduce photographs taken by his famed father, Hans Namuth, while Gloria McDarrah graciously allowed us to use photography by her late husband, Fred McDarrah. Wendy Hurlock Baker at the Archives of American Art responded with good humor and patience to our many requests for images and research materials. She and her colleagues Elizabeth Botton, Kathleen Brown, and Marisa Bourgoin provided expert leads to uncatalogued documents we certainly would have missed. Sandra H. Olsen, director of the art museums at the University of Buffalo, gave us full access to the Martha Jackson Archives, where we found materials that expanded our understanding of the radical activities of this elegant New

York dealer. Jackson's son, David Anderson, generously shared memories of his mother and of exhibitions that changed the face of New York in the early 1960s. Thanks, also, to Mary Moran, Kitty Marmion, and Jim Snider for making our visit to Buffalo so productive. The Smithsonian's Research Opportunity Fund provided travel support.

Jeanie Deans of Carroll Janis, Inc. graciously provided photographs of the late Sidney Janis and of *The International Exhibition of the New Realists*. Katy Rogers of the Dedalus Foundation, Debra Burchett-Lere of the Sam Francis Foundation, Susanne Emmerich, Kira Osti of the Joan Mitchell Foundation, Peter C. Jones of the Josef and Yaye Breitenbach Charitable Foundation, Lacey Peckenpaugh at Staley-Wise Gallery, Beverly Feldman at Stephen Cohen Gallery, halley k harrisburg of Michael Rosenfeld Gallery, and Jeffrey Hoffeld at Jeffrey Hoffeld Fine Art, Inc. generously assisted us with photographs, as did Anne Coleman Torrey, executive director of the Aaron Siskind Foundation; Phil Taylor of Robert Mann Gallery; Amy Rule, Tammy Carter, and Denise Gose of the Center for

Creative Photography; Nicolette A. Dobrowolski and Mary Beth Hinton of the Special Collections Research Center at Syracuse University Library; Matt Giermala at Getty Images; Regina Feiler and Bobbi Baker Burrows at Time, Inc.; and Frank Goodyear and Lizanne Garrett at the National Portrait Gallery. We very much appreciate your help.

A touring exhibition involves many on the museum staff. My colleagues in the curatorial office have, as always, been terrific. Special thanks go to the interns whose constant questions reinforced the need for a catalogue directed at nonspecialist audiences. Ashleigh Holloway, Laura Johnson, Gayoung Lee, Saranga Nakhooda, Katherine Stilwill, Sakoto Suzuki, and Michelle Yee pored through books and curatorial records as the checklist took shape. Summer interns Katherine Kelley, Tegan Hoover, Kathleen Sheehy, and Lauren Taylor scoured the holdings of our library and the Archives of American Art for information about the artists and constructed a marvelous model of the exhibition as it might appear in a gallery setting. Catherine Homsey and Andrea Ferber joined the project in its final stages, helping with photographs, bibliographic materials, and fact-checking. Special thanks go to Emily Riffle, who began as a summer intern, but continued as a volunteer long after her assignment ended. All worked under the able eye of Judith Houston Hollomon, SAAM's intern coordinator, and were ably assisted by Betsy Anderson, collections coordinator in the curatorial office. I thank each of you more than I can say. I am also grateful to Cecilia Chin and Alice Clarke of the Smithsonian's American Art and National Portrait Gallery Library for their untiring goodwill in filling requests for books and magazines, and to Andrew Thomas and Christine Hennessey for assistance with SAAM's photo archives.

Through the special efforts of Jim Concha, Heather Delemarre, and Denise Wamaling—collections managers in the registrar's office—I was able to examine paintings and sculpture not currently on view. Gene Young and Mildred Baldwin photographed artworks, and Richard Sorensen and Leslie Green provided transparencies and digital scans. Through the good efforts of Ann Creager, Helen Ingalls, Kate Maynor, Martin Kotler, Hugh Shockey, Amber Kerr-Allison, and Tom Irion, who conserved and prepared the works, more than forty-five of the museum's treasures will safely travel throughout the country. Jane Terrell and Jennie Lee coordinated plans for the tour. David DeAnna and Craig Pittman oversaw packing and shipping arrangements, and Registrar Melissa Kroning made certain that works are appropriately insured. Administrators Douglas Wilde and Maggie Stone handled financial aspects of the exhibition and tour, Elizabeth Dyches and Marie Elena Amatangelo coordinated the project within the museum's busy exhibition schedule, and Elaine Webster identified financial support. Deputy Director Rachel Allen has helped with all aspects of planning the exhibition and tour. Thanks go to Betsy Broun, the museum's Margaret and Terry Stent Director, who has made the full resources of the museum available.

Modern Masters: American Abstraction at Midcentury is dedicated to the three people whose love and support constantly refresh my life: Marion and Edward Mecklenburg, my husband and son, and Barbara Tobias, my very special sister.

Virginia Mecklenburg
May 2008

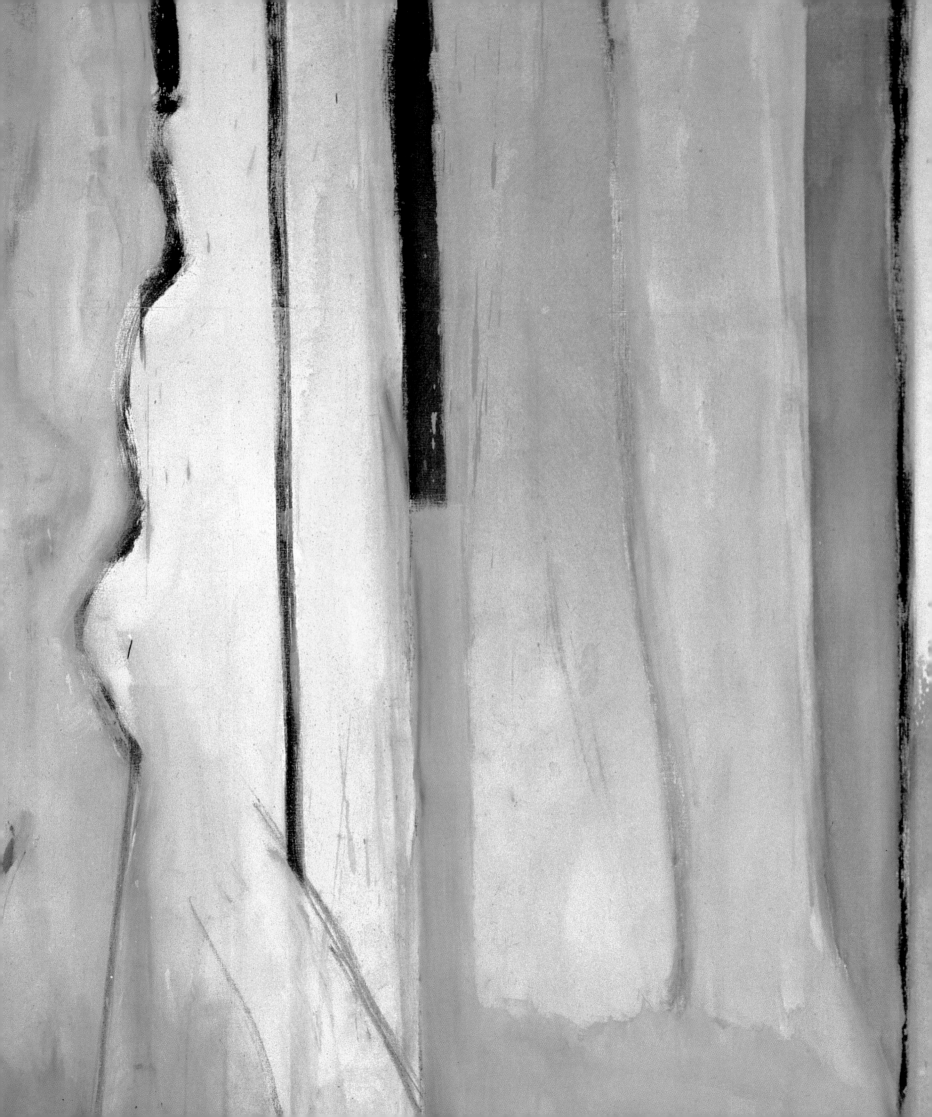

ABSTRACT ROUNDUP
making and marketing postwar modernism

In February 1962, *Vanguard American Painting* opened at the American Embassy in London. It was a highly selective exhibition: just eighty paintings by thirty abstract expressionists and geometric painters were chosen to represent "recent tendencies" in American art. Catalogue author H. H. Arnason, vice president of the Guggenheim Museum in New York and one of the country's leading curators of contemporary art, explained, "The war created a ferment in 1942 that marked...the creation of the first original direction in the history of American art."[1]

Indeed, the postwar period was a heady time for American art. *Life*, *Time*, and *Newsweek* brought images of contemporary abstraction to households throughout the country. With the blessing of the U.S. government, New York museums toured exhibitions to the capitals of Europe. Galleries discovered new markets in the country's growing middle class, and newspapers celebrated American culture as an equal partner with technology in catapulting the United States to preeminence on the world stage. By the late 1950s, Sam Francis (fig. 1),

Philip Guston, Hans Hofmann, Franz Kline, and other painters and sculptors who embraced abstraction early in the decade enjoyed success, celebrity, and international acclaim.

Many of the leading "vanguard" artists had begun to paint or sculpt in the 1930s as beneficiaries of government support under the Works Progress Administration (WPA). Others were immigrants who fled to the United States as Nazi power grew in Germany. Some were highly educated; several abandoned school at an early age to pursue lives as artists. Working across the United States and abroad, they probed human experience and the value of rational systems in the creative process. Blending knowledge gleaned from old masters, Picasso, and Matisse, Jungian and existential philosophy, and Greek and Roman mythology, they addressed current social concerns and personal history. They mixed hardware-store paint with expensive artist colors and bits of paper torn from magazines to link their work with contemporary life. Aided in their efforts by a group of New York dealers, prominent critics, and the influential

editor of *ARTnews* magazine, abstract artists gained credibility.

Regionalism had reigned during the 1930s, despite the best efforts of a group of young abstract artists.[2] A self-portrait of Thomas Hart Benton graced the cover of the December 24, 1934 issue of *Time* magazine; inside Grant Wood and John Steuart Curry were pictured wearing overalls.[3] With support from the WPA and other art programs organized as part of President Franklin D. Roosevelt's New Deal (fig. 2), American scene painters celebrated industry and small town life. Social realists acknowledged the suffering of unemployed Americans during the Great Depression, and communities around the country clamored for post office murals that showed local people and scenes. But once the United States had entered World War II, the regionalists' insular focus on small towns and ordinary people no longer coincided with America's self-image as a world power. A critic reviewing the Art Institute of Chicago's Grant Wood memorial exhibition in 1942 went so far as to remark that Wood's art

Richard Diebenkorn, *Ocean Park, No. 6* (detail)
See page 118

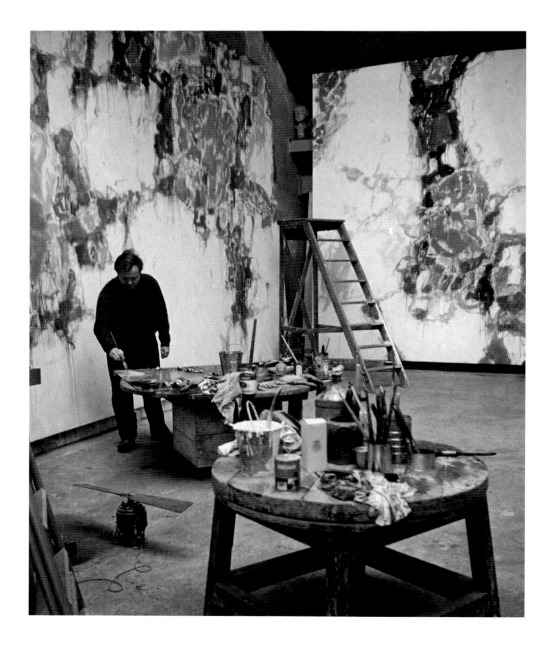

represented "a trend of escapist and isolationist thought…which is definitely obsolete today."[4]

As Arneson noted in *Vanguard American Painting*, World War II marked a turning point. The welcome financial and moral support provided as part of the New Deal evaporated when Roosevelt's programs closed down in the early 1940s. Artists, like their countrymen, turned to war work. Social realist Ben Shahn was hired by the Office of War Information to make propaganda posters, abstract sculptor Theodore Roszak worked in a factory, and Michael Goldberg, who would become an abstract expressionist, served as a paratrooper behind enemy lines. European artists, among them Max Ernst, László Moholy-Nagy, and Piet Mondrian, fled to the United States, affording American artists the opportunity to interact with contemporary European masters, many for the first time. The war changed art just as it changed lives. Theodore Roszak, for one, rejected the utopian purity of his prewar work in favor of twisted, menacing forms that speak of aggression and conflict.

Moses Soyer, *Artists on WPA*, 1935, oil
on canvas, 36 ⅛ × 42 ⅛ in., Smithsonian
American Art Museum, Gift of Mr. and
Mrs. Moses Soyer

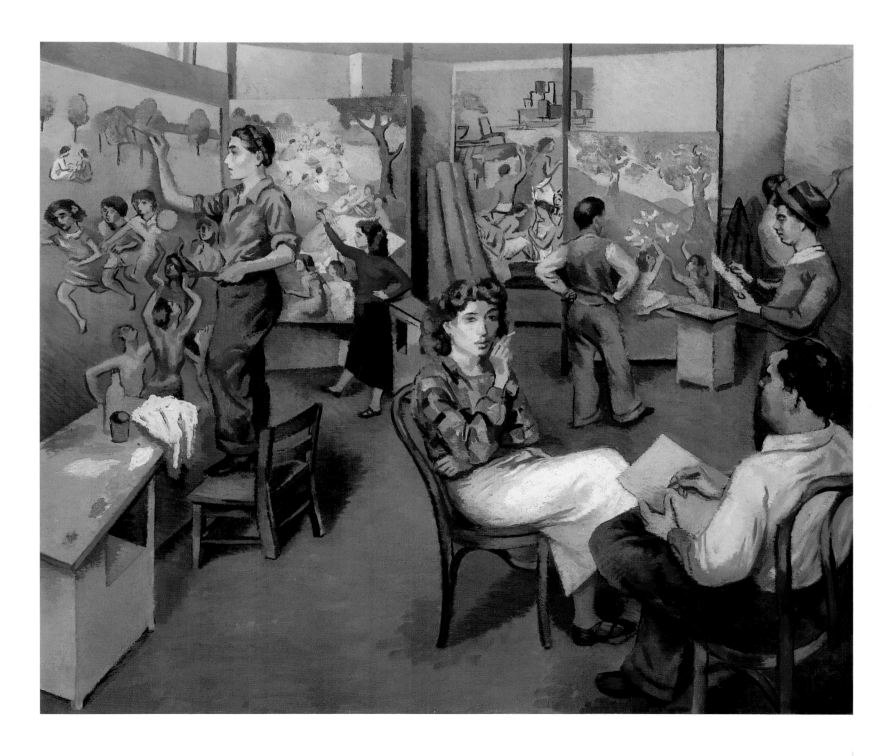

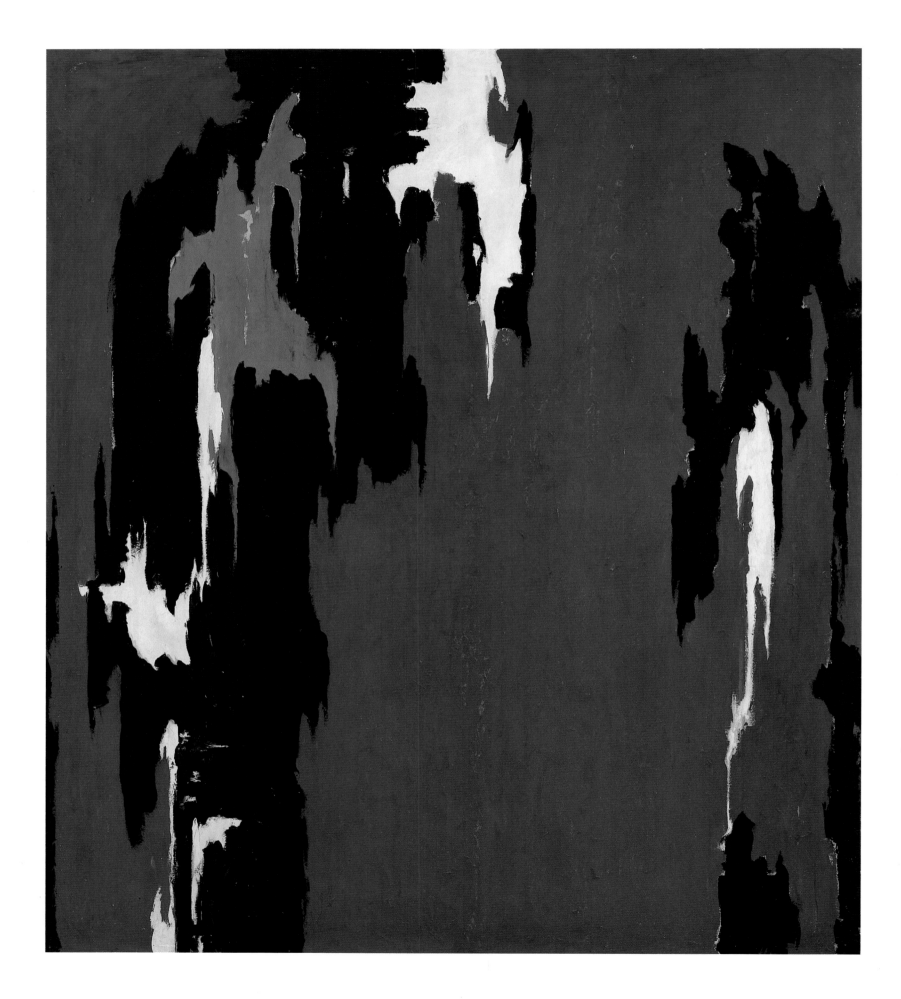

Clyfford Still, *1946-H (Indian Red and Black)*, 1946, oil on canvas, 78 ¼ × 68 ⅜ in., Smithsonian American Art Museum, Museum purchase from the Vincent Melzac Collection through the Smithsonian Institution Collections Acquisition Program

The midcentury art we now call abstract expressionism or the New York school was not homogeneous in style or intent. The dramatic black and white canvases of Franz Kline, for example, bear little resemblance to the figure-based paintings of Larry Rivers. The squares used by Ad Reinhardt and Josef Albers are similar in format, but represent very different philosophies of art. Nor was abstract expressionism restricted to New York. Clyfford Still (fig. 3) and Mark Rothko worked in California as well as New York, opening new avenues of thought and practice for West Coast painters Richard Diebenkorn and Nathan Oliveira. A cursory skim through art magazines of the period reveals the broad stylistic range of art on view in New York in any given year. Despite the polyglot nature of American art, abstract expressionism gained traction, and in 1970 art historian Irving Sandler titled his history of the movement *The Triumph of American Painting*.

The story of the emergence of postwar abstraction, and abstract expressionism in particular, in the late 1940s, and its "triumph"

in the late 1950s, is a complex, sometimes contradictory tale. Dealers—the connecting links between artists, the press, collectors, and the public—played major roles, as did critics who interpreted the new abstraction for the public. Museum exhibitions and the prestige they afforded were important, as were the social networks and professional affiliations of the artists themselves.

Modern Masters: American Abstraction at Midcentury features paintings and sculpture by many of the artists who reshaped American art in the late 1940s and 1950s, as well as works by others who are lately recognized for their contributions to midcentury art. It is organized around three loosely defined themes to suggest the multivalent nature of postwar abstraction. "Optics and Order," "Significant Gestures," and "New Images of Man" indicate commonalities of thought and practice among the artists grouped together. Some were friends who dropped by each other's studios, attended each others' openings, and then retired to bars and restaurants to continue talking about art. Others

never met, but they knew of the paintings and sculpture created by their stylistic colleagues through photographs in catalogues and the press. Neither they nor their work falls squarely within the framework of these categories—different works from different moments, though painted by the same hands, would certainly be grouped differently. They evolved as artists, shifting focus, finding new themes, and revisiting discarded motifs. Some of the artists probed the dark side of man's unconscious; several explored the mysteries of space and the beauty of the natural landscape; others tested the nature of perception and the interaction of color. Individuals all, they experimented, reversed course, refined, and readjusted as they searched to express what it meant to live in the mid-twentieth century.

The narrative that follows highlights some of the people and events that combined to redefine American art from the late 1940s through the Cold War years of the 1950s, until postwar abstraction was eclipsed by the emergence of pop art and minimalism in the early 1960s.

THE DEALERS

ART OF THIS CENTURY

Wealthy expatriate Peggy Guggenheim, who had lived abroad for more than twenty years, returned to New York when the war made staying in Europe untenable. She opened a gallery she called Art of This Century as a "research laboratory for new ideas" in late October 1942.[5] For five years, until she moved to Venice in the summer of 1947, the gallery was the locus for avant-garde art in America.[6] Surrealist Max Ernst, Guggenheim's husband at the time, and his émigré friends André Breton, Roberto Matta Echaurren, and Yves Tanguy congregated there, as did Marc Chagall, Piet Mondrian, Jean-Paul Sartre, and Theo van Doesburg.

Art of This Century was an unconventional enterprise. In three galleries designed by architect Frederick Kiesler, Guggenheim's impressive collection of abstract and surrealist art was shown. A fourth, the "Daylight Gallery," was a sales space for European abstract and surrealist art as well as works by then-unknown young Americans. It was

a commercial and critical success from the start—sometimes because Guggenheim herself bought works from her shows. To encourage young artists, Guggenheim hosted "salon" exhibitions open to abstract or surrealist artists under thirty-five years of age and invited Marcel Duchamp, whom she had known in Paris and London, Mondrian, curators from the Museum of Modern Art, and other art notables to serve as jurors, acquainting them with new work and younger artists.

In the spring of 1943, Peggy Guggenheim organized an exhibition of collages and asked Jackson Pollock and Robert Motherwell to participate, prompting them to explore the medium.[7] Guggenheim was immediately impressed when she visited Pollock's studio several months later. She offered to pay him $150.00 a month, which allowed him to quit his job, and to hold a show that would open in November. On Pollock's recommendation, she visited Hans Hofmann and offered him an exhibition in March 1944. Hofmann, who had immigrated from Germany in 1932,

had shown several times in California in the early 1930s, and again in 1941 at the Delgado Museum in New Orleans, but this solo exhibition, from which eleven works were sold, was the first to introduce his work in New York. William Baziotes was thrilled when twelve works sold from his first solo show at Art of This Century in 1944, and noted in his diary, "Underestimated interest of public. Not a hard-luck pioneer. Strange, most astonishing people would come and buy. Very exciting period. Fantastic."[8] Critic Clement Greenberg bought a Baziotes painting, as did the brother of Sidney Janis, who would open a gallery five years later. More than a dozen collectors purchased works from Guggenheim's next exhibition, Motherwell's first solo show (fig. 4), and critical reception of it was "overwhelmingly positive."[9] In a prophetic review in *The Nation*, Greenberg wrote, "the future of American painting depends on what he [Motherwell], Baziotes, Pollock, and only a comparatively few others do from now on."[10]

4

Robert Motherwell, exhibition brochure,
Art of This Century, 1944, Courtesy of the
Peter A. Juley & Son Collection,
Smithsonian American Art Museum

Art of This Century

30 W. 57 St.
New York City

Robert Motherwell

Preface

Robert Motherwell is an authentic painter. He thinks directly in the materials of his art. With him a picture grows, not in the head, but on the easel — from a collage, through a series of drawings, to an oil. A sensual interest in materials comes first. From their combination comes a structural suggestion. He articulates this in pencil, line and wash, or ink. Finally he fuses both in the more exacting medium, oil. Yet each step has its independent integrity as a picture. They are only stages when we consider the artist's private approach to his problem.

Nature for Motherwell is a source book. It is not something to be copied. It is a vocabulary of forms — elements to be reorganized by the artist according to pictorial logic, not as a replica of things seen. The artist must constantly return to nature for refreshment and restimulation; but his findings must always be translated into the terms of his medium. And the vitality of his work will depend on the tension which he maintains in it between the logic of pictorial expression and that of visual reality.

This is the root of Motherwell's effectiveness. His work shows a natural sensibility. He is a Californian. Bougainvilleas and baked clay have both left their colors on his palette. But he realizes sensibility is not enough. It may charm for the moment. But if the spectator is to be brought back to a painting again and again it must have an organization which will suggest new relationships each visit. To accomplish this the painter must learn to exploit fully the ambiguities of his medium in adapting nature to it, as Motherwell has already begun to do.

James Johnson Sweeney

OILS
1. Mallarmé's Dream, 1942-44
2. Equilibrium Abstracted, 1943
3. [Untitled] (Mexico), 1943
4. The Ambiguity of Experience, 1944
5. The Little Spanish Prison, 1944
6. The Spanish Prison (Window), 1944
7. The Spanish Jailer's Wife, 1944

TEMPERA
8. The Red Sun, 1941
(Lent by Mrs. Motherwell senior)

PAPIERS COLLES
9. Joy of Living, 1943
10. The Displaced Table, 1943
(Lent by the Baltimore Museum)
11. Pancho Villa, Dead and Alive, 1944
(Lent by the Museum of Modern Art)
12. The Painter, 1944
13. Personage (Autoportrait), 1944
(Lent by Art of This Century)
14. Jeune Fille, 1944

ETCHINGS
15. Figure with Mandoline, 1940
(Lent by Mr. & Mrs. L. Gearhart)
16. Personage (first state), 1944

COLORED DRAWINGS
17. The Structure of Space, 1941
(Lent by M. Darius Milhaud)
18. Landscape, 1941
(Lent by Mme. Matta Echarruen)

19. Landscape, 1941
(Lent by Mr. & Mrs. L. Gearhart)
20. The Door (Mexico), 1943
21. Mexican Air (Mexico), 1943
22. Configuration (Mexico), 1943
23. Three Personages Shot (6 June), 1944
(Lent by Mrs. Jane Bowles)
24. Three Personages Shot (12 June), 1944
25. Two Personages Shot, 1944
26. The Spanish Flying Machine, 1944
27. The Sun, 1944
28. Imaginary Scene, 1944
(Lent by Mme. Dollie Chareau)
29. The Blue-Nosed Mexican, 1944
30. Flight, 1944
31. The Bloody Queen, 1944
32. Yellow with White Figures, 1944
33. Mad Clown (20 August), 1944
(Lent by Maria)
34. Kafka's Room, 1944
35. The Peasant Actors, 1944
36. The Indians, 1944
37. Zapata Imprisoned, 1944
38. Yellow Personage, 1944
39. The Redness of Red, 1944
40. Several Forms, 1944
41. Personage (el torero), 1944
42. Small Personage, 1944
43. Figure, 1944
44. Figure, 1944
45. Figures on Pink, 1944
46. Drawing, 1944

DRAWINGS
47. Constructed Figures, 1944
(Lent by M. Pierre Chareau)
48. Figures, 1944

Guggenheim was ambitious for her artists. She collaborated with Grace L. McCann Morley, director of the San Francisco Museum of Art, and Rue Winterbotham Shaw of the Arts Club of Chicago to send shows to their cities, and she lent works from her collection for display in Bonwit Teller's department store windows and in the arcade of Brentano's Fifth Avenue bookstore. At heart an expatriate, Guggenheim had lived in Europe before the war and always intended to return. By the time she closed the gallery on May 31, 1947, several other dealers receptive to the new avant-garde were in business.

SAMUEL KOOTZ GALLERY

Samuel Kootz opened his eponymous gallery in the spring of 1945.[11] Fascinated by surrealist theories about myth, primitivism, and the unconscious as sources for art, Kootz relished the challenge of showing difficult images by little known artists. However, he recognized that impressive names were more likely to attract buyers, so he bolstered his first exhibition, which included paintings by William Baziotes, Fritz Glarner, Carl Holty, and Robert Motherwell, with works by modern French masters Picasso and Fernand Léger. Although reviews were generally positive, the gallery struggled through its first year. The Americans rarely sold, but the European paintings were quickly snapped up. In December 1946, determined to buy as many works by Picasso as possible, Kootz left for Paris (fig. 5). He returned with nine paintings, placed ads for Picasso's "first postwar show of recent paintings," and arrived at the gallery on opening day to find people lined up on the sidewalk.[12] Within days the show sold out, and for the next several years sales of Picasso's work effectively subsidized the gallery, allowing Kootz to pay stipends to his "American men." Although the sums were small, Robert Motherwell remembered that Kootz "guaranteed...money for the abstract expressionists."[13]

In May 1950, Kootz borrowed Guggenheim's salon idea and invited Clement Greenberg and Columbia University professor Meyer Schapiro to select a show he called *Talent 1950*. Among the artists they chose were Grace Hartigan, Franz Kline, Larry Rivers, and Esteban Vicente. The show proved popular in the press. Thomas Hess exclaimed in *ARTnews*, "It all adds up to one of the most successful and provocative exhibitions of younger artists I have ever seen. And not the least part of the excitement comes from the fact that almost all the works have never been shown before and are by unrecognized talents."[14]

Between 1947 and the mid-1950s (with the exception of 1949, when he took a year off to serve as Picasso's agent in the United States), Kootz presented William Baziotes, Adolph Gottlieb, and Robert Motherwell yearly in group and solo exhibitions that received positive, sometimes glowing, reviews.[15] Hans Hofmann joined the gallery in 1947 and showed annually until his death in 1966. By the early 1950s, expressionist sculptor Ibram Lassaw was also a regular exhibitor. Nonetheless, Kootz maintained that the gallery lost money on the American artists until the mid-1950s, so he continued to show Picasso and introduced other international painters. Artworks by Léger, Joan Miró, Mondrian, and Maurice de Vlaminck helped fill the coffers, as did the paintings of Georges Mathieu and Pierre Soulage, who signed with Kootz in 1954. Yet he felt he had made his greatest mark with abstract expressionism. Reminiscing about "the movement," his term for abstract expressionism, Kootz said, "The general feeling that I had, whether it was from the men in my own gallery or the men who were also instrumental in the movement—Pollock, [Willem] de Kooning, Rothko, and other men—was that this opened a new avenue of painting. It unleashed a possibility for untrammeled subject matter, or for no subject matter at all."[16]

Samuel Kootz (left) and Pablo Picasso,
December 29, 1947, Courtesy of the
Kootz Gallery records, 1931–1966,
Archives of American Art,
Smithsonian Institution

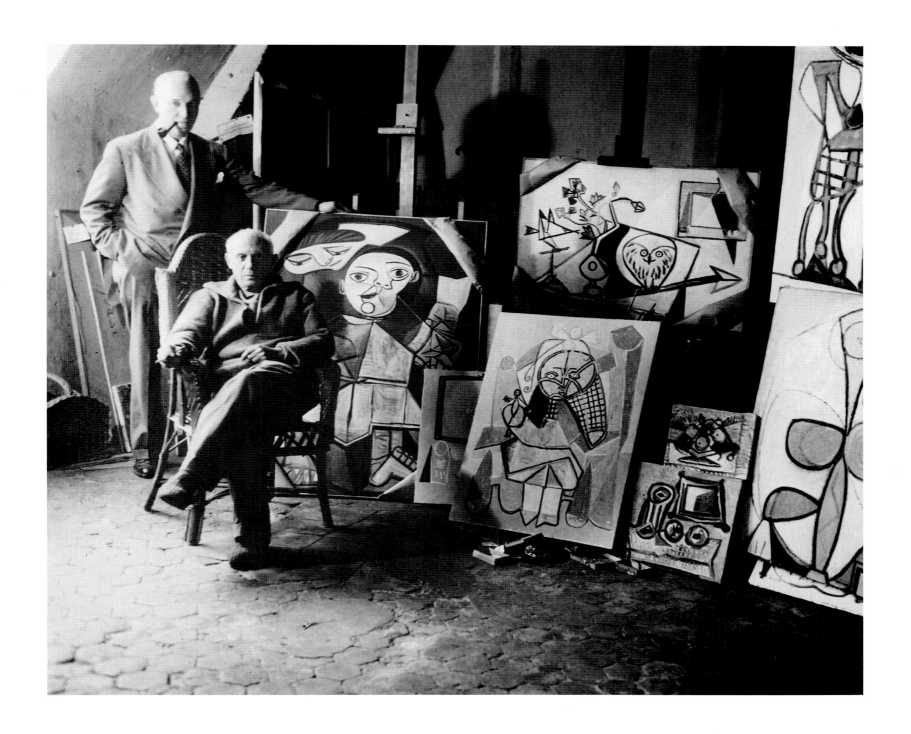

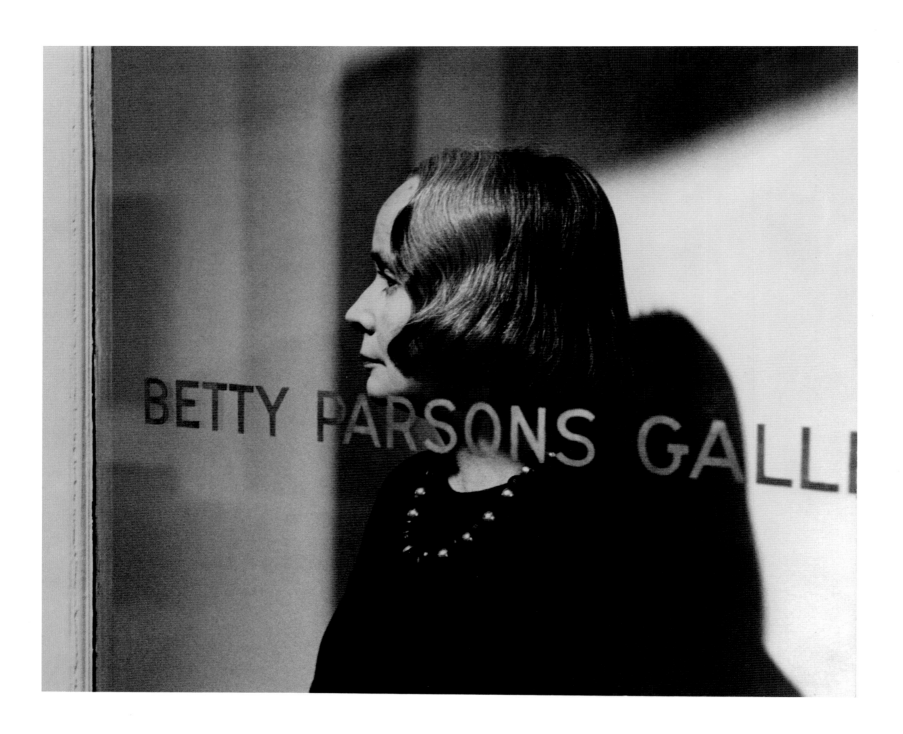

7

Peggy Guggenheim letter to Betty Parsons
regarding Jackson Pollock, May 5, 1947,
Courtesy of the Betty Parsons papers and
Gallery records, 1927–1985, Archives of
American Art, Smithsonian Institution

BETTY PARSONS GALLERY

An artist in her own right, Betty Parsons (fig. 6) opened the gallery bearing her name in the fall of 1946.[17] The venture gave rein to the maverick side of a woman who had grown up in socially prominent circumstances. She rejected the sumptuous interior décor preferred by most successful dealers in favor of white walls and plain wood floors and set about showing abstract art. In her first year, she exhibited paintings by Hans Hofmann, Ad Reinhardt, Mark Rothko, Theodoros Stamos, and Clyfford Still, and sculpture by Seymour Lipton. By early 1947, when Guggenheim was planning to close Art of This Century to return to Europe, she looked for another dealer to take over her contract with Jackson Pollock. In May, Parsons agreed to take him on (fig. 7), and in January 1949, she presented a one-person exhibition of Jackson Pollock's paintings.[18] The camaraderie among the Parsons Gallery artists during the early years is now legendary. They installed each other's exhibitions and enjoyed the relaxed atmosphere of a gallery run by a painter.

Parsons was personally committed to the artists, but sales were slow. She was reluctant to aggressively approach collectors and continued to seek out new talent to introduce to the New York scene, rather than seed her schedule with work by European masters—a tactic that had proved successful for Kootz. Ironically, the openness to new art that prompted Parsons to show abstract expressionism in the 1940s ultimately proved counterproductive. Except for Ad Reinhardt, who remained with her into the 1960s, many of the artists she showed early on moved to dealers more adept at sales. In 1951, Barnett Newman, Pollock, Rothko, and Clyfford Still proposed that she drop most of the others she represented to concentrate on promoting their work. She declined, so Pollock went to Sidney Janis, who had opened a gallery across the hall in 1949. Rothko soon followed. Newman, who served as an advisor to the gallery, withdrew

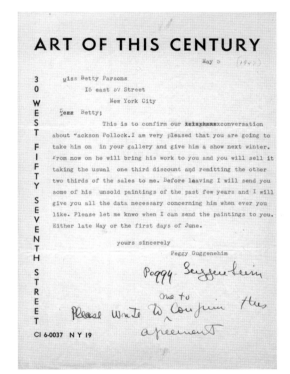

his paintings after his 1951 show received poor reviews, and refused to show again in New York for another eight years. She later reflected, "Most artists don't think I'm tough enough. I don't go out and solicit."[19]

CHARLES EGAN GALLERY

Charles Egan worked at Ferargil Gallery before launching his own enterprise in February 1946 at 63 East Fifty-Seventh Street, an address he shared with Kootz and Parsons. He, too, promoted abstraction, and during the first several years the gallery showed Josef Albers, Georges Braque, Joseph Stella, and Mark Rothko. Willem de Kooning's first solo show in New York, at Egan Gallery in 1948, launched the artist's career (fig. 8). In August 1950, after seeing Franz Kline's new black-and-white canvases at the artist's Ninth Street studio, Egan offered to give Kline a show in the fall. That exhibition, and a second in 1951, cemented Kline's reputation.[20] Between 1946, when he opened, and the fall of 1955, when he closed the gallery for several years, Egan featured Joseph Cornell, Willem de Kooning, Robert de Niro, Philip Guston, Franz Kline, George McNeill, Reuben Nakian, Robert Rauschenberg, Aaron Siskind, and others in solo and group shows, although only Nakian returned when Egan reopened the gallery in 1960.

SIDNEY JANIS GALLERY

A one-time dancer on the vaudeville circuit and a collector of European modernism, Sidney Janis (fig. 9) opened a gallery across the hall from Parsons in space vacated by Kootz when he closed to represent Picasso in 1949.[21] Janis brought a deep knowledge of twentieth-century art and a distinctly historical perspective to a schedule that showcased modern European masters. His first exhibition featured paintings by his friend Fernand Léger; Wassily Kandinsky and Josef Albers shows followed. Over the next several years, Matisse and the fauves, Italian futurists, and Dada (organized by Marcel Duchamp) appeared in the gallery line-up. From the beginning Janis's exhibitions were well received. Critics described them as museum-quality shows where visitors could see important works by modern European masters.[22]

In 1950, Janis introduced young American artists into the mix. He paired Arshile Gorky, Pollock, Rothko, Mark Tobey, and others with Jean Dubuffet, Jimmy Ernst, and Roberto Matta in *Young Painters in the United States and France*. Pollock joined the gallery in 1952, after

leaving Parsons, and Rothko signed on in 1953. By the mid-1950s—with a roster that included Josef Albers, Baziotes, de Kooning, Gottlieb, Gorky, Guston, Kline, Motherwell, Pollock, and Rothko, as well as Braque, Léger, Mondrian, and Picasso—Janis was New York's leading dealer for American abstract expressionist and geometric painters, as well as for European moderns.[23]

For each of the artists, the decision to join Janis proved fruitful. After years of poverty, Kline finally enjoyed financial freedom. For the first time since the Depression, Guston, who had sold only eleven paintings between 1941 and 1956, was able to support himself with his artwork.[24] Janis could never explain why the mid-1950s marked a financial and critical turning point for abstract expressionism, but he said, although the country was in a recession, work by abstract artists sold and sold well.

In the 1950s, other dealers opened galleries that launched the careers of now well-known painters and sculptors. John Myers, director of Tibor de Nagy Gallery, which opened in 1951, had served as managing editor of *View*, a

8

Willem de Kooning, *Untitled*, 1950,
enamel on paper mounted on paper-
board, 22 × 30 in., Smithsonian American
Art Museum, Museum purchase from the
Vincent Melzac Collection through the
Smithsonian Institution Collections
Acquisition Program

Sidney Janis in his office at the Sidney
Janis Gallery, January 1980, Gisèle Freund,
photographer, © Gisèle Freund, Courtesy
of Carroll Janis Inc.

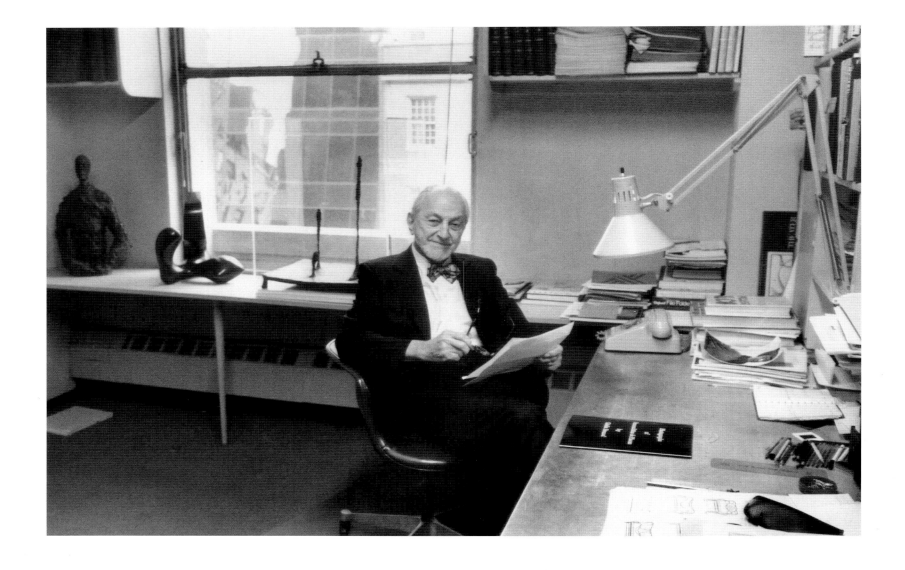

Grace Hartigan (left) and Helen Frankenthaler, 1952, Courtesy of the Grace Hartigan papers, Special Collections Research Center, Syracuse University Library

magazine devoted to the surrealists in exile, from 1944 until 1947. On the advice of Pollock, Lee Krasner, and Clement Greenberg, Myers determined to promote artists of his own generation. He introduced Grace Hartigan (who showed under the name George Hartigan for the first several years), Helen Frankenthaler (fig. 10), and Larry Rivers. Martha Jackson opened a space in 1953, where she showed Sam Francis along with nineteenth-century art, and by the end of the decade would profoundly shock New York critics with the first exhibition of junk art in a mainstream New York gallery. The Los Angeles galleries of Felix Landau and Paul Kantor were seminal as well. Kantor bought into Fraymart Gallery in the late 1940s, renamed it Paul Kantor Gallery in 1952, and is credited with discovering Diebenkorn and mounting the first Los Angeles exhibitions of Baziotes, Gottlieb, Willem de Kooning, Motherwell, and Rothko. Landau, who opened in 1951, showed Richard Diebenkorn, Sam Francis, John McLaughlin, along with fellow Austrians Gustav Klimt and Egon Schiele, as well as Picasso and Francis Bacon.

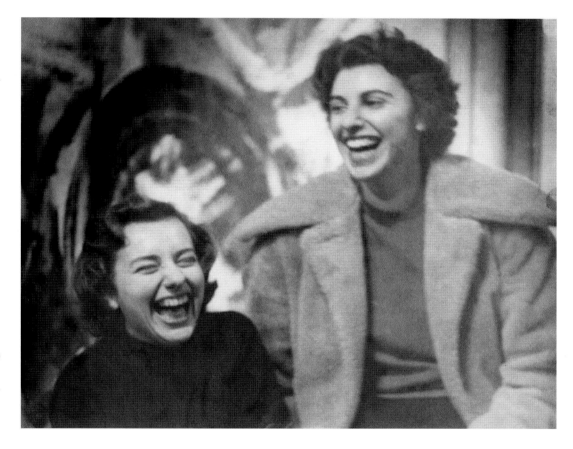

THE CRITICS

Although artists, museum curators, and dealers frequently lamented negative reviews, several influential critics energetically supported the new art. Thomas Hess, Harold Rosenberg, and Clement Greenberg wrote reviews and essays in both specialized and mass-market publications, ensuring greater exposure for postwar abstraction and contributing to the spirited public debates surrounding American art and culture.

THOMAS HESS

Under the editorship of Thomas Hess, *ARTnews*, the country's leading art publication, promoted abstract expressionism.[25] His 1951 book, *Abstract Painting: Background and American Phase*, was the first serious treatment of postwar abstraction in the United States. Illustrating paintings by Jan van Eyck and Pieter de Hooch, as well as medieval sculpture, Hess argued that realism had rarely been the aim of art historical masters. Meaning, Hess said, lies not in the subject depicted, but in the space, rhythms, and repetitions that give a painting its "mysterious, fugal" power.[26] His descriptions—of solids and voids in Quentin Massys's *Mary Magdalene*, the white

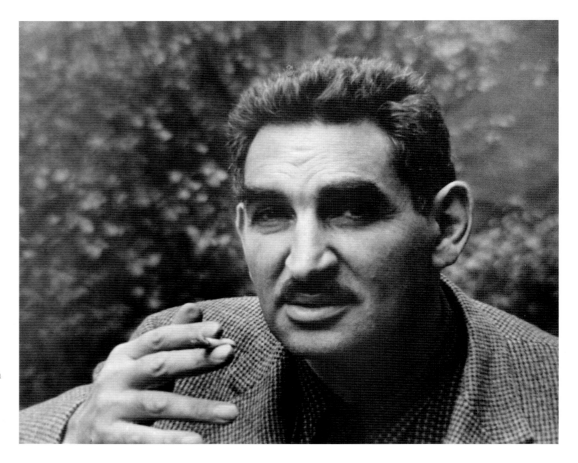

spaces in Pieter Saenredam's *Interior of St. Bavo, Haarlem*, and the "almost mystical" embodiment of age-old forest fears conveyed by Albrecht Altdorfer's *St. George and the Dragon in a Woody Landscape*—introduced the concept of abstraction as a vehicle for conveying powerful human feeling through the materials and processes of paint. While Hess was editor, *ARTnews* consistently reviewed exhibitions of contemporary abstract art and published informal essays that showed photographs of contemporary artists at work in their studios along with excerpts of interviews that explained their aims and processes.[27]

HAROLD ROSENBERG

Harold Rosenberg (fig. 11) is now most famous for inventing the phrase "action painting." He was trained as a lawyer and served as national editor of the WPA's *American Guide* series that surveyed life in the United States. Through the WPA, Rosenberg came to know Holger Cahill, director of the Federal Art Project, and Cahill's wife, Dorothy Miller, a young curator at the Museum of Modern Art. Rosenberg began to frequent art galleries in the late 1930s and spent countless hours reading about art at the New York Public Library. By the late 1940s, he was

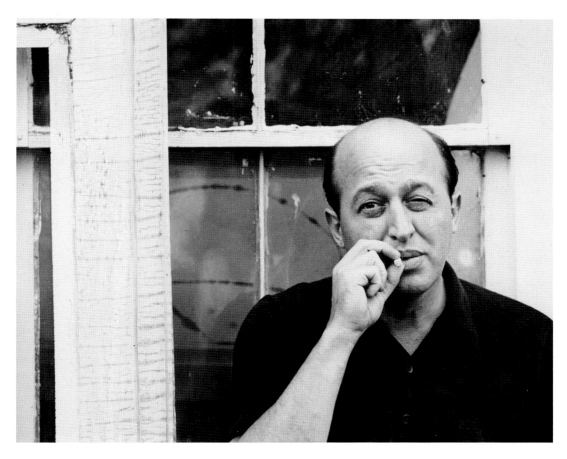

11

Harold Rosenberg, about 1950, Maurice Berezov, photographer, Courtesy of the Harold and May Tabak Rosenberg papers, about 1950–1985, Archives of American Art, Smithsonian Institution

12

Clement Greenberg, 1951, Hans Namuth, photographer, © Hans Namuth Ltd., Courtesy of the Hans Namuth photographs and papers, 1952–about 1985, Archives of American Art, Smithsonian Institution

contributing articles to *Encounter, Partisan Review*, and other little magazines.[28] Rosenberg's 1952 article, "The American Action Painters," defined contemporary art in terms of abstract expressionism. "At a certain moment the canvas began to appear to one American painter after another as an arena in which to act—rather than as a space in which to reproduce, re-design, analyze or 'express' an object, actual or imagined. What was to go on the canvas was not a picture but an event."[29] This new painting, he said, eliminated distinctions between art and life and liberated art from political, aesthetic, and moral values.

CLEMENT GREENBERG

Described as "a major chronicler of an extraordinary epoch in American cultural history," critic Clement Greenberg (fig. 12) began writing articles on culture for *Partisan Review* in the 1930s.[30] By the late 1940s his enthusiasm for postwar abstraction found voice in *The Nation* and *Commentary* magazines as well. By the early 1950s Greenberg was very much a man about the art world. He socialized with artists (he and Frankenthaler dated for some five years) and made frequent studio visits. Greenberg was a brilliant and opinionated writer who argued for the

painting as a self-contained object, independent of external associations. He championed Jackson Pollock and sculptor David Smith, and later, color field painter Morris Louis. Greenberg's enthusiastic pen provided much-needed, but not unqualified, moral support for abstract artists. Recalling a review he had written of a Theodoros Stamos exhibition he said, "I scorched his show and I was wrong. You keep on learning."[31]

Other critics, some writing under bylines, others who went unnamed, reported on artists, exhibitions, and art events for the *New York Times, Time, ARTnews, Arts, Ladies' Home Journal, Newsweek, Life, Vanity Fair*, and a host of other national and regional publications. Meyer Schapiro, who taught art history at Columbia, wrote frequently on vanguard art; Howard Devree, Stuart Preston, Aline B. Louchheim, Dore Ashton, Edward Alden Jewell (a *New York Times* critic who had begun to "get" abstraction shortly before his death in 1947), John Canaday (who never warmed to postwar abstraction), and others praised and censured.[32] Regardless of their preferences, these reviewers ensured that Americans were exposed to postwar abstraction.

The Ideographic Picture exhibition catalogue,
Betty Parsons Gallery, January 20–February 8,
1947, Courtesy of the Betty Parsons papers
and Gallery records, 1927–1985, Archives of
American Art, Smithsonian Institution

BETTY PARSONS
GALLERY
15 EAST 57th STREET, NEW YORK CITY

Representing

HANS HOFMANN
PIETRO LAZZARI
BORIS MARGO
B. B. NEWMAN
AD REINHARDT
MARK ROTHKO
THEODOROS STAMOS
CLIFFORD STILL
HEDDA STERNE
GOLLO DANTE
LAWRENCE KUPFERMAN
HERBERT LESPINASSE
DWIGHT MAXFIELD
WALTER MURCH
ALFONSO OSSORIO
CHARLES OSWALD

NORTHWEST COAST INDIAN ART
PRE-COLUMBIAN MEXICAN ART

THE IDEOGRAPHIC
PICTURE

OPENING JANUARY 20th to FEBRUARY 8th, 1947

BETTY PARSONS GALLERY
15 EAST 57th STREET, NEW YORK, N. Y.

Ideograph—A character, symbol or figure which suggests the idea of an object without expressing its name.

Ideographic—Representing ideas directly and not through the medium of their names; applied specifically to that mode of writing which by means of symbols, figures or hieroglyphics suggests the idea of an object without expressing its name.
—*The Century Dictionary*

Ideograph—A symbol or character painted, written or inscribed, representing ideas.
—*The Encyclopaedia Britannica*

THE Kwakiutl artist painting on a hide did not concern himself with the inconsequentials that made up the opulent social rivalries of the Northwest Coast Indian scene, nor did he, in the name of a higher purity, renounce the living world for the meaningless materialism of design. The abstract shape he used, his entire plastic language, was directed by a ritualistic will towards metaphysical understanding. The everyday realities he left to the toymakers; the pleasant play of non-objective pattern to the women basket weavers. To him a shape was a living thing, a vehicle for an abstract thought-complex, a carrier of the awesome feelings he felt before the terror of the unknowable. The abstract shape was, therefore, real rather than a formal "abstraction" of a visual fact, with its overtone of an already-known nature. Nor was it a purist illusion with its overload of pseudo-scientific truths.

The basis of an aesthetic act is the pure idea. But the pure idea is, of necessity, an aesthetic act. Here then is the epistemological paradox that is the artist's problem. Not space cutting nor space building, not construction nor fauvist destruction; not the pure line, straight and narrow, nor the tortured line, distorted and humiliating; not the accurate eye, all fingers, nor the wild eye of dream, winking; but the idea-complex that makes contact with mystery—of life, of men, of nature, of the hard, black chaos that is death, or the grayer, softer chaos that is tragedy. For it is only the pure idea that has meaning. Everything else has everything else.

Spontaneous, and emerging from several points, there has arisen during the war years a new force in American painting that is the modern counterpart of the primitive art impulse. As early as 1942, Mr. Edward Alden Jewell was the first publicly to report it. Since then, various critics and dealers have tried to label it, to describe it. It is now time for the artist himself, by showing the dictionary, to make clear the community of intention that motivates him and his colleagues. For here is a group of artists who are not abstract painters, although working in what is known as the abstract style.

Mrs. Betty Parsons has organized a representative showing of this work around the artists in her gallery who are its exponents. That all of them are associated with her gallery is not without significance.

—B. B. NEWMAN

CATALOGUE

HANS HOFMANN
1. THE FURY I 750
2. THE FURY II 750

PIETRO LAZZARI
3. BURNT OFFERING 600
4. THE FIRMAMENT 550

BORIS MARGO
5. ASTRAL FIGURE 750
6. THE ALCHEMIST 450

B. B. NEWMAN
7. GEA 200
8. THE EUCLIDIAN ABYSS 200

AD REINHARDT
9. DARK SYMBOL 200
10. COMIC SIGN 300

MARK ROTHKO
11. TIRESIAS
12. VERNAL MEMORY 450.00

THEODOROS STAMOS
13. THE SACRIFICE 400.00
14. IMPRINT 200.00

CLIFFORD STILL
15. QUICKSILVER 600.00
16. FIGURE 400.00

EXHIBITING THE "NEW" MODERNISM

THE IDEOGRAPHIC PICTURE

In perhaps the first exhibition to attempt to identify common ground among postwar artists, Betty Parsons organized *The Ideographic Picture* (fig. 13) in the spring of 1947. The show featured two paintings each by Hofmann, Lazzari, Margo, Newman, Reinhardt, Rothko, Stamos, and Still. Their common ground, according to Newman, who wrote the exhibition's catalogue, was the search for a "pure idea." The paintings, he said, embodied "the idea-complex that makes contact with mystery— of life, of men, of nature, of the hard black chaos that is death or the grayer, softer chaos that is tragedy."[33] Reporting for the *New York Times*, Edward Alden Jewell noted that many of the "designs" were "handsome and striking," and suspected that the group represented some sort of a "crystallizing movement," but he was bewildered by Newman's explanatory language.[34] Nonetheless, Jewell was receptive. In 1947, he reported, "Hofmann's new show at the Betty Parsons Gallery, is, as you enter, like a sudden burst of sunshine." The paintings, he said, were "suffused with an enkindling dramatic power."[35]

THE INTRASUBJECTIVES

In September 1949, Kootz opened *The Intrasubjectives* (fig. 14) and invited Harold Rosenberg to write a catalogue. The title for the show came from Spanish philosopher José Ortega y Gasset, who, according to the catalogue, described the evolution of painting, as "a steady march from external reality through the subjective to the 'intrasubjective.'"[36] Featuring Baziotes, Gorky, Gottlieb, Morris Graves, Hofmann, de Kooning, Motherwell, Reinhardt, Pollock, Mark Toby, and Bradley Walker Tomlin, the show surveyed many of the emerging new abstract painters. Yet, as with Parsons's *Ideographic Picture*, reviewers were challenged to find links among artists whose paintings looked different one from another. An anonymous critic for *Time* ridiculed the exhibition by paraphrasing Rosenberg's exhibition catalogue: "The intrasubjective artist is not inspired by anything visible. He begins with nothingness. That is the only thing he copies. The rest he invents."[37] These were damning words for

audiences accustomed to art that resembled the natural world.

Many art reporters looked without success for a unifying style or theme among works featured in *The Ideographic Picture*, the *Intrasubjectives* exhibition, and other shows presented by Parsons, Kootz, and Janis. In spite of catalogue introductions that aimed to explain conceptual parallels among the artists, their differences were more apparent than their similarities. Some painters (Baziotes and Stamos, for example) used motifs from nature as starting points for serene, lyrical canvases; others (Albers, Bolotowsky, and Reinhardt, among them) restricted themselves to rectangles and straight lines. Paintings by Guston, Hofmann, Pollock, and Kline offered great sweeps of paint that seemed to have no reference to anything except the energy of the artists and the act of painting, so reviewers were challenged to explain and evaluate what they saw. Even sympathetic critics often reverted to timeworn terminology to describe their reactions. A *New York Times* critic, for

14

The Intrasubjectives exhibition catalogue,
Kootz Gallery, September 14–October 3,
1949, Courtesy of the Kootz Gallery records,
1931–1966, Archives of American Art,
Smithsonian Institution

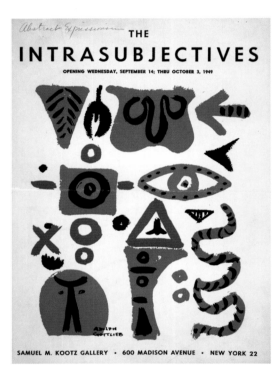

Although the article catapulted Pollock to national attention, its effect, apparent from outraged letters to the editor two weeks later, was less an endorsement than the rhetorical question posed by the title.[39]

The confusion is not surprising. Several of the most prominent abstract expressionists had developed the styles for which they are now known only in the 1950s. Guston shifted from figurative-based imagery to abstraction in 1950, the same year Kline first showed his large-scale black-and-white canvases. Gottlieb moved from pictographs to bursts in the early 1950s. Even so, *New York Times* critic Aline Louchheim recognized that something akin to a new movement was afoot. In the fall of 1949, she remarked that abstract art, whether based on nature or "motivated solely by 'idea,'" was the discernable trend of the year.[40] Her observation was borne out when the Whitney's annual, which opened in December, featured Jackson Pollock's drip painting *No. 14* and Willem de Kooning's *Attic*, and when the 1950 Venice Biennale presented Arshile Gorky, Willem de Kooning, and Pollock.[41]

example, characterized Parsons's 1948 show of paintings by Theodoros Stamos as evidence of a "neo-romantic revival."[38]

It was sometimes difficult to tell whether reviewers were serious or writing tongue-in-cheek. *Life* magazine's now-famous 1949 article "Jackson Pollock: Is He the Greatest Living Painter in the United States?" confronted readers with a photograph of Pollock posed beside one of his huge drip paintings (fig. 15).

15

Life, August 8, 1949, pages 42–43,
"Jackson Pollock: Is he the greatest living
painter in the United States?" Copyright
1949, Life Inc. Reprinted with permission.
All rights reserved.

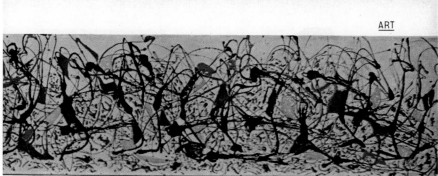

JACKSON POLLOCK, 37, stands moodily next to his most extensive painting, which is called *Number Nine*. The picture is only 3 feet high, but it is 18 feet long and sells for $1,800, or $100 a foot. Critics have wondered why Pollock happened to stop this painting where he did. The answer: his studio is only 22 feet long.

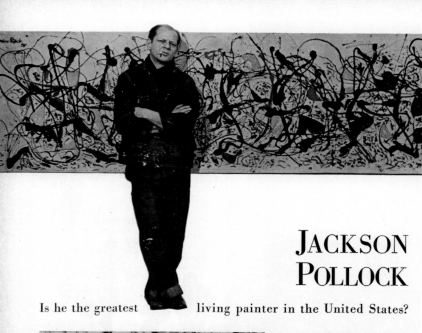

JACKSON POLLOCK

Is he the greatest living painter in the United States?

"NUMBER TWELVE" reveals Pollock's liking for aluminum paint, which he applies freely straight out of the can. He feels that by using it with ordinary oil paint he gets an exciting textural contrast.

Recently a formidably high-brow New York critic hailed the brooding, puzzled-looking man shown above as a major artist of our time and a fine candidate to become "the greatest American painter of the 20th Century." Others believe that Jackson Pollock produces nothing more than interesting, if inexplicable, decorations. Still others condemn his pictures as degenerate and find them as unpalatable as yesterday's macaroni. Even so, Pollock, at the age of 37, has burst forth as the shining new phenomenon of American art.

Pollock was virtually unknown in 1944. Now his paintings hang in five U.S. museums and 40 private collections. Exhibiting in New York last winter, he sold 12 out of 18 pictures. Moreover his work has stirred up a fuss in Italy, and this autumn he is slated for a one-man show in *avant-garde* Paris, where he is fast becoming the most talked-of and controversial U.S. painter. He has also won a following among his own neighbors in the village of Springs, N.Y., who amuse themselves by trying to decide what his paintings are about. His grocer bought one which he identifies for bewildered visiting salesmen as an aerial view of Siberia. For Pollock's own explanation of why he paints as he does, turn the page.

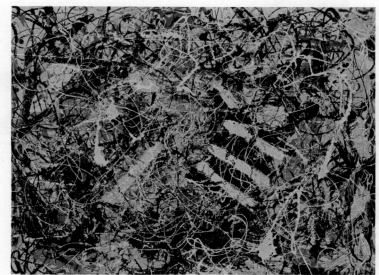

"NUMBER SEVENTEEN" was painted a year ago in several sessions of work which took place weeks apart so Pollock could appraise what he was doing and "get acquainted with the picture." He numbers his paintings instead of naming them, so his public will not look at them with any preconceived notion of what they are.

CONTINUED ON NEXT PAGE

BUILDING A CASE FOR POSTWAR ABSTRACTION

By the late 1940s, European modernism was familiar territory for the American public. *Life's* 1949 feature article on Vincent van Gogh, which described the artist as "the one great painter of modern art whose greatness Americans have never doubted," proved the point. Irving Stone's *Lust for Life*, a biography of van Gogh published in 1934, had been hugely successful, and the first U.S. exhibition devoted to van Gogh's art, in 1935, attracted 900,000 visitors.[42] For another 1949 article, a pictorial spread entitled "The Old Men of Modern Art," *Life* published photographs of Léger, Matisse, and Picasso (whom the photographer had found on a beach "grandly holding court in his swimming shorts"), and noted their advancing ages. According to *Life*, modern art, at least modern European art, was a well-established phenomenon.[43]

But the history of American abstraction was less familiar territory, a fact the Whitney Museum of American Art in New York aimed to rectify. In 1946, the Whitney opened an exhibition called *Pioneers of Modern Art in America*. Tracing the history of abstraction in the United States, Director Lloyd Goodrich, who with the museum's founding director Juliana Force was the leading exponent of the country's art, presented Marsden Hartley, Maurice Prendergast, Max Weber, and others who went to Paris in the early years of the twentieth century as "pioneers" who epitomized the virtues of the early settlers who had struggled to build the nation. Perhaps unwittingly, Goodrich laid the groundwork for the emergence of a new postwar avant-garde. He wrote, "Abstraction may serve as an escape from troubling realities into a world of aesthetic order where the artist is in full control, just as surrealism is an escape into the private world of fantasy." With the early modernists, he concluded, "American art entered once and for all into the main stream of world art."[44]

Life seemed to agree. The magazine inaugurated its 1950 art coverage with a story on the 1913 Armory Show. The article reprinted a selection of cartoons mocking abstraction that had appeared when the show originally opened in New York. In a sidelong reference to the photographs of Pollock pouring paint the magazine had published five months earlier, editors selected a cartoon showing an artist tossing a bucketful of paint at an empty canvas. Remarking that the Armory Show had been "the most influential exhibit ever held in the U.S.," *Life* noted the shift from initial ridicule to acceptance of early twentieth-century abstraction and cautioned against dismissing new art, no matter how outlandish it might seem.[45] The previous year, *Life* offered readers the chance to measure their own sophistication about art in a humorous article titled "High-Brow, Low-Brow, Middle-Brow," (fig. 16) in which the "high-brow," dressed in relaxed tweeds, examined a Picasso. The "low-brow," in shirt sleeves, admired a buxom beauty on a wall calendar, while the "middle-brow" stood in front of a reproduction "suitable for framing" of Grant Wood's *American Gothic*.[46]

In January 1951, the Museum of Modern Art opened *Abstract Painting and Sculpture in America*. Featuring almost eighty artists, the

16

Life, April 11, 1949, page 99, "High-Brow,
Low-Brow, Middle-Brow," Copyright 1949,
Life Inc. Reprinted with permission.
All rights reserved.

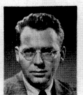

exhibition also traced the history of abstraction in the United States from early modernists Marsden Hartley, Morgan Russell, and Max Weber, and linked them to recent work by Albers, Hofmann, and Pollock. With almost one-third of the exhibition devoted to recent abstraction, the show was the first presentation of abstract expressionism by a major New York museum. (Also included were Baziotes, James Brooks, Herbert Ferber, Maurice Golubov, Gorky [who, though dead, was counted with the abstract expressionists], Guston, Willem de Kooning, Lassaw, Lipton, Motherwell, Pollock, Reinhardt, Theodore Roszak [represented by his constructivist work], David Smith, and Stamos.) The historical focus of the catalogue and the extensive bibliography argued a distinguished lineage for contemporary abstraction.[47]

DEFENDING POSTWAR ABSTRACTION:
THE "IRASCIBLE EIGHTEEN" AND THE CLUB

Although *Life* increasingly presented vanguard art in positive terms, attacks on modern art and artists escalated. In 1949, Michigan congressman George A. Dondero, with the backing of the House Un-American Activities Committee (HUAC), launched a widespread exposé of the "communist" affiliations of artists, galleries, and institutions (especially the Museum of Modern Art). He claimed that abstract art sought "to destroy the high standards and priceless traditions of academic art," and charged that modernist "isms" (cubism, futurism, surrealism, Dada, and so on) were communist "instruments and weapons of destruction."[48]

In response, the Whitney Museum of American Art, the Museum of Modern Art, and Boston's Institute of Contemporary Art issued a joint manifesto to "help clarify current controversial issues about modern art, which are confusing to the public and harmful to the artist" that was printed in the *New York Times*. A defense of contemporary abstraction, the manifesto compared abstract artists with research scientists and explained, according to the *Times*

article, the "so-called 'unintelligibility' of some modern art" as the "inevitable result of its exploration of new frontiers." Advanced artists, the museums claimed, play a spiritual and social role in contemporary life by "helping humanity to come to terms with the modern [i.e. postwar] world."[49] The argument had merit. Sculpture by Roszak, Seymour Lipton, and others addressed the destruction wrought by the war and the dropping of atomic bombs on Nagasaki and Hiroshima; Nathan Oliveira and Adolph Gottlieb questioned man's essential nature; Sam Francis and Ibram Lassaw pondered the vast universe that was increasingly made visible by advances in science and technology.

THE "IRASCIBLE EIGHTEEN"
Shortly after the museums' manifesto was published, the Metropolitan Museum of Art in New York announced a national competitive exhibition. *American Painting Today, 1950* would be selected by five regional juries who screened a first round of submissions, with a national jury making final decisions. The competition

announcement provoked a howl of protest among abstract artists. Gottlieb, Hofmann, Lassaw, Lipton, Motherwell, Reinhardt, Roszak, Stamos, and others sent an open letter to Roland Redmond, the museum's president, protesting the choice of William M. Milliken, Franklin C. Watkins, and several others considered unsympathetic to postwar abstraction, as jury members. The artists vowed to boycott the exhibition. The letter made national news. *The New York Times* ran the story on the front page, and the *New York Herald Tribune* dubbed the artists the "Irascible Eighteen." *Time* printed excerpts of the artists' letter under the headline "The Revolt of the Pelicans," a reference to a comment by Metropolitan Director Francis Henry Taylor, who likened the modern artist to "a flat-chested pelican strutting upon the intellectual wastelands."[50] When the Metropolitan's show opened in December 1950, the dialogue continued to play out in the press.[51] Facing *Life's* multipage pictorial coverage of the Metropolitan's exhibition was a photograph of fifteen well-dressed protestors (fig. 17) who looked more like prominent business executives than angry, vanguard painters.[52]

17

Life, January 15, 1951, pages 34–35, "The Irascibles" and the facing article "The Metropolitan…" Copyright 1951, Life Inc. Reprinted with permission. All rights reserved.

IRASCIBLE GROUP OF ADVANCED ARTISTS LED FIGHT AGAINST SHOW

The solemn people above, along with three others, made up the group of "irascible" artists who raised the biggest fuss about the Metropolitan's competition (*following pages*). All representatives of advanced art, they paint in styles which vary from the dribblings of Pollock (LIFE, Aug. 8, 1949) to the Cyclopean phantoms of Baziotes, and all have distrusted the museum since its director likened them to "flat-chested" pelicans "strutting upon the intellectual wastelands."

From left, rear, they are: Willem de Kooning, Adolph Gottlieb, Ad Reinhardt, Hedda Sterne; (next row) Richard Pousette-Dart, William Baziotes, Jimmy Ernst (with bow tie), Jackson Pollock (in striped jacket), James Brooks, Clyfford Still (leaning on knee), Robert Motherwell, Bradley Walker Tomlin; (in foreground) Theodoros Stamos (on bench), Barnett Newman (on stool), Mark Rothko (with glasses). Their revolt and subsequent boycott of the

show was in keeping with an old tradition among avant-garde artists. French painters in 1874 rebelled against their official juries and held the first impressionist exhibition. U.S. artists in 1908 broke with the National Academy jury to launch the famous Ashcan School. The effect of the revolt of the "irascibles" remains to be seen, but it did appear to have needled the Metropolitan's juries into, turning more than half the show into a free-for-all of modern art.

34

FIRST PRIZE ($3,500) went to *Basket Bouquet* by Karl Knaths, veteran abstractionist of Provincetown, Mass., who picked lilacs from sand dunes, painted them in geometric patches of lavender.

SECOND PRIZE ($2,500) was won by Rico Lebrun of Los Angeles. An ardent horseman, he did *Centurion's Horse* as a study for painting of the Crucifixion.

The Metropolitan and Modern Art

AMID BRICKBATS AND BOUQUETS THE MUSEUM HOLDS ITS FIRST U.S. PAINTING COMPETITION

Over the past 75 years New York's Metropolitan Museum of Art has been the greatest collector of art in the U.S. But in the last decade the venerable Metropolitan has been the target of attacks from artists, critics and museum members who have become alarmed over the museum's worship of art of the past to the almost total exclusion of art of the present. They complained that out of an average $400,000 spent by the museum each year on acquisitions, barely $10,000 went for contemporary art. These nettling accusations finally goaded the Metropolitan into deciding to hold a giant competition of contemporary art. But this move, instead of bringing loud hurrahs, has brought the museum nothing but headaches from the time it announced the contest last spring until it opened its show last month.

The great competition, which offered prizes totaling $8,500, was open to all painters of the U.S. whose work was to be screened and chosen by an elaborate network of juries. This announcement had no sooner been made than it was pounced upon by a crew of 18 indignant painters (*opposite page*), all exponents of the most extreme varieties of abstract art, who denounced the juries as

"notoriously hostile to advanced art." Promptly 75 other artists united to cry down the attackers, who were labeled "the irascible 18." These outbursts unleashed blasts and counterblasts across the country, echoing in museum corridors, art galleries and newspaper columns.

When the show finally opened brickbats and bouquets started flying again. Conservatives were irked by the fact that top awards went to abstract paintings (*above and right*). Moderns complained that most of the abstractions were arid and academic. Critics deplored the absence of famous names in American painting—John Marin, Max Weber, Georgia O'Keeffe, who were unwilling to submit their works to the Metropolitan's jury. Also missing was Grandma Moses, whom the jury rejected. But the exhibit did contain a number of distinguished paintings and a few fresh talents, some of which appear on the following pages. And almost everybody commended the Metropolitan for finally taking an active interest in American art. Emboldened, the museum announced a similarly grand-scale exhibition of contemporary U.S. sculpture, with a show of watercolors and drawings to follow.

CONTINUED ON NEXT PAGE

THE CLUB

The artists in *Life*'s photograph had been meeting in studios, at the Waldorf Cafeteria, and the now-famous Cedar Street Tavern (fig. 18) for several years by the time the Metropolitan provided the opportunity for a public protest. They talked about everything, Ibram Lassaw later recalled, "art, and women, and more art, and more women."[53] In the fall of 1948, Motherwell, Baziotes, Rothko, and sculptor David Hare started a school they called "Subjects of the Artists" that quickly became a locus for conversations about art. When the school folded after just two semesters, artists who had gathered there missed the evening discussions. Ejected one night from the Waldorf Cafeteria for spending more time than money, they determined to find a regular place to congregate.[54] Lassaw offered his studio for an organizational meeting; sculptor Philip Pavia came up with funds for a loft space, and the now-famous Eighth Street Club, often called The Club, was launched.[55]

Wednesday nights were devoted to informal conversations among members; on

Fridays Pavia organized panel discussions that featured avant-garde artists, writers, and composers. Jean Arp, Alexander Calder, Dylan Thomas, and Edgard Varèse are just a few who appeared on the roster of distinguished speakers. Membership in The Club was by invitation, although nonmembers could attend the Friday evening programs. Younger artists, among them Helen Frankenthaler, Joan Mitchell, and Larry Rivers, were invited to join; Alfred Barr and Dorothy Miller from the Museum of Modern Art came, as did Lloyd Goodrich from the Whitney. Collector Ben Heller, several dealers, and a host of others flocked to the Friday night events. By 1952, membership approached 150 and included art and book dealers, as well as critics, writers, and composers.

THE NINTH STREET SHOW

In early 1951, Franz Kline passed by the empty storefront of a soon-to-be demolished antique shop on Ninth Street as he returned to his studio in the evenings. The space was huge; except for the fact that it looked derelict, it was perfect for a show of large-scale paintings and sculpture. Enlisting the help of other Club members and young collector Leo Castelli (who contributed money to fix up the space), Kline rented the first floor and basement. The group cleaned it up, painted the walls white, and launched a large-scale show of the new abstraction. Almost ninety artists delivered paintings and sculpture, many of them hand-carried through the streets of Greenwich Village. Most of The Club's members participated, as did nonmembers invited by friends. Some of the artists were represented by galleries, so their work was already familiar to those who frequented New York galleries. Others had been featured in one of Dorothy Miller's *Americans* exhibitions (see pages 45–47) at the Museum of Modern Art; but most showed rarely unless they were accepted for one of the Whitney Museum's large annual exhibitions.

With a banner strung across Ninth Street and a spotlight aimed at the front door, the *Ninth Street Show* premiered on May 21, 1951 (figs. 19, 20, and 21). News of the exhibition had spread mostly by word of mouth, so the artists were amazed at the line of taxis and limousines that pulled up on opening night. The evening, Hess reported, had "an air of haphazard gaiety, confusion, punctuated by moments of achievement."[56]

The sheer number of abstract expressionist artists in the *Ninth Street Show* stunned the New York art world, including the artists. Critics, dealers, and museum curators immediately recognized that something resembling a movement had emerged. Although a one-time event, the *Ninth Street Show* had a huge impact. Socialite Eleanor Ward was inspired to rent a horse stable near Central Park and open Stable Gallery, where from 1953 through 1957, she presented annual exhibitions of abstract expressionism. Joan Mitchell and several of the other artists in the *Ninth Street Show* joined Ward's "stable" where they showed throughout the 1950s and 1960s.[57]

19, 20, 21

Installation photos, *Ninth Street Show*,
1951, Aaron Siskind, photographer,
© Aaron Siskind Foundation, Courtesy
Center for Creative Photography

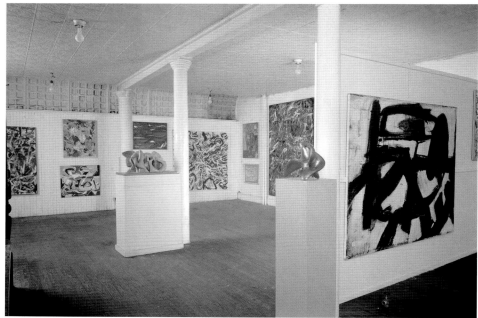

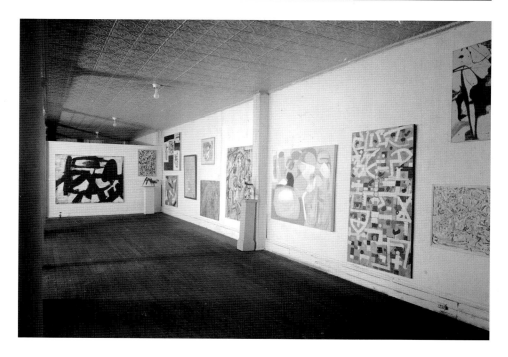

DOROTHY MILLER'S *AMERICANS*

If the *Ninth Street Show* was a revelation to art world insiders, Dorothy Miller's exhibition *Fifteen Americans*, on view at the Museum of Modern Art from April through July 1952, opened the public's eyes to the huge scale and physical power of action painting. The new art was becoming familiar territory for those who followed art events in the national press. In addition to articles in *Life* and *Time*, "highbrow" readers perused stories in *The New Yorker*, and in the spring of 1951, shortly before the *Ninth Street Show* opened, *Vogue's* spread on "the new soft look" in women's clothing confirmed that abstract expressionism was hip by posing fashionably dressed models in front of Pollock's *Lavender Mist* and *Autumn Rhythm* at the Betty Parsons Gallery.[58]

Despite recognition in the popular press, professional validation for artists lay in the hands of the museums. Inclusion in shows at the Whitney or the Museum of Modern Art marked the pinnacle of achievement. The Modern's first director, Alfred H. Barr Jr.,

had been a devotee of modernism since his undergraduate days at Princeton. He characterized the museum's mission as a balance between European and American modern art and tirelessly promoted, explained, and defended European modernism. But during its first five years (the museum opened just days after the October 29, 1929, Stock Market Crash), the exhibition schedule was weighted toward European art, much to the consternation of American painters and sculptors.[59] Abstract artists picketed the Modern's 1936 exhibition *Cubism and Abstract Art* because it included only two contemporary Americans (Alexander Calder and Stuart Davis). *Fantastic Art, Dada, Surrealism*, also on view in 1936, provoked the ire of American figurative painters who were left out.[60] The limited roster of *Realists and Magic Realists* in 1943 proved controversial as well.

In 1942, Barr and curator Dorothy Miller launched a series of exhibitions featuring recent American art.[61] Rather than presenting

one or two works by dozens of artists—the model followed in annual and biennial exhibitions at the Whitney Museum, the Corcoran Gallery in Washington, D.C., the Carnegie Museum in Pittsburgh, and other institutions around the country—the *Americans* shows offered an in-depth look at recent work by a limited number of painters and sculptors. With a gallery devoted to each artist, the exhibitions were, in effect, a series of small solo shows in which Miller aimed for breadth rather than stylistic uniformity. Each catalogue included a brief introduction (repeated with slight variations from one show to the next) and statements by the featured artists. Almost uniformly the *Americans* shows provoked controversy. *Americans 1942: Eighteen Artists from Nine States* showcased figurative, social realist, and magic realist artists living outside New York. Not surprisingly, abstract and semiabstract artists elsewhere in the country objected.[62]

Fourteen Americans in 1946 presented a wider stylistic range. Abstract expressionists

Robert Motherwell, Arshile Gorky, David Hare, and Theodore Roszak were included, along with surreal compositions by Alton Pickens, two hyperreal panels that formed part of Honoré Sharrer's *Tribute to the American Working People*, and witty figurative and landscape drawings by *New Yorker* cartoonist Saul Steinberg.[63] The selection for this and later *Americans* exhibitions was intended as an in-depth presentation of significant work. But the variety confused many, and reviews were often mixed. Emily Genauer of the *New York World Telegram* expected to see new art and faulted the museum for including artists already familiar to gallery-goers. Clement Greenberg, writing for *The Nation*, criticized the diverse selection and described the overall impact of the show as "shabby" and "half-baked." On a brighter note, though, he stated that "the fate of American art" lay in the hands of about half the artists presented.[64] He was referring to Gorky, Hare, Motherwell, and Roszak.

In 1952, the third in the series, *Fifteen Americans*, also proved controversial. Galleries devoted to Baziotes, Herbert Ferber, Frederick Kiesler, Richard Lippold, Pollock, Rothko, Still, and Bradley Walker Tomlin were filled with abstractions that overshadowed in size and impact the figurative and semiabstract work of the five other artists shown.[65] (Miller invited Willem de Kooning to participate, but he withdrew without explanation.) The sheer size of the works by Lippold, Kiesler, and Pollock was impressive, and although Miller reiterated in the catalogue that the artists represented "widely differing aims," the show validated the abstract expressionists Miller included and provided an opportunity for the artists' voices to be heard.[66]

Nonetheless, *Fifteen Americans* was a difficult show to organize. Clyfford Still rarely allowed visitors to his studio and routinely refused to show in New York. He acquiesced when offered the opportunity for what was essentially a solo exhibition at the Modern. When Rothko's paintings arrived at the museum, Miller was astonished to discover that he had significantly altered her selection. The previous *Americans* shows had been seen in other cities as part of the museum's touring exhibition program, but Rothko and Still refused to allow their works to travel, so *Fifteen Americans* was seen only in New York. Henry McBride, an elderly critic and longtime advocate of American abstraction, acknowledged that "for the first time since these wars, it has not been necessary to stumble over references to Matisse, Juan Gris, Picasso, Léger, etc. etc. before arriving at the exhibitor's part of the work."[67] Yet the museum's archives are filled with letters protesting the selection, especially of Rothko and Still. A member who normally contributed at a significant level resigned, to the dismay of the museum's administration, and the show provoked outrage in the press. Yet Miller considered it a success. She later recollected,

ABSTRACTION ASCENDANT:
REACTION OF THE REALISTS

Fifteen Americans "made, I think, the biggest splash of any of them....Oh, it made no splash with the critics. It was beyond them. That's one way I knew it was a success."[68]

Miller lamented the lack of a predictable schedule for the *Americans* exhibitions. She and Barr had become interested in Motherwell's work around 1945, so she included him in *Fourteen Americans* the following year, not knowing when the next opportunity would come. But she later said she thought they had shown him too soon. She also regretted that she had not had the opportunity to show Pollock's drip paintings in the late 1940s when they were first made. "You see I was always either too early or too late with those shows. We didn't have them often enough....Peggy Guggenheim never forgave me for the fact that I didn't put Pollock in that show in 1946....When I did put him in it was already six years later. It should have been three years later. Then [it] would have meant something."[69]

In 1954, *Time* declared, Manhattan had replaced Paris as the "queen city of contemporary painting," and the *New York Times* reported that the movement "christened Abstract Expressionism" had made remarkable progress.[70] Jackson Pollock's show at Janis, Grace Hartigan's exhibition at Tibor de Nagy Gallery, and the Stable Gallery's 1954 annual, which included paintings and sculpture by more than 150 artists "who make up the local detachment of the advance guard," proved that American art was no longer "mortgaged to the past" of either Europe or America.[71]

This increasing attention to abstraction alarmed leading New York realists. Edward Hopper, one of the country's most successful realists, had sold $30,000 worth of paintings in 1954, but he, Philip Evergood, Reginald Marsh, Raphael and Moses Soyer, and forty other figurative artists were distressed at the increasing amount of press devoted to abstract art. They formed a group called Reality to

affirm the continued validity of figurative art and to protest the widespread endorsement of abstract expressionism. New York collector and sometime artist Sara Roby, who had studied with Reginald Marsh, was equally concerned. On Marsh's advice and that of Whitney director Lloyd Goodrich, she established a foundation committed to buying the work of figurative artists.[72]

AMERICANS ABROAD: *SALUTE TO FRANCE* AND *THE NEW DECADE*

By the mid-1950s, art was seen as a potent vehicle for spreading democracy around the world. President Dwight D. Eisenhower established the United States Information Agency (USIA) in 1953, "to submit evidence to people of other nations...that the objectives and policies of the United States are in harmony with and will continue to advance their legitimate aspirations for freedom, progress, and peace."[73] It was not the first time the government proposed art as an arm of cultural diplomacy.

In 1946, the U.S. government sponsored a large-scale international presentation of contemporary American art. Organized by the U.S. State Department, *Advancing American Art* was the country's first major art-as-propaganda initiative. Conceived to bring vanguard American art to the nations of the world, the show featured 150 "progressive" oils and watercolors that were purchased for the tour (buying the artworks proved less expensive than insuring them), with half to be sent to Latin American and Caribbean countries, the other half to Europe. Abstract painters Arthur Dove, Georgia O'Keeffe, and

John Marin, whose careers had been well established for two decades, and Edward Hopper, the country's most beloved realist, were included, as were William Baziotes, Adolph Gottlieb, and Robert Motherwell. Emotionally tough works by social realists Philip Evergood, William Gropper, and Ben Shahn addressed the trauma of the recently concluded war.

The show proved to be a public relations disaster. After openings in Paris, Prague, Port-au-Prince, and Havana, requests for the shows poured in from embassies around the world. But the American press, with William Randolph Hearst's syndicate leading the charge, was appalled at the selection of works, the choice of artists, several of whom had belonged to leftist organizations in the 1930s, and the fact that the works had been purchased by the government. After *Look* magazine reproduced seven of the offending images in an article titled "Your Money Bought These Paintings," letters poured in from irate citizens to congressmen, who demanded an investigation of the State Department's art program.[74] Even President

Harry Truman voiced outrage. On seeing an image of Yasuo Kuniyoshi's figurative *Circus Girl Resting*, he replied, "If that's art, I'm a Hottentot."[75] Within months the exhibition's tours were canceled, its curator fired, and the paintings sold as government surplus.

Although the initial furor settled down after the works were sold, the concept of cultural diplomacy raised conflicting issues. Many of the country's leading figurative artists had been active in leftist organizations in the 1930s and were politically suspect in the eyes of Congressman Dondero, who continued to scour the HUAC's voluminous files to identify artists with communist sympathies. But for cultural diplomacy to have the desired effect, it was important for international audiences to see the best and latest art the country had to offer.[76] Unwilling to risk the inevitable political fallout, the government ceded the job of organizing United States participation in the Venice and São Paulo biennials and other international exhibitions to privately funded organizations. The Museum of Modern Art, the American

Federation of Arts, the College Art Association, and later the National Collection of Fine Arts (now the Smithsonian American Art Museum) took on the responsibility of sending American art abroad.[77]

In 1953, with a five-year grant from the Rockefeller Brothers fund, the Modern inaugurated an international program. Although an official of the newly established USIA declared, "our government should not sponsor examples of our creative energy which are nonrepresentational.... we are not interested in purely experimental art," one of the first major exhibitions to go abroad, *Twelve Modern American Painters and Sculptors*, included Gorky, Pollock, Roszak, and David Smith, as well as Ivan Albright, Stuart Davis, Morris Graves, Hopper, John Kane, Marin, and Shahn, and sculpture by Calder.[78] After premiering at the Musée d'Art Moderne in Paris, the show toured to Zurich, Düsseldorf, Stockholm, Helsinki, and Oslo.

Choosing which artists and works to send were perennially difficult issues. The American Federation of Arts (AFA) was forced to substitute another artist for Ben Shahn in the 1952 Venice Biennale, at the insistence of the government, which partially funded the show.[79] In 1954, U.S. Ambassador Claire Boothe Luce denounced the Museum of Modern Art's selection of "a communist and [a] foreigner" (she was referring to Shahn and de Kooning) for the Venice Biennale that year.[80] Yet, with politically well-connected trustees and Rockefeller funding, the Modern continued to send shows featuring abstract expressionists and other contemporary artists to Asia, Latin America, and Europe, and in several included paintings by the controversial Ben Shahn.[81] Ironically, the very "unintelligibility" of abstract expressionism provided the strongest argument for its service as cultural ambassador. Freedom of expression, a key concept in the Cold War battle against communism, was obvious in such works, as was the lack of narrative content that could be interpreted as propaganda. Detroit businessman Lawrence Fleischman, whose collection toured Latin America in 1955 and 1956, declared, "In this propaganda battle today, Russia's weakest point is that its artists have to create according to the way the government tells them. Nobody who sees these shows [of contemporary American art] can fail to understand that our artists paint the way they feel."[82]

SALUTE TO FRANCE

In the spring of 1955, in a confident display of cultural muscle-flexing, the American Embassy in Paris invited the Modern to organize a series of exhibitions and cultural events that was called *Salute to France*. The program featured the musical *Oklahoma!*, performances by the New York City Ballet and the Philadelphia Orchestra, and an exhibition entitled *De David à Toulouse-Lautrec*, which assembled a group of French paintings from U.S. collections to demonstrate the sophisticated taste of American museums and collectors.

The Parisian press was thrilled with *De David à Toulouse-Lautrec*, which included Auguste Renoir's *Luncheon of the Boating Party*, van Gogh's *Starry Night*, Paul Cézanne's *Bathers*, and other masterworks from American collections. But

the tour-de-force in the eyes of the American organizers was *Fifty Years of American Art*, a sprawling presentation of more than five hundred paintings, prints, sculpture, architectural models and photo enlargements, typographical and industrial designs, photographs, and films from the collection of the Museum of Modern Art. The 2,500 guests who attended opening night festivities were enthusiastic about the films, which they considered America's special contribution to world culture, and the architecture section, which featured large scale models and "ceiling-high photomurals" of the aluminum-clad Alcoa building in Pittsburgh, Frank Lloyd Wright's S. C. Johnson corporate headquarters in Racine, Wisconsin, and international-style structures by Mies van der Rohe. But those who reviewed the show in the French press were unimpressed with the American painting and sculpture displayed.

For the paintings section of *Fifty Years of American Art*, Miller selected 130 works by Max Weber, Marsden Hartley, and other founders of the modern movement; realists George Bellows and Edward Hopper; American scene painters; and self-taught "primitives." Gottlieb, Hofmann, de Kooning, Lassaw, Pollock, Rivers, and others represented the "School of New York."[83] Paintings by Ben Shahn and Joseph Pickett were popular, but the French could find nothing "American" in a drip painting by Jackson Pollock or a black canvas by Clyfford Still. Nonetheless, a reviewer for *Time* observed, "that U.S. art packed a wallop, no one any longer disputed."[84]

THE NEW DECADE AND THE CONTEST OVER CULTURE

Although the French remained skeptical about the importance of postwar American abstraction, New Yorkers who had the opportunity to compare recent American and European artists at the Museum of Modern Art and the Whitney in the spring of 1955 were more enthusiastic. The two museums presented simultaneous shows of painters and sculptors who had come to prominence since World War II. In the Whitney's show, *The New Decade: Thirty-Five*

American Painters and Sculptors, Baziotes, James Brooks, de Kooning, Ferber, Gottlieb, David Hare, Kline, Lipton, Lassaw, Motherwell, Pollock, Richard Pousette-Dart, Reinhardt, Stamos, and Bradley Walker Tomlin represented the most recent trends.[85] The Modern's show included twenty-two contemporary Europeans. According to New York critics, the winners in this erstwhile contest for artistic hegemony were the Americans: "The best European work shown is less vigorous, less innovating than the best of the Americans at the Whitney," wrote Robert Rosenblum in *Arts Digest*. "Whereas American painting and sculpture would have looked provincial and derivative when seen against its European counterpart at almost any time until about 1945," he declared, "by far the best painting and probably the best sculpture of the post-Second World War period was done right here." Citing Pollock's *Blue Poles* and Gottlieb's *Labyrinth*, Rosenblum continued, "There is little, if anything, among the European works which is comparable to such canvases in authority and invention."[86]

Howard Devree of the *New York Times* agreed. The American work "is full of a profound probing for meaning in a disjointed period of history."[87] The diversity and "headlong vitality" of the American paintings and sculpture, he concluded, gave the Whitney's show "the greater impact."[88] In the Cold War competition for artistic hegemony, the idea that American artistic accomplishments finally surpassed those of Europe confirmed America's status as a world power in culture as well as in technology. In the fall of 1955, even *Time* reluctantly acknowledged that "the steadily mounting flood of [American] abstract painting, instead of subsiding, has now surged across all national boundary lines and established itself as the international style of the mid-twentieth century."[89]

REFRIGERATORS AND ART:
THE NEW AMERICAN PAINTING
"Refrigerators and other fruits of the assembly line are not the only kinds of American products prized overseas," reported the *New York Times* in March 1958.[90] European deal-

ers, collectors, museums, and gallery-goers were clamoring for abstract expressionism. The organizers of the American pavilions at the 1957 São Paulo biennial, the 1958 and 1960 Venice Biennales, and international exhibitions in Japan and India were happy to comply. By far the largest exhibition, and the one that had the greatest impact in Europe and at home, was Dorothy Miller's *The New American Painting*, an exhibition of eighty-one works by seventeen artists whom European curators had requested by name (fig. 22). All were leading abstract expressionists: Baziotes, Brooks, de Kooning, Sam Francis, Gorky, Gottlieb, Guston, Grace Hartigan, Kline, Motherwell, Barnett Newman, Pollock, Rothko, Theodoros Stamos, Still, Tomlin, and Jack Tworkov.[91]

In 1958 and 1959, *The New American Painting* traveled to museums in Basel, Milan, Madrid, Berlin, Amsterdam, Brussels, Paris, and London before returning for a final showing at the Museum of Modern Art.[92] It was a smash hit. With the predictable exception of several conservative French and English reviewers,

critics raved about the exhibition. John Russell, writing for the *London Sunday Times*, admitted, "When paintings of this sort were first shown at the Tate, in 1956, I made the error, as it now seems to me, of judging them according to the canons of traditional aesthetics. They do not, in reality, relate to these aesthetics at all; or, if they do, it is as a result of what Mr. Alfred Barr calls 'an intuitive struggle for order.'"[93] The artists' catalogue statements were as compelling as the paintings were impressive. A Spanish reviewer remarked, "Each picture is a confession, an intimate chat with the Divinity...faithful to the more profound identity of conscience"; a Dutch critic declared, "The projection of their personal tensions represent...a projection of the spirit of our time, experienced by all of us."[94] Critic Hilton Kramer remarked that the "European imagination" was excited by the "raw power...daring...and scale" of the American paintings, and he concluded, "in this country, Abstract Expressionism is now our certified contemporary art style so far as museums, the critics, and the big investors in

22

Sanka Knox, "Abstract Art is Going to Europe," *New York Times*, Mar. 11, 1958, clipping from Motherwell scrapbook, Courtesy Dedalus Foundation.
© 1958 The New York Times. All rights reserved. Used by permission.

modern painting are concerned."[95] Although he intended the comment as a disparagement, he was right about the investment potential. *Time* reported that shows of abstract expressionist works were selling out and fetching record prices. Most in demand were paintings by Jackson Pollock. In 1956, the year he died, they commanded $10,000. Within two years the prices for his major paintings had tripled. Hofmann's work was going for $7,500 (which allowed him finally to close his school), canvases by Guston and Gottlieb sold for $4,000, and a Seymour Lipton show sold sixteen of twenty-one sculptures with a top price of $15,000.[96] These were astonishing figures at a time when the average yearly income in the U.S. was just over $5,000, new family cars were priced around $2,200, and houses went for $12,400.[97] If the marketplace can be considered an indicator, postwar abstraction had finally arrived, and some of its artists had achieved superstar status.

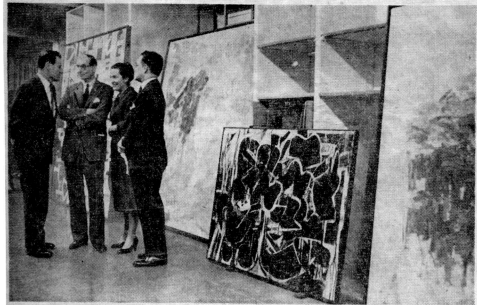

New World Prepares to Show Its Cultural Achievements to Old World

Paintings chosen by Museum of Modern Art for a year's European tour are discussed here as works are crated for shipment. From left: Nelson A. Rockefeller, museum trustee; Alfred H. Barr, director of museum collections; Miss Dorothy C. Miller, curator of museum collections, and Porter McCray, head of museum's international program.

Miss Virginia Pearson, museum's Circulation Director, supervises work of craftsmen who are building a frame.

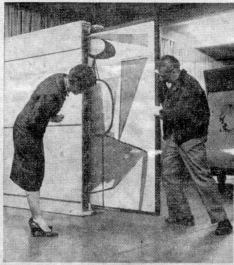

The New York Times (by Allyn Baum)

Miss Miller follows the packing of one of the pictures in a special crate. She chose the pictures for the tour.

REQUIEM FOR ABSTRACT EXPRESSIONISM

In the summer of 1960, Alfred Barr was quoted in *Esquire* magazine as saying, "During the past dozen years we have had a strong movement: Abstract-expressionism, which has enjoyed an international reputation and great success here. The vigor and quality of this movement is bound to generate a reaction—but where we are going to go I'm not willing to prophesy. What I see is a new concern with the figure, and a movement toward a new severe style." Barr's words, coupled with the arrival of the latest issue of *It Is*, a magazine of abstract expressionist thought and images edited by Philip Pavia, provoked a vehement attack by *New York Times* critic John Canaday.[98] With the headline "In the Gloaming: Twilight Seems to be Settling Rapidly for Abstract Expressionism," Canaday wrote, "for a decade the bulk of abstract art in America has followed that course of least resistance and quickest profit." He interpreted Barr's words as an obituary for abstract expressionism, "a pat on the back for the corpse," and suggested that, as the country's leading tastemaker of contemporary art, Barr's comments would send artists and collectors racing to embrace a new style.[99] Although Barr wrote a spirited rejoinder, Harold Rosenberg, one of the abstract expressionists' most ardent devotees, acknowledged change when he moderated a panel discussion hosted by the Philadelphia Museum of Art. He teasingly introduced Guston, Motherwell, Reinhardt, and Jack Tworkov as "old hat" in their approach to making art. "When they paint they stand on the floor instead of riding bicycles, use no bird nests or armor plate, and still paint manually."[100]

FIGURATION RESURGENT

In 1957, the Oakland Museum opened an exhibition titled *Contemporary Bay Area Figurative Painting* featuring David Park, Richard Diebenkorn, Paul Wonner, and nine others that signaled the emergence of a new figurative "movement" around San Francisco. By the late 1940s, abstract expressionism was familiar territory to Bay-Area audiences.[101] Paintings by Baziotes, Motherwell, Pollock, Rothko, and Still had been shown at the San Francisco Museum of Art through the joint efforts of Director Grace McCann Morley and Peggy Guggenheim. In 1946, Clyfford Still joined the faculty of the California School of Fine Arts, and Rothko taught there in the summers of 1947 and 1949. These abstract expressionist exhibitions and artists had been an important influence on the prevailing aesthetics of West Coast art. California artists nevertheless retained their sense of independence from the New York art world and cultivated their own artistic ethos (fig. 23).

In the early 1950s, David Park, a faculty member at the California School of Fine Arts and one of the central figures in the "California wing" of abstract expressionism, shocked friends and colleagues by submitting a small figure-based image painted in a brushy expressionist style to a local art competition. Park's use of the human image, and the landscapes, figures, and loose geometric spaces that Elmer Bischoff, Richard Diebenkorn, Nathan Oliveira, and Paul Wonner painted in the mid-1950s were seen as a repudiation of abstract expressionism despite their sometimes paint-dripped surfaces.[102]

Artists (left to right) Richard Diebenkorn,
Elmer Bischoff, Paul Wonner, and Nathan
Oliveira at Diebenkorn's home, 1960, Fred
Lyon, photographer/Time & Life Pictures/
Getty Images

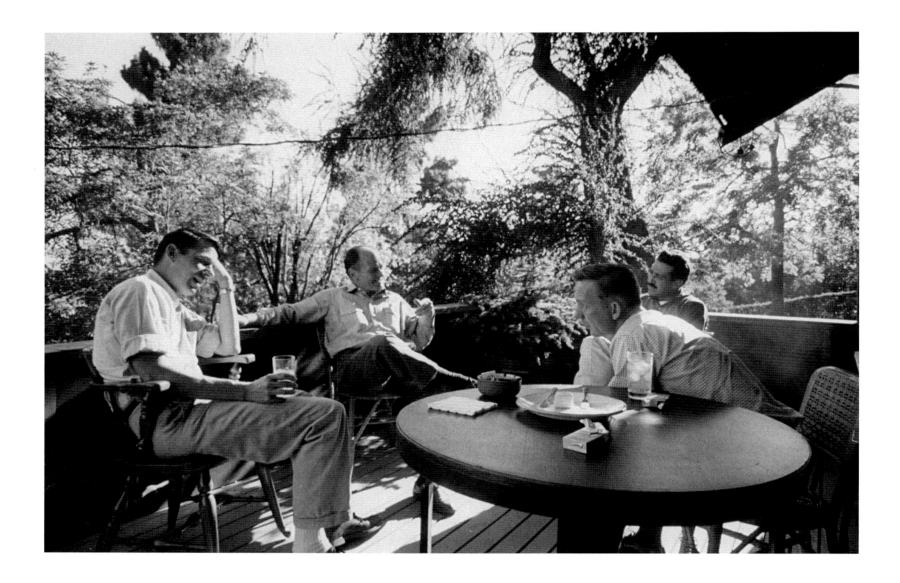

The Oakland Museum exhibition, which coined the name Bay Area Figuration, highlighted an alternative trend that was brewing in other parts of the country as well. The reluctance of the California-based artists to relinquish figurative-based paintings was shared by painters and sculptors in New York and abroad.

The Whitney's 1958 exhibition *Nature in Abstraction* highlighted landscape elements within abstract expressionism, and the Museum of Modern Art's *Sixteen Americans* and *New Images of Man*, both in 1959, revealed other alternatives. For *New Images of Man* curator Peter Selz selected Willem de Kooning (a New York abstract expressionist who had achieved superstar status, largely through his "woman" paintings), Diebenkorn, Oliveira, Theodore Roszak, and twenty other European and American artists who used figural motifs to express the anxiety and solitude of contemporary life. Selz compared their work to the writings of existentialist philosophers Camus, Heidegger, and Kierkegaard, and concluded, "These artists are aware of anguish and dread, of life in which man—precarious and vulnerable—confronts the precipice, is aware of dying as well as living."[103] He included two artists—Richard Diebenkorn and Nathan Oliveira from the San Francisco Bay area—whose paintings confirmed the relevance of human and landscape subject matter in vanguard contemporary art.

For *Sixteen Americans,* Dorothy Miller chose artists whose work was ironic and, if not optimistic, at least less fatalistic than were the paintings and sculpture featured in *New Images of Man*. As in the previous *Americans* exhibitions, her selection was not entirely homogeneous. Louise Nevelson's beautiful totemic forms were featured, as were American flags, numbers, and targets painted by Jasper Johns and five of Robert Rauschenberg's combine paintings (in one a stuffed pheasant was perched atop the canvas). The introduction of commercial imagery and junk, along with austere black paintings by Frank Stella and sweeping, hard-edged geometric forms by Jack Youngerman and Ellsworth Kelly were evidence that several new avant-gardes were emerging.

NEW FORMS—NEW MEDIA

The *New Forms—New Media* exhibition at Martha Jackson's gallery in the summer and fall of 1960 was even more startling (figs. 24, 25, and 26). *Arts Magazine* reporter Rosalind Constable was writing a story on what she called the new 'junk' artists, who were exhibiting at a small gallery downtown. "In the course of a discussion with Martha," Constable recollected, "she decided to bring the Junk artists uptown. It was a bold step."[104] The exhibition (the first part opened in June, the second in October) included future pop artists Jim Dine, Robert Indiana, and Claes Oldenburg, Happenings impresario Allan Kaprow, and Ronald Bladen and Dan Flavin, who would soon be described as minimalists.

24, 25, 26

Installation photos, *New Forms—New Media* exhibition, Martha Jackson Gallery, 1960, Rudolph Burckhardt, photographer, Courtesy of the Martha Jackson Gallery Archives, UB Anderson Gallery, Buffalo, NY, © 2008 Estate of Rudy Burckhardt/Artists Rights Society (ARS), New York

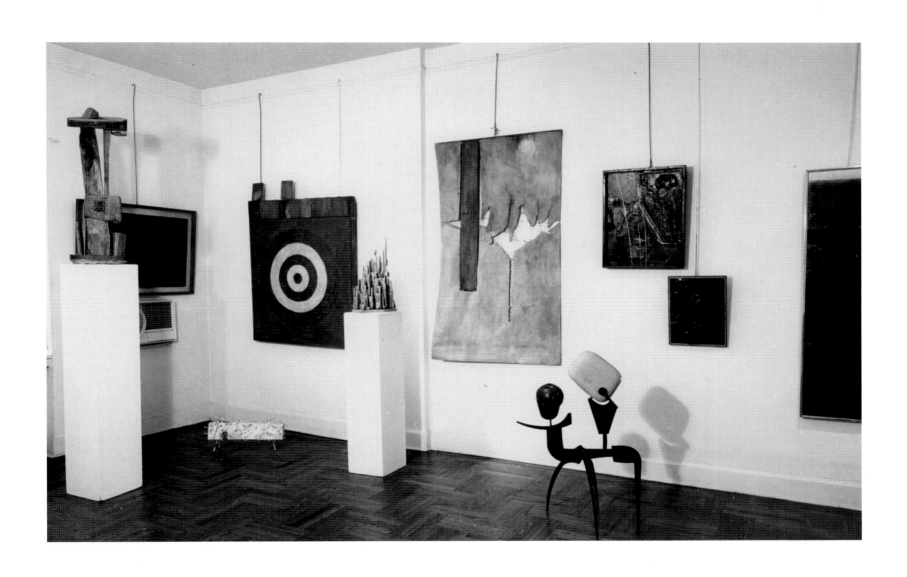

Jackson (fig. 27) had opened her gallery in 1953, initially to feature American art and to provide an opportunity for out-of-towners unfamiliar with the New York scene to visit a gallery without feeling intimidated. At first she focused on American art of the previous hundred years—cowboy artist Charles Russell, early modernists Charles Burchfield and John Marin, and realist Andrew Wyeth, among them—then expanded the program to include European artists as well. She gave Sam Francis and Jim Dine their first New York shows, and in 1957, in an exhibition called *Salute to Modern Art*, showed abstract expressionists Robert Motherwell, Jackson Pollock, and Willem de Kooning. An adventurous woman of catholic tastes, Jackson openly welcomed black artists at a time when race relations were tense. She showed paintings by Eldzier Cortor, Bob Thompson, and Emilio Cruz, who remembered her as "a woman who knew no prejudice at a time when racism in the art world would have gone unnoticed. She

gave opportunity based on merit or perhaps magic, what reached inside of her and unraveled her inner core."[105]

Press coverage of *New Forms—New Media* was extensive.[106] *Esquire* noted, "The variety of the junk, or new media, pressed into the service of the new art, made the plush Martha Jackson Gallery look like a swap shop."[107] CBS television reported on the show, as did a number of national magazines. But the exhibition angered John Canaday of the *New York Times*. On his way to the gallery, Canaday had passed protestors demonstrating against Soviet Premier Nikita Khrushchev's appearance that day at the United Nations. When he arrived at the gallery, he was appalled at what he considered the trivial nature of the art in *New Forms—New Media*.

Relations with the Soviet Union had been tense for several years. In August 1957, the Soviet Union had fired a long range intercontinental ballistic missile that Russian officials boasted could wreak death and destruction

on their opponents. The successful launch of *Sputnik* in October 1957 had put the United States on notice that it was losing the race for science and space.[108] In May 1960, a month before the first *New Forms—New Media* show opened, an American U-2 spy plane, initially identified by the White House as a "weather reconnaissance" craft, was shot down over Soviet airspace, and many believed the United States was close to war. In light of these events, Canaday could find no moral justification for the work in *New Forms—New Media*. He was ashamed, he wrote, to stand in a gallery that showed work by "a bunch of artists playing at sticking string on paper and spraying it white...at cutting out crudely drawn paper dolls and hanging them from chicken wire, at ripping old nylon stockings and stretching them across odds and ends of wire or stuffing them with trash." "You knew," he wrote, "that not far away from you [referring to the United Nations] men from all over the world were trying to find means

to preserve their countries, their continents
and their world, possibly even our planet."[109]

The transgression against good taste that
Jackson launched with the *New Forms—New
Media* shows was exacerbated when she
opened *Environments, Situations, Spaces* in
May, 1961. The show featured just six artists:
George Brecht, Jim Dine, Walter Gaudnek,
Allan Kaprow, Claes Oldenburg, and Robert
Whitman, each of whom created an installa-
tion or event. Claes Oldenburg installed *The
Store*; Robert Whitman built a fisherman's
shack that was draped with yards of paint-
spattered loose cloth. Allan Kaprow created
an installation he called *The Yard* (fig. 28),
which involved filling the gallery's courtyard
with truck tires from a junkyard.

'POP' GOES THE NEW ART

If Jackson's *New Forms—New Media* and *Environments, Situations, Spaces* struck a major blow against 1950s abstraction, Sidney Janis's *The International Exhibition of the New Realists* (figs. 29, 30, and 31), which opened on Halloween night 1962, delivered the coup de grâce. Pictures of beer bottles and Brillo boxes, an old stove, a seven-foot comic-strip-like image of a fighter plane, a riff on a paint-by-numbers image—everything about the artworks in the show flew in the face of ideas about the primacy of the autographic gesture and the concept of a painting as an independent object, which Harold Rosenberg and Clement Greenberg had argued for the previous decade. Janis included artists from England, France, Italy, and Sweden, but it was the American work that stole the show.[110] Jim Dine positioned a push lawnmower on a pedestal in front of a partially painted canvas; James Rosenquist exercised his skill as a billboard painter in oversized images of automobiles, tires, Franco-American spaghetti, and

a painted bird's head; Tom Wesselmann used magazine images of Del Monte tomato sauce cans, a telephone, a hamburger, and potato chips in a still life of middle-class consumer objects. Even the painterly Bay Area artist Wayne Thiebaud transgressed with a canvas showing slices of pie, cantaloupe wedges, and sandwiches with crusts neatly trimmed off arrayed on a luncheonette counter.

Many of the paintings were large. The Thiebaud canvas was six feet wide; *Blam*, Roy Lichtenstein's fighter plane picture, was slightly larger. Rosenquist's *I Love You with My Ford* stretched across eight feet of wall; George Segal's *The Dinner Table*, with white plaster figures sitting in real chairs around a real table, was literally human in scale. To accommodate the show's size, Janis rented an empty store across Fifth Avenue from the gallery. Passersby had to look past a hanging Oldenburg sculpture of brightly painted women's underwear, to see the installation through the shop's plate glass window.

The show "hit the New York art world with the force of an earthquake," according to

Harold Rosenberg.[111] *New York Times* critic Brian O'Doherty remarked on the works' wit, irony, and wisecracking sophistication, and concluded, "With this show, 'pop' art is officially here."[112] Although criticism was predictably mixed, Hess declared that the exhibition was "an implicit proclamation that the New had arrived and that it was time for the old fogies to pack."[113] *The International Exhibition of the New Realists* was a risky venture for Janis.[114] Although Dine, Oldenburg, Segal, and Wesselmann soon joined the gallery, the abstract expressionists who showed with Janis felt betrayed. Gottlieb, Guston, Motherwell, and Rothko withdrew from the gallery in protest. Only de Kooning stayed, although Janis later surmised that had Pollock and Kline been alive, they, too, would have remained.[115]

Within a year, pop art had been featured in major exhibitions at the Guggenheim (*Six Painters and the Object*) and Oakland (*Pop Art USA*) museums, the Pasadena Art Museum (*The New Painting of Common Objects*), The Nelson Gallery of the Atkins Museum in Kansas City (*Popular Art*), the Contemporary

29, 30, 31

Installation photo, *The New Realists* exhibition, Sidney Janis Gallery, 1962, Jim Strong, photographer, © Jim Strong, Courtesy Carroll Janis Inc.

Installation photo, *The New Realists* exhibition, Sidney Janis Gallery, 1962, Eric Pollitzer, photographer, © Eric Pollitzer, Courtesy Carroll Janis Inc.

Installation photo, *The New Realists* exhibition, Sidney Janis Gallery, 1962, Eric Pollitzer, photographer, © Eric Pollitzer, Courtesy Carroll Janis Inc.

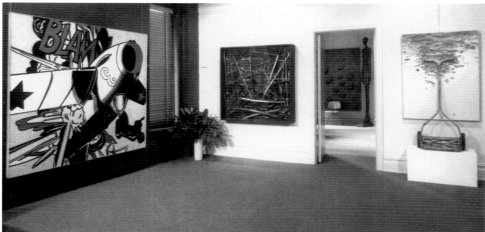

Art Museum in Houston (*Pop Goes the Easel*), the Washington Gallery of Modern Art (*The Popular Image Exhibition*), and the Los Angeles County Museum of Art (*Six More*). Dorothy Miller's last *Americans* show, *Americans 1963*, with Robert Indiana, Marisol, Oldenburg, and Rosenquist, was a de facto endorsement of pop.[116] Newer galleries and younger dealers— Leo Castelli, Allan Stone, André Emmerich, and Richard Bellamy (of Green Gallery)—signed Robert Indiana, Oldenburg, James Rosenquist, George Segal, Tom Wesselmann, as well as minimalists Robert Morris, Frank Stella, and Anne Truitt. Collectors vied for the new work. Tom Wesselmann remembered that, starting with Janis's *New Realists* exhibition, money "just came roaring in . . . everything I did we could sell."[117] Although Harold Rosenberg remarked, "Abstract Expressionism may not be as dead as we keep being told it is," Clement Greenberg lamented that purity was crumbling in the face of pop art.[118] He need not have worried. "The movement," as Sam Kootz had called it, not only survived, it flourished.

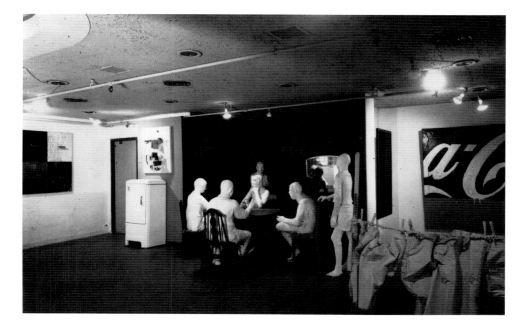

CANONIZING POSTWAR ABSTRACTION

In 1962, S. C. Johnson and Son, Inc., familiarly known as the Johnson Wax Company, hired dealer Lee Nordness to assemble a collection of work by the nation's top artists and provided an eye-popping budget of $750,000, the "largest single industrial investment in art to date" by an American corporation. Herbert F. Johnson, the company's forward-looking chairman, had previously commissioned Frank Lloyd Wright to build a corporate headquarters in Racine, Wisconsin, that was widely hailed as an architectural landmark. Hoping to do something with contemporary art that would have a similar impact, he approached Nordness, who was assembling images for a book on contemporary American art. Nordness showed his selections to Johnson and was stunned when Johnson asked him to buy all 102 paintings.

The collection, called *Art USA Now*, was a smorgasbord of recent art. Canvases by the country's leading figurative artists and abstractions by prewar masters joined geometric and abstract expressionist canvases as well as work by several younger artists—Ellsworth Kelly, Robert Rauschenberg, and Jack Youngerman among them. Albers's *Homage to the Square–Insert*, Gottlieb's *Three Discs*, Guston's *Painter III*, and Oliveira's *Nineteen Twenty-Nine*—all pictured in this catalogue—as well as works by Kline, de Kooning, Mitchell, and other midcentury abstract painters joined Paul Cadmus's satirical *Bar Italia*, Edward Hopper's enigmatic *People in the Sun*, Stuart Davis's jazzy *Int'l Surface No. 1*, Georgia O'Keeffe's lyrical *Only One*, and dozens of other canvases to reveal the breadth and range of American art. Intended as a survey, the collection ignored the notion that each new "style" supplanted previous ones and instead revealed the enormous range of artistic styles in the United States around 1960.

After a 1962 debut in Milwaukee, the collection embarked on a five-year international tour sponsored by the United States Information Agency.[119] *Art USA Now* presented paintings by abstract expressionists, postwar artists who preferred structure and geometric order, and those for whom the figure offered an avenue for probing the human psyche, treating all of them as full partners with preceding generations in the American artistic enterprise. According to USIA director Edward R. Murrow, the collection confirmed the significance of art in American society and its potential for healing a wounded world. In 1964, he wrote, "We rely on the artist to record human experiences in the context of the times." For perhaps the first time in the country's history, abstract artists and their figurative contemporaries could no longer be considered parochial or isolationist. Instead they reflected experiences that represented, in Murrow's words, "the stuff of a true common bond of understanding among all peoples."[120] The postwar abstract artists had raised the bar. America had at last entered the canon of international art.

NOTES

1 H. H. Arnason, *Vanguard American Painting* (New York: The Guggenheim Museum, 1962).

2 Abstract artists who had been associated with pioneering modernist dealer Alfred Stieglitz, among them Arthur Dove and Georgia O'Keeffe, continued to make abstract paintings and sculpture throughout the Depression and war years. In 1936, a group called the American Abstract Artists joined forces to hold exhibitions of their work. See John R. Lane and Susan C. Larsen, *Abstract Painting and Sculpture in America, 1927–44* (Pittsburgh: Carnegie Institute Museum of Art in assoc. with Harry N. Abrams, 1984); Virginia M. Mecklenburg, *American Abstraction 1930–45: The Patricia and Phillip Frost Collection* (Washington, DC: National Museum of American Art, Smithsonian Institution, 1989); and Susan E. Strickler and Elaine D. Gustafson, *The Second Wave; American Abstraction of the 1930s and 1940s* (Worcester, MA: Worcester Art Museum, 1991) for histories of American abstract art during the 1930s and 1940s.

3 *Time*, Dec. 24, 1934, 24.

4 Fritzi Weisenborn, quoted in "Knocking Wood," *Art Digest* 17, no. 5 (Dec. 1, 1942): 12. See also Wanda Corn, *Grant Wood* (New Haven: Yale University Press, 1983), 60–61.

5 Art of This Century, press release, n.d. (about Oct. 20, 1942), New York Public Library Pamphlet Box, Archives of American Art, Smithsonian Institution, Washington, DC, microfilm N-429: 159–60 (see pl. 59a and b), quoted in Susan Davidson, "Focusing an Instinct: The Collection of Peggy Guggenheim," in *Peggy Guggenheim and Frederick Kiesler: The Story of Art of This Century*, ed. Susan Davidson and Philip Rylands (New York: Guggenheim Museum Publications, 2004), 77. Guggenheim had spent twenty years abroad, first in Paris and later in London, where, in 1938, she opened Guggenheim

Jeune Gallery. She returned to New York with her collection in the summer of 1942.

6 Alfred Stieglitz, who had been the leading dealer for early twentieth-century art, died in 1946. Edith Halpert, who had opened an important gallery in the 1920s, continued to show Stuart Davis, Charles Sheeler, and other modernists who had come to prominence in the 1920s.

7 The 1943 collage exhibition marked an important debut for William Baziotes, David Hare, Robert Motherwell, Jackson Pollock, and Ad Reinhardt. Baziotes sold his first work from the collage show to collector Saidie May of Baltimore. See Jasper Sharp, "Serving the Future: The Exhibitions at Art of This Century," in Davidson and Rylands, *Peggy Guggenheim*, 295.

8 William Baziotes, quoted in Donald Paneth, "William Baziotes: A Literary Portrait," William and Ethel Baziotes papers, 1916–1922, microfilm N70-21, Archives of American Art, Smithsonian Institution, Washington, DC. See also Sharp, "Serving the Future," 309.

9 "Art of This Century Sales of Art Works for the Year Ended December 31, 1944," Bernard and Rebecca Reis papers, Research Library and Special Collections, The Getty Institute, Los Angeles, quoted in Sharp, "Serving the Future," 310.

10 Clement Greenberg, "Art," *The Nation* 159, Nov. 11, 1944, 599, quoted in Sharp, "Serving the Future," 311.

11 Kootz was described as a "businessman with a discerning eye and a gambler's daring" who had a law degree, spent eleven years in advertising, and commissioned designs for the silk fabric industry. He was also a writer, who published plays, mystery stories, and articles and books on art. His *Modern American Painters* (New York: Brewer & Warren) came out in 1930, and his articles on Preston Dickinson, Charles Sheeler's River Rouge Plant photographs,

and Edward Steichen were published in the magazine *Creative Arts* in 1931 and 1932. He argued against art as the patriotic manifestation of national culture at the expense of a wider international view in a *New York Times* article "America Uber Alles," Dec. 20, 1931, X11 and reprinted as "Uber Alles?" in *Art Digest* 6, no. 7 (Jan. 1, 1932): 7–8, prompting responses from painters Thomas Donnelly and James A. Porter. See "What is American Art?," *New York Times*, Dec. 27, 1931, 100. Kootz's book *New Frontiers in American Art* (New York: Hastings House, 1943)—which illustrated paintings by Thomas Hart Benton, Stuart Davis, Charles Demuth, Philip Evergood, Balcomb Greene, William Gropper, Marsden Hartley, Yasuo Kuniyoshi, John Marin, Irene Rice Pereira, Charles Sheeler, Grant Wood, and others—presented a broad stylistic range.

12 Edward Alden Jewell, "Picasso Puts Spice into City Galleries," *New York Times*, Jan. 29, 1947, 23.

13 Robert Motherwell, quoted in "Artworld: Samuel M. Kootz, 1899–1982," *Art in America* 70, no. 10 (Nov. 1982): 174.

14 Thomas B. Hess, "Seeing the Young New Yorkers," *ARTnews* 49, no. 3 (May 1950): 23, quoted in Harry F. Gaugh, *The Vital Gesture: Franz Kline* (New York: Abbeville Press in assoc. with the Cincinnati Art Museum, 1985), 88, 90.

15 In an interview with Dorothy Seckler on July 17, 1963, Nathan Halper suggested Motherwell and Gottlieb left over disagreements with Kootz about financial matters. See Archives of American Art, Smithsonian Institution, Washington, DC, online transcript, www.aaa.si.edu/collections/oralhistories/transcripts/halpert63.htm.

16 Samuel Kootz, interview with Dorothy Seckler, Apr. 13, 1964, Archives of American Art, Smithsonian Institution, Washington, DC, online transcript, www.aaa.si.edu/

collections/oralhistories/transcripts/ Kootz64.htm.

17 Parsons had determined to become an artist after seeing the 1913 Armory Show as a teenager. She moved to Paris in the early 1920s and spent ten years studying sculpture and getting to know avant-garde expatriates, among them Alexander Calder, Man Ray, Gertrude Stein, and Gerald and Sara Murphy. Her career as a dealer began in 1940 when the owner of Wakefield's, a New York bookstore, invited her to organize art exhibitions. Between 1941 and 1944, Parsons exhibited work by Joseph Cornell, Adolph Gottlieb, Theodoros Stamos, and Saul Steinberg in the shop's basement gallery. In 1945, she introduced Hofmann, Ad Reinhardt, and Mark Rothko in a short-lived modern department she ran at Mortimer Brandt's old master gallery. While running her gallery, she showed her own artwork at Midtown Gallery. See Calvin Tomkins, "Profiles: A Keeper of the Treasure," *The New Yorker*, June 9, 1975, 44–45.

18 Sharp, "Serving the Future," 342.

19 Tomkins, "Keeper of the Treasure," 45.

20 Charles Egan, interview with Harry F. Gaugh, Mar. 11, 1970, quoted in Gaugh, *The Vital Gesture*, 87.

21 Janis launched a successful men's shirt manufacturing business, retired early, and began collecting art in the 1920s. In 1935, his collection—which included paintings by Léger, Matisse, Picasso, a Mondrian he had purchased from the Dutch artist's studio in 1932, an early painting by de Chirico, and a 1929 Dalí—was shown at the Museum of Modern Art. During his collecting years, he met many of the European artists who fled to the United States at the outset of World War II, and renewed the friendships when they arrived in New York. He edited a surrealist publication and helped organize *The First Papers of Surrealism*, a 1942 exhibition that introduced the émigré

Europeans to New York. His book *Abstract and Surrealist Art in America* (New York: Reynal & Hitchcock, 1944) was a seminal contribution to early scholarship, and his volume *Picasso: The Recent Years, 1939–46* (Garden City, NY: Doubleday, 1946) was widely praised as an important contribution to the literature on postwar modernism.

22 Grace Glueck, "Sidney Janis, Trend-Setting Art Dealer, Dies at 93," *New York Times*, Nov. 24, 1989, D8. For background on Janis's life, see Richard F. Shepard, "Janis Gives $2-Million in Art to Modern Museum," *New York Times*, June 17, 1967, 1.

23 Pierre Matisse Gallery, Julien Levy Gallery, J. B. Neuman's New Art Circle, and more than a dozen others also advertised paintings, prints, and sculpture by European masters.

24 Robert Storr, *Philip Guston* (New York: Abbeville Press, 1986), 39.

25 Hess had been a brilliant student at Yale University, where he majored in the art, literature, and history of seventeenth-century France. He embraced modernism when working for Alfred H. Barr Jr. and Dorothy C. Miller at the Museum of Modern Art in the summer and fall of 1942. After serving as a pilot during World War II, he returned to New York and joined the *ARTnews* staff, where he was named executive editor in 1949. John Russell, "Thomas Hess, Art Expert, Dies; Writer and Met Official Was 57," *New York Times*, July 14, 1978, B2.

26 Thomas B. Hess, *Abstract Painting: Background and American Phases* (New York: Viking, 1951), 14–15.

27 See, for example, Elaine de Kooning, "Hans Hofmann Paints a Picture," *ARTnews* 48, no. 10 (Feb. 1950): 38–41, 58–59; Elaine de Kooning, "Albers Paints a Picture: Homage to the Square," *ARTnews* 49, no. 7 (Nov. 1950): 40–43, 57; and Fairfield Porter,

"Rivers Paints a Picture: Portrait of Berdie," *ARTnews* 52, no. 9 (Jan. 1954): 56–59, 81–83.

28 After the demise of the WPA, Rosenberg worked for the government's Office of War Information and served as a consultant to the Treasury Department. He joined the faculty of the University of Chicago as a professor of social thought in 1966 and in 1967 began writing for *The New Yorker*. See John Russell, "Harold Rosenberg Is Dead at 72, Art Critic for The New Yorker," *New York Times*, July 13, 1978, D16.

29 Harold Rosenberg, "The American Action Painters," *ARTnews* 51, no. 8 (Dec. 1952): 22–23.

30 Michael Kimmelman, "The Art Critic Whose Viewpoint Remains Central," *New York Times*, May 10, 1994, C18. Greenberg settled in New York after graduating from Syracuse University in 1930. He made an unsuccessful stab at the wholesale dry-goods business, then taught himself Latin, German, French, and Italian and found work as a book translator. In 1937, he took a job with the U.S. Customs Service, where, during idle moments on the job, he wrote essays he submitted to *Partisan Review*. "Avant-Garde and Kitsch," which appeared in 1939, and "Towards a Newer Laocoön," the following year, influenced subsequent generations of artists and art historians. *Art and Culture*, a 1961 compilation of his essays, became an overnight classic. His advocacy of Color-Field painters Morris Louis and Jules Olitsky is now legendary.

31 Clement Greenberg, quoted in Raymond Hernandez, "Clement Greenberg Dies at 85; Art Critic Championed Pollock," *New York Times*, May 8, 1994, 38.

32 Alexander Eliot who wrote without a byline for *Time*, Robert Coates of *The New Yorker*, and many others covered art exhibitions around the country.

33 Barnett Newman, statement for exhibition brochure, "The Ideographic Picture," Betty Parsons Gallery, 1947.

34 E. A. Jewell, "New Phase in Art Noted At Display," *New York Times*, Jan. 23, 1947, 21.

35 Jewell, "Cézanne Tops List," *New York Times*, Mar. 30, 1947, X10.

36 Samuel M. Kootz Gallery, *The Intrasubjectives*, exh. cat. (New York: Samuel M. Kootz Gallery, 1949).

37 "Into the Void," *Time*, Oct. 3, 1949, 38.

38 Sam Hunter, "The Archaic, Fantasy and Realism," *New York Times*, Feb. 1, 1948, X8;

39 "Jackson Pollock: Is He the Greatest Living American Painter?" *Life*, Aug. 8, 1949, 42–43.

40 Aline B. Louchheim, "A Partial View," *New York Times*, Sep. 18, 1949, X12.

41 For *Time*'s reaction to the Whitney Annual, see "Handful of Fire," *Time*, Dec. 26, 1949, 26. The 1950 Venice Biennale was jointly organized by the Museum of Modern Art and the Art Foundation of New York. The other artists were Hyman Bloom, Lee Gatch, Rico Lebrun, and John Marin. Alfred Barr and Alfred Frankfurter were among those selecting the artists. See *Time*, "What's in Fashion," June 12, 1950, 50.

42 "Vincent Van Gogh: The Dutch Master of Modern Art Has His Greatest American Show," *Life*, Oct. 10, 1949, 82–88, 90.

43 "The Old Men of Modern Art," *Life*, Dec. 12, 1949, 87–92. Also featured in the article were Jean Arp, Marc Chagall, Raoul Dufy, Maurice de Vlaminck, and Ossip Zadkine. Abstract art, even that by an artist as famous as Picasso, was an acquired taste for many Americans.

44 Lloyd Goodrich, *Pioneers of Modern Art in America* (New York: Whitney Museum of American Art, 1946), 17–18.

45 "The Great Armory Show of 1913," *Life*, Jan. 2, 1950, 58. In the months that followed, *Life* embraced modernism in articles ranging from contemporary furniture design, Henri Toulouse-Lautrec, Marino Marini (a "best seller" in the U.S.), Richard Lippold, John Marin, and the decoration of a church in Assy, France by abstract artists. See *Life*, "Prize-Winning Furniture," May 8, 1950, 98–100; George P. Hunt, "Toulouse-Lautrec," May 15, 1950, 93–100; "Marino Marini," May 22, 1950, 99–102; "Moon Sculpture," June 12, 1950, 50–60; "John Marin," July 10, 1950, 62–65; and "The Assy Church," June 19, 1950, 72–76.

46 Russell Lynes, "High-Brow, Low-Brow, Middle-Brow," *Life*, Apr. 11, 1949, 99–101.

47 The exhibition presented artists associated with Alfred Stieglitz's 291 Gallery, along with precisionist images by Charles Sheeler, nonobjective and expressionistic compositions by members of the American Abstract Artists, and the jazzy, cubist-inspired semiabstractions of Stuart Davis.

48 George A. Dondero, in a speech before the 81st Congress, Second Session, House Committee on Foreign Affairs, *Congressional Record*, Aug. 16, 1949, 11581, 11585, quoted in Helen M. Franc, "The Early Years of the International Program and Council," in *The Museum of Modern Art at Mid-Century: At Home and Abroad*, ed. John Elderfield (New York: The Museum of Modern Art, 1994), 115. See also Gary O. Larson, *The Reluctant Patron: The United States Government and the Arts, 1943–1965* (Philadelphia: University of Pennsylvania Press, 1983).

49 "Museums Demand Freedom for Arts: Manifesto on Modern Work Cites Its Broad Influence, Defines Exhibitor's Role," *New York Times*, Mar. 28, 1950, 33.

50 "The Revolt of the Pelicans," *Time*, June 5, 1950, 54.

51 *American Art Today, 1950* featured 307 paintings from around the country. Many leading figurative artists—Edward Hopper, Reginald Marsh, Andrew Wyeth, and others—were selected, as were Will Barnet, Mark Tobey, and a host of other abstract and semiabstract painters.

52 "Irascible Group of Advanced Artists Led Fight Against Show," *Life*, Jan. 15, 1951, 34. Gottlieb, who served as the group's spokesman, arranged with Dorothy Seiberling, *Life's* art editor, for a photograph session. He later said that *Life* "wanted us to come to the steps of the Metropolitan Museum with paintings under our arms and to stand there and be photographed. So we said, we don't mind being photographed, but we're not going to be photographed that way...because that would look as if we were trying to get into The Metropolitan and we were being turned down on the steps." So the photograph was taken in *Life's* Forty-Fourth Street studio. The fifteen artists in the photograph were Willem de Kooning, Adolph Gottlieb, Ad Reinhardt, Hedda Sterne, Richard Pousette-Dart, William Baziotes, Jackson Pollock, Clyfford Still, Robert Motherwell, Bradley Walker Tomlin, Theodoros Stamos, Jimmy Ernst, Barnett Newman, James Brooks, and Mark Rothko. Missing were Hans Hofmann, Franz Bultman, and Weldon Kees, who were out of town the day of the shoot. See Mary David MacNaughton, "Adolph Gottlieb: His Life and Art," in *Adolph Gottlieb, A Retrospective*, Lawrence Alloway, Sanford Hirsch, and Mary Davis MacNaughton (New York: The Arts Publisher in assoc. with the Adolph and Esther Gottlieb Foundation, 1981), 47–49 for a detailed discussion of Gottlieb's involvement in Studio 35 and the "Irascibles" protest. Sam Kootz invited some of the Irascibles as would agree to participate in a group show at his gallery at the time of the Met's exhibition. See Kootz, letter to Ad Reinhardt, June 16, 1950, Ad Reinhardt papers, Archives of American Art, Smithsonian Institution, Washington, DC, microfilm reel N69-100: 428.

53 Ibram Lassaw, interview with Irving Sandler, Aug. 26, 1968, Archives of American Art, Smithsonian Institution, Washington, DC, quoted in Nancy Gale Heller, "The Sculpture of Ibram Lassaw," (PhD dissertation, Rutgers University, 1982), 164.

54 The space occupied by Subjects of the Artists was taken over in the fall of 1949 by three New York University instructors, Robert Inglehart, Tony Smith, and Hale Woodruff, who continued lectures and discussions under the name Studio 35.

55 For accounts of the founding and history of The Club, see Bruce Altshuler, *The Avant-Garde in Exhibition* (New York: Abrams, 1994), 156–73; Heller, "The Sculpture of Ibram Lassaw," 164–65; Irving Sandler, "The Club," *Artforum* 4, no. 1 (Sep. 1965): 27–31; and L. Alcopley, "the club," *Issue, A Journal for Artists* 4 (1984): 45–47.

56 Thomas Hess, "New York's Avant-Garde," *ARTnews* 50, no. 4 (Summer 1951): 46–47.

57 See Marika Herskovic, ed., *New York School, Abstract Expressionists: Artists Choice by Artists, A Complete Documentation of the New York Painting and Sculpture Annuals: 1951–1957* (New Jersey: New York School Press, 2000) for an exceptional and thorough history of the Stable annuals. See also Marika Herskovic, *American Abstract Expressionism of the 1950s: An Illustrated Survey, With Artists' Statements, Artwork and Biographies* (New York: New York School Press, 2003) for a carefully researched and beautiful volume on the New York artists whose work was featured in exhibitions of abstract expressionism in the 1950s.

58 Altshuler, *The Avant-Garde in Exhibition*, 166.

59 Early shows at the Museum of Modern Art included retrospectives of van Gogh, Matisse, Picasso, Klee, Odilon Redon, Toulouse-Lautrec, and Henri Rousseau and survey exhibitions featuring modern German painting, International Style architecture, and the Bauhaus. Solo exhibitions of American artists featured Charles Burchfield, Edward Hopper, and Max Weber. A survey of American "romantic" painters featured Thomas Eakins, Winslow Homer, and Albert Pinkham Ryder. Exhibitions of primitive art, industrial design, and folk art complemented the museum's presentation of European movements and masters. A 1943 show of Morris Hirshfield's paintings that Sidney Janis organized for the Museum of Modern Art resulted in Barr's being fired from his post as director, although he remained on the staff for two more decades.

60 In 1936, the Museum of Modern Art organized *Cubism and Abstract Art*, a survey exhibition tracing the history of cubism and other vanguard European movements. Important in exposing the history of European modernism, the exhibition ignored Americans, with the exception of Alexander Calder and Stuart Davis. Picketing American abstract artists handed out flyers designed by Ad Reinhardt titled "How Modern is the Museum of Modern Art?"

61 After graduating from Smith College, Miller worked at the Newark Museum, where she met her future husband Holger Cahill. She was initially hired at the Modern in 1932, when Barr was on leave in Europe. In 1934, he asked her to handle liaison with contemporary artists, and by 1942, she knew many of the most prominent and promising artists in the country. See Lynn Zelevansky, "Dorothy Miller's 'Americans,' 1942–63," in *The Museum of Modern Art at Mid-Century*, ed. Elderfield, 67. Zelevansky's essay is a fascinating and thorough discussion of the contents, difficulties, decisions, and impact of this important series of exhibitions.

62 *Americans 1942, Eighteen Artists from Nine States*, included Darrel Austin, Hyman Bloom, Raymond Breinin, Samuel Cashwan, Francis Chapin, Emma Lu Davis, Morris Graves, Joseph Hirsch, Donal Hord, Charles Howard, Rico Lebrun, Jack Levine, Helen Lundeberg, Fletcher Martin, Octavio Medellin, Knud Merrild, Mitchell Siporin, and Everett Spruce. Many of the works in the "Americans" shows were for sale. See Zelevansky, "Dorothy Miller's 'Americans,'" 94–97 for lists of paintings and sculpture from each show that were purchased by or for the Museum of Modern Art.

63 *Fourteen Americans* actually included fifteen artists. In addition to those mentioned here, David Aronson, Ben L. Culwell, Loren MacIver, Isamu Noguchi, I. Rice Pereira, C.S. Price, Mark Tobey, and George Tooker were featured. Tooker was added after the catalogue went to press. See Zelevansky, "Dorothy Miller's 'Americans,'" 65.

64 Clement Greenberg, *The Nation*, Nov. 23, 1946, 594, quoted in Zelevansky, "Dorothy Miller's 'Americans,'" 67.

65 The other artists were Edward Corbett, Edwin Dickinson, Joseph Glasco, Herbert Katzman, Irving Kriesberg, Herman Rose, and Thomas Wilfred.

66 Alfonso Ossorio wrote Pollock's statement; collector Edward Root provided the entry for Tomlin. Catalogues for the *Americans* exhibition series are compiled in Dorothy C. Miller, ed., *Americans 1942–1963: Six Group Exhibitions* (New York: Museum of Modern Art and Arno Press, 1972 reprint). In the *Fifteen Americans* section, Pollock and Tomlin's statements appear on pages 15–16, and 24. After *Fifteen Americans*, the next in the series, *Twelve Americans*, opened in May 1956. For the first time, the differences among the artists were less apparent than the similarities. Expressionist canvases by James Brooks, Sam Francis, Guston, Hartigan, Kline, and the younger Ernest Briggs were featured, as were paintings by Swiss-born Fritz Glarner, whose colorful geometries owed a debt to Piet Mondrian. The abstract sculptors Lassaw, Lipton, and José de Rivera

Jackson Pollock, Clement Greenberg, Helen Frankenthaler, and Lee Krasner (left to right) with an unidentified child at the beach, about 1952, Courtesy of the Jackson Pollock and Lee Krasner papers, about 1905–1984, Archives of American Art, Smithsonian Institution

complemented stylized figural wood and marble creations by Raoul Hague. Among the group, Larry Rivers, whose installation included the figurative *Double Portrait of Berdie* from the Whitney's collection and his brushy interpretation of *Washington Crossing the Delaware* that the Museum of Modern Art had purchased in 1953, was the odd man out. (Miller also invited Joseph Cornell, who accepted, but later withdrew because he lacked sufficient time to complete his installation). See Zelevansky, "Dorothy Miller's 'Americans,'" 75.

67 Henry McBride, "Half Century or Whole Cycle?," *ARTnews* 51, no. 4 (Summer 1952): 135, quoted in Zelevansky, "Dorothy Miller's 'Americans.'" See also, Zelevansky, "Dorothy Miller's 'Americans,'" 73, 75.

68 Holger Cahill Oral History, Columbia University, New York, transcript of interviews conducted by Joan Pring, Apr.–June 1957, 607, which include remarks by Miller, quoted in Zelevansky, "Dorothy Miller's 'Americans,'" 70.

69 Dorothy Canning Miller, transcript of an interview conducted by Paul Cummings, May 26, 1970–Sep. 28, 1971, Archives of American Art, Smithsonian Institution, Washington, DC, 115–16, quoted in Zelevansky, "Dorothy Miller's 'Americans,'" 65.

70 "Words & Pictures," *Time*, Mar. 8, 1954, 78. Stuart Preston, "Abstract Roundup," *New York Times*, Feb. 7, 1954, X10. Six months later, under the lead "Which way is U.S. art heading?," *Time* quoted the director of the Colorado Springs Fine Arts Center, James Byrnes, who reported that "nonobjective painting...has permeated to the grass roots. Regionalism is essentially dead....U.S. nonobjective artists are in the forefront of world painting." See "Which Way is U.S. Art Heading?" *Time*, Sep. 13, 1954, 88. *Time*'s article was prompted by the Colorado Springs Fine Arts Center's fifth biennial in which, of

fifty-nine paintings, only fourteen were described as "realistic."

71 Stuart Preston, "Abstract Roundup," *New York Times*, Feb. 7, 1954, X10.

72 "Natural Language," *Time*, Oct. 27, 1952, 90. Also see Virginia M. Mecklenburg, *Edward Hopper, The Watercolors* (New York: W. W. Norton in assoc. with the National Museum of American Art, 1999), 152–53. Although Hopper participated in the group, his work was far from ignored. Press reviews praised his work and his shows at Rehn Gallery usually sold out. For the history of the Sara Roby Foundation collection, see Virginia M. Mecklenburg, "Realist Choices: A History of the Sara Roby Foundation," in *Modern American Realism* (Washington, DC: Smithsonian Institution Press for the National Museum of American Art, 1987), 9–13.

73 Frances K. Pohl, "An American Venice: Ben Shahn and United States Foreign Policy at the 1954 Venice Biennale," *Art History* 4 (Mar. 1981): 82–83, 108.

74 "Your Money Bought These Paintings," *Look*, Feb. 18, 1947, reproduced in Margaret Lynn

Ausfeld, "Circus Girl Arrested, A History of the *Advancing American Art* Collection, 1946–1948," in Margaret Lynn Ausfeld and Virginia M. Mecklenburg, *Advancing American Art: Politics and Aesthetics in the State Department Exhibition, 1946–1948* (Montgomery, AL: Montgomery Museum of Fine Arts, 1984), 21.

75 Quoted in Ausfeld, "Circus Girl Arrested, A History of the *Advancing American Art* Collection, 1946–1948," 20.

76 Earlier efforts included a members' exhibition that toured in France, Germany, and Italy organized by the American Abstract Artists, a group formed in 1937 by painters and sculptors protesting the Modern's exhibition *Cubism and Abstract Art*. Sidney Janis assembled *American Vanguard Art for Paris Exhibition*, a show of twenty works by Albers, Baziotes, de Kooning, Gorky, Gottlieb, Guston, Hofmann, Kline, Motherwell, Reinhardt, Vicente, and several others in 1951 at the request of the Galérie de France in Paris.

77 The 1950 Venice Biennale was selected by Alfred Barr and Alfred M. Frankfurter, who

included de Kooning, Gorky, and Pollock, along with several semiabstract artists. For the São Paulo biennial in 1953, the Modern organized three shows: one featured forty-five works by Alexander Calder, the second included paintings by sixteen artists ranging from Baziotes and de Kooning to Alton Pickens and Ben Shahn, and the third showcased contemporary architecture. Franc, "The Early Years of the International Program and Council," *The Museum of Modern Art at Mid-Century*, 118–20.

78 Alfred H. Barr Jr., letter to the editor, *College Art Journal* 15 (Spring 1956): 184, quoted in Franc, "The Early Years of the International Program and Council," 116.

79 Franc, "The Early Years of the International Program and Council," 116–17.

80 Franc, "The Early Years of the International Program and Council," 123. The decision to feature Shahn again in the 1954 Venice Biennale reflects the ongoing battle for freedom of expression and the insistence of the government on political purity of artists selected to represent the country internationally. See Larson, *The Reluctant*

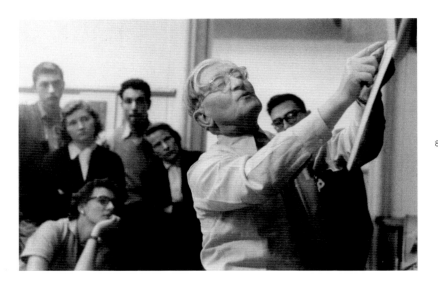

Josef Albers teaching at Yale University, 1955, John Cohen, photographer/Hulton Archive/Getty Images

Patron, 115–18. The USIA cancelled *100 American Artists of the Twentieth Century* after AFA trustees refused to remove works by ten politically suspect artists, and in 1956, *Sport in Art*, organized by AFA, sponsored by *Sports Illustrated* magazine, and scheduled to tour Australia under USIA auspices at the time of the 1956 Olympic Games was cancelled when AFA refused to pull paintings by Shahn, Leon Kroll, Kuniyoshi, and William Zorach, all of whom were cited in the HUAC's files for having leftist sympathies. The USIA also cancelled a tour of the Symphony of the Air due to alleged communist activities of several performers.

81 For a history of the Modern's international program and the involvement of trustee Nelson A. Rockefeller and various employees of the Modern with government cultural programming in the 1940s and 1950s, see Franc, "The Early Years of the International Program and Council," 109–16; and Eva Cockcroft, "Abstract Expressionism, Weapon of the Cold War," *Artforum* 12, no. 10 (June 1974): 39–41, reprinted in Francis Franscina and Jonathan Harris, eds., *Art in Modern Culture* (London: Phaidon, 1992), 82–90. Franc reports that *Twelve Modern American Painters and Sculptors* was one of a dozen shows circulating or in preparation by the International Program that year.

82 The collection of Detroit businessman Lawrence Fleischman, which toured throughout Latin America in 1955 and 1956, was a survey of some sixty-five paintings and sculptures ranging from a John Singleton Copley portrait to early modernist works by Burchfield and Marin and more recent paintings by Charles Sheeler, Edward Hopper, and Morris Graves. The press expostulated on the "rags to riches" story of the thirty-one-year-old son of poor Russian immigrants. Fleischman's family had scraped through hard years when the family lived for days on nothing but hard-boiled eggs. As a youth, he had helped his father, whose small linoleum store grew to become Detroit's largest carpet business. By 1956, Fleischman, whose patriotism was demonstrated by his service as a combat infantryman in World War II, was part owner of two television stations and a rotary-press company. Fleischman traveled to Latin America almost monthly for two years to speak at openings of his exhibition. See "Gringo Success," *Time*, Sep. 10, 1956, 101. Quotation in "Contemporaries Abroad," *Time*, July 22, 1957, 56, 61.

83 See John Bernard Myers, Letter to the Editor, *Arts Digest* 29, no. 16 (May 15, 1955): 4; John Lucas, "America's 'Salute to France,'" *Arts Digest* 29, no. 16 (May 15, 1955): 6–9; and

Franc, "The Early Years of the International Program and Council," 125.

84 "Americans in Paris," *Time*, Apr. 18, 1955, 76–77. The show "proved almost too much to take," reported the *Time* critic covering the opening events. After Paris, the show traveled to London, where the response was also mixed. Although the conservative *London Times* said that the paintings by Pollock, Still, and Motherwell "bombinate in a void," another reported that abstract expressionism is the "one development in American art…[that] has gained for the United States an influence upon European art which it has never exerted before." See "Impermanent Invasion," *Time*, Jan. 23, 1956, 72. See also "Paris is Critical of U.S. Exhibition," *New York Times*, Apr. 4, 1955, 27.

85 Other abstract and semiabstract artists were Leo Amino, Sue Fuller, Sidney Gordin, John Heliker, Herbert Katzman, William Kienbusch, Richard Lippold, and Attilio Salemme. Figurative and surrealist painters included Carlyle Brown, William Congdon, Jimmy Ernst, Joseph Glasco, Stephen Greene, Walter Murch, Bernard Perlin, Alton Pickens, Alfred Russell, Honoré Sharrer, George Tooker, and Robert Vickrey.

86 Robert Rosenblum, "The New Decade," *Arts Digest* 29, no. 16 (May 15, 1955): 21.

87 Howard Devree, "Museum Surveys Reveal Artists' Reactions," *New York Times*, May 22, 1955, 135.

88 Howard Devree, "Development Since 1920 Seen in Three Shows," *New York Times*, May 15, 1955, X9.

89 "The Lost Generation," *Time*, Oct. 24, 1955, 88. Paintings by Karel Appel, Willem de Kooning, John Hultberg, Matta, and Tamayo were illustrated.

90 Sanka Knox, "Abstract Art Is Going to Europe to Represent American Culture," *New York Times*, Mar. 11, 1958, 31.

91 Still and Rothko refused to lend, so works by them had to come from other sources. Miller relied heavily on the cooperation of Ben Heller, who had an important collection of abstract expressionism. Before the exhibition became a show of just paintings, Barr and Miller considered including sculptors Ferber, Hare, Lassaw, Lipton, Roszak, and David Smith. See Zelevansky, "Dorothy Miller's 'Americans,'" 86–87.

92 Following the format of the *Americans* shows, the catalogue included an introduction, this time by Alfred Barr, and statements by each of the artists. The American edition of *The New American Painting* (New York: Museum of Modern Art, 1959), published at the conclusion of the show, also featured excerpts from press reviews in the countries where the show toured.

93 John Russell, review of *The New American Painting*, *Sunday Times*, London, Mar. 8, 1959, quoted in Alfred Barr and Dorothy Miller, *The New American Painting*, 14.

94 Mercedes Molleda, review of *The New American Painting*, *Revista*, Barcelona, Aug. 30, 1958; and unsigned review of *The New American Painting*, *Nieuw Rotterdamse Courant*, Rotterdam, Nov. 15, 1958; quoted in Barr and Miller, *The New American Painting*, 9, 11.

95 Hilton Kramer, "The End of Modern Painting," *The Reporter*, New York City, July 23, 1959, reprinted in Clifford Ross, ed., *Abstract Expressionism: Creators and Critics, An Anthology* (New York: Abrams, 1990), 292–95. See also Zelevansky, "Dorothy Miller and the 'Americans'," 106.

96 "Boom on Canvas," *Time*, Apr. 7, 1958, 80.

97 For comparative values, see http://www. thepeoplehistory.com/1950s.

98 *It Is* had been launched in the spring of 1958 as a "magazine for abstract art" by Philip Pavia, one of The Club's founders and the

organizer of the panel discussions for the first five or six years. The magazine featured articles on abstract expressionism, statements by artists, and thought pieces by critics and art historians (among them Hess and Irving Sandler), and was liberally illustrated with reproductions, some of them in color, of recent work by dozens of abstract painters and sculptors. Five issues were published from 1958 through the 1960 issue that elicited Canaday's scorn. The lead article in the 1960 issue, "Unwanted Title: Abstract Expressionism" written by Pavia, provoked Canaday. In it Pavia retraced a series of seven panels held at The Club from mid-January to early April 1952, that addressed the terms abstract and expressionism, as used in Hess's *Abstract Painting*, which most of the artists found unacceptable.

99 *Esquire* article quotations come from John Canaday, "In the Gloaming," *New York Times*, Sep. 11, 1960, X21. Canaday described The Club as "a pustule" that rises "in that section of New York where abstract art is lived, breathed and almost literally eaten." He called Jackson Pollock The Club's Cronus, Willem de Kooning its Zeus, and Grace Hartigan, Helen Frankenthaler, and Joan Mitchell the goddesses who compete for the golden apple. "The great legend maker who serves the gods as a middleman for mortals," he continued, "is the critic Thomas B. Hess, and his lyre is the magazine ARTnews."

100 In a lengthy rejoinder two weeks later, Barr voiced objections to the article. See "Tastemaking, Mr. Barr of the Museum of Modern Art Files a General Demurrer," *New York Times*, Sep. 25, 1960, X13. Harold Rosenberg, quoted in John Canaday, "Word of Mouth: Four Abstract Painters Make a Brave Try at Explaining Their Ideas," *New York Times*, Apr. 3, 1960, X13.

101 For the history of Bay Area figuration, see Caroline A. Jones, *Bay Area Figurative Art, 1950–1965* (Berkeley: University of California Press, 1989).

102 See Sidney Tillim, "Month in Review," *Arts Magazine* 36, no. 3 (Mar. 1962): 36–41.

103 Peter Selz, introduction to *New Images of Man* (New York: Museum of Modern Art in collaboration with the Baltimore Museum of Art, 1959), 11.

104 Rosalind Constable, ""Martha Jackson: An Appreciation," *Arts Magazine* 44, no. 1 (Sep.–Oct. 1969): 18.

105 Emilio Cruz, undated [June 1981] letter to Harry Rand, curatorial files, Smithsonian American Art Museum, Washington, DC. In 1966, Jackson held an exhibition of work donated by artists for the benefit of the Congress of Racial Equality.

106 Jackson was masterful at generating press coverage. *Time* published a photograph of Jackson headlined "A Gallery of Galleries in Manhattan" in November 1962; *Mademoiselle* quoted her at length in an article on New York galleries in 1964, and she was one of six from the art world named by *Harper's Bazaar* as among "100 American Women of Accomplishment" in 1967. (The others were Helen Frankenthaler, Agnes Martin, Louise Nevelson, Georgia O'Keeffe, and Betty Parsons.)

107 Untitled art reviews, *Esquire, the Magazine for Men*, June 1961, 88, in Martha Jackson vertical file, American Art/National Portrait Gallery Library, Smithsonian Institution.

108 Harry Schwartz, "A Propaganda Triumph," *New York Times*, Oct. 6, 1957, 43.

109 John Canaday, "The Blind Artist," *New York Times*, Oct. 2, 1960, X21. In "Month in Review," *Arts* 35, no. 2 (Nov. 1960): 50, Hilton Kramer agreed: "what a bore; what an irrelevance."

110 Poet John Ashbery, who wrote the introduction for the catalogue, located the roots of new realist art in the collages of Picasso and Gris, Fauve posters, Gaudi's mosaic of broken dishes in the Parque Güéll in Barcelona, Dada and surrealist art, and Marcel Duchamp. They worked with ordinary objects precisely because they were ordinary: "a neutral language understood by everybody and therefore the ideal material with which to create experiences which transcend the objects." The artists, he explained, are "calling attention…to the ambiguity of the artistic experience; to the crucial confusion about the nature of art.…" The balance of power "seems to repose in the objects that surround us." In his preface, Janis described the artists, whose average age was about thirty, as urban folk artists who explored mass media sources. Billboards, magazine illustrations, comic strips, and daily newspapers were direct inspirations. He noted that Rivers and Rauschenberg were not included because their techniques "are less factual than they are poetic or expressionist," but lamented that Johns was not featured. The catalogue also included an excerpt from "A Metamorphosis in Nature," by French critic Pierre Restany, who had organized shows of *Nouveau Réaliste* artists Arman, Yves Klein, Martial Raysse, and Jean Tinguely in France and Italy and had helped Janis secure work for the show. See *International Exhibition of the New Realists* (New York: Sidney Janis Gallery, 1962). For a fascinating discussion of the developments leading up to the formation of the *Nouveaux Réalistes*, Sidney Janis's interactions with Restany, and a lengthier account of Janis's *International Exhibition of New Realists*, see Altshuler, *The Avant-Garde in Exhibition*, 192–219.

111 Harold Rosenberg, "The Game of Illusion: Pop and Gag," reprinted in Rosenberg, *The Anxious Object* (New York: New American Library, 1964), 58, quoted in Jean Feinberg, *Jim Dine* (New York: Abbeville Press, 1995), 16.

112 Brian O'Doherty, "Avant-Garde Revolt: 'New Realists' Mock U.S. Mass Culture in Exhibition at Sidney Janis Gallery," *New York Times*, Oct. 31, 1962, 59.

113 Thomas Hess, quoted in Altshuler, *The Avant-Garde in Exhibition*, 214–15.

114 Jeanie Deans, conversation with the author, Mar. 21, 2008.

115 Sidney Janis, in *The Art Dealers: The Powers Behind the Scene Tell How the Art World Really Works*, Laura de Coppet and Alan Jones (New York: Clarkson N. Potter, 1984), 39–40.

116 Richard Anuskiewicz, Chryssa, Lindner, and Ad Reinhardt, represented by square black paintings, were also included.

117 Tom Wesselmann, interview with Irving Sandler, Jan. 3–Feb. 8, 1984, Archives of American Art, Smithsonian Institution, Washington, DC, online transcript, http://www.aaa.si.edu/collections/oralhistories/transcripts/wessel84.htm.

118 Harold Rosenberg, "Black and Pistachio," reprinted in Rosenberg, *The Anxious Object* (Chicago: University of Chicago Press, 1966), 49, as quoted in Zelevansky, "Dorothy Miller's 'Americans,'" 85.

119 In 1963 and 1964, *Art USA Now* was seen in Milwaukee, Tokyo, Honolulu, London, Athens, Rome, Munich, Monaco, Berlin, Copenhagen, Stockholm, Milan, Brussels, Dublin, Madrid, Lucerne, Paris, and Vienna. It traveled in 1965 and 1967 to Washington, DC, Philadelphia, New York, Providence, Boston, Detroit, Minneapolis, Urbana, St. Louis, Cincinnati, Omaha, Denver, Seattle, Fresno, San Diego, Fort Worth, Des Moines, Nashville, Birmingham, Wichita, Ithaca, Coral Gables, Columbia (SC), Mexico City, and Toronto.

120 Edward R. Murrow, "Why Export Culture?" *Art in America* 50, no. 4 (1964): 86–87.

OPTICS AND ORDER

In 1962, the Whitney Museum of American Art opened an exhibition titled *Geometric Abstraction in America*. The show featured almost one hundred works by more than seventy artists who, according to the exhibition catalogue, represented a thirty-year-long movement that focused on squares, triangles, and other geometric shapes and volumes. Josef Albers was among the oldest artists represented in the show; Frank Stella, the youngest. The exhibition located the origins of the movement in Russian constructivism around World War I and in the de Stijl group of the late 1910s and 1920s, whose best known member was Dutch painter Piet Mondrian. For New Yorkers unable to travel to Europe, by the 1930s, Albert Gallatin's Gallery of Living Art, the Museum of Modern Art, and Solomon R. Guggenheim's Museum of Non-Objective Art provided opportunities to see geometric abstraction firsthand. Nevertheless, abstract artists were frustrated by their lack of exposure, and in 1936, organized the American Abstract Artists, which opened the first of many annual exhibitions the following year.

Mondrian, who immigrated to the United States in 1940 and was celebrated in a retrospective at the Museum of Modern Art in 1945, was one of the key transmitters of geometric abstraction in America. Another was Josef Albers. A teacher, for seventeen years at Black Mountain College in North Carolina and later at Yale University, Albers was unquestionably one of the most influential artists in midcentury America. In his now-famous "Homage to the Square" series, as well as published writings, Albers's ideas about mathematical proportion and the interaction of carefully controlled color were absorbed by hundreds of artists. Ilya Bolotowsky, Maurice Golubov, and Louise Nevelson, all immigrants from Russia; Esteban Vicente, who left Madrid at the start of the Spanish Civil War; Ad Reinhardt, an intellectual and graduate of Columbia University; Zen-inspired John McLaughlin in California; Anne Truitt, who transformed childhood memories into austere totemic structures; and many others developed visual vocabularies in which constructed or assembled geometric forms determined emotional content.

If geometric abstraction played a secondary role during the heyday of American scene painting in the 1930s, by the mid-1960s, it was central to the paintings of Richard Anuszkiewicz, Ellsworth Kelly, Agnes Martin, and Frank Stella, and to the sculptures of Truitt, Tony Smith, and Donald Judd. All of these artists explored the optics of color and reductive geometric forms, launching the movements now called op art and minimalism.

Maurice Golubov, *Untitled* (1948) (detail)
See page 86

Do less in order to do more.[1]

JOSEF albers

1888 | 1976

A mathematical formula seems an odd starting point for a painting. But this is precisely the way Josef Albers began laying out the more than one thousand panels he called "Homage to the Square." His strict, unforgiving formats—using several proportional combinations—reduced pictorial possibilities to a minimum.[2] Even the size of the panels he worked on for almost thirty years was limited. None was smaller than twelve by twelve inches, none larger than four feet on a side. The single variable he allowed himself was color—sometimes glorious, sometimes subdued—and the perceptual and intellectual possibilities that result when different colors are placed side by side. But Albers was no theoretician. He selected the colors for the "Homage" paintings by trying out various combinations in brushy disorderly sketches before carefully applying paint to panel.

The central form of *Homage to the Square–Insert* (1959) is yellow, surrounded by soft hues of gray. At four feet square, the painting is big for Albers. The colors are precisely noted. On the reverse of the painting he listed the pigments and varnishes he used and the names of the companies that manufactured them. Yet knowing this information does little to

explain why the painting looks sometimes like a deep room with a large yellow window against the back wall, sometimes like a yellow square framed in a shadow box, and sometimes like an aerial view of a flat-topped, gray pyramid. The issue here, as for much of Albers's work, was the mystery and unpredictability of the way the eye sees and the mind interprets images. He aimed for neutrality. The paintings have no emotional content and bear no resemblance to objects in nature. Most are painted on the toothy reverse of fiberboard panels, and he was careful to eliminate all traces of his own hand. Yet their impact varies dramatically depending on the palette he chose.

Albers began paying homage to the square in 1949, shortly after leaving his teaching post at Black Mountain College in North Carolina. He had always been a teacher. After training at art schools in Berlin, Essen, and Munich, he worked as an elementary school instructor for more than a decade. In 1920, he moved to Weimar to study at the Bauhaus, a new, innovative school of graphic and industrial design where Wassily Kandinsky, Paul Klee, László Moholy-Nagy, and other abstract painters and designers would work under the guidance of founding director Walter Gropius. After three years as a student, Albers was hired to teach the experimental introductory class in principles of design and the behavior of materials. He stayed until June 1933, when Adolf Hitler's National Socialist Party closed the school, weathering Bauhaus moves from Weimar to Dessau, and then to Berlin, and remaining steadfast to his mission even after Gropius and Moholy-Nagy left the school in 1928. In August 1933, Albers and his wife, Anni, who was an accomplished weaver, were approached by Museum of Modern Art curators Edward Warburg and Philip Johnson about teaching positions at Black Mountain College. They accepted immediately. Warburg personally paid passage for the Alberses, and the Committee to Rescue German Artists, a newly formed group of affluent Americans aware of the growing oppression in Germany, helped arrange visas and passports.[3]

At the Bauhaus, at Black Mountain College, and beginning in 1950, as chair of the department of design at Yale University, Albers systematically set problems for himself, as well as his students, in his constant search for ways to express the mysteries

HOMAGE TO THE SQUARE–INSERT
1959, acrylic on fiberboard, 48 × 48 in.
Gift of S. C. Johnson & Son, Inc.

of perception and the way movement and mood could be implied through straight lines, right angles, and unmixed color. Along the way, he tried a number of formats. In some, rectangles set diagonally in pictorial space look like folded planes that float or revolve in slow rhythmic cadences. In a series called "Variants" that he worked on in the late 1940s and early 1950s, Albers explored the way colors alter their appearance according to their surroundings. There is a playful quality to the asymmetry of *On Tideland* (1947–55), which, he noted on the reverse, was organized according to "Scheme M." It is painted with only three colors: gray, ochre, and orange-rose. (The tone of the fourth, M-shaped form results from ochre painted over rose.) The large gray "background" takes on a blue cast next to the ochre and seems recessive, a platform on which the other rectangles rest. Although Albers used the same gray paint for the smaller vertical forms, they appear to be a different hue by virtue of their placement within the neighboring pinkish shade. The left, gray rectangle looks to be twice as wide as the one on the right, when in fact it is three times

broader. Albers's goal, he said, was to examine the "exciting discrepancy between physical fact and psychic effect."[4]

The austere geometries of Josef Albers's art give no clue to the chaotic times in which he lived. There is no hint of the rise of the Nazi party or of the accusation of bolshevik political activity that the Dessau City Council leveled against him simply because he taught in the unconventional program at the Bauhaus.[5] The works he created while living in the mountains of North Carolina bear no indication of Depression-era poverty or of the horrors of World War II. There is no trace of Cold War angst or of the contentious events of the civil rights movement in paintings he created during his time at Yale. But Albers deeply believed in the connections between art and modern life: "Art," he said, "is a province in which one finds all the problems of life reflected—not only the problems of form (e.g. proportion and balance) but also spiritual problems (e.g. of philosophy, of religion, of sociology, of economy)."[6] He considered teaching almost a sacred endeavor: "Making ourselves and others grow . . . is one of the highest human tasks."[7]

ON TIDELAND
1947–1955, oil on fiberboard, 27 ¼ × 36 in.
Gift of Patricia and Phillip Frost

By the time he died in 1976, just a week after his eighty-eighth birthday, Josef Albers was one of the country's best-known artists. His work was exhibited widely in the United States and Europe, and, in 1980, *Homage to the Square—Glow* appeared on a postage stamp. *Life* and *Time* as well as countless art magazines celebrated his paintings, and in 1970, *Vogue* ran a feature article titled "Josef Albers, 'Prophet and Presiding Genius of American Op Art.'"[8] One of the most versatile artists of the twentieth century, he worked in glass, paint, collage, metal, brick, paper, and photography in such diverse fields as architecture, furniture construction, graphic and textile design, and printmaking. He made sculpture, designed fireplace surrounds, and created stained glass windows for churches and corporate headquarters. Albers counted as friends and colleagues some of the era's most accomplished architects and designers. And he taught thousands of students. One of them, Robert Rauschenberg, later commented, "Albers was a beautiful teacher and an impossible person.... He wasn't easy to talk to, and I found his criticism so excruciating and so devastating that I never asked for it. Years later, though, I'm still

learning what he taught me, because what he taught had to do with the entire visual world.... I consider Albers the most important teacher I've ever had."[9]

[1] Paul Overy, "'Calm Down, What Happens, Happens Mainly Without You'—Josef Albers," *Art and Artists* (London), Oct. 1967, 33, quoted in Nicholas Fox Weber, "The Artist as Alchemist," in Solomon R. Guggenheim Museum, *Josef Albers, A Retrospective* (New York: Solomon R. Guggenheim Foundation, 1988), 42.

[2] Nicholas Fox Weber, executive director of the Josef and Anni Albers Foundation, described Albers's formats as follows: "Three of the schemes have three squares each, and one has four squares; in all cases, the intervals to the left and right of the central square are twice the distances beneath it, and the intervals above the central square are three times as great as beneath it. This arrangement deliberately avoids the static and results in a simultaneous weight and movement. The horizontal axis appears flat and pulls the viewer across the picture plane, while the vertical axis goes back and forth in space, inviting different concurrent readings.... By setting up opposing forces, Albers intentionally creates a certain tension, not a released tension but rather the perpetual flux of a living presence." See "A Master's Example," *Josef Albers, His Art and His Influence* (Montclair, NJ: Montclair Art Museum, 1981), 8–10.

[3] Weber, "The Artist as Alchemist," 31.

[4] Josef Albers, "Words of a Painter," *Art Education* 23, no. 9 (Dec. 1970): 34.

[5] Weber, "The Artist as Alchemist," 30.

[6] Josef Albers, "Concerning Art Instruction," *Black Mountain College Bulletin*, no. 2 (June 1934), quoted in Mary Emma Harris, "Josef Albers: Art Education at Black Mountain College," in Solomon R. Guggenheim Museum, *Josef Albers, A Retrospective*, 51.

[7] Josef Albers, unpublished lecture at the Black Mountain College Meeting at the Museum of Modern Art, New York, Jan. 9, 1940, in Josef Albers papers, Yale University Library, New Haven, quoted in Harris, 56.

[8] Sam Hunter, "Josef Albers: 'Prophet and Presiding Genius of American Op Art,'" *Vogue* (Oct. 15, 1970), 70 and 126–27.

[9] Calvin Tomkins, *The Bride and the Bachelors: Five Masters of the Avant-Garde* (New York: Viking, 1968), 199, quoted in Harris, 55.

> *My art is based on the relationship of the right angle and of straight lines which result in rectangles. Association, images, literature do not belong in this style.... The aim is to realize a feeling of timeless harmony and dynamic equilibrium.*[1]

ILYA bolotowsky

1907 | 1981

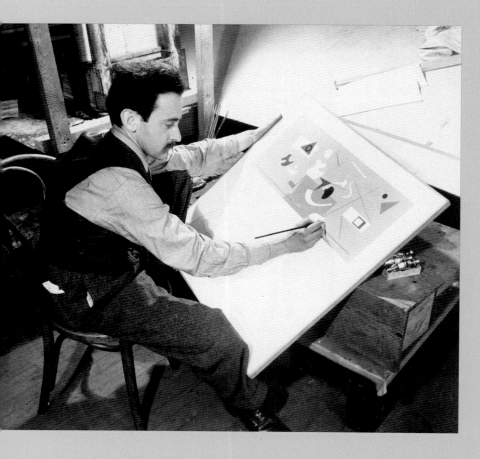

Ilya Bolotowsky delighted in being a maverick. In the 1930s, when regionalist and American scene painters were featured in *Time* and *Life* magazines, he painted with the expressive intensity of Vincent van Gogh (see *In the Barber Shop*, about 1934). After discovering Piet Mondrian and Joan Miró in 1933, Bolotowsky converted to abstraction, was a founding member of the American Abstract Artists, and covered huge expanses of public walls with biomorphic abstractions for the WPA's Federal Art Project. As abstract expressionism gained popularity in the late 1940s and 1950s, he exiled all traces of brushwork and his own hand, seeking, instead of angst and energy, an increasingly pure and reductivist format.

Architectural Variation of 1949 was a key step along the way. A moderately scaled canvas of colored rectangles, its solemn cadence comes from the careful consideration of proportion and of the relationships among blocks of color. Although each color is contained within a strict geometric configuration, it pulses with a slow, quiet energy. Bolotowsky had the idea, he said later, of "creating a counterpoint of colors" that would work together like one of Johann Sebastian Bach's contrapuntal motifs.[2] The painting

ILYA BOLOTOWSKY, about 1939
David Robbins, photographer, Courtesy of the Federal Art Project, Photographic Division collection, 1935–1942, Archives of American Art, Smithsonian Institution

is structural and architectonic, with something of the order and regularity of an urban ground plan in which buildings and streets are schematically aligned. Colors recede and project within the shallow plane, held in check by the muted quality of each hue. Bolotowsky could not resist an autographic note, however. The painting is signed with his name along the lower right edge, and like a spot of graffiti, he has "tagged" the upper left edge with brushy strokes of blue.

Bolotowsky was acutely sensitive to the optical effects produced by the adjacency of color. He had studied impressionist painting as a student at the National Academy of Design in the mid-1920s, but was taught to avoid "color vibrations" because his teachers at the time considered them to be in "bad taste."[3]

By the late 1940s, after he returned from service with the U.S. Army Air Corps, he launched his own version of Mondrian's famous neoplastic style. A teaching position at the University of Wyoming from 1948 to 1957, far from the hubbub of the New York art scene, gave him time to work, think, and refine the philosophy he would pursue for the rest of his life. He acknowledged that he was an intuitive painter who sought a sense of proportion, not mathematical precision. His style, he said, was "my own reaction to whatever I experienced."[4] Bolotowsky's early years had been difficult. He and his family had immigrated from Baku, Russia, to New York via a two-year stop in Constantinople. After the "violent historical upheavals in my early life," he said, "I came to prefer a search for an ideal harmony and order which is…not militaristic, not symmetrical…not academic."[5] There is nothing predictable about this "ideal harmony," however. Within self-set limitations of line, edge, and right angles, he constantly experimented. He ignored the proscription against color vibrations he had learned at the National Academy and explored variations in hue and intensity, which, coupled with his experiments in proportion, allowed for infinite possibilities.

When Bolotowsky was teaching in Wyoming, a farmer gave him several wagon wheels. He stripped away the spokes and stretched canvas over the rims. He called these round paintings tondos, as a reminder of circular paintings by Raphael and other Renaissance masters. Although he used

IN THE BARBER SHOP
about 1934, oil on canvas, 23⅞ × 30⅛ in.
Transfer from the U.S. Department of Labor

IN THE BARBER SHOP
about 1934, oil on canvas, 23⅞ × 30⅛ in.
Transfer from the U.S. Department of Labor

wagon wheels only briefly, he was intrigued with the special challenges posed by the round format. Straight lines tended to appear curved or bowed out when placed on a circular plane, and, unless visually anchored, round paintings might appear to roll. Over the next twenty years, he experimented with creative solutions to these optical phenomena. In *Tondo Variation in Red* (1978)—a canvas in which a very few elements produce a powerful, dynamic impact—the weighty, dark red of the upper half of the painting is bolstered by horizontal whites that stabilize the composition. An even darker red, vertical plane below, bounded by a slim, perfectly straight, blue band, anchors the plane above and keeps the canvas from appearing to roll to the left.

By the late 1970s, when Bolotowsky painted *Tondo Variation in Red*, he had eliminated the illusion of depth. He worked directly on the canvas in a process he described as intuitive. "[A]s I start dividing the canvas, somehow the divisions suggest colors. Then I wipe them out, change proportions, and a different set of colors imposes itself."[6]

ARCHITECTURAL VARIATION ▸
1949, oil on canvas, 20 × 30 in.
Gift of Patricia and Phillip Frost

TONDO VARIATION IN RED

1978, acrylic on canvas, 39 ¼ in. diam.
Gift of the American Academy and
Institute of Arts and Letters through its
Hassam and Speicher Purchase Fund

[1] William Kloss, *Treasures from
the National Museum of
American Art* (Washington, DC
and London: National Museum
of American Art with the
Smithsonian Institution Press,
1985), 177.

[2] Louise Averill Svendsen and
Mimi Poser, "Interview with Ilya
Bolotowsky," *Ilya Bolotowsky*
(New York: Solomon R.
Guggenheim Foundation,
1974), 23.

[3] Ibid., 15.

[4] Ibid., 32.

[5] Ibid.

[6] Ibid., 30.

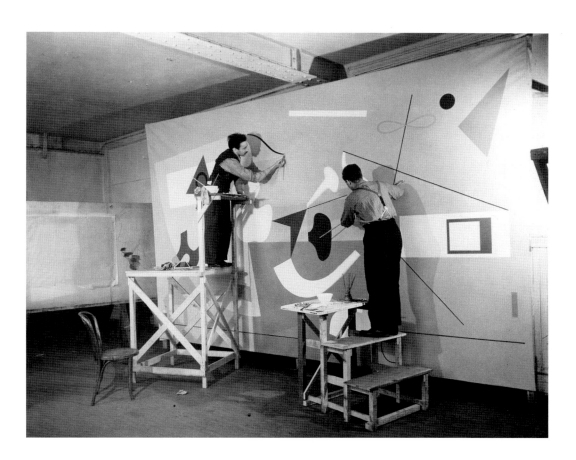

Ilya Bolotowsky (left) and John Joslyn
painting a mural for the WPA, about 1939,
David Robbins, photographer, Courtesy of the
Federal Art Project, Photographic Division col-
lection, 1935–1942, Archives of American Art,
Smithsonian Institution

*I was self-taught in my painting, which
might be described as realistic, expres-
sionistic, abstract, non-objective and
surrealistic....I was trying to reconcile
all these tendencies into one dish, as if
to merge all streams into one river.*[1]

MAURICE golubov

1905 | 1987

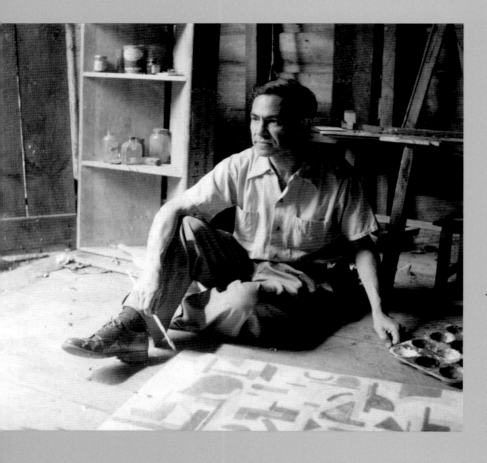

Untitled (1948) is a complex of arcs, diagonals, bands
of color, and circles within circles painted with oil
thinned to translucency. It resembles a partially
planned cityscape seen from on high to reveal spaces
and structures that abut and overlap. Areas of tawny
browns reminiscent of tilled earth laid down beside
rectangles of green suggest fields of newly planted
growth. Boundaries are clear but not sharp; each soft
shape exists in quiet dialogue with surrounding forms.
The canvas is bisected by a dynamic diagonal that
separates denser, more intense color from pale, almost
vaporous tones that seem viewed through a nebulous
cloud. Insistent central pink tones at the center deacti-
vate the flatness of the picture plane, in a sort of urban
riff on the Mayan motifs painted by Uruguayan artist
Joaquín Torres-García. *Untitled* is a gentle landscape,
a place of lyricism and beauty absent hard edges and
dark colors. "I wanted," the artist said, "to make order
out of chaos," so "I started to make landscapes of the
mind."[2] Golubov professed no theories about art, but,
in his quirky, unconventional way of looking at the
world, he hoped to capture the "essence of a landscape
in an abstract way. How this particular world would
look from the top, the side?"[3]

MAURICE GOLUBOV, 1952
in his Woodstock, New York, studio
Lee Sievan, photographer
Courtesy of Michael Golubov

Golubov had arrived in New York in 1917, when he was twelve, a refugee with his family from the pogroms of tsarist Russia. He stumbled across John Sloan's art class at a Hebrew Educational Society settlement house in Brooklyn the following year, dropped out of school, and apprenticed himself to a fashion studio, thinking it an avenue for learning to make art. A chance encounter with Mark Tobey introduced Golubov to the National Academy of Design, and for the next four years, he worked days and spent evenings at the National Academy, training his hand and eye by copying plaster casts. He excelled at figurative work, but continued to make abstract doodles in the margins of his drawing paper.[4]

By the late 1920s, he had discovered Cézanne, Kandinsky, Klee, and Picasso and for the first time realized that he was not alone in exploring non-objective art. Golubov took a break from art classes and his work in a commercial art studio to concentrate full time on painting. He spent a summer in Woodstock at the invitation of Ivan Olinsky, one of his teachers from the National Academy. Meetings at the leftist John Reed Club in the 1930s brought him into contact with Saul and Eugenie Baizerman, Ad Reinhardt, Moses Soyer, and other like-minded artists. Over the next ten years, Golubov met many who would become art world luminaries: Adolph Gottlieb, Hans Hofmann, Louise Nevelson, Mark Rothko, and Theodoros Stamos.

Betty Parsons invited Golubov to have a solo exhibition at Mortimer Brandt Gallery in 1944, but was surprised, even alarmed, when she discovered him painting figurative compositions alongside the abstract art she hoped to feature. Recounting the episode more than thirty years later, he was bemused at her reaction. "One is a relief from the other. . . . I find doing figurative things so much easier."[5] In the early 1950s, the Museum of Modern Art and the Whitney Museum of American Art featured Golubov's work in important exhibitions, and success in the fast-paced museum and gallery world seemed imminent. But Golubov was uncomfortable exposing his abstractions to public view, so opted to exhibit at the Artists' Gallery, a cooperative space run by artists, where he could select the work to be shown.

Golubov had grown up in a Hasidic household and as a boy began studies toward a rabbinical

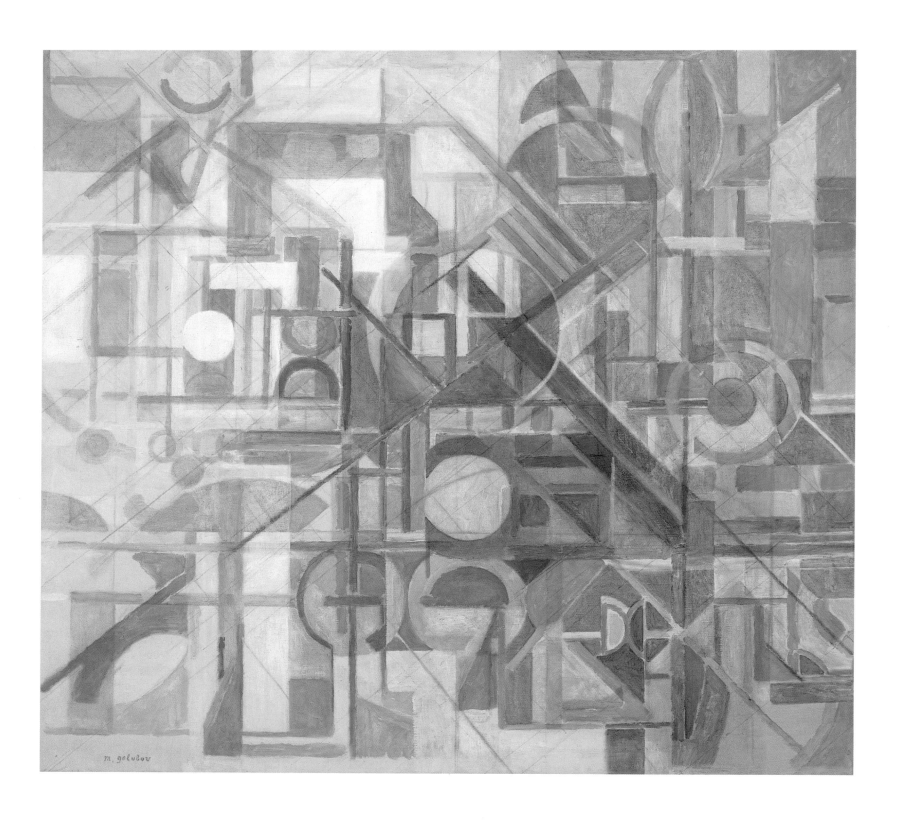

UNTITLED
1948, oil on canvas, 41 ½ × 45 ¼ in.
Gift of Patricia and Phillip Frost

education. "Mysticism," he said, "was grounded into me,"[6] and he came to understand that there existed a reality beyond the world of surface appearances.[7] Although he had begun doing abstractions as experiments in design, he came to see them as a way to explore the mystical and spiritual. He was also captivated by the world of philosophy, and in the 1920s read George Berkeley, Ralph Waldo Emerson, Johann Gottlieb Fichte, Immanuel Kant, Arthur Schopenhauer, and Baruch Spinoza. Their work, along with Eastern philosophy and medieval Jewish theology, provided a basis for his philosophy of art. Golubov said, "I could sense and feel more closely the things I felt were real and yet unseen. I didn't feel comfortable trying to express these in words...instead I started to find symbolic means to be able to represent them pictorially."[8] Abstraction became a way to convey a personal realism that embraced the seen and the unseen, the timely and the timeless. In *Untitled*, Golubov expressed the complexities of a "world that would be logical only as a picture, a world where endless moments are arrested into one whole *instant* moment."[9]

[1] John Yau, "Some Motifs in Maurice Golubov's Life and Work," in Daniel J. Cameron, ed., *Maurice Golubov: Paintings 1925–1980* (Charlotte, NC: Mint Museum, 1980), 5.

[2] Greta Berman, "'All That Light Was Myself...,' An Interview with Maurice Golubov," in Cameron, *Maurice Golubov*, 14.

[3] Berman, in Cameron, *Maurice Golubov*, 17.

[4] Biographical information is drawn from the essays and chronology in *Maurice Golubov*.

[5] Berman, in Cameron, *Maurice Golubov*, 15.

[6] Susan C. Larsen, "Expanded Spaces: The Paintings of Maurice Golubov," in Cameron, *Maurice Golubov*, 11.

[7] Yau, in Cameron, *Maurice Golubov*, 5.

[8] Undated autobiographical typescript in artist's vertical file, Smithsonian American Art Museum/National Portrait Gallery Library.

[9] Larsen, in Cameron, *Maurice Golubov*, 11.

JOHN mclaughlin

1898 | 1976

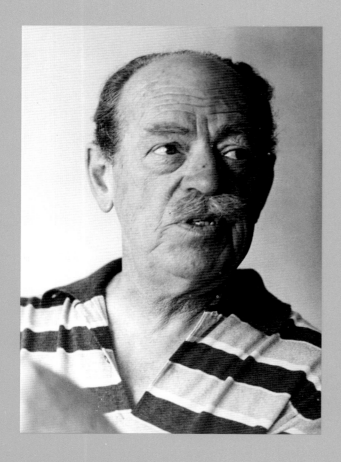

John McLaughlin came late to making art. But the years he spent as a sailor, military intelligence officer, collector, and resident of Japan and China, and his deep knowledge of Asian art, all fueled ideas that shaped the paintings he began to make at age forty-eight.

#13 Untitled (1960)—a rectangle of unrelenting black, within which rests rectilinear horizontal bands of beige and white—speaks to the directness and simplicity he aimed for. The forms bear no relation to observable reality, yet the perfect alignment, strict symmetry, and carefully considered hues prompt associations of weight, balance, and stability that exist in felt, if not perceived, experience. The surface is intentionally smooth. "I have gone to considerable pains to eliminate from my work any trace of my own identity with the view to making the viewer the subject matter [of the painting]," he said.[2] Individual brushstrokes are subsumed into monochromatic fields. The subtle differences in sheen detectable across the surface come from the slightly different light refracting qualities of the oil and acrylic paints he used. *#13 Untitled* is consummate evidence of McLaughlin's

JOHN McLAUGHLIN, about 1970
Courtesy of the John McLaughlin papers, 1936–1979, Archives of American Art, Smithsonian Institution

beliefs about painting, the role of the artist—at least in his own work—and the nature of the experience he hoped to provide for the viewer.

The long route McLaughlin took to arrive at the rectangular format he used in all his mature paintings took him from Boston, where he grew up, to sea during World War I, to a prosperous real estate business, and an early sideline collecting and selling Japanese prints. The Asian art at Boston's Museum of Fine Arts was a direct stimulus for his decision, in 1935, to go to the Far East to study art, language, and culture. He and his wife lived first in Tokyo, where a tutor came daily to teach him Japanese. The couple moved to Beijing, where he made business connections that allowed him to trade in Asian antiquities. McLaughlin returned to Japan for several months in 1937 to acquire inventory, then sailed for Boston, where he opened a gallery.[3]

McLaughlin's linguistic skills led to language and intelligence work with the Marine Corps and U.S. Army during World War II. Released from duty in 1945, he joined his wife in Laguna Beach, California, and began seriously to paint, working in the garage of a house they built in Dana Point. His

first artistic success came when he won third prize in oil painting at the 1946 San Diego County Fair. The early canvases were abstractions with undulating geometric forms; these were soon replaced by the rectilinear format that would captivate and compel him for the rest of his life.

He identified the rectangle as a way to remove all sense of the real. "I believe that forms other than rectangles assume a kind of entity and in a sense become objects and are therefore misleading. By the use of the rectangle in concert with relatively large 'empty' areas I strive to create a feeling of anonymity in terms of the total canvas."[4] Elsewhere he elaborated, "objects may manifest themselves in many ways...quite apart from the familiar and recognizable there are...unseen forces, motion, rhythm, ideas and symbolism. These...demand identification on their own restricted terms."[5]

McLaughlin kept abreast of exhibitions in New York by reading art magazines. In long letters to friends he acknowledged his debt to Paul Cézanne, Kasimir Malevich, and Piet Mondrian, whose paintings helped crystallize his own thinking. Their goals did not fully align with his, however. He was driven

#13 UNTITLED
1960, oil and acrylic on canvas, 60 × 48 in.
Bequest of Edith S. and Arthur J. Levin

instead by the possibilities for meditation he associated with Japanese art. "Certain Japanese painters of centuries ago found the means to overcome the demands imposed by the object, by the use of large areas of empty space. This space was described by Sesshu [1420–1506] as the 'Marvelous Void.'... The viewer was induced to enter the painting unconscious of the dominance of the object. Consequently there was no compulsion to ponder the significance of the object as such. On the contrary, the condition of 'Man versus Nature' was reversed to that of man at one with nature."[6]

In his earliest works McLaughlin experimented with media, using encaustic and casein, sometimes in concert with oil. Circles appear in some, and others resemble cityscapes in which structures recede into space. By the mid-1950s, only rectangular forms remained. Expanses of single colors, mostly black and white, but also red, yellow, orange, blue, and green, and empty space provided occasions for meditation.[7] He arrived at his compositions by trial and error, moving and adjusting rectangles cut from construction paper before committing a configuration to paint. It was an intuitive process, he said, that

prevented "fortuitous happenings" that might take place if he worked directly on canvas.[8]

By 1960, when he painted *#13 Untitled*, McLaughlin's work had been featured by museums in Los Angeles; San Francisco; Houston; Washington, D.C.; Denver; Richmond, Virginia; and elsewhere, and he had joined Felix Landau's Los Angeles Gallery. Yet he was not fully confident as a painter and appreciated the validation that came with positive reviews. "To be accepted...wholly and generously is an enormous satisfaction because it does so much to relieve, momentarily at least, the awful pressure of doubt."[9]

[1] John McLaughlin, letter to Gerald Nordland, Sep. 25, 1960, in John McLaughlin papers, Archives of American Art, microfilm reel 1411:10.

[2] McLaughlin, undated note in McLaughlin papers, Archives of American Art, microfilm reel 1411: 993.

[3] This and subsequent biographical information is drawn from Lisa Buck, "Biography, Exhibitions, and Bibliography," in Susan C. Larsen and Peter Selz, *John McLaughlin, Western Modernism, Eastern Thought* (Laguna Beach, CA: Laguna Art Museum, 1996), 73–78.

[4] McLaughlin, draft of letter to Jules Langsner, Mar. 11, 1959, reproduced in *California: Five Footnotes to Modern Art History* (exh. cat.) (Los Angeles: Los Angeles County Museum, 1971), 88–90, quoted in Sheldon Figoten, "An Appreciation of John McLaughlin," *Archives of American Art Journal* 20, no. 4 (1980):12.

[5] McLaughlin to Nordlund, Sep. 25, 1960, McLaughlin papers, Archives of American Art, microfilm reel 1411:10–11.

[6] Ibid., reel 1411:13.

[7] To preserve the geometrical purity of their surfaces, prints made at Tamarind Lithography Workshop were signed on the back and rubber stamps used instead of chops. See Tamarind Lithography Workshop, "John McLaughlin, Tamarind Fellowship Artist: May–June 1963," press release, curatorial files, Smithsonian American Art Museum.

[8] McLaughlin, letter to Paul Karlstrom, Dec. 7, 1973, McLaughlin papers, Archives of American Art, microfilm reel 1411:1206.

[9] McLaughlin, letter to Nordland, Sep. 18, 1960, McLaughlin papers, Archives of American Art, microfilm reel 1411:2.

I gave myself the title 'The Architect of Shadow.' Why? You see, shadow and everything else on earth actually is moving.... Shadow is fleeting... and I arrest it and give it a solid substance.[1]

LOUISE nevelson

1899 | 1988

Louise Nevelson created dramatic architectural environments—yet aimed at something ephemeral that she often called order, rightness, or a spiritual essence. Beginning her sculpture career in the early 1940s, when materials and money were scarce, she scoured the lower Manhattan cityscape for castaway wooden objects. She characterized her scavenging as a "resurrection," wherein she found "discarded, beat-up," "neglected and overlooked" items that she assembled and transformed.[2] Following her intuitive sense of arrangement via trial and error, she made no sketches. Nevelson painted all of the components one color—most often black, though sometimes white or gold. An alchemist who acknowledged her own mystical role, Nevelson separated the parts from their original function and identity, creating resplendent visual experiences.

Sky Totem (1956) reveals Nevelson's fascination with Native American, Mayan, African, and other ancient cultures. She first saw African sculpture in 1931 at a museum in Paris. When Nevelson returned to New York, she recognized the similarity of form and power in the city's subway support columns.[3] On two trips to Mexico in 1950, the

artist became entranced with the pyramids of the Yucatan and other pre-Columbian sculptures.[4] *Sky Totem* conjures the soul's yearning for awe and worship. Flat, wooden planks form the back of the piece, enabling it to be mounted to a wall. Abstract, organic shapes—suggesting beaks, feathers, or other animal features—create a frontal dimension. Unlike traditional totems, which are grounded and visible a full 360 degrees, Nevelson's floating structure and barely discernible forms evoke a primal dream or genetic memory, urging a sigh of wonder.

Sky Cathedral (1982) enlarges the celestial and religious aspects of her work to a much greater scale. At more than eight feet tall and twenty-four feet long, this wall sculpture of concatenated shadow boxes encompasses table legs, chair backs and seats, a twin-size headboard, and other recognizable wooden parts. Yet Nevelson's divine reordering, with its resulting beauty and balance, creates a transcendent peace and dignity. Each object has been glorified and given a new life by the creator—not unlike the rebirth many experience in a newfound faith or deeply moving religious experience. Because of the obvious wear and tear on the castaway parts,

these artworks convey a profoundly uplifting, healing message.

Louise Nevelson poured her soul into her art. "The nature of creation is that you have to go inside and dig out. The very nature of creation is not a performing glory on the outside, it's a painful, difficult search within."[5] By the time Nevelson created *Sky Totem*, after decades of struggling to find success as an artist and to overcome periods of depression, she—like her works—embodied perseverance, strength, and spiritual depth.

Born in Kiev, Russia in 1899, Louise Berliawsky immigrated to Maine with her family in 1905. There her father established a lumber business and built homes, explaining her affinity with wood and architectural spaces. Of her father's influence, Nevelson admitted, "I didn't want to imitate him, but I think it's in the genes."[6] At the age of twenty, she married shipping magnate Charles Nevelson and began a new life in New York City. Although she ultimately divorced, moving to New York proved crucial to her art career. There Louise Nevelson took voice, dance, and fine art lessons. In 1929 and 1930, she studied with Kenneth Hayes Miller. In 1931, she took

classes in Munich, Germany, with Hans Hofmann. Back in New York, Nevelson worked as an assistant to Diego Rivera for a short time. At the Art Students League, she again studied with Hofmann, who had by then immigrated to New York, and also with German immigrant George Grosz. In the mid-1930s, she signed up for the Works Progress Administration, creating sculpture that would ultimately populate her first solo show in 1941 at Nierendorf Gallery.[7]

After scraping through the 1940s, when Nevelson sold few artworks, she finally gained recognition with three exhibitions at Grand Central Moderns Gallery in 1955, 1956, and 1958. For her groundbreaking 1958 show, *Moon Garden + One*, she created a complete environment of *Sky Cathedrals*. Nevelson used a blue light and covered a window to further manipulate mood and space. She was then included in the *Sixteen Americans* exhibition at the Museum of Modern Art in 1959. Of this belated appreciation Nevelson said, "My whole life's been late."[8]

The sculptor went on to have two successful shows at the Martha Jackson Gallery in 1959 and 1961. Achieving much wider acclaim, Nevelson represented the United States in the Venice Biennale in 1962, and in 1967 had her first retrospective at the Whitney Museum of American Art. By the 1970s a spirited grande dame of the American art scene, Nevelson declared, "I built my empire. Now I use the word in a way that is very personal for myself. I mean an empire of aesthetics, and that is the true empire for me, and it's never limited and you never finish."[9]

With her success, Nevelson experimented in other media. The cast bronze of *Gate V* (from the "Garden Gate" series) (1959–60) creates the illusion of timeworn wood. The patchwork of boards suggests a family or building that has fallen on hard times, while the iron hinges impart a sense of age and dignity. What kind of garden might one find behind such a gate? One that was formerly cultivated lavishly, but is now overgrown and wild. Gates and doorways allude to metaphorical transitions and inspire the imagination, two important concepts to Nevelson. "I don't use color, form, wood as such. It adds up to the in-between place, between the material I use and the manifestation afterwards; the dawns and the dusks, the places between the land and the sea."[10]

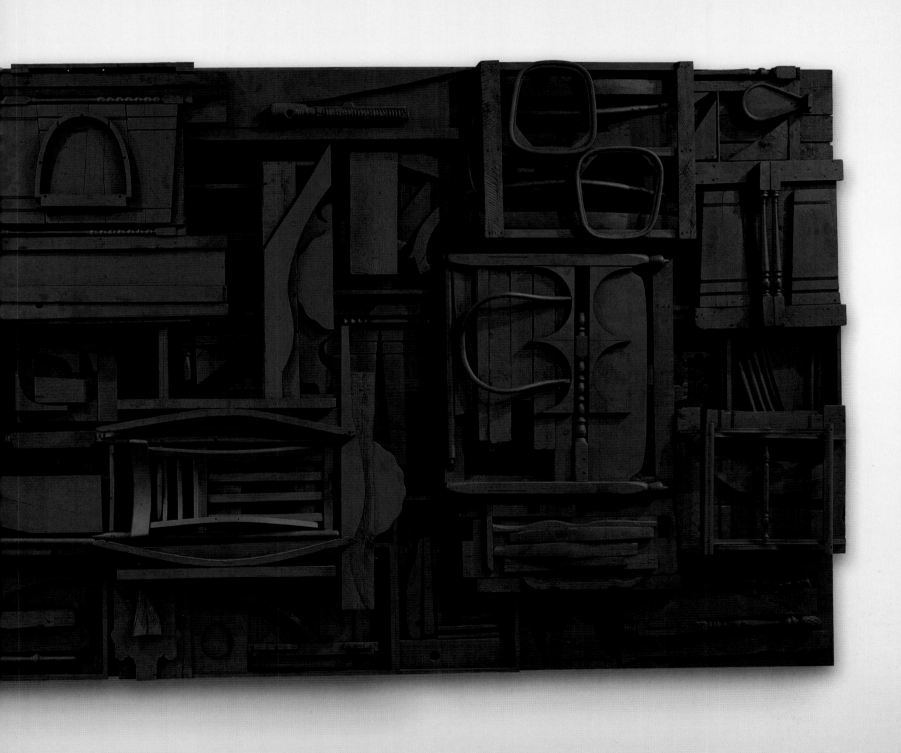

GATE V
from the "Garden Gate" series
1959–60, cast bronze, 46 × 31½ × 2¾ in.
Gift of Mr. and Mrs. David K. Anderson,
Martha Jackson Memorial Collection

Time is a persistent theme for Nevelson. Each work creates awareness of the past, while the delightful textures and pleasing forms ground viewers in the aesthetic present. Coincidentally, the works' spiritual dimension takes one out of time to an eternal grace. The apparent contradiction of a simultaneous past, present, and eternity is central to Nevelson's philosophy. As she explained it, "After a tree is cut down, it is assumed that the tree is dead. It may be the finish of that life as such. But even in that state of matter, there's activity, livingness. So there is no death in that sense. There's transformation....Patterns of life change, but life doesn't change. Life is forever life. Livingness."[11] [TDF]

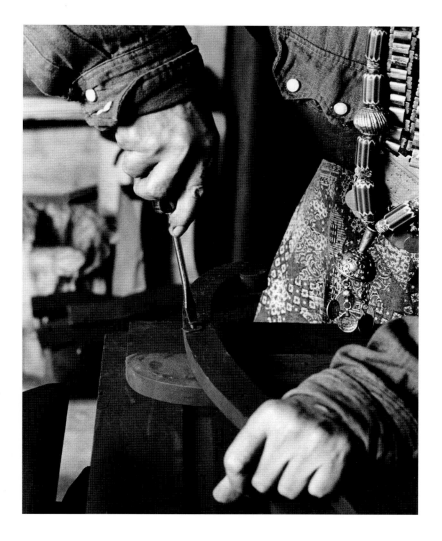

[1] Louise Nevelson with Diana MacKown, *Dawns + Dusks* (New York: Charles Scribner's Sons, 1976), 127.

[2] Ibid., 81.

[3] Louise Nevelson, artist statement in *Nevelson: Sky Gates and Collages May 4–June 8, 1974* (exhibition brochure) (New York: The Pace Gallery, 1974).

[4] Arnold B. Glimcher, *Louise Nevelson* (New York: E. P. Dutton, 1976), 71.

[5] Nevelson with MacKown, *Dawns + Dusks*, 72.

[6] Louise Nevelson, interview with Arnold B. Glimcher, Mar. 3, 1976, in Glimcher, 185.

[7] Nevelson with MacKown, *Dawns + Dusks*, 73.

[8] Ibid., 133.

[9] Ibid., 177–80.

[10] Ibid., 125.

[11] Ibid., 190.

Louise Nevelson's hands at work, between 1964 and 1975, Lewis Brown, photographer, Courtesy of the Louise Nevelson papers, about 1903–1979, Archives of American Art, Smithsonian Institution

No texture; no brushwork or calligraphy; no sketching or drawing; no forms; no design; no colors; no light; no space; no time; no size or scale; no movement; no object, no subject, no matter.[1]

AD reinhardt

1913 | 1967

Ad Reinhardt's comments about art divert, distract, and negate. They are intense and insistent markers of an aesthetic and intellectual journey from early cubist-inspired compositions to late black rectangles that admitted neither illusion nor allusion. As his ideas evolved, Reinhardt's views became increasingly radical. Painting, he argued, is a nonnarrative medium, and over the course of two decades he tried to purge from his works all storytelling, imagery, and even traces of his own hand.

Reinhardt's evolution helps explain the visual and conceptual chasm between *Untitled* (1940) and *Abstract Painting no. 4* (1961). *Untitled* is an exuberant, high-energy kaleidoscope of colored rectangles dancing in space that owes a debt both to Piet Mondrian and to Reinhardt's close friend and mentor Stuart Davis. It resembles a collage whose elements are painted rather than clipped and pasted. Reds and pinks butt up against yellows and greens in an optical display that defies the flatness of the canvas. Not quite an all-over composition—darker areas at the corners suggest space beyond—the angles and curves pulse against a central white ground, and small patches of brushy paint remind one that the hand of an artist is at work.

Although knowing something of Reinhardt's biography does little to illuminate individual paintings, familiarity with his background helps explain the path he took to arrive at the isolate and self-contained purity of *Abstract Painting no. 4*. From the beginning Reinhardt was an active and engaged member of the community of abstract artists working in New York in the 1930s. He belonged to the American Abstract Artists group, was employed by the WPA Federal Art Project, and drew flyers circulated at artist demonstrations. He was a member of The Club, and in 1950, along with Gottlieb, Hofmann, Lassaw, Lipton, Motherwell, Stamos, Roszak, and other "Irascibles" (see p. 41), signed an open letter to the president of the Metropolitan Museum of Art protesting the museum's stance on abstraction.

Reinhardt the activist drew cartoons for the liberal New York newspaper *P.M.*, as well as *ARTnews* and other publications, in which he lambasted American scene painting, social realism, and corporate involvement in art. When he later turned his barbed wit and acerbic pen on the contemporary art world, he alienated friends and colleagues. He made fun of the Bauhaus (he called it "Bowhows"), described painters as boxers and dealers as wrestlers, and condemned avant-garde artists who had "sold out" in the rush of press attention that surrounded abstract expressionism in the 1950s.[2] Turning his critical eye on his own work, he mockingly described the phases he had gone through as "late-classical-mannerist" in the 1930s, "rococo-semi-surrealist fragmentation" and "baroque-geometric expressionist" in the early 1940s, "archaic color-brick-brushwork impressionism" in the late 1940s, and "early-classical hieratical red, blue, black...square-cross-beam symmetries" in the early 1950s.[3] The joking tone belies the degree to which Reinhardt subjected his own motives and accomplishments to critical analysis in light of his increasing search for purity. As his ideas evolved from the 1930s to the 1950s, he simplified forms and reduced color until he reached the "classic black square uniform five foot timeless, trisected evanescences" that he painted from 1960 until his death in 1967.[4]

Abstract Painting no. 4 and the other "evanescent" canvases from the 1960s mark the culmination of Reinhardt's pursuit of perfection. The matte black

surface absorbs light, initially concealing then slowly revealing subtle blue and plum squares arranged in a cruciform shape. He leached medium from his oils to eliminate gloss ("gloss reflects and relates to the changing surroundings"[5]), used canvases that were precisely five feet square (the reach of the human body), and worked horizontally rather than at an easel because it better enabled him to achieve anonymous surfaces. Pressed to explain his use of black, Reinhardt replied that the reason was an "aesthetic–intellectual one.... It's because of its non-color.... [C]olor has to do with life."[6]

The dark surface of *Abstract Painting no. 4* is not read quickly. Concentration and contemplation are the rewards for a viewer willing to disregard extraneous sensation and meditate on its soft surface. Slowly one begins to understand what Reinhardt meant when—riffing on Gottlieb and Rothko's assertion, "There is no such thing as good painting about nothing"[7]—Reinhardt claimed the opposite, "There is no such thing as a good painting about something."[8]

ABSTRACT PAINTING NO. 4
1961, oil on linen, 60⅛ × 60¼ in.
Gift of S. C. Johnson & Son, Inc.

1 Ad Reinhardt, "Twelve Rules for a New Academy," *ARTnews* (May 1957): 38, 56. This quotation cites headings in the article, which Reinhardt noted was an excerpt "from a paper read at the College Art Association annual meeting at the Detroit Institute of Art, Saturday morning, January 26, 1957, 'a nice clear sunny morning.'"

2 See Thomas B. Hess, "The Art Comics of Ad Reinhardt," *Artforum* 12 (Apr. 1974): 46–51.

3 Undated notation, Ad Reinhardt papers, Archives of American Art, reel N/69-100:104, also reproduced in Barbara Rose, *Art-as-Art: The Selected Writings of Ad Reinhardt* (New York: Viking, 1975), 10. Rose dates the list to 1965.

4 Ibid.

5 Reinhardt, "Twelve Rules for a New Academy," 56.

6 Reinhardt, "Black as Symbol and Concept," reprinted in Rose, *Art-as-Art*, 87.

7 Adolph Gottlieb and Mark Rothko (with the assistance of Barnett Newman), "Letter to Edward Alden Jewell, Art Editor," *New York Times*, June 7, 1943, reproduced in Sanford Hirsch and Mary David MacNaughton, *Adolph Gottlieb: A Retrospective* (New York: The Arts Publisher in assoc. with the Adolph and Esther Gottlieb Foundation, 1981), 169.

8 Clifford Ross, *Abstract Expressionism: Creators and Critics* (New York: Abrams, 1990), 153.

Ad Reinhardt, 1962
Fred W. McDarrah, photographer,
Courtesy of the Lee Nordness business records and papers, about 1950–1974,
Archives of American Art, Smithsonian Institution

Experience…is ingrained in your body like color staining cloth. It is actually as if it were staining your body. It becomes yours. In a sense, you own it, and you're responsible to it and for it.[1]

ANNE truitt

1921 | 2004

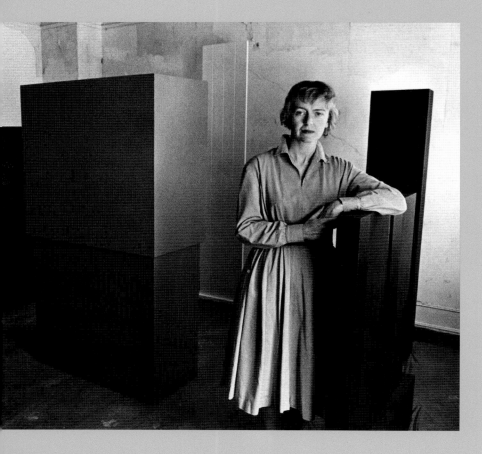

The stark, simple forms of Anne Truitt's sculpture are literally colored with experience. Lived, felt, observed, absorbed—the visual impressions and human understanding Truitt accumulated throughout her life are the content of her art. Meanings are sometimes concrete, referring to places she lived and people she knew. More often the work is allusive, reflecting fleeting experiences—impressions of sunlight on a field of new growth in a landscape with a low horizon line or the bulk and weight of the "shouldering" forms of mountains. All are made to human scale, not so much for formal reasons, but to relate each piece to human experience. "Our sense of scale," she said, "comes from the size and reach of our bodies."

At six feet high, the black presence of *Keep* (1962) is both intimate and intimidating. The immediate impression is that of crenellated battlements (a keep is the innermost and strongest structure of a medieval castle). But "keep" is a linguistically loaded word that also means possession, restraint, protection, and preservation. Sitting directly on the floor, the artwork appears weighty, solid, even stolid.

Truitt spent her early childhood on the Eastern Shore of Maryland, then moved to Asheville, North

Carolina, where the mountains were filled with "valleys and clefts." After graduating from Bryn Mawr with a major in psychology, she worked in psychological research at Massachusetts General Hospital and served as a nurse's aide in Boston during World War II. In 1947, she married a dashing young journalist, moved to Washington, D.C., and took up writing. But working with words was a struggle, she said. "I was like a fly in honey. . . . I couldn't get my wings. I couldn't do anything. And one day I was standing in the living room . . . and I thought to myself, 'If I make a sculpture, it will just stand up straight and the seasons will go around it and the light will go around it and it will record time.'" So in January 1949, she enrolled at Washington's Institute of Contemporary Art and learned to work in clay. In Dallas, San Francisco, Washington— wherever her husband's assignments with *Life*, *Time*, and *Newsweek* took them—she took classes and taught herself, carving wood, casting plaster and concrete, and making what she described as "bestial looking" life-sized figures out of pipes, chicken wire, and plaster.

Her artistic epiphany came in November 1961, during a visit to the Guggenheim Museum in New York. She saw a black painting by Ad Reinhardt and Barnett Newman's *Onement IV*, which she described as a "universe of blue paint." The experience was cathartic. These two pictures tipped the balance for her "from the physical to the conceptual," and set her to thinking about her life. "The fields and trees and fences and boards and lattices of my childhood rushed across my inner eye as if borne by a great, strong wind."[2] Miraculously, she later said, "I turned from looking on the outside to looking on the inside." "The solutions were just put in my hands. . . . All I did was to render real what had already been given to me." *Keep* is one of thirty-seven sculptures Truitt made in 1962, the year when, at age forty, she jettisoned all her previous work and began anew. She met the influential critic Clement Greenberg through Kenneth Noland and Morris Louis, and in 1963 had her first exhibition at André Emmerich's New York gallery.

In 1964, Truitt moved with her husband to Tokyo. She described the three years in Japan as a time she "simply endured." The culture was alien, and, apart from her family (she had three children), she felt isolated and disconnected. "I suffered very

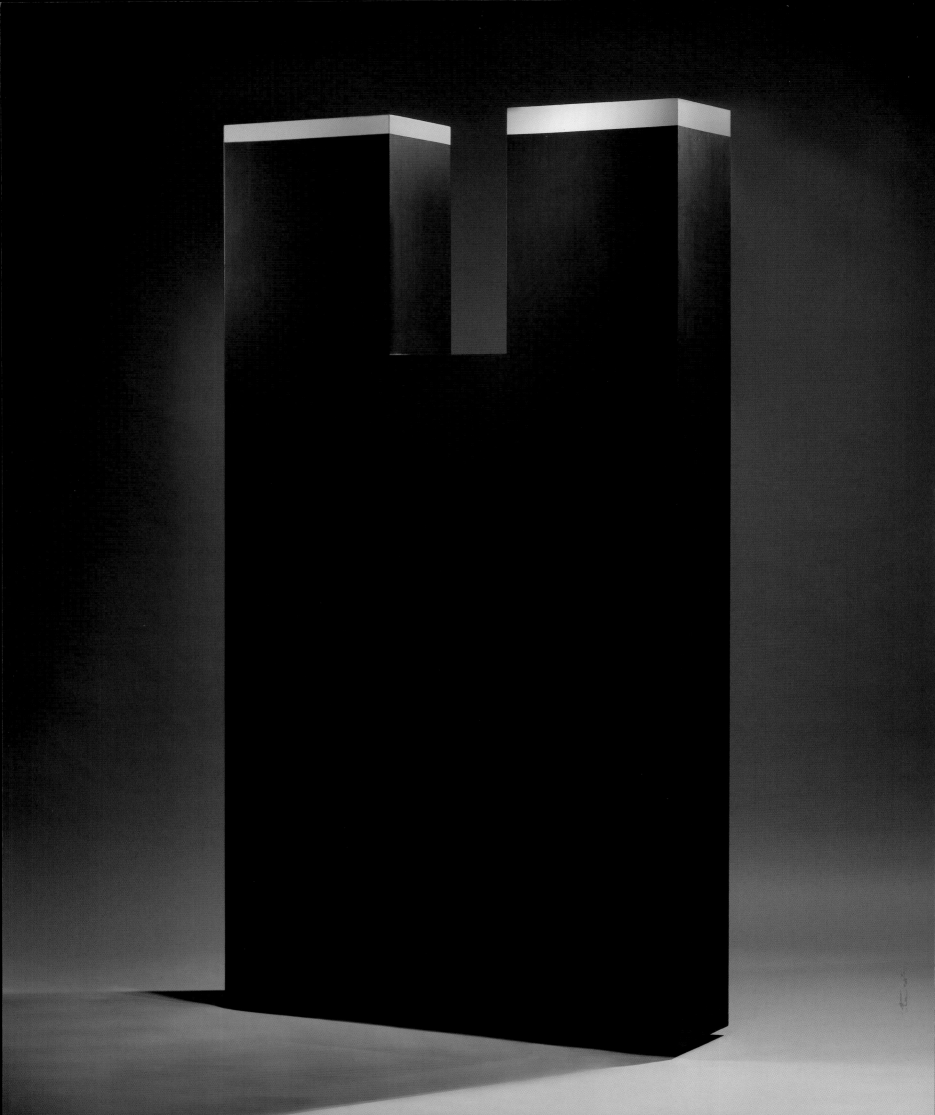

17th SUMMER
1974, acrylic on wood,
95⅝ × 15⅝ × 8⅛ in.
Gift of Kenneth Noland

much from a lack of imaginative nourishment, which I've gotten all my life from my environment without really thinking much about it." She began working in steel because the sculptures would be easier to ship, but knew she was going in the wrong direction. It was "intelligent work," she said, but spiritually numb and lifeless. Back in Washington in 1967, on her "own soil" again, she destroyed the steel sculptures and turned again to wood. To create the luminous surface of *17th Summer* (1974) and other columns painted in bright, sometimes pastel hues, she laid down as many as forty coats of vibrant color. Its evocative title and those of *Breeze, Autumn Dryad, Morning Moon,* and others celebrate her return to a place of familiar light and seasonal rhythms. In 1969, she separated from her husband. Surviving on grants, Guggenheim fellowships, and teaching, first at the Madeira School and then at the University of Maryland, she raised her children and made sculpture.

The course of Truitt's career is filled with incidental ironies. Many of her New York shows sold out. She was celebrated by Clement Greenberg for the formal purity of her work and included in groundbreaking shows of minimal art. But she described her

life in terms that had little to do with either the style or substance of postmodernism. *Discipline, order, structure,* and *endurance* are words she used to characterize her life and thought. But meaning in her sculpture comes from deeply felt, personal associations. "It's the human experience that is distilled into art that makes it great," she said. "I go back and re-collect—not only recollect, but re-collect—experience."

[1] Anne Truitt, interview with Anne Louise Bayle, Apr. 16, 17, 25, and Aug. 8, 2002, Archives of American Art, online transcript, http://www.aaa.si.edu. Unless otherwise noted, quotations come from this interview.

[2] Anne Truitt, *Daybook, The Journal of an Artist* (New York: Pantheon Books, 1982), 150–51. Truitt's *Daybook* offers a warm and human look at Truitt's life as an artist. It was written shortly after retrospective exhibitions at the Whitney Museum of American Art in New York and the Corcoran Gallery in Washington, D.C., forced her to confront the artist side of her nature.

◄ **KEEP**
1962, acrylic on wood, 72 × 39¼ × 10⅛ in.
Gift of Mr. and Mrs. Philip M. Stern

The great mistake of many artists is that they close their eyes to the past....You have to look to tradition....The artist has to be part of something. Art belongs in a traditional line that reaches back and will go on forever.[1]

ESTEBAN vicente

1903 | 2001

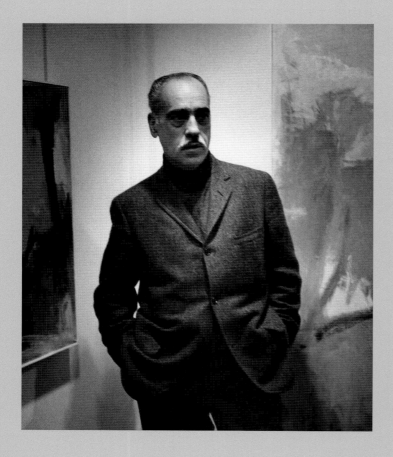

A sense of being part of art's long tradition may seem an odd statement for an artist who spent more than half of his career eliminating all traces of recognizable imagery from his canvases. But for Vicente, who felt the lineage of the Spanish masters of his country of birth, the physicality of paint he first discovered in Goya, Velázquez, and Zurbarán became a lodestar. "The pigment is a very complicated thing," he said. "A painter has to deal with the physicality first. He has to understand on real, physical terms. That's the beginning. With that you transform it into meaning."[2] Paint applied by brush or spray gun, torn pieces of paper glued to surfaces, and color were the compelling realities of his art.

The diaphanous floating rectangles of *Spring* (1972), painted when the artist was almost seventy, provide entry into the contemplative possibilities of paint. Layers of thin color are lightly brushed and sprayed to create shapes that seem to hover in space. Vicente has created a place of felt experience, distant and distinct from the observable, tactile world. The painting seems less an object existing on a flat plane than an environment operating in three unbounded dimensions. Dark bands at either vertical

edge, customary devices for delimiting a pictorial field, hint at something beyond. Wisps drift upward from the gray rectangle at the top, and, along with "clouds" of pink, red, and orange, give the sense of colored air. Unmodulated by tone, they give the illusion of both projection and recession into space. At first glance, *Spring* resembles the field paintings of Mark Rothko, but Vicente felt a closer kinship with the black paintings of his friend Ad Reinhardt that simultaneously veil and reveal shapes within their inky darkness.

Vicente met Reinhardt in New York around 1950, the year the Spanish artist was elected a voting member of The Club, a group that included Franz Kline, Willem and Elaine de Kooning, Joan Mitchell, sculptor Philip Pavia, Reinhardt, and others who met Friday evenings to talk—and argue—about art. Vicente had grown up in Spain, the son of a casual painter who often dragged his bored child to the Prado on Saturdays. He spent three years at the Royal Academy before coming across illustrations of work by Braque, Cézanne, Gris, Matisse, and Picasso, and realized he had to go to Paris. Although Picasso welcomed his young countryman, Vicente was lonely in the unfamiliar culture, and left for Barcelona. There his paintings of flamenco dancers, bars, boats, and brothels sold well enough that Vicente could live by his art.

In 1936, he had gone to Madrid to introduce his new American wife to his family when the Spanish Civil War broke out. He worked briefly for the loyalist cause, then late in the year sailed for New York. Increasingly dissatisfied with his images, Vicente stopped showing for most of the 1940s. "I wanted to go back and solve certain problems," he said, "I needed to be free," and he began experimenting with cubist structure and form.[3] In the mid-1940s he turned to abstraction.

By the late 1940s, Vicente had formed lasting friendships with Kline, Willem de Kooning, Barnet Newman, Jackson Pollock, and Rothko, and in 1950 Clement Greenberg and Meyer Schapiro selected his work for *Talent 1950* at the Sam Kootz Gallery. Vicente began showing at Peridot, Alan Frumkin, and Stable galleries (and later with Charles Egan and André Emmerich), and was included in Thomas Hess's *Abstract Painting: Background and American Phase*, the first definitive

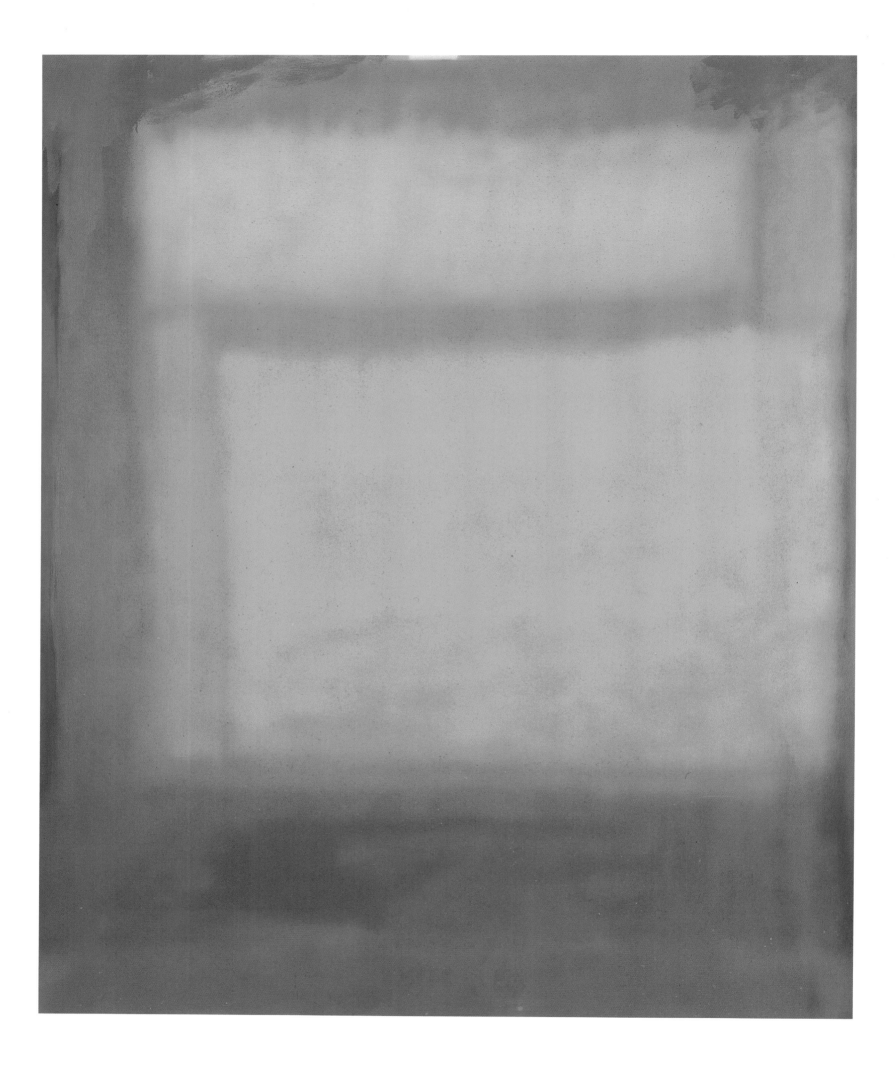

SPRING
1972, oil on canvas, 68 × 56 in.
Bequest of Edith S. and Arthur J. Levin

volume published on the New York school. A feature article by Elaine de Kooning in *ARTnews* in 1953 established Vicente as one of the country's leading abstract artists.

In his paintings, and in the collages he began to make in 1949, Vicente explored the complexities of form, the relationship of forms to each other and to surrounding space, and the interaction of color with ground. Control and the skillful manipulation of materials—à la the early Spanish masters—rather than accident and spontaneity, defined his working method. He began using a spray gun in 1965, while serving as artist-in-residence at Princeton University. Soon thereafter, color emerged as a dominant concern. "I didn't understand color really until very late. I did try and try but I didn't get it....found that...in order to paint with color you have to get rid of the tone....I didn't realize that at first. And then in the process I saw clearly. And to me color is one thing: light."[4]

[1] Riva Yares Gallery, *Esteban Vicente, A Retrospective View: 1951–2000* (Scottsdale, AZ: Riva Yares Gallery, 2002), 35.

[2] Elizabeth Frank, *Esteban Vicente* (New York: Hudson Hills, 1995), 48.

[3] Irving Sandler, "A Tape-Recorded Interview with Esteban Vicente at his Home in East Hampton," Aug. 26, 1968, typescript, Archives of American Art, 16, quoted in Frank, *Esteban Vicente*, 18.

[4] Sandler, 22, quoted in Frank, *Esteban Vicente*, 67.

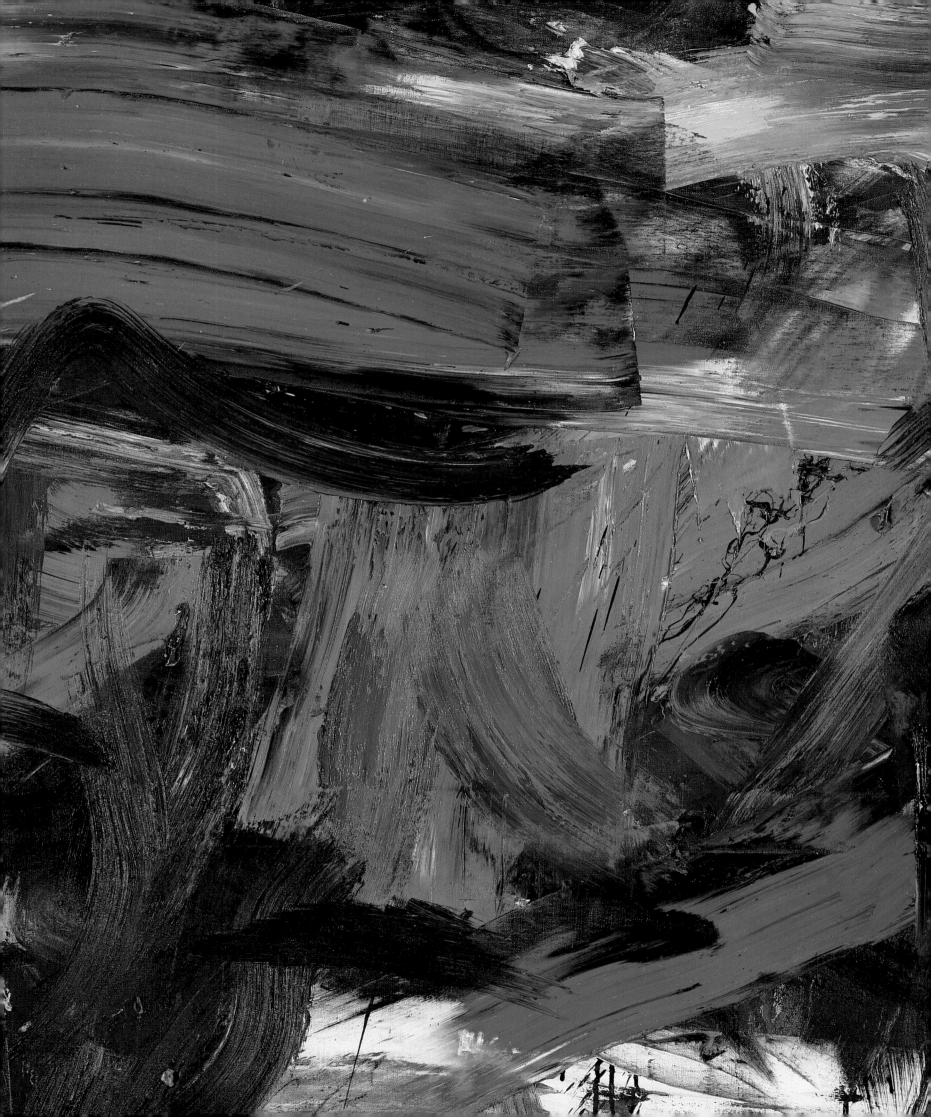

SIGNIFICANT GESTURES

By 1958, European museums were clamoring for abstract expressionism. In response to their requests, the Museum of Modern Art organized *The New American Painting*. The show featured eighty-one works by Sam Francis, Adolph Gottlieb, Philip Guston, Franz Kline, Robert Motherwell, and a dozen others whose working methods had, in 1952, prompted critic Harold Rosenberg to coin the term "action painting." The show created a sensation in Basel, Berlin, Madrid, Milan, and eight other European capitals. Critics raved about canvases executed in turbulent swirls of paint that captured the conflicted spirit of the postwar world.

European moderns had been an early source for the new American paintings. Hans Hofmann had emigrated from Germany in the early 1930s, bringing knowledge accumulated in Paris in the early years of the century. He was followed at the outset of World War II by surrealists and other European artists who fled to the United States to escape Nazi aggression. In American classrooms and studios, in jazz clubs and bars, these émigrés and the artists who met them discussed new ideas in philosophy and art. They argued about the nature of human experience, the role of accident in revealing the unconscious, and the value of rational systems in the creative process.

The autographic mark—unpremeditated drips and spatters of pigment and sweeping strokes of brilliant color—became the expressive vehicle for many. Philip Guston worked and reworked surfaces to capture his own restless search for meaning. Joan Mitchell, Helen Frankenthaler, and Theodoros Stamos translated perceptions of the natural world into huge canvases of color and light. Adolph Gottlieb and Sam Francis explored recent discoveries in physics. Franz Kline and Michael Goldberg drew on the built environment in images that at first seem sheer explosions of paint. The highly intellectual Robert Motherwell painted stick figures reminiscent of ancient cave painting to elicit thoughts of primitive man and the urge to create. Theodore Roszak and fellow sculptor Ibram Lassaw manipulated obdurate metal with a new freedom as they and others rejected conventional ways of making art.

Michael Goldberg, *The Creeks* (detail)
See page 136

RICHARD diebenkorn

1922 | 1993

Ocean Park, No. 6 (1968) is striking in its monumentality. At nearly eight feet tall and six feet wide, the painting envelops the viewer. The vertical bands of color are both seductive and disarming. They create a sense of space—but not a recognizable one. The angularity of the brown and blue areas, divided from the rest of the painting by a thick black band, conjures an interior. Yet those colors, together with the green on the bottom right corner, also suggest a landscape—as does the title. At the same time, multiple shades of white, gray, and pink manifest in organic forms that remind many critics of the backs of figures. These curving lines and pastel colors soften the imposing vertical structure of the painting while creating a tension—between dark and light, rigid geometry and organic forms, and even, when considering the band of unpainted canvas on the far right, between art and barrenness. In short, compositional elements give an insight into Diebenkorn's struggle in this canvas. An early work in a series he went on to pursue in more than one hundred pieces, *Ocean Park, No. 6* reflects the formal challenges Diebenkorn set for himself, and perhaps even the realignment of his thinking, as

RICHARD DIEBENKORN, 1977
Mimi Jacobs, photographer, Courtesy of
the Photographs of Artists taken by Mimi
Jacobs collection, 1971–1981, Archives
of American Art, Smithsonian Institution

he shifted from representational painting back to abstraction. Here one can see him divesting himself of recognizable figures, landscapes, and interiors as he searches for a new mode of expression.

Many aspects of *Ocean Park, No. 6* give the sense of improvisation. The thinly applied paint reveals canvas. The gestural black lines vary in intensity, suggesting a kinetic technique. The green paint from the right corner has splattered across the canvas, and the visible pentimenti document Diebenkorn's working process. Altogether, these elements convey a sense of movement and time. Yet it is probably inaccurate to suggest that this painting was executed quickly. Speaking of his process in making the "Ocean Park" series, Diebenkorn said, "I guess never in 'Ocean Park' has there been a one-day painting, from blank canvas to finish. There are probably almost no two-day paintings. I think there are a few [finished in] a week, five days—others have gone on for a year."[2] Describing the difficulty of beginning a work, he once said, "Of course, I don't go into the studio with the idea of 'saying' something—that's ludicrous. What I do is face the blank canvas,

which is terrifying. Finally I put a few arbitrary marks on it that start me on some sort of dialogue. I need a dialogue to get going."[3]

When *Ocean Park, No. 6* was exhibited in 1968 at Poindexter Gallery in New York City, it marked the debut of what would become Diebenkorn's most highly regarded series. A *New York Times* review of the show carried a reproduction of this painting and proclaimed Diebenkorn "one of the most serious and best balanced American painters," high praise from the New York establishment for a West Coast artist.[4] The "Ocean Park" series, named after his studio's location in a section of Santa Monica, California, marked one of many shifts in the artist's long and distinguished career. As a young artist he explored abstract expressionism from the late 1940s until 1955. He then turned to figurative works until about 1966, when he returned to abstraction for much of the rest of his life.

After studying art at Stanford and the University of California at Berkeley and then serving in the Marines in World War II, the San Francisco-raised painter settled in the Bay Area. There he became affiliated with David Park and Elmer Bischoff, first as

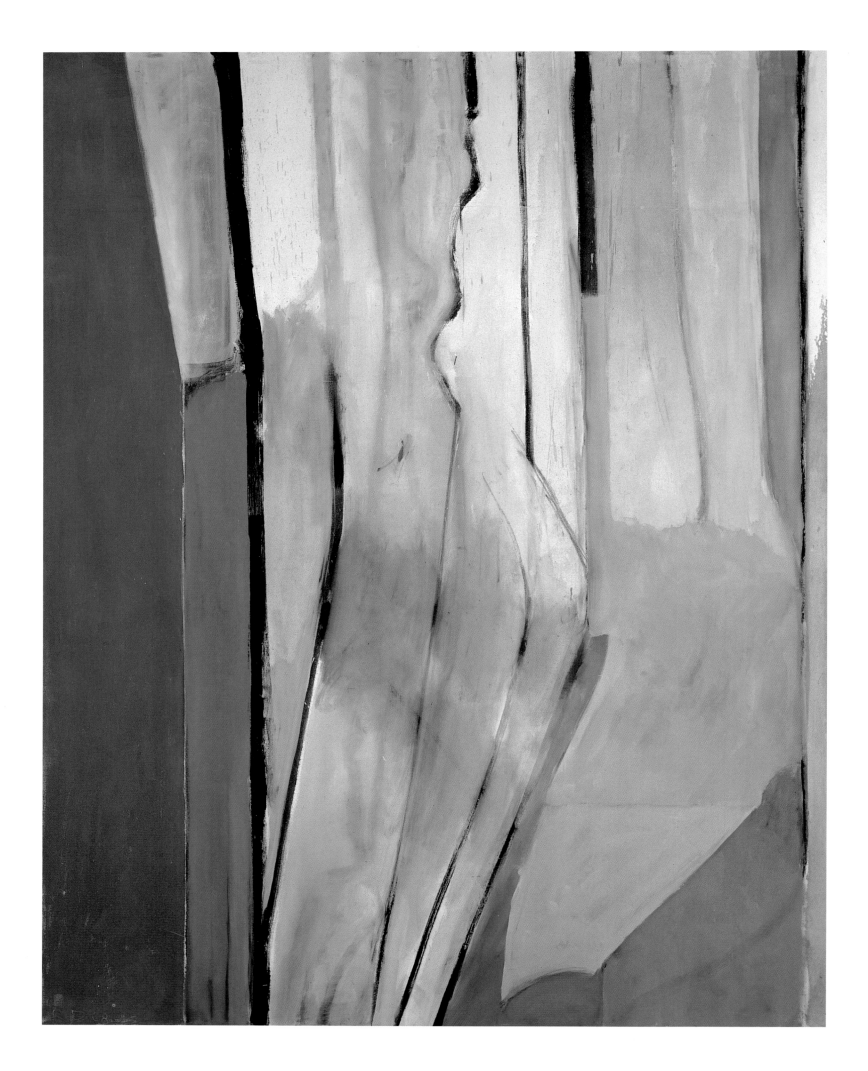

OCEAN PARK, NO. 6
1968, oil on canvas, 92 × 72 in.
Gift of Arthur J. Levin in memory
of his beloved wife Edith

a student, then as a teacher at the California School of Fine Arts. After first exploring abstract expressionism, in late 1955 Diebenkorn began working in the representational mode. For about a decade, he was considered part of the Bay Area figurative school. Always an individualist, Diebenkorn scorned any notion of forming a movement. "I didn't like being labeled a 'California Figurative Painter.' But of course I *was* a California figurative painter and so were my friends—David [Park] and Elmer [Bischoff] and the others—and I enjoyed working with them, drawing with them, talking with them and drinking with them. But I got very upset, when we were all supposed to become a movement. I hated that. But it *did* become a movement, and I really didn't know what I could do about it."[5]

View of Oakland (1962) is an example of his painting from this period. The cityscape, executed in a nearly square format, depicts the skyline from a high vantage point in somber colors. Even in this representational canvas, one can detect Diebenkorn's abstract expressionist roots in the incised areas, the gestural paint application, and the abstracted, flattened forms across the vista. The contemplative mood conjured in

this painting also foretells the calm serenity found in many later "Ocean Park" works.

In explaining his 1955 turn to figuration, which was derided by the avant-garde art world at that time, Diebenkorn said, "You see, I was trying to demonstrate something to myself—that I wasn't going to get stuck in any dumb rut. I felt I could move on to something else. I got kind of a thrill out of doing that. I said, 'I can leave this [abstract expressionism] all behind.'"[6] Diebenkorn made breaking out of "ruts" a personal challenge throughout his career.

In 1966, Diebenkorn moved from San Francisco to Santa Monica to teach at UCLA, a transition that coincided with his shift back to abstract painting. That year he saw an exhibition of Henri Matisse's work at UCLA's University Art Gallery, which included two 1914 canvases that had never before been shown in the United States. These nearly abstract cityscapes, *Porte-Fenêtre à Collioure* (French Window, Collioure) and *View of Notre Dame*, inspired his return to abstraction.[7]

About that time, Diebenkorn acquired studio space from his friend, artist Sam Francis, in the Ocean Park neighborhood. Once there, Diebenkorn

VIEW OF OAKLAND
1962, oil on canvas, 58⅝ × 53⅞ in.
Gift of S. C. Johnson & Son, Inc.

savored the light and space, which allowed him to explore his abstractions in large formats. Diebenkorn pursued the series for about twenty years. Meanwhile, his setting formal problems and wrestling with them continued. In a 1986 interview he summarized his perfectionist aims. "Now, the idea is to get everything right—it's not just color or form or space or line—it's everything all at once."[8] [TDF]

[1] From Richard Diebenkorn's unpublished studio notes, undated note, collection of Phyllis Diebenkorn, quoted in Jane Livingston, *The Art of Richard Diebenkorn* (Berkeley: University of California Press, 1997), 67.

[2] Richard Diebenkorn, interview with Susan Larsen, Dec. 15, 1987, Archives of American Art, online transcript, http://www.aaa.si.edu/collections/oralhistories/transcripts/dieben85.htm.

[3] John Gruen, "Richard Diebenkorn: The Idea Is to Get Everything Right," *ARTnews* 85, no. 9 (Nov. 1986): 87.

[4] John Canaday, "Richard Diebenkorn: Still Out of Step," *New York Times*, May 26, 1968.

[5] John Gruen, "Artist's Dialogue: Richard Diebenkorn, Radiant Vistas from Ocean Park," *Architectural Digest* 43, no.11 (Nov. 1986): 60.

[6] Gruen, "Richard Diebenkorn: The Idea Is to Get Everything Right," 84.

[7] Livingston, *The Art of Richard Diebenkorn*, 62–64.

[8] Gruen, "Richard Diebenkorn: The Idea Is to Get Everything Right," 87.

*I am fascinated by gravity. I like to fly,
to soar, to float like cloud, but I am tied
down to place.*[1]

SAM francis

1923 | 1994

Sam Francis came to art by accident. He had gone
to the University of California, Berkeley, as a sci-
ence major in 1941. Two years later, he left college
to join the Army Air Corps. During a training
exercise his plane crashed, and he spent the next
three years in hospitals in Colorado and California,
recovering from severe injuries and previously un-
diagnosed tuberculosis of the spine. In bed, able to
move only his head and arms, he watched the "play
of light on the ceiling, the dawn sky and sunset
sky effect over the Pacific."[2] He was given a set of
watercolors to help allay the boredom of confine-
ment and began painting as therapy. David Park,
then teaching at the California School of Fine Arts
(now the San Francisco Art Institute), saw one of
Francis's watercolors, heard the story, and began
making weekly visits to work with Francis. Like
many student painters, his early works were stylized
landscapes, portraits, and still lifes, but by 1947,
the year he was released from the San Francisco
Veterans Administration hospital, Francis had aban-
doned figuration. The following year he returned
to Berkeley to finish B.A. and M.A. degrees in
studio art and art history.

In 1950, with support from the G.I. Bill, Francis moved to Paris, where he met Joan Mitchell and other American painters who congregated there after the war. He soon abandoned the luminous color of the abstractions he painted in Berkeley and filled canvases edge to edge with diaphanous veils of muted hue. Two years later, he wrote his father, "Have been struggling hard to get all feeling of rhetoric out of the works. To present a work which is *apart*—distant, demands contemplation—does not tell the seer what to feel.... A kind of universe or world that seems to have formed by its own laws."[3] He reported that he had been reading a lot of astronomy but, he told his father, who was a math professor, "Wish I knew more math—the old idea of limited + bounded business you dropped this summer, dad, has already influenced my paintings. The paintings have become, since, much more cosmological in feeling + of much greater spatial expansion."[4] Light, and its corollary, space, became vehicles for Francis's exploration and experimentation.

The mid-1950s in Paris were exciting years for Francis. Critics applauded his canvases and in January, 1956, a *Time* magazine article called him "the hottest American painter in Paris."[5] In February, his dealer,

Martha Jackson, opened his first one-person show in New York; he had a solo exhibition at the Galerie Rive Droite in Paris; and Dorothy Miller included Francis in *Twelve Americans* at the Museum of Modern Art. He also began the *Basel Triptych*, three huge paintings for the grand staircase of the Kunsthalle in Basel, Switzerland.[6] (See photo, page 18.) Francis spent most of 1957 on his first trip around the world. While living in a temple in Tokyo, he became interested in space and the Japanese idea of the void, and began exploring fields of white as an arena for drips and loose cells of brighter color.[7] He had exhibitions in Tokyo, London, and Bern, Switzerland, that year, and in 1958 was included in the Basel showing of the touring exhibition *New American Painting*. By 1960, Francis was an international art star with studios in Paris, Tokyo, and Bern.

In *Untitled* (1960), orbs of color, mostly blue, float in a white field, touching but not colliding. The image is activated by multiple energies. Gravity pulls drips downward to puddle at the lower edge of the paper. Spatters mark movement through space. Using watery paint, Francis defines two universes, one cosmic, one earthbound, in which loosely bound color

shapes mingle, merge, and recombine. *Untitled* (1960) reflects Francis's earlier thoughts about space and cloud forms. In it he soars and floats.

Blue Balls (1960) is quieter, as though the universe has settled after the big bang. Loosely bounded spheres of blue, some touched with green and purple, hover at right and left, leaving an empty white center. Even the spatters have calmed; their trajectories seem the unhurried residues of a previous cataclysmic event.

Although Francis spent much of 1961 in a hospital in Bern, suffering from tuberculosis of the kidney, his work was in demand for shows in the United States and abroad, and he continued to explore the blue tonalities and fields of primed but unpainted canvas at the center of the "Blue Balls" paintings, a series he worked on from 1960 through 1963. Energy is more explosive in *Untitled* (1965). Centrifugal rather than gravitational forces compel high-keyed shapes toward all four margins of the paper, their organic forms seemingly defined by an invisible expanding force. Fast-paced spatters dance across the field like high-velocity particles traveling through space.

William Agee characterized Francis's art as an "essential act of affirmation" and remarked on the irony "that the art of Sam Francis, an art of color conceived as light and air and space, was born of sustained and recurring pain and illness. [During his postwar illness,] he began painting as a form of therapy, and through it found a way back to life.... [Later,] painting saw him through grave illnesses in the early sixties, and again in the last years of his life."[8]

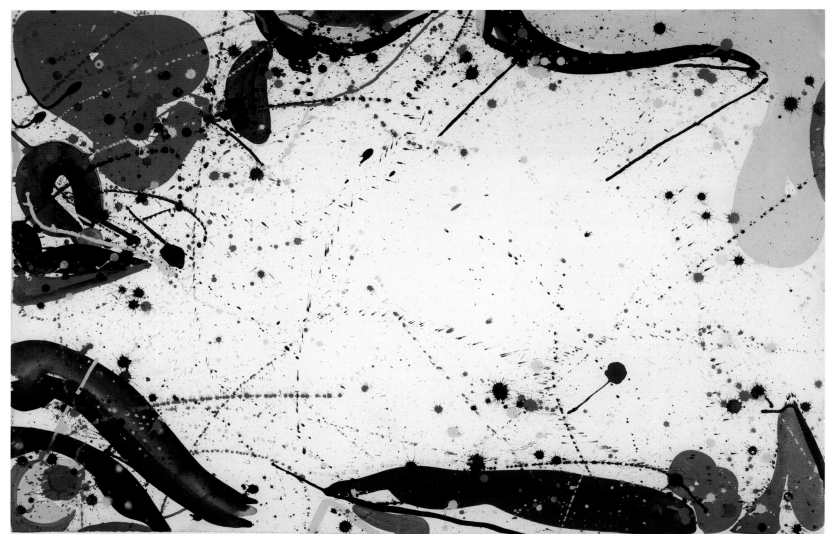

UNTITLED
1965, acrylic on paper, 27 × 40½ in.
Bequest of Edith S. and Arthur J. Levin

[1] Peter Selz, *Sam Francis* (New York: Abrams, 1982, rev. ed.), 14.

[2] James Johnson Sweeney, *Sam Francis* (Museum of Fine Arts, Houston and University Art Museum, Berkeley, 1967), 14, quoted in Selz, 34.

[3] Excerpt from a letter by Francis to his father and stepmother, Jan. 18, 1952, reprinted in Pontis Hulten, *Sam Francis* (Bonn, Germany: Kunst- und Ausstellungshalle der Bundesrepublik Deutschland, 1993), 48.

[4] Ibid.

[5] "New Talent," *Time*, Jan. 16, 1956, 72.

[6] Robert Buck, who organized a major retrospective of Francis's work for the Albright-Knox Art Gallery in Buffalo, New York, described the Basel paintings as "linked in spirit" with Claude Monet's late water lily paintings. The paintings, which were not approved for purchase, were later separated. One of the canvases was destroyed in shipping; another is now in the collection of the Norton Simon Museum of Art in Pasadena, California; and the third is owned by the Stedelijk Museum in Amsterdam. See Robert T. Buck Jr., *Sam Francis: Paintings 1947–1972* (Buffalo: Buffalo Fine Arts Academy, 1972), 20.

[7] Nancy Mozur, "Sam Francis Chronology," in *Sam Francis, The Shadow of Colors*, ed. Ingrid Mössinger (Zurich: Edition Stemmle, 1995), 110.

[8] William C. Agee, "Sam Francis: Color, Structure, and the Modern Tradition," in *Sam Francis: Paintings, 1947–1990* (Los Angeles: Museum of Contemporary Art, 1999), 9–10. Francis died in November 1994, following a long and painful siege of prostate cancer. See Ferdinand Protzman, "'Steering by the Torch of Chaos and Doubt,'" *ARTnews* 101, no. 11 (Dec. 2002): 107.

Sam Francis at Ft. Miley Veterans' Hospital, San Francisco, about 1945, Courtesy of the Samuel L. Francis Foundation, © Corbis/Bettmann

What concerns me when I work is not whether the picture is a landscape, or whether it's pastoral, or whether somebody will see a sunset in it. What concerns me is—did I make a beautiful picture?[1]

HELEN frankenthaler

born 1928

Helen Frankenthaler's title, *Desert Pass* (1976), certainly suggests a landscape, though few would recognize traditional landscape conventions in this canvas. Like most of her works, it evokes a time, place, or state of mind, rather than a literal subject. Its date and the warm, southwestern palette indicate Frankenthaler painted it after her first trip to Arizona in 1976, when she was invited to lecture at the Phoenix Art Museum.[2] The turquoise field at right offsets the glowing yellow burst that surrounds the central brown area. Is that hovering form a rocky mesa? A backlit cactus? Or merely a complementary shape and color?

Because Frankenthaler denies any concrete references in her abstract works, she would probably prefer the latter. Yet she also admits, "Of course paintings echo, in varying degrees, one's inner psychic surroundings as well as outside orbits."[3] In creating the painted "echo," Frankenthaler uses her sophisticated knowledge of color, space, scale, and media to create an experience, not just a picture, for the viewer. Frankenthaler's abstract paintings might be understood as mindscapes—products of a highly creative person's assimilation of her inner life and the

world around her. Comparing paintings illustrates the point. *Desert Pass* and *Summerscene, Provincetown* (1961), with their divergent palettes, evoke totally different associations and emotional responses. Indeed, bright colors and exposed canvas in *Summerscene, Provincetown* create a sense of lightheartedness, play, and frivolity, while *Desert Pass* seems weighty and intense.

One of the most well-known American artists of the twentieth century, Frankenthaler gained fame for her signature technique—known as the "soak-stain" method—which she developed in 1952. Although she was just twenty-four years old at the time, her artistic development already had deep roots. When Frankenthaler was nine years old, she won honorable mention in a children's drawing contest. Her father, who was a judge on the New York State Supreme Court, encouraged her artistic talent. After Frankenthaler's father died two years later, a devastating event for the young artist, her family sent her to private schools, culminating in her senior year of study with Mexican painter Rufino Tamayo at the Dalton School. She then trained with Paul Feeley at Bennington College in Vermont, where she focused on cubism. After graduating in 1949, she returned home to New York City, and in the summer of 1950, she studied with Hans Hofmann and began to explore contemporary abstraction.

Frankenthaler met the influential art critic Clement Greenberg at the opening of an exhibition of Bennington College alumni in New York City in early 1950. They began a five-year romance, attended gallery openings, and discussed contemporary art. In late 1950, they saw the groundbreaking exhibition of Jackson Pollock's drip paintings at the Betty Parsons Gallery. Frankenthaler was inspired to abandon not only cubism, but the easel as well. Of Pollock's work, Frankenthaler said, "It was original, and it was beautiful, and it was new, and it was saying the most that could be said in painting up to that point—and it really drew me in. I was in awe of it, and I wanted to get at why."[4]

Soon after, Frankenthaler began the experiments that led to the soak-stain method and her breakthrough painting, *Mountains and Sea*, executed in October 1952. In her stain paintings, she laid unprimed canvas on the floor, as did Pollock. Instead of dripping paint over the canvas and building up

DESERT PASS
1976, acrylic on canvas, 39 × 54 in.
Bequest of Edith S. and Arthur J. Levin

a thick surface, however, she thinned the paint and allowed it to soak into the canvas—a technique that emphasized the flatness of the picture plane, the color, and the support itself. Some critics likened her method to watercolor in the paint's luminosity and its seeming ability to flow and float. The process lends a dreamlike, mystical quality to Frankenthaler's works.

Of her technique and Pollock's influence, Frankenthaler later said, "Unlike Pollock, I didn't feel like using a stick, dripping enamel, but I liked his idea of rolling out unsized, unprimed cotton duck on the floor. And the gesture of a limitless but still censorable 'sketch'—only on that scale! So, influenced by his painting and taking hints from his methods and materials, I experimented and proceeded to try other ideas."[5] To achieve different effects, Frankenthaler sometimes pours the paint, or applies it using sponges and brushes.[6]

Greenberg immediately recognized the genius of Frankenthaler's new approach, and he began to show her paintings to other artists, among them Kenneth Noland and Morris Louis. They, too, explored Frankenthaler's techniques and acknowledged her as an important influence in the Color Field movement.

Greenberg also introduced Frankenthaler to others who came to be known as the New York school in the early 1950s. She and Greenberg spent time with Jackson Pollock and his wife, Lee Krasner, on Long Island. (See photo, page 67.) She met Willem de Kooning and Franz Kline and, along with friends Elaine de Kooning and Grace Hartigan, was an early member of The Club. In 1957, Frankenthaler began dating Robert Motherwell, and they wed the following year.

Her marriage to Motherwell, which lasted until 1971, coincided with wider critical acclaim. By the late 1950s, Frankenthaler began to exhibit internationally, and in 1966, her work was featured in the Venice Biennale. Throughout the 1960s, she was included in group exhibitions at prestigious U.S. museums, culminating in her 1969 retrospective at the Whitney Museum of American Art. Since then, there has been a sense of continuity in her painting style, though she has explored printmaking with great success as well. The spontaneity inherent in her technique, however, has allowed for continuing experimentation and surprise. After working for several decades, Frankenthaler remains enamored by the wonder and elusive qualities

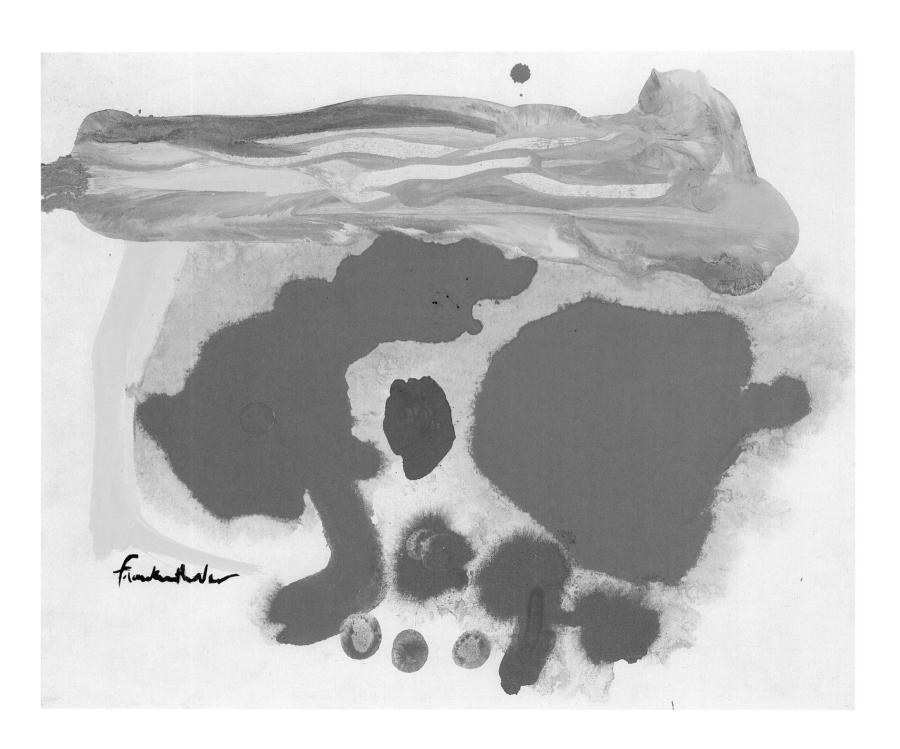

SUMMERSCENE, PROVINCETOWN
1961, acrylic on canvas mounted on
paperboard, 20 × 24 in.
Gift of the Woodward Foundation

of art. She said, "It cannot be explained. If I felt I could give a formula, a recipe, or an arrangement for it I would be in trouble....We should allow more for spirit, for magic, for *je ne sais quoi* as true elements in themselves."[7] [TDF]

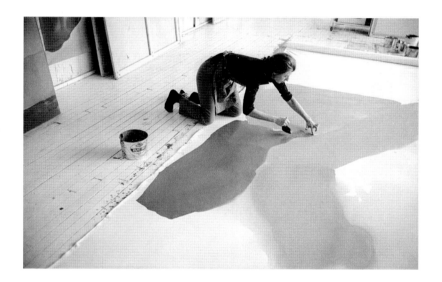

[1] Deborah Solomon, "Artful Survivor," *New York Times Magazine*, May 14, 1989, 68.

[2] E. A. Carmean, Jr., *Helen Frankenthaler: A Paintings Retrospective* (New York: Abrams, Inc., 1989), 70. In Carmean's interpretation of the painting *Natural Answer*, he notes Frankenthaler's 1976 lecture at the Phoenix Art Museum. During the lecture, Frankenthaler said, "Touring Phoenix today I came up with lots of good [artwork] titles, but I don't have the pictures [for them] yet."

[3] Cindy Nemser, "Interview with Helen Frankenthaler," *Arts Magazine* (Nov. 1971): 51.

[4] Solomon, 63.

[5] Grace Glueck, "The 20th Century Artists Most Admired by Other Artists," *ARTnews* (Nov. 1977): 85.

[6] Nemser, 52.

[7] Theodore Wolff, "Artist Helen Frankenthaler, Hand in Hand with the Rest of Life," *The Christian Science Monitor*, Nov. 13, 1979, 28.

Helen Frankenthaler, about 1970
Ernst Haas, photographer/
Hulton Archive/Getty Images

[A]rt comes out of art.... It's...an obligation to know as much as you possibly can....[Y]ou make art out of selective thievery almost. If your vocabulary is pretty big, then you have sources, if you need them, that you can make choices from. Sometimes your choices are more deliberate than at other times.[1]

MICHAEL goldberg

1924 | 2007

Old master artists and Renaissance architecture seem unlikely starting points for Michael Goldberg's expanses of richly layered paint. Expressive color laid down in sweeping strokes epitomizes critic Harold Rosenberg's famous definition of abstract expressionist painting as an arena in which the artist acts.[2]

For Goldberg, the "selective thief," the act of painting meant blending perceptions, ideas, and forms. The works are physical, but not entirely spontaneous. Describing his self-conscious process, Goldberg said, "I'm trying to make each stroke be as specifically exact to me as I can make it....I want to be as exact about color, the brush I use to put it down, the amount of color I put down, where it exists and how it moves."[3] Goldberg's sources are far ranging. As influences, he claimed Pollock, de Kooning's fusion of gesture and structure, Gorky's use of line, the way Italian mannerist painter Domenico Beccafumi opened up space, the energy and bizarre color of Il Pordenone, and the S-curves that characterize Poussin's compositions.[4]

Goldberg's subjects were moments, places, or ordinary objects. He described a painting called *Red Sunday Morning* as a mental collage of a breakfast

with Joan Mitchell—the two were a couple in the early 1950s—in which a table with crooked legs, sunlight streaming in the windows, and a pan with fried eggs were points of departure for an intense red and yellow surface.[5]

From around 1957 to 1960, Goldberg worked on a series he dubbed "house paintings" after realizing that they contained centralized forms that seemed "architectural."[6] Works such as *Park Avenue Façade*, *Summer House*, *Georgica-Association*, and *The Creeks* (1959) allude to place as structure and as landscape. *The Creeks* is titled after the sixty-acre estate in East Hampton that painter Alfonso Ossorio bought in 1952. (Goldberg spent the summer of 1959 there.) An Italianate villa with extensive gardens, the Creeks became a meeting place and informal showcase where works by Pollock, Lee Krasner, Clyfford Still, and Willem de Kooning were hung along with paintings by Jean Dubuffet, and the Art Brut collection, which he had recently brought over from France. Any specific references to the Long Island location on Georgica Pond, the lushness of the grounds, or the sense of camaraderie among visitors to the Creeks are subsumed within the all-over surface of the painting. Efforts to associate the central blue area with water, horizontal green and yellow with foliage and sun, or bold horizontal white with architecture subvert the painting's impact and the power of the paint. "Reading" meaning in this painting involves examining the way black is applied on top of blue and discerning the insistently horizontal and vertical laying down of white, green, and yellow that give structure and reveal which strokes came first. Twenty years later, Goldberg again titled paintings for buildings. (*Santa Maria Novella*, *San Miniato*, and *Palazzo Medici* are a few.) He realized that he had always been concerned with "the human architectural response to nature and nature itself."[7]

As a teenager in New York, Goldberg had studied with Robert Brackman at the Art Students League and with Hans Hofmann. At seventeen he enlisted in the U.S. Army and from 1942 to 1946 was a paratrooper in North Africa and behind Japanese lines in Asia. Badly wounded during the war and partially paralyzed, he returned to New York and studied with sculptor José de Creeft as a form of physical therapy.[8] Healthy again after eight

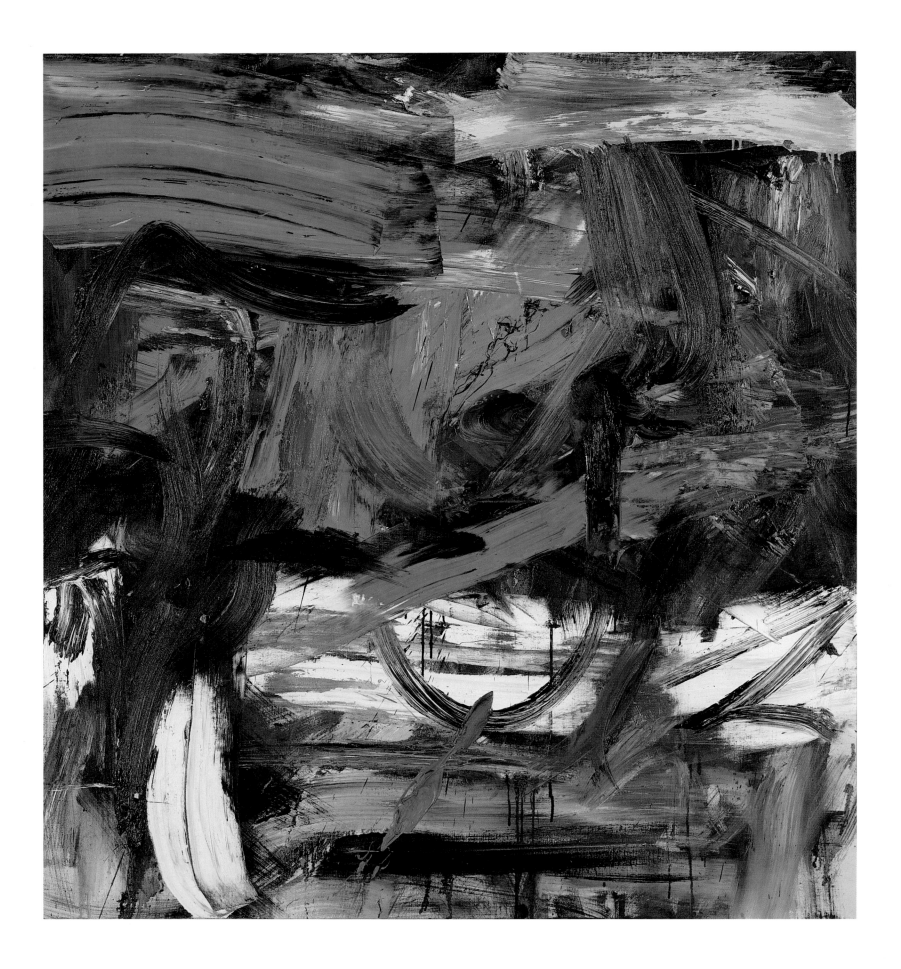

THE CREEKS
1959, oil on canvas, 52 × 47¾ in.
Gift of Mr. and Mrs. David K. Anderson,
Martha Jackson Memorial Collection

months, he crossed the United States on a motor-cycle several times. "I was very interested…in the American Sublime: the whole idea of the ever-expanding frontier, the vastness of this country, and the quality of life here," Goldberg recalled.[9] Back in New York after his travels, he spent two more years at Hofmann's school, even though he couldn't understand much of what Hofmann said, given the teacher's thick German accent. "What was really vitally important were the other students at the school and the fact that almost everybody would drop in sooner or later."[10] He soon became a member of The Club and showed in the *Ninth Street* exhibition (see page 43), and by 1956 had solo exhibitions at Tibor de Nagy and Poindexter galleries.

There is a cyclical quality to Goldberg's themes and processes, which combined, in the words of art historian David Acton, "purposeful calculation and creative spontaneity."[11] Over the years he used, discarded, and returned to compositional approaches and moved between specific and abstract content. "Making abstract art is probably the profoundest challenge that one visually faces today. . . . I get to a certain level and then find that what I can do is

no longer believable to myself. So I…go back to earlier, more figurative concerns and then I try to approach it again."[12]

[1] Ellen Lee Klein, "All Kinds of Rational Questions: An Interview with Michael Goldberg," *Arts* 59, no. 6 (Feb. 1985): 81.

[2] Harold Rosenberg, "The American Action Painters," *ARTnews* 51, no. 8 (Dec. 1952): 22–23, 48–50.

[3] Klein, 83–84.

[4] Ibid., 81–82; Donald Bartlett Doe, "Reckoning with Michael Goldberg," *Sheldon Memorial Art Gallery Resource and Response* 1, no. 2: 2.

[5] Tom Heller, "Michael Goldberg, *Red Sunday Morning*," in Paul Schimmel, *Action/Precision: The New Direction in New York, 1955–60* (Newport Beach, CA: Newport Harbor Art Museum, 1984), 68.

[6] Ellen Breitman, "Michael Goldberg, *Split Level*," in Schimmel, *Action/Precision*, 72.

[7] Ibid., 81.

[8] Ibid., 80.

[9] Ibid., 81.

[10] Ibid., 82.

[11] David Acton, *The Stamp of Impulse, Abstract Expressionist Prints* (Worcester, MA: Worcester Art Museum in assoc. with Snoeck-Ducaju & Zoon, 2001), 184.

[12] Klein, 83.

The role of the artist ... has always been that of image-maker....To my mind, certain so-called abstraction is not abstraction at all. On the contrary, it is the realism of our time.[1]

ADOLPH gottlieb

1903 | 1974

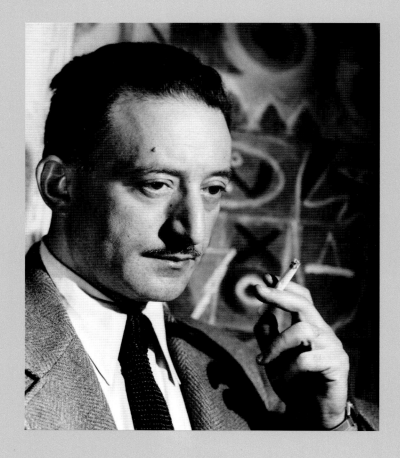

Blues (1962) is both cosmic and earthbound—a supernova and the resonant sound of a muted saxophone played in a late-night, smoky bar opposite the clarion notes of an improvising trumpet. It is a sensation visualized through a veil of memory. "When I work," Gottlieb said, "I'm thinking in terms of purely visual effects and relations....But it's inconceivable to me that I could experience things and not have them enter into my paintings."[2]

 Three Discs (1960) is simpler. Circles hover in an expanse of canvas above a calligraphic notation of black brushstrokes. The orbs—one blue, one white, and the third a rust-tinged red—are slathered with spatula or palette knife onto a field of smooth, even strokes. They are surrounded by thin halos that at first appear to be oil residue that has seeped from richly painted forms. But Gottlieb more likely scrubbed the halos on the gray-white field, probably with a rag, to locate the circles in space and give depth and expansiveness to the surrounding area. Bold black lines energize and support the forms above. The contrasting configurations of circle and scribble resolve into a quiet energy, as though the cosmos has settled after the big bang. In *Three Discs*,

ADOLPH GOTTLIEB, about 1948
Alfredo Valente, photographer, Courtesy of the Alfredo Valente papers, 1941–1978, Archives of American Art, Smithsonian Institution

Gottlieb achieved an equilibrium that balances and unites opposing forces. Both *Blues* and *Three Discs* are "bursts," the simplified paintings Gottlieb began in 1957, the year the circular Russian satellite *Sputnik* was launched. The bursts marked a dramatic new direction in his art.

A lifelong New Yorker, Gottlieb dropped out of high school against his father's wishes, and traveled to Europe on a freighter. When he returned he worked in his annoyed father's store, then did odd jobs—painting signs, retouching photographs, and teaching arts and crafts in a summer camp. At night he took classes at the Art Students League, the Cooper Union, Parsons School of Design, the Educational Alliance, everywhere, he said, except the National Academy of Design. During a year on the WPA, he painted *Sun Deck* (1936), a softly rendered image of people relaxing on the deck of a ship. Between 1937 and 1938, Gottlieb spent a year in the Arizona desert, which doctors had said would help alleviate his wife's arthritis. If not precisely conventional, like *Sun Deck*, the landscapes, portraits, and still lifes of shells he painted there broke no new ground.

By 1939, Gottlieb had reached what he described as a "crisis" in his art. "I felt that I had to dig into myself, find out what it was I wanted to express."[3] He had seen photographs of prehistoric rock paintings in a 1937 show at the Museum of Modern Art and had discovered ancient petroglyphs when he lived in Arizona. Their enigmatic signs and suggestion of shamanistic rituals coincided with ideas he discussed with his friends Mark Rothko and John Graham, and in 1941, Gottlieb began a decade-long series he called "Pictographs" (*Pictograph*, about 1941–46). He divided surfaces into compartments that contained seemingly symbolic forms. Eyes, hands, heads, squiggly lines, and other hieroglyphic look-alikes conveyed cryptic, undecipherable meanings. He drew signs freely, without preplanning. Like the automatic writing of the surrealists, images flowed directly from his unconscious onto the canvas. Gottlieb had no particular allegiance to Carl Jung; he freely mingled Freudian and Jungian theories. But Jung's ideas about the atavistic nature of myth resonated. "If we profess a kinship to the art of primitive man," he declared, "it is because the feelings they express have pertinence today."[4]

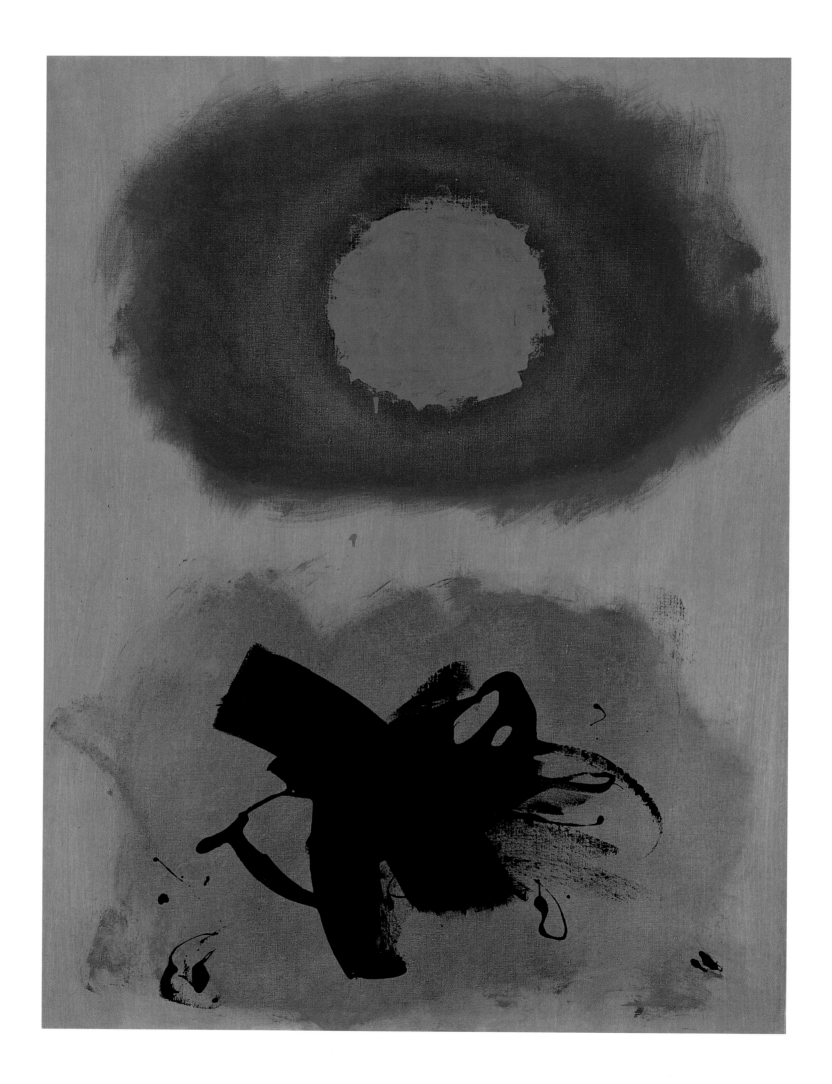

By the early 1950s, Gottlieb had reached another turn-
ing point. The pictographs no longer surprised him,
he said.[5] Instead he wanted to deal with polarities of
nature and life.[6] In the resulting paintings, the bursts,
Gottlieb dramatically reduced the number of elements,
simplified shapes and color, and replaced the all-over
configuration with condensed areas of focus. The bal-
ance, clarity, tension, and therefore meaning, in *Three
Discs* and *Blues* are inconceivable in the earlier formats.

The seeming disjuncture among the early
representational work, the all-over pictographs,
and the dramatically simplified forms of the bursts,
is deceptive. Surface division and forms changed
radically, but the ideas that impelled Gottlieb are
remarkably consistent throughout. They reflect
ideas that he and Rothko expressed in their now-
famous letter to the *New York Times* in 1943: "We
favor the simple expression of the complex thought.
We are for the large shape because it has the impact
of the unequivocal.... We are for flat forms because
they destroy illusion and reveal truth.... There is no
such thing as good painting about nothing.... The
subject is crucial and only that subject-matter is *valid
which is tragic and timeless*."[7]

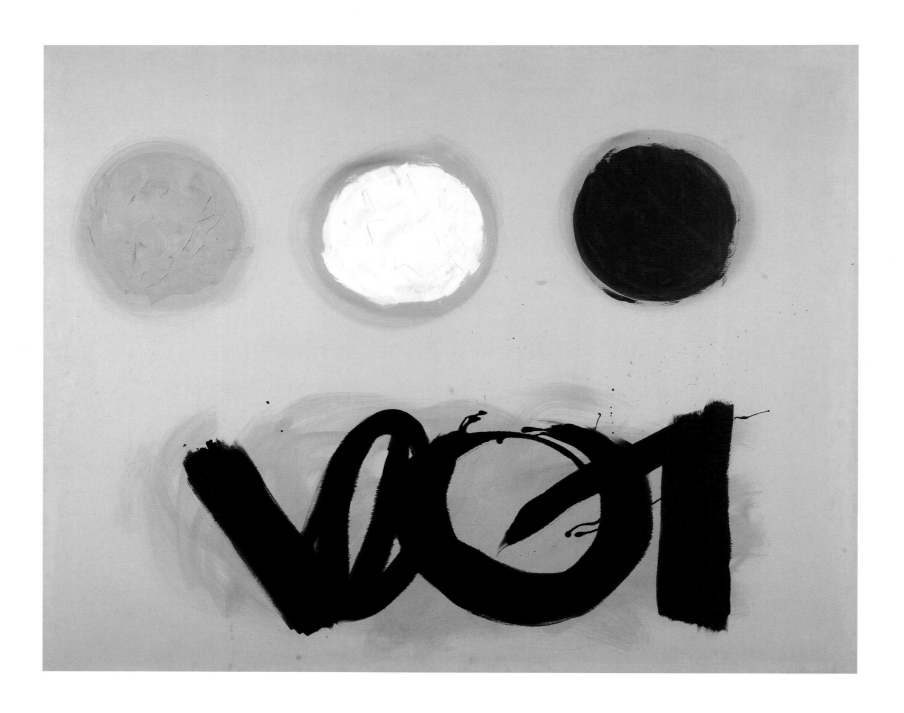

PICTOGRAPH
about 1941–46, linoleum cut
on paper, 11 ⅞ × 14 ¾ in.
Museum purchase

[1] Adolph Gottlieb, artist statement in "The Ides of Art: The Attitudes of Ten Artists on Their Art and Contemporaneousness," *The Tiger's Eye* 1, no. 2 (Dec. 1947): 43.

[2] Harold Rosenberg, "The Art World: Signs," *The New Yorker*, Mar. 23, 1968, 110.

[3] Dorothy Seckler, "Interview with Adolph Gottlieb," Oct. 25, 1967, Archives of American Art, online transcript, http://www.aaa.si.edu/collections/oralhistories/transcripts/gottli67.htm.

[4] Adolph Gottlieb and Mark Rothko, "The Portrait and the Modern Artist," typescript of a broadcast on "Art in New York," WNYC, Oct. 13, 1943,

1–2, quoted in Mary David MacNaughton, "Adolph Gottlieb: His Life and Art," in Sanford Hirsch and Mary David MacNaughton, *Adolph Gottlieb: A Retrospective* (New York: The Arts Publisher in association with the Adolph and Esther Gottlieb Foundation, 1981), 42. Also reproduced in Hirsch and MacNaughton, Appendix B.

[5] Seckler, online transcript.

[6] "The Older," *Newsweek*, Feb. 24, 1964, 82.

[7] Adolph Gottlieb and Mark Rothko (with the assistance of Barnett Newman), "Letter to Edward Alden Jewell, Art Editor," *New York Times*, June 7, 1943, reproduced in Hirsch and MacNaughton, 169.

◀ **THREE DISCS**
1960, oil on canvas, 72 × 89 ⅞ in.
Gift of S. C. Johnson & Son, Inc.

PHILIP guston

1913 | 1980

Painter III (1960) is an agitated painting. Restless forms and multiple points of focus vie for space in a blue field that is part surface and part background, as though the artist has struggled to control rebellious shapes. Dark red strokes bisect the image vertically and horizontally, creating a wall that separates opposing forms. The title of *Painter III* is a reference to Guston himself. It was created at the halfway mark in his exploration of abstraction. He had begun as a social realist of dark, surreal images, but in 1950 he jettisoned recognizable content, and within two years was crafting pastel colored canvases in which thousands of crisscrossing brushstrokes mass into shallow constellations. On seeing these paintings, Guston's friend, musician Morton Feldman, observed that applying paint was "like touching the keys of a piano. You can strike softly and go long, or strike sharply and quick," he said. "Pollock and de Kooning were quick—Guston and Rothko soft, elegant, and long."[2]

Guston was born in Montreal, the son of Russian immigrants who moved to Los Angeles when Guston was a boy. Life in California proved no easier than in the Jewish ghetto of Montreal,

especially for his mother, who raised seven children after the suicide of her husband. But with her encouragement, Guston made art. Drawings dated 1930, when he was just seventeen, show remarkable technical skill. He tried art school, but felt insufficiently challenged, so he left after three months, determined to figure it out on his own. He copied Krazy Kat cartoons and reproductions of works by Paolo Uccello, Piero della Francesca, and other Renaissance masters to learn pictorial structure and organization. For income he worked in a factory and took small roles in films. (He played an artist working at his easel in the 1931 John Barrymore film *Svengali*.) In 1934, Guston traveled to Mexico with Reuben Kadish, met social realist David Alfaro Siqueiros, and painted a mural.

In the winter of 1935 to 1936, Guston went to New York at the urging of Jackson Pollock, a high-school friend and fellow mischief-maker. (The two had been disciplined for distributing broadsides mocking the school's emphasis on sports.) Guston met with quick success as a WPA muralist, and, with several important commissions to his credit, was offered a teaching post at the University of

Iowa (1941–45), a residency as a visiting artist at Washington University in St. Louis (1945–47), and commissions from *Fortune* magazine to illustrate war-training programs. Guston's paintings of these years are troubling and surreal. In one dark canvas, children brandishing wooden sticks play at war. Another shows the effects of a bomb blasting unsuspecting people in a town.

In 1948, Guston was awarded a fellowship to the American Academy in Rome. In Italy he finally saw firsthand work by the Renaissance masters that would be a source of artistic sustenance throughout his life. The year in Rome—with time to look, think, and learn—proved pivotal. Returning to New York, Guston jettisoned the dark palette and difficult subjects to paint the lyrical abstract canvases of interlaced brushstrokes that Feldman described as "elegant."[3] Exhibitions at Charles Egan Gallery and later with Sidney Janis brought critical acclaim, and Dorothy Miller included Guston's work in *Twelve Americans*, the landmark 1956 exhibition at the Museum of Modern Art that affirmed abstract expressionism as a major force in the American art world. For the

PAINTER III
1960, oil on canvas
60 ⅝ × 68 in.
Gift of S. C. Johnson & Son, Inc.

first time since his years on the federally funded WPA, Guston was able to support himself with his artwork.

But Guston constantly questioned himself, his motivations, and the meaning of the work he produced. He described his art-making process as a dialogue with himself. "[W]e have *terrible* arguments going on all night, weeks and weeks....I argue with myself, not 'do I like it or not,' but 'is it true or not?'"[4] Dore Ashton, a friend and well-known interpreter of abstract art of the 1950s, observed that for Guston "painting is a mode of inquiry and a mode of stating an intuition concerning the meaning of existence."[5]

In the late 1950s, Guston's fields of softly applied paint and serene color modulations gave way to the insistent energy and dissonant hue of *Painter III* and other anxious, agitated canvases. In the later 1960s, paint strokes, records of the artist's decisions about the conception and realization of each canvas, began to coalesce into expressionistic forms that critics thought looked vaguely like heads and the soles of shoes.

Painter III, with its autobiographical overtones, is evidence of the struggle that began to plague Guston in the late 1950s. Within a decade,

he reversed course and rejected abstraction as "a cover-up for a poverty of spirit."[6] The artist explained:

> When the 1960s came along I was feeling split, schizophrenic. The war, what was happening in America, the brutality of the world. What kind of a man am I, sitting at home, reading magazines, going into a frustrated fury about everything—and then going into my studio to adjust a red to a blue. I thought, there must be some way I could do something about it. I knew ahead of me a road was laying. A very crude, inchoate road. I...wanted to be whole between what I thought and what I felt."[7]

He filled his new canvases with objects that appear to be symbols yet resist easy interpretation. Friends and reviewers alike were shocked and dismayed when the new paintings were unveiled in Guston's 1970 exhibition at Marlborough Gallery. A hand, a clock, a stretcher, and a small doorway drawn in the cartoonlike manner Guston had

TRANSITION
1975, oil on canvas
66 × 80 ½ in.
Bequest of Musa Guston

explored as a youth fill the white space of *Transition* (1975). Each element seems part of a nonnarrative story that speaks to time, man's passage through life, and the potential for the artist to act. The hands, heads, shoes, and clocks that appear repeatedly in these later paintings reflected Guston's new thinking about the power of visual association as a way to construct meaning. Damned by critics, they offered the vehicle for Guston to again feel whole.

[1] "Philip Guston Talking," a lecture given at the University of Minnesota in March 1978, in Renée McKee, ed., *Philip Guston: Paintings 1969–1980* (London: Whitechapel Art Gallery, 1982), 49.

[2] Michael Auping, *Philip Guston Retrospective* (Fort Worth: Modern Art Museum of Fort Worth in assoc. with Thames and Hudson, 2003), 45.

[3] Ibid.

[4] Philip Guston, "Boston University Talk" (Dialogue with Joseph Ablow, Boston University, 1966), excerpt from transcript, in Henry T. Hopkins, "Selecting Works for the Exhibition," *Philip Guston* (New York and San Francisco: George Braziller in assoc. with the San Francisco Museum of Modern Art, 1980), 46.

[5] Dore Ashton, "Philip Guston, Painter as Metaphysician," *Studio International* 169, no. 862 (1964). See online archive at http://www.studio-international.co.uk.

[6] Musa Mayer, *Night Studio: A Memoir of Philip Guston* (New York: Alfred A. Knopf, 1988), 170.

[7] Ibid., 171.

I paint under the dictate of feeling or sensing, and the outcome all the time is supposed to say something. And that is most often my sense of nature.[1]

HANS hofmann

1880 | 1966

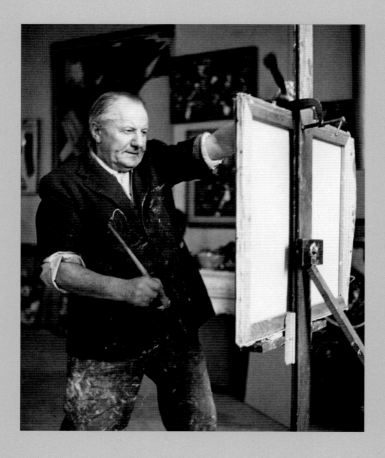

For an artist acclaimed as the most influential teacher of the first half of the twentieth century, Hans Hofmann came late to the abstractions that confirmed him as a brilliant expressionist painter. The dense, encrusted oranges, browns, and intense greens of *Fermented Soil* (1965), painted the year before he died, are troweled onto the canvas as though Hofmann were a mason laying mortar. Using wide brushes and a five-inch palette knife, he dragged paint layer over layer and cut away the skin of partially dried color to reveal recesses below. Small gobs of paint, kneaded like clay or scooped up from a glass palette loaded with pigments, are pressed onto a surface that in places is almost an inch thick. The dense materials record the direction and pressure of each brushstroke as well as the sequence in which they were applied. The result is a tour-de-force of controlled energy and glowing color that synthesizes a lifetime of visual analysis and experimentation.

Hofmann had immigrated to New York in 1932, lured from his native Germany by American students who had stumbled across his classes in Munich and the summer sessions he offered in

Bavaria, France, and Italy after World War I. He had spent the crucial decade between 1904 and 1914 in Paris. He knew Picasso, studied alongside Matisse, and was on the scene when the great Cézanne retrospective opened in 1906. He read Kandinsky's 1911 book *On the Spiritual in Art*, worked through color theory with his friend Robert Delaunay, and spent many hours at the Café du Dôme arguing art, Einstein's theory of relativity, and Henri Bergson's notion that movement and constant change are basic characteristics of reality.[2]

Hofmann was home in Munich for a visit in 1914, when World War I broke out. Prevented from returning to Paris, he opened the school that later attracted young Americans. Vaclav Vytlacil, Worth Ryder, and others found in Hofmann a teacher who reconciled the pictorial experiments of Cézanne, Matisse, Mondrian, and Picasso, and the classicism of Giotto, Piero della Francesca, and Rembrandt into a coherent and compelling curriculum.

Many who flocked to the school Hofmann opened in New York in 1934 and to summer classes he offered in Provincetown, on Cape Cod, were initially surprised at what seemed traditional class assignments. Hofmann set up still-life arrangements, hired models, and required that students draw not just the figure or bowls of flowers and fruit, but the environments in which they were placed. They needed to understand, he said, that color, volume, and void interact. Hofmann's point, remembered former student Glenn Wessels, was "things exist only in relation" to their surroundings.[3] He took students to Albert Gallatin's Gallery of Living Art at New York University and recommended they see exhibitions of work by van Gogh, de Chirico, Alexander Calder, Kandinsky, Gorky, and others at New York's museums and galleries. Yet not until 1944, when Hofmann had his first solo show in New York, at Peggy Guggenheim's Art of This Century gallery, did most of his students encounter his work for the first time. Many were puzzled by what they saw.

Identifying a singular style for Hofmann challenged critics, dealers, and even his friends in the 1940s. He talked about planes of color moving into and out of space (a concept he called "push and pull"), yet the pictures they saw at Guggenheim's exhibition were smears and dribbles of paint that seemed more surrealist than cubist or fauve.

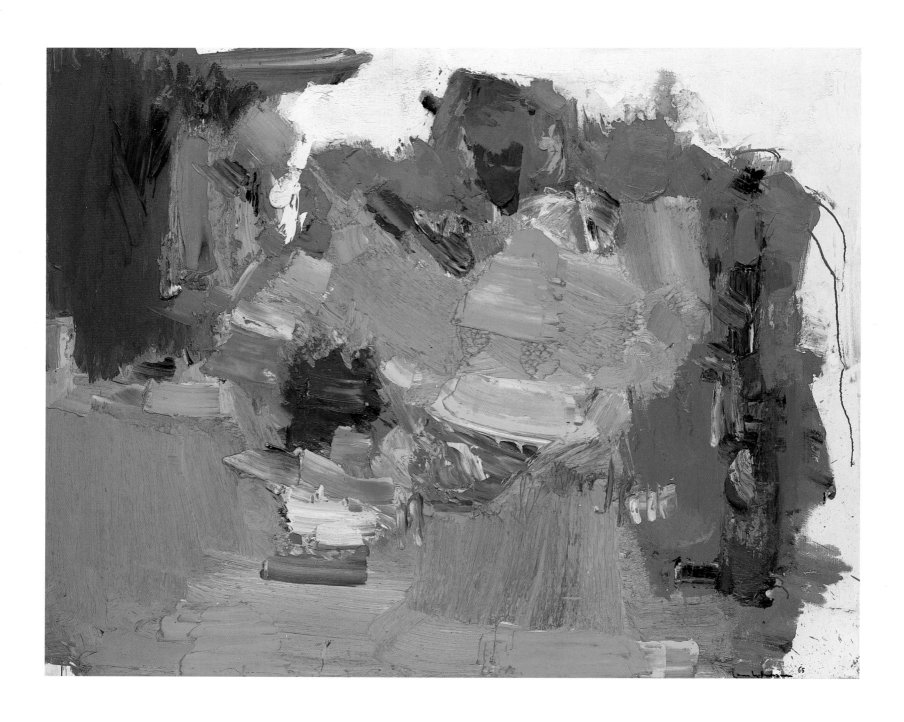

Hofmann, who was sixty-four when the exhibition opened, was still searching.

Part of the reason for his struggle was the constant demand of teaching three sessions a day summer and winter. Part, though, was that Hofmann had not yet found a way to fully integrate nature and pure abstract composition. He painted the lyrical semiabstraction called *Afterglow* during the summer of 1938 in Provincetown. Buildings and trees emerge from a welter of seemingly random lines and abbreviated marks to resolve into a landscape of high-keyed color. Recognizable as a physical location with a yellow sky, blotches of blue water, and an open central field delineated by strokes of brown fencing, it epitomizes Hofmann's conviction that a composition is a created universe in which active and dynamic forces establish an equilibrium.[4]

After the exhibition at Art of This Century, Hofmann began showing regularly, yet he continued to experiment. The black-and-white composition *Untitled* (1949) explores volume and line in cubist terms. But much of his work from the late 1940s on exploits the "advancing and receding properties…expansiveness or contractiveness, weight [and]

temperature" of color.[5] He used paint, sometimes confined within rectangular geometries, sometimes applied in swirling maelstroms, and sometimes laid down in rich, thick strata of color, to create universes that pulse with energy.

Hans Hofmann, 1948
Bill Witt, photographer, National
Portrait Gallery, Smithsonian Institution;
gift of Bill Witt, © Bill Witt

UNTITLED
1949, tempera on canvas, 32 × 34⅞ in.
Gift of Harry E. Kreindler

In 1958, at age seventy-eight, Hofmann closed his school to paint full time. Although the time spent teaching and exploring had often drained him of time and energy for his own painting, these demands might have been, as he wrote in 1938, "a precondition for the positive" he accomplished in life.[6]

[1] Irma B. Jaffe, "A Conversation with Hans Hofmann," *Artforum* 9, no. 5 (Jan. 1971): 35.

[2] For an in-depth discussion of Hofmann's Paris years, see Ellen G. Landau, "The French Sources for Hans Hofmann's Ideas on the Dynamics of Color-Created Space," *Arts Magazine* 51 (Oct. 1976): 76–81.

[3] Suzanne B. Reiss, "Glenn Wessels: Education of an Artist," unpublished interview, 1967, Bancroft Library, University of California, Berkeley, 135, quoted in Cynthia Goodman, "Hans Hofmann: A Master in Search of the 'Real,'" in Cynthia Goodman, *Hans Hofmann* (New York: Whitney Museum of American Art in assoc. with Prestel-Verlag, 1990), 34.

[4] Irving Sandler, "Hans Hofmann, the Dialectical Master," in Goodman, *Hans Hofmann*, 80.

[5] Allan Kaprow, "Hans Hofmann" (obituary), *The Village Voice*, Feb. 24, 1966, 2, quoted in Sandler, "Hans Hofmann, The Dialectical Master," in Goodman, *Hans Hofmann*, 80.

[6] Hofmann to Hodges and Kiesler, Aug. 16, 1938, quoted in Goodman, "Hans Hofmann: A Master in Search of the 'Real,'" in Goodman, *Hans Hofmann*, 31.

◄ **AFTERGLOW**
1938, oil on fiberboard, 30 × 36 in.
Gift of Patricia and Phillip Frost

*The emotion must be there. If I feel a painting
I'm working on doesn't have imagery or emo-
tion, I paint it out and work over it until it does.*[1]

FRANZ kline

1910 | 1962

Untitled (1961) seems the quintessential "action"
painting. But the initial impression of opaque black
paint impetuously laid down with a five-inch brush
on a white field that shows spatters and smears is
deceptive. Kline worked and reworked edges and
intersections, overpainting black on white and white
on black to create a ragged, dynamic structure that
can be interpreted as a bridge seen from below or
a fragment of one of the huge bins that dumped
coal into hopper cars in the train yards of his native
Pennsylvania. The forms have an internal logic that
eludes specific identification yet feels "right."

Kline had already turned forty when, in 1950,
he first showed the dramatic black–and–white
canvases that brought immediate critical acclaim.
It was time. With the exception of *Palmerton, Pa.*
(1941), which won the S. J. Wallace Truman Prize
at the National Academy of Design in 1943 (and a
much–needed $300 cash award), success had been
elusive. A scene of a hilly town in the eastern part of
the state near where he had grown up, *Palmerton, Pa.*
is typical of his paintings of the 1940s. It features
an industrial stack spewing smoke, a bridge, several
figures, and a train with a red caboose, all familiar

FRANZ KLINE, about 1960
Bert Stern, photographer, Courtesy
of the Miscellaneous Photograph
Collection, Archives of American
Art, Smithsonian Institution

elements from his childhood. Although fragments of these and other urban structures, enlarged beyond recognition, would reemerge a decade later, neither *Palmerton, Pa.* nor the other landscapes, portraits, and interiors he painted throughout the 1940s hint at the power of the canvases to come.

Kline had grown up in nearby Lehighton, where his father worked as a foreman for the Lehigh Valley Railroad. A high school football star and president of the art club, Kline loved comics and drew cartoons.[2] Determined to learn illustration, he studied in Boston and London. Back in the States in 1938, he settled in Greenwich Village. The illustrations he sent to New York magazines were constantly rejected, so he worked as a designer of department store displays, did carpentry, and, in 1939, had a portrait-drawing concession at the New York World's Fair. But economic distress was the norm. He worked at odd jobs and continued to draw but, in the words of his wife Elizabeth, whom he had met in London, the couple lived in "grinding poverty."[3]

Kline's decisive moment came one day in the late 1940s when he dropped by Willem de Kooning's studio.[4] De Kooning had borrowed a Bell-Opticon to project images on a wall. Pulling a handful of drawings from his pocket, Kline placed one in the device. The resulting enlargement, a fragment of the base and cross-bars of his wife's rocking chair, was cathartic. It gave meaning and scale to his increasingly abstract drawings and offered a way to express the loneliness and loss he felt after she was institutionalized for depression and schizophrenia.

If the realization that a small drawing could be transformed into a monumental abstract painting was immediate, the ingredients had been percolating for years in Kline's quick drawings, often on newsprint. He drew "little sketches of *anything*, figures, cat, furniture, etc. in detail at first . . . gradually shedding all detail and then representing the subject with a few basic significant lines which retained the idea more than the image."[5] He began transferring drawings into the bold black-and-white canvases featured in his first solo show in 1950 at Charles Egan's Fifty-Seventh Street gallery. Their impact was dramatic. Critics thrilled at the calligraphic power of the compositions and remarked the subtle working of what critic Paul Brach called "deceptively spontaneous" surfaces.[6] When Richard Diebenkorn, who had

UNTITLED
1961, acrylic on canvas, 72½ × 106 in.
Museum purchase from the Vincent
Melzac Collection through the
Smithsonian Institution Collections
Acquisition Program

PALMERTON, PA.
1941, oil on canvas, 21 × 27 ⅛ in.
Museum purchase

seen the work in reproduction, visited Kline in 1953, he was stunned to discover that the large paintings were "exact blow-ups of very small sketches (tele-phone-book pages), accidents and all."[7]

For Kline, idea and emotional response were inseparable. He acknowledged that some of the paintings looked like bridge structures or the trusses of the old Sixth Avenue El, and often named paint-ings for towns, friends, or architectural forms. But he resisted specific comparisons. "When I look out the window—I've always lived in the city—I don't see trees in bloom or mountain laurel," he said.

"What I do see—or rather not what I see but the feelings aroused in me by that looking—is what I paint."[8]

By the mid-1950s, having worked in black and white for more than five years, Kline reintroduced color. The short, choppy strokes, dripping black square, and disharmonious swaths of yellow and red in *Untitled* (about 1959) make for an anxious, agitated composition. The black shape, a central element in many of the paintings, resembles a form Kline had used in a drawing of Elizabeth sitting in the rocking chair ten years earlier. Asked at the time why he had portrayed her head as an empty square, he replied, "She isn't there anymore."[9] Although squares occur often in Kline's work, it is tempting to link the charged energy of the black form in *Untitled* (about 1959) with his long-standing, if rarely voiced, distress over Elizabeth's continued illness. (She was hospitalized for more than a decade.)

The centralized green, black, and red strokes set against a blue field in *Blueberry Eyes* (1959–60) project the aspect of a figure against a background space. The energy here is electric, even joyous. In a rare acknowledgment of a specific source, Kline told

UNTITLED ▶
about 1959, oil on paper, 24 × 19 in.
Museum purchase

BLUEBERRY EYES
1959–60, oil on paperboard, 40 ⅛ × 29 ¾ in.
Gift of the Woodward Foundation

the painting's first owner that he named the composition for the color of the eye shadow worn by his companion when she returned from a trip to Paris.[10] Whether either painting conveyed these associations to Kline will never be known, but their very different emotional valences underscore the inextricable link between image and mood in Kline's work.

By all accounts a gregarious man and an inveterate storyteller, Kline spent evenings wisecracking with friends, often closing down the Cedar Street Tavern, the Waldorf Cafeteria, or The Club. He painted at night, when the street outside his studio was quiet, and he preferred bright artificial light, which enhanced contrast and surface texture, to sunlight. After years of poverty (he was evicted three times for nonpayment of rent), success came in the 1950s. Critical acclaim was first; and by 1956, when he joined Sidney Janis's gallery, financial success was also assured. But Kline's lifestyle took a toll on his health, and in May 1962, he suffered a heart attack and died just days before his fifty-second birthday. His "mature" career had lasted just eleven years, but in that time he left an indelible mark.

[1] Selden Rodman, "Revolution in Paint: Franz Kline," *Conversations with Artists* (New York: Devin-Adair, 1957), reprinted in *Franz Kline 1910–1962* (Rivoli-Turin, Italy: Castello di Rivoli, Museo d'Arte Contemporanea, 2004), 110.

[2] Harry F. Gaugh, *Franz Kline: The Vital Gesture* (New York: Abbeville Press in assoc. with the Cincinnati Art Museum, 1985) is an excellent source of information on Kline's life and art.

[3] Elizabeth V. Kline, letter to Harry F. Gaugh, Apr. 28, 1971, quoted in Gaugh, 48.

[4] Elaine de Kooning, "Franz Kline," in *Franz Kline Memorial Exhibition* (Washington, DC: Washington Gallery of Modern Art, 1962), 14–15.

[5] Elizabeth V. Kline, letter to Harry F. Gaugh, June 23, 1971, quoted in Gaugh, 77.

[6] Paul Brach, "Fifty-Seventh Street in Review," *Art Digest* 26 (Dec. 1, 1951): 19.

[7] Richard Diebenkorn, letter to Harry F. Gaugh, Feb. 20, 1985, quoted in Gaugh, 85.

[8] Selden Rodman, "Revolution in Paint: Franz Kline," reprinted in *Franz Kline 1910–1962*, 110.

[9] Gaugh, 43.

[10] Undated note in Kline, *Blueberry Eyes* curatorial file, Smithsonian American Art Museum.

I am constantly absorbed by things that are going on around me, the motion of people in the streets, the movement of clouds, the patterns of branches. There is no duality, everything is nature.[1]

IBRAM lassaw

1913 | 2003

IBRAM LASSAW, 1959
Courtesy of the Kootz Gallery records,
1931–1966, Archives of American Art,
Smithsonian Institution

Banquet (1961) is built up of thousands of droplets of metal melted over thin rods, buttressed and joined by crumpled sheets of copper. Color variations come from alloys—phosphor bronze, silicon bronze, nickel-silver—and other metals Lassaw treated with chemicals to create subtle hues. The surface is nubbly, encrusted; each tiny layer records a process of accretion that resembles the growth of stalagmites in an underground cave or the calcified secretions of primal living organisms that have joined to form an underwater forest. *Banquet* unites Lassaw's beliefs about the holistic nature of the universe in which cosmic and microcosmic, spirit and substance are one. When asked whether nature was an apt subject for abstract art, he replied that everything is nature; "every atom that makes me up is nature."[2]

 Banquet and other plantlike sculptures Lassaw made in the early 1960s represented a new direction from the astronomical themes he had explored since 1950. An immigrant from Egypt as a child, he had been working as an artist since the 1920s and was an active participant in the New York avant-garde art scene in the 1930s. He was a founding member of the American Abstract Artists and a member of

the Artists Union, and during the 1940s learned to weld while serving in the U.S. Army. In 1949, he offered his studio for the organizational meeting of The Club. Yet he had no dealer and had sold only one work, a figurative piece purchased by a studio model in 1929. For two decades he experimented with ideas about space and light and with materials. He used plaster formed around wire armatures to create biomorphic shapes reminiscent of the work of Jean Arp. He made wooden boxes illuminated from the interior with electric lights. He dripped molten latex over metal wire (a process he quickly abandoned because it smelled so bad). In a short-lived geometric phase, he tried out translucent plastic and fashioned open-form sculptures from rectangles made of metal. In the late 1940s, he projected painted glass slides on the walls of the studio to transform the space into an environment of color and light. Throughout, he was seeking a way to integrate material and idea.[3]

Lassaw read constantly and widely. Volumes by German mystic Meister Eckhart and Carl Jung, Buddhist manuscripts, science fiction books, and physics and astronomy texts filled his studio. From them he learned about scientific structure and evolved a philosophy about the holistic nature of the universe in which force and matter, man and nature are integral elements. "The universe performs its divine work of art with both galactic clusters and sub-atomic particles," Lassaw said. "Life is enacted moment by moment."[4]

He was never able to explain just how, in 1950, his twenty years of study and practice came together. But personally and professionally it was a breakthrough moment. *Milky Way* and several other sculptures were shown at the Whitney Museum's annual exhibition. One of Lassaw's sculptures sold. He used the money to buy oxyacetylene welding equipment. Suddenly he had the means to bring about the "collaboration of material, tools, unconscious forces, ego and other factors" that he had been seeking.[5] He began welding and brazing and by late 1951 had made more than fifty sculptures. The work attracted the attention of critics and of dealer Samuel Kootz, who included several pieces in a group show. In November 1951, Kootz opened Lassaw's first solo exhibition. Sales and commissions followed; at age thirty-eight, his career was launched.

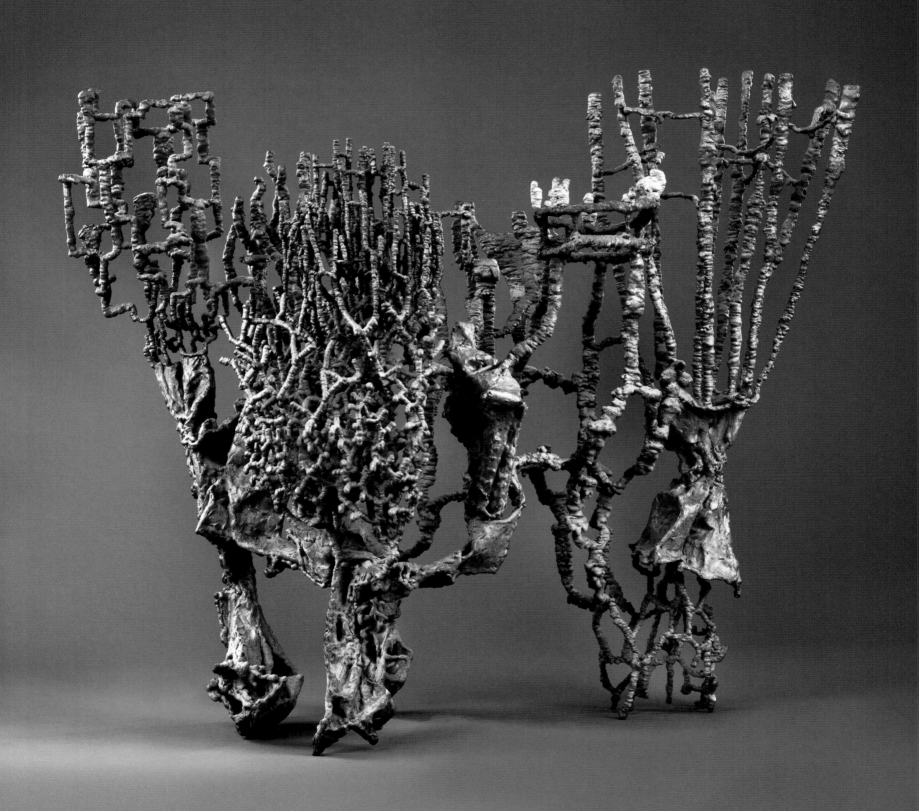

THE HYADES
1951, bronze, 13¾ × 21½ × 6½ in.
Gift of Patricia and Phillip Frost

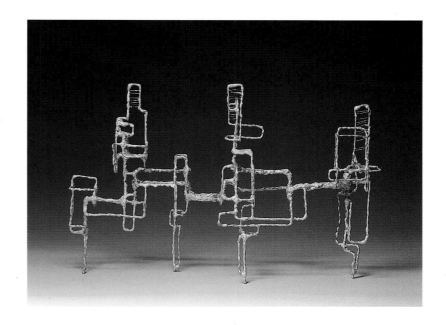

The glittering, gold-colored network of lines that he called *The Hyades* (1951) is named for a constellation. Its organized structure is tangible evidence of Lassaw's understanding that "great bunches of stars known as 'extra galactic nebulae' are not strewn haphazardly in space," but rather "are disposed in a gigantic ordered system."[6] Lassaw had made *The Hyades* by dripping molten metal onto a wire framework in a process that combined conscious intention with spontaneous process. He was immediately heralded as an abstract expressionist sculptor whose work captured the spontaneity of action painting. He agreed. "I respond to the felt needs of the work as it progresses. Conception and execution are not to be separated."[7] Lassaw had come to resemble the medieval alchemists he studied. Part scientist, part philosopher, part artist, part scholar, he turned base metal into objects that contain the mysteries of the universe.

[1] Martica Sawin, "Ibram Lassaw," *Arts* 30, no. 3 (Dec. 1955): 24.

[2] Ibram Lassaw, "American Abstract Artists: The Artists Speak," interactive video, filmed June 1989, Smithsonian American Art Museum.

[3] For discussions of Lassaw's life and work, see Nancy Gale Heller, "The Sculpture of Ibram Lassaw" (PhD diss., Rutgers University, 1982); *Ibram Lassaw, Space Explorations, A Retrospective Survey, 1929–1988* (East Hampton, NY: Guild Hall Museum, 1988); and Arthur F. Jones and Denise Lassaw, *Ibram Lassaw: Deep Space and Beyond* (Radford, VA: Radford University Art Museum, 2002).

[4] Ibram Lassaw, "Perspectives and Reflections of a Sculptor: A Memoir," *Leonardo* 1, no. 7 (Oct. 1968): 354–55.

[5] Ibid., 361.

[6] Ibid., 354.

[7] Ibid., 361.

◄ **BANQUET**
1961, bronze, 32 × 38 × 25 in.
Gift of Harold Tager, Jr.

I paint from remembered landscapes that I carry with me—and remembered feelings of them, which of course become transformed. I could certainly never mirror nature. I would like more to paint what it leaves with me.[1]

JOAN mitchell

1926 | 1992

My Landscape II (1967) lays claim to place. It is an exuberant tumbling together of lush greens and shimmering blues that fill the canvas and intimate a world beyond. The dramatic verticality of the painting, almost nine feet high, but less than six feet wide, evokes the sense of a tall window (a French door?) flung open to a verdant natural world. The vantage point is an interior one—literally, as though through a window, and metaphorically, as if envisioned in memory. Dense rather than airy above, with a thin, light-filled middle ground, and lively foreground, it reverses the horizontal format typical of landscape painting in which ground and sky are divided by the horizon. Here, clumps of gently applied blues, scumbled reds, and a myriad of greens connected by drips, ropy threads of red, and rivulets of blue are loosely bounded. Greens infused with yellow reminiscent of spring foliage offer a sense of possibility and new life. Paint goes edge to edge, continuing beyond the range of the view. *My Landscape II* is a place of serenity and quiet joy.

In July 1967, with money inherited after the death of her mother, Mitchell bought a two-acre estate on a hillside overlooking the Seine in Vétheuil,

about thirty miles northwest of Paris. She worked in her Paris studio for the rest of 1967, spending summer weekends in Vétheuil before moving there permanently the following year. The view from the house was magnificent. From the narrow terrace, Mitchell could see the river, and, beyond, a reservoir in the distance. The effect on her work was immediate and powerful. She said of Vétheuil, "It's a secure landscape, not desperate. I've chosen one you can live in."[2]

Emotionally, *My Landscape II* is very different from the tumultuous *Marlin* (1960). Its thrashing brushstrokes and chaotic energy were sparked by memories of deep-sea fishing trips off the coast of Montauk. The vortex of thick, vivid strokes and thin spatters and stains "thrown" out to the margins of *Marlin* are characteristic of other paintings of the early 1960s that Mitchell described as "violent and angry."[3] Gone, too, are the somber tones of the "black paintings" Mitchell painted in the mid-1960s that she said marked the end of her "violent" phase. Instead, the implied space from which *My Landscape II* is viewed offers a safe enclosure from which to view a light-filled world outside.

Mitchell lived in France for more than half her life but chafed at the idea that she was an expatriate. After graduating from the School of the Art Institute of Chicago, she went first to New York and then on to Paris, where she met Philip Guston. After a bout of bronchitis contracted from working in an unheated studio, she returned to New York determined to meet the artists whose work she admired. The first studio she visited was that of Franz Kline, where "there were all these [black-and-white] Klines, unstretched, hanging on the brick walls. Beautiful."[4] She renewed her friendship with Guston, set up housekeeping with Michael Goldberg, and abandoned what she called the "sort of cubed-up landscapes"[5] she had been painting, and adopted the dense, high-energy brushwork associated with action painting. Rapidly accepted as one of the youngest members of The Club, she joined Eleanor Ward's Stable Gallery, where she showed from 1953 through 1965. A 1955 summer trip to France proved decisive. Although she often returned to New York in the ensuing decades, and maintained a studio there, she decided to settle in Paris with Jean-Paul Riopelle, a French-Canadian

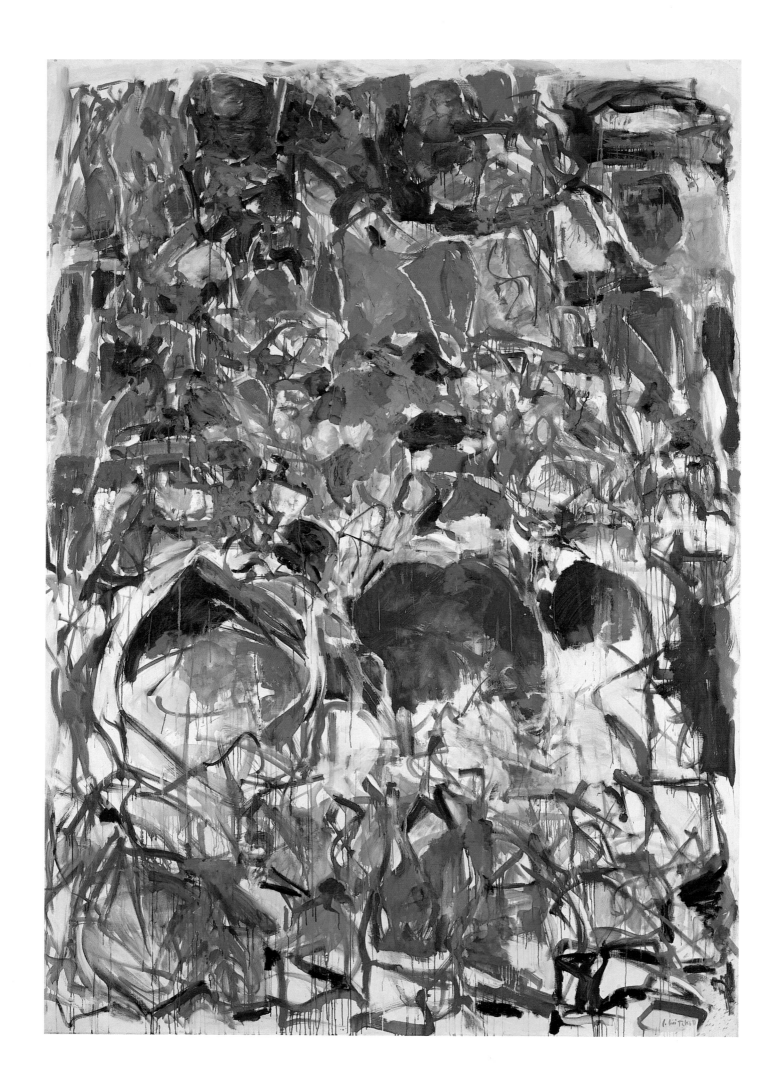

MY LANDSCAPE II
1967, oil on canvas, 103 × 71½ in.
Gift of Mr. and Mrs. David K. Anderson,
Martha Jackson Memorial Collection

painter and close friend of Sam Francis. In 1967, the year she painted *My Landscape II*, she established an important professional relationship with Jean Fournier, who exhibited her paintings in his spacious, well-lighted Paris gallery. A year later she had her first exhibition at the Martha Jackson Gallery in New York.

Despite generally positive reviews and annual or biennial gallery exhibitions, museum attention remained elusive. The Everson Museum in Syracuse opened her first solo museum exhibition in 1972. It was followed two years later by a retrospective at the Whitney Museum of American Art. A return to New York might have precipitated wider exposure, but even after her separation from Riopelle in 1979, she remained in France, working in the Vétheuil estate that had become home.

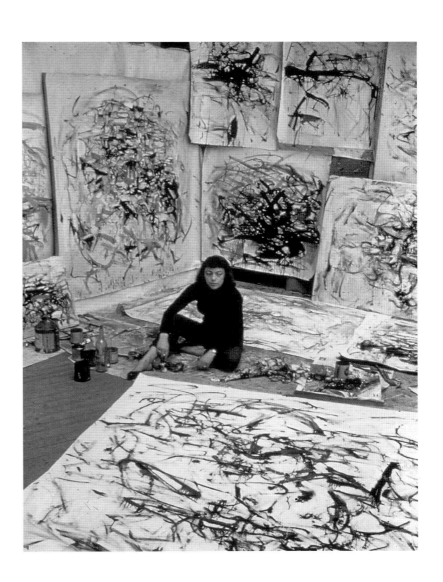

Joan Mitchell in her studio on the rue Daguerre, 1956, © Estate of Joan Mitchell, Courtesy of the Joan Mitchell Foundation and Cheim & Read Gallery, New York

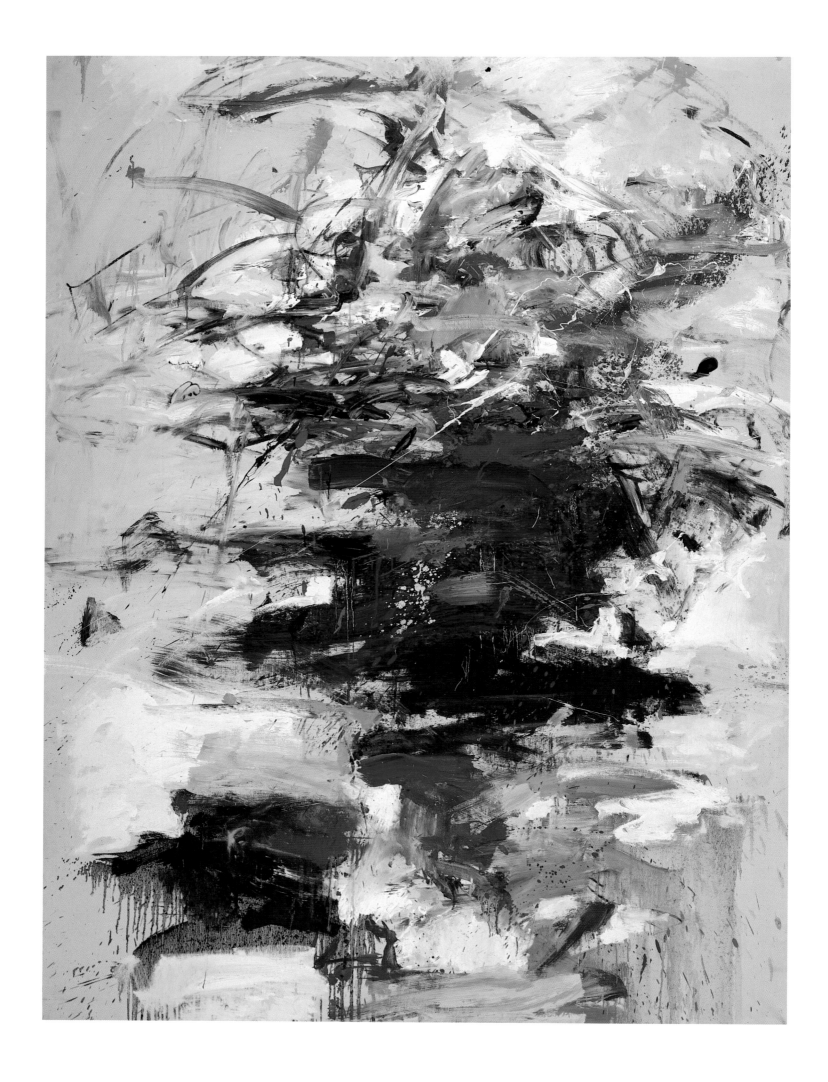

MARLIN
1960, oil on canvas, 95 x 71 in.
Gift of S. C. Johnson & Son, Inc.

[1] Joan Mitchell, artist statement in John I. H. Baur, *Nature in Abstraction: The Relation of Abstract Painting and Sculpture to Nature in Twentieth-Century American Art* (New York: Whitney Museum of American Art, 1958), 75.

[2] Joyce Campbell, "In the Land of Monet, American Painter Joan Mitchell More Than Pulls Her Weight," *People Weekly,* Dec. 6, 1982, 83. quoted in Judith E. Bernstock, *Joan Mitchell* (New York: Hudson Hills in assoc. with the Herbert F. Johnson Museum of Art, Cornell University, 1988), 72.

[3] Bernstock, 60.

[4] Jane Livingston, *The Paintings of Joan Mitchell* (New York: Whitney Museum of American Art, 2002), 20.

[5] Joan Mitchell, interview with Linda Nochlin, Apr. 16, 1986, Archives of American Art, online transcript, http://www.aaa.si.edu/collections/oralhistories/transcripts/mitche86.htm.

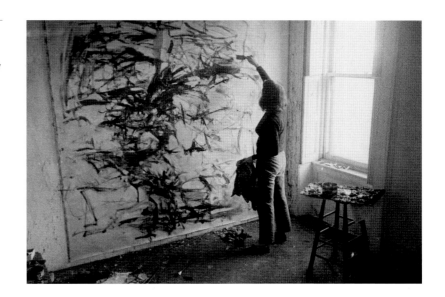

Joan Mitchell at work on *Bridge,* 1957, Rudy Burckhardt, photographer, © Estate of Joan Mitchell, Courtesy of the Joan Mitchell Foundation and Cheim & Read Gallery, New York

Painting becomes sublime when the artist transcends his personal anguish, when he projects in the midst of a shrieking world an expression of living and its end that is silent and ordered.[1]

ROBERT motherwell

1915 | 1991

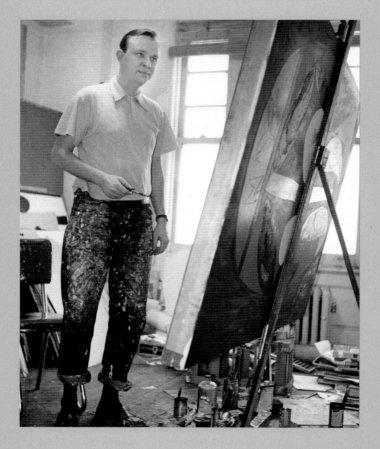

Robert Motherwell made his first collage in the spring of 1943, at the invitation of Peggy Guggenheim, who was planning an international collage exhibition at Art of This Century, the gallery she had opened the previous October. She invited Motherwell, Jackson Pollock, and William Baziotes to contribute. Although none of the three had yet worked in collage, all accepted; the chance to show alongside Picasso, Matisse, Braque, and Miró was too good to pass up.[2] For Motherwell collage was a revelation. "I had discovered something that was really me," he said.[3] Painting over and around bits of cut or torn paper allowed for greater spontaneity than did conventional painting, and he came to think of collage as a kind of private "journal" that offered a way to introduce bits of the everyday world into otherwise abstract compositions.[4]

An intellectual turned artist, Motherwell had been painting seriously for less than two years when Guggenheim asked him to contribute collages to her show. He had graduated from Stanford University with a degree in philosophy, gone to Harvard for graduate work, and then moved on to Columbia University, where professor

Meyer Schapiro introduced him to Stanley William Hayter. Through Hayter, Motherwell met Roberto Matta Echaurren, Guggenheim, and the émigré surrealists clustered around her gallery. He spent the summer of 1941 in Mexico with Matta. On his return Motherwell created a group of works, including *Pancho Villa Dead and Alive*, which dealt with imprisonment and death, inspired partly by photographs showing blood-spattered bodies taken during the Mexican Revolution, and partly by a sense of the human tragedies wrought by the civil war in Spain—an elegiac theme he explored repeatedly beginning in the late 1940s.

Collage No. 2 (1945) is loaded with associative implications. A figure with a diamond-shaped "head," white "skirt," and upraised arms is held in check by black paper at either side. Contained front to back between a gray background field and an assertive tan rectangle on the surface, the figure is captive within an uncomfortably shallow space. Its raised "hand" reaches out toward a bright, white "window" that suggests an opening to a world beyond, as if seeking release from spatial and psychological confinement. Motherwell used the same splotchy red and black paper in *Pancho Villa Dead and Alive* to insinuate violence. "Splashed paint on rice paper reminded me of blood stained bandages," the artist said.[5]

By 1945, when he made *Collage No. 2*, Motherwell the scholar was frustrated by the lack of primary documents related to the European moderns. He reported, "Matta gave me a ten year education in surrealism during the three months of the summer of 1941," when the two worked in Mexico,[6] but few of the essays written by European masters were available in print. He knew their work through shows at Art of This Century and the Museum of Modern Art and had studied paintings by Léger, Miró, and Picasso at Albert Gallatin's Gallery of Living Art before it closed in 1943. To remedy this lack, in 1944, Motherwell began editing *The Documents of Modern Art*, a series of books that chronicle the key developments of twentieth-century modernism.

Around 1946, Motherwell met several of the writers associated with *Partisan Review*, which had recently begun publishing articles on existentialism. He had already explored surrealist ideas of automatism

COLLAGE NO. 2
1945, oil on paper mounted on
paperboard, 21 ⅞ × 15 in.
Gift of the Dedalus Foundation
and museum purchase

as a way to capture and objectify emotional states, but was unwilling, as Dore Ashton wrote, "to forsake his sense of history and his ties to the primordial," and found the existentialist emphasis on action and willed choice a natural fit with his own thinking.[7] *Figure in Black (Girl with Stripes)*, painted the following year, grew out of this new interest. Like *Collage No. 2*, *Figure in Black (Girl with Stripes)*, presents a figure in an undefined space, but rather than contained, the stick-like figure (except for the title, the painting gives no clues to gender) is active. The black stripes at right can be read as the equivalent of long, painted strokes executed by an artist/person who looks directly out at the viewer. The primal act of the artist is asserted here. The simple black stick figure, resembling marks prehistoric painters applied to the walls of the caves of Lascaux, is a forceful statement of a will to action.[8]

If, as Motherwell later said, he realized sometime in 1947 that all of his personages were self-portraits, the figures in these two works suggest Motherwell's very different states of mind in the mid-1940s.[9] The ochre that dominates the lower half of *Figure in Black (Girl with Stripes)* reinforces the

FIGURE IN BLACK (GIRL WITH STRIPES) ▷
1947, oil and paper on fiberboard, 23 ⅞ × 19 ¾ in.
Gift of the Dedalus Foundation and museum
purchase

autobiographical implication. Motherwell associated earth colors generally with the expression of basic humanity and considered ochre a distinctly personal hue related to his childhood in Southern California. "Certain childhood impressions last a lifetime.... The color I've consistently used throughout my painting life has been yellow ochre, and the hills of California [where he had grown up] most of the year are yellow ochre."[10]

If the collages and smaller paintings are intimate and informal, Motherwell's wall paintings are "grand and heroic."[11] Implicit in the great classic epics is the theme of the voyage—the voyage of adventure which, in a larger sense, becomes a spiritual voyage. For him *Wall Painting III* (1952) is both epic and joyous. Motherwell named a 1949 canvas after a poem by Baudelaire that describes modern art as a voyage toward the new. He described the star-like ochre shape which appears in *Wall Painting III* and other images around this time as a figural form pushing against boundaries;[12] its echo, an organic shape—similar to another he described as a nude—dances to the right. If *Collage No. 2* reflects the serious study of Picasso and *Figure in Black* acknowledges

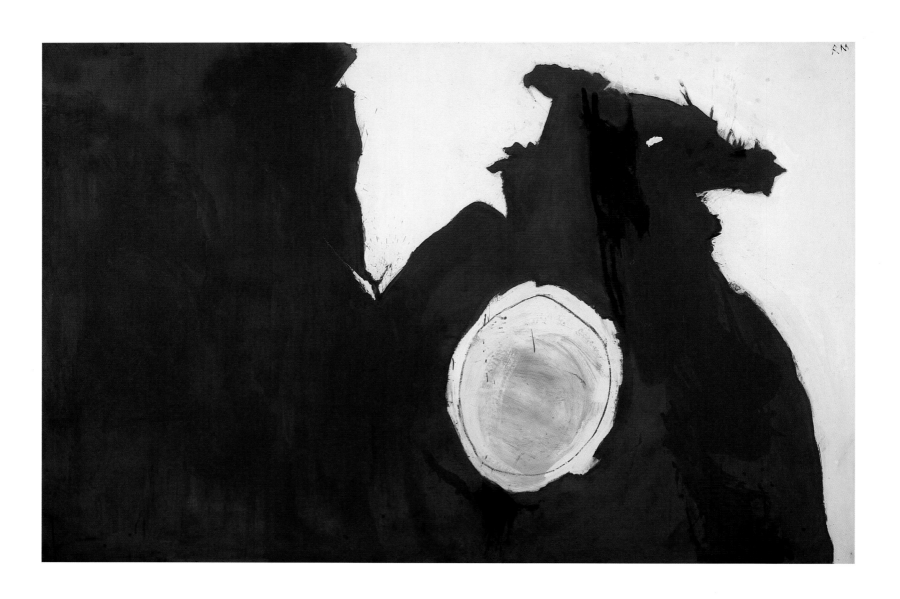

MONSTER (FOR CHARLES IVES)
1959, oil on canvas, 78¼ × 118¼ in.
Gift of S. C. Johnson & Son, Inc.

the personal motifs of Miró, *Wall Painting III* is a celebration of life akin to figures in the great cutouts of Matisse. Flat, frontal, and expansive, it is a statement of personal and artistic confidence.

At the heart of Motherwell's lifelong effort was the need to infuse his work with meaning. Human themes, autobiographical allusions, and elegies of human loss and struggle are pervasive throughout the artist's long career. He viewed the modern artist as a voyager into the unknown beset at times by monsters, at times by tragedy, and at times by joy. He dedicated *Monster (For Charles Ives)* (1959), painted during a Charles Ives radio festival that he listened to in 1957, to the avant-garde composer, "for the title also refers to the monstrous ambiguity of the modernist artist's situation, which Ives no less (and no more) epitomizes than other deeply serious composers, poets, playwrights, painters and sculptors in the U.S.A. in the twentieth century."[13]

[1] Dore Ashton, "Robert Motherwell: The Painter and His Poets," in H. H. Arnason, *Robert Motherwell*, 2nd ed. (New York: Abrams, 1982), 9.

[2] H. H. Arnason, "Robert Motherwell: The Work," in Arnason, *Robert Motherwell*, 18–19.

[3] Robert Motherwell, discussion with Robert Saltonstall Mattison, June 6, 1980, Robert Saltonstall Mattison, *Robert Motherwell: The Formative Years* (Ann Arbor, MI: UMI Research Press, 1987), 80.

[4] Ashton, 10.

[5] Robert Motherwell, conversation with author, June 6, 1980, Mattison, 92. The collage is a direct offspring of a drawing Motherwell made in 1944 after Picasso's 1938 *Woman in an Armchair*. See E. A. Carmean, Jr., *The Collages of Robert Motherwell, A Retrospective Exhibition* (Houston: Museum of Fine Arts, 1972), 15–17.

[6] Sidney Simon, "Concerning the Beginnings of the New York School, An Interview with Robert Motherwell conducted by Sidney Simon in New York in January 1967," *Art International* 11, no. 6 (1967): 21, quoted in Martica Sawin, "'The Third Man,' or Automatism American Style," *Art Journal* 47, no. 3 (Fall 1988): 184.

[7] Ashton, 10; Mattison, 160.

[8] Motherwell kept a Feb. 24, 1947 issue of *Life* magazine that featured extensive color reproductions of the Lascaux cave paintings. See Mattison, 176.

[9] Mattison, 166.

[10] Conversation between Bryan Robertson and Robert Motherwell, 1965, quoted in Mattison, 165–66.

[11] Ashton, 11.

[12] See Motherwell's description of *Doorway, with Figure* (about 1951), in Arnason, 113.

[13] Arnason, 135.

[My sculptural] forms...are meant to be blunt reminders of primordial strife and struggle, reminiscent of those brute forces that not only produced life, but in turn threatened to destroy it....One must be ready to summon one's total being with an all-consuming rage against those forces that are blind to the primacy of life-giving values.[1]

THEODORE roszak

1907 | 1981

The prickly, spikey forms of *Thistle in the Dream (To Louis Sullivan)* (1955–56) were Roszak's response to a world transformed by the horrors of World War II. Yet the menacing shapes and mottled surfaces enclose a vulnerable life-form within, representing a duality of existence that blends threat and optimism, defiance and hope. Roszak learned to weld and braze during the war while working for a plant that manufactured aircraft—a disturbing endeavor, given the utopian beliefs that had shaped his work in the 1930s.

Roszak's art training had been conventional. After several years as a full-time student at the Art Institute of Chicago in the mid-1920s, a short stint at the National Academy of Design in New York, and private sessions with George Luks, Roszak adopted a vision of the artist as philosopher, explorer, and social designer whose work reflected the infinite possibilities of science in the modern world. Even before a 1929 trip to Europe, where he encountered constructivist and Bauhaus philosophies about the integration of art and life, he explored positivist ideas of man and science. Back in New York he took classes at a technical school to learn to manipulate industrial materials. He set up a machine shop in his

THEODORE ROSZAK, SELF PORTRAIT, 1954
Courtesy of Sara Roszak

studio and created sculpture using plastics, fiber-board, and other new materials with immaculate surfaces that obliterated all traces of the artist's hand. He described one of these pieces, *Construction in White* (1937), as a "utopian symbol of perfection, a life-sized diagram of the unification of architecture and engineering, and idealized conception of man's creative potential."[2]

After the war, believing the constructivist view to be "a disarming and innocent illusion," Roszak reversed his positivist ideas about man and science.[3] Instead of having clean, planar edges, his forms became gnarled and knotted as he sought to deal with the less innocent aspects of human experience. The twisted forms of a sculpture titled *Anguish* reflect deep human suffering; the ptero-dactyl-like aspect of another, *Spectre of Kitty Hawk*, speaks to the travesty man had made of the soaring possibilities of flight and the betrayal of the Wright brothers' dreams.

By the late 1940s, notes of mitigated optimism appear. A long-standing belief in the power of nature to regenerate reemerged, tempered by oppositions he had come to believe were keys to

man's physical and psychological survival. Crescent shapes, reminiscent of both the slivers of moon that lift the Virgin Mary into heaven in Renaissance and baroque art and the shape of primordial flying creatures, appear repeatedly.

Thistle in the Dream (To Louis Sullivan) brings together divergent associations of threat, protection, and a cautious hope for the future in immutable steel. It has the look of an avian predator with a spearlike beak whose powerful wings protect the plant form concealed within. The title's dedication to Louis Sullivan reflects Roszak's understanding of the visionary role of the complex, often conflicted, individual in modern society. After immigrating from Poland at age two, Roszak had grown up in Chicago, where Sullivan had rejected conventional architectural design in favor of an "organic" archi-tecture that incorporated modern materials and technology. He dreamed of, and then constructed buildings enclosing steel armatures that were orna-mented with interlaces of leafy plant forms. Sullivan believed, as did Roszak, that the artist had a moral role to play in society, but Sullivan was renowned as both a genius and a demagogue, whose tactics

CONSTRUCTION IN WHITE
1937, wood, masonite, plastic, acrylic,
and plexiglass, 80¼ × 80⅛ × 18¼ in.
Gift of the artist

alienated clients and other architects.[4] Sullivan's blend of brilliance and ruthlessness placed him in Roszak's small pantheon of heroes (he had read Joseph Campbell's *Hero with a Thousand Faces* of 1949). For Roszak, modern heroism meant acknowledging that in man, the terrible coexisted with the ideal.[5] Sculpture, he concluded, "is a projection of a constantly recurring dream built upon the hopes and despairs of Man."[6]

[1] Theodore Roszak, "In Pursuit of an Image," lecture given at the Art Institute of Chicago, Mar. 1955, published in *Quadram*, no. 2 (Nov. 1956): 52.

[2] Theodore Roszak, phone conversation with Joan French Seeman, Feb. 20, 1977, quoted in Joan French Seeman, "The Sculpture of Theodore Roszak: 1932–1952" (PhD diss., Stanford University, 1979), 66.

[3] Roszak, "In Pursuit of an Image," 49.

[4] Don de Nevi, "Louis Sullivan on Art Education," *Art Journal*, 30, no. 1 (Fall 1970): 45.

[5] Seeman, note 297, 216.

[6] Roszak, "In Pursuit of an Image," 59.

◄ **THISTLE IN THE DREAM (TO LOUIS SULLIVAN)**
1955–56, cut and welded steel
41⅜ × 40½ × 30 in.
Gift of the Sara Roby Foundation

Nature is so vast, with so many moods and the ocean is so large and every wave is infinite. And as long as we have the curiosity of children (and sometimes we have to be children) discovery is not only possible, but indispensable.[1]

THEODOROS stamos

1922 | 1997

There is a primal, primitive quality to *Sea Images* (1947) that resonates with Jungian ideas of the collective unconscious that fascinated Jackson Pollock, Adolph Gottlieb, and other New York painters during the 1940s. Yet Jung is never credited as a source for Stamos, nor are the automatist searchings of European surrealists who took refuge in New York City during World War II. Instead, the artist claimed as his direct antecedents the transcendental canvases of America's Hudson River painters and the lyrical abstractions from nature of Arthur Dove and Milton Avery.

 Sea Images is divided horizontally into three expanses of color. A sandy "floor" is separated from a green dark "sky" by a wavy area of murky black. A shape with thin radiating lines resembling the striations of a sand dollar or sea urchin is otherwise unidentifiable as a particular life form. At center, a curious fish-headed shape emerges to touch a floating figure above, as though connecting the archaic inhabitants of the depths with the world of the surface. *Sea Images* was purchased the year it was painted for the SS *Argentina*, a passenger ship launched in 1929 that was pressed into service as a

troop ship during World War II. At the end of the war, the *Argentina* was converted into a luxury liner. Interiors designed by Donald Deskey's firm included paintings, among which, appropriately, was *Sea Images*.[2]

Sea Images was not the first of Stamos's paintings to probe the undersea world. Small panels featuring shells and other biomorphic sea life he collected in tidal pools on the beaches around New York had attracted the attention of Adolph Gottlieb and Barnett Newman. The two encouraged the twenty-year-old Stamos when they encountered his work at a show organized by Betty Parsons in 1943. An exhibition at Mortimer Brandt's gallery in 1946 followed, and in the spring of 1947, when Parsons featured Stamos in a solo exhibition at her newly established gallery, Newman wrote a foreword for the catalogue. Using the words "ideographic" and "totemic affinity," Newman said "Stamos is on the same fundamental ground as the primitive artist who never portrayed…romance or sentiment, but always…noumenistic mystery….Stamos is…able to catch not only the glow of an object in all its splendor but its inner life with all its dramatic implications of terror and mystery."[3]

Stamos had begun painting when he was fourteen, and in 1937 began visiting the few galleries in Depression-era New York that showed contemporary vanguard work. He worked in a frame shop where he met Léger and Gorky and had the chance to examine the many works by Paul Klee that came into the shop to be matted and framed. The mid-1940s were exceptional years for Stamos. The Museum of Modern Art purchased a painting in 1946; his work was featured in a 1947 article in *ARTnews* by the influential critic Thomas Hess; and the December issue of *The Tiger's Eye* featured a statement he wrote and illustrated his painting *Ancestral World*. The titles of Stamos's works are evocative and allusive. *The Altar, Sacrifice*, and *Ascent for Ritual*, as well as *Ancestral World*, call to mind beliefs and practices of long-dead civilizations, as well as the spirit and mystery of stories his immigrant parents told about life in Greece.

Stamos made his first trip there in 1948, traveling via France and Italy. The light and color of Greece and the sense of connectedness with the ancient land and with his own heritage prompted shifts in Stamos's work. On his return to New York,

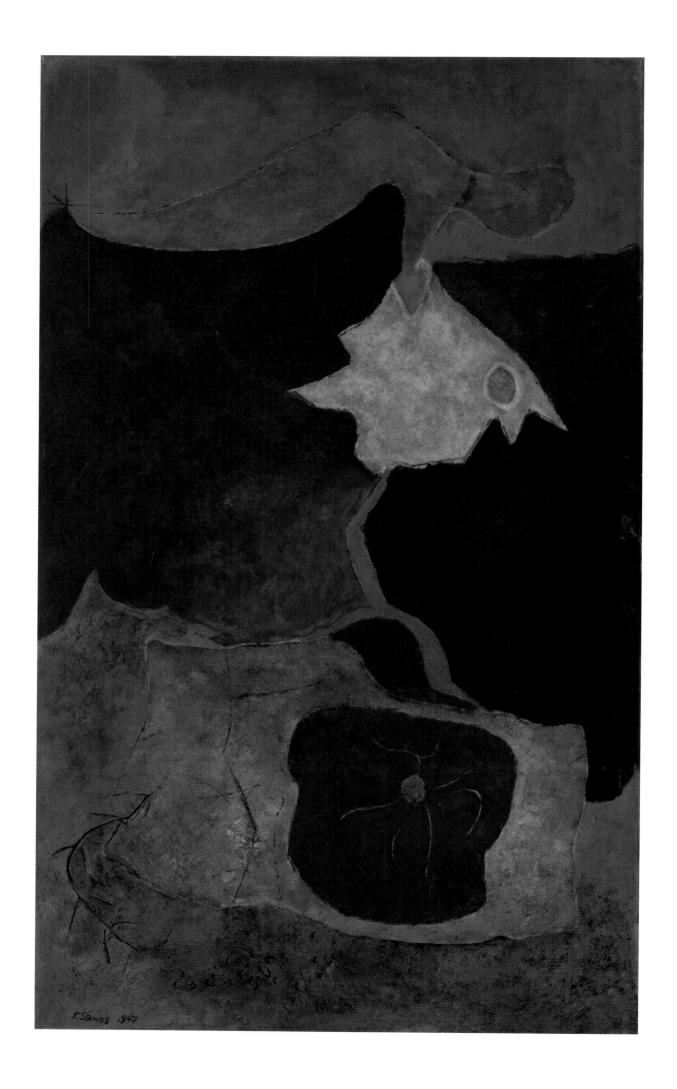

WHITE FIELD VII
1961, oil on canvas, 68 ⅛ × 60 in.
Gift of S. C. Johnson & Son, Inc.

his work took on, in his words, "a broader sweep in treatment and in the elimination of detail."[4] The change went deeper, however. By the late 1950s, Stamos had moved beyond abstractions of natural forms to create nonreferential paintings, among them *White Field VII* (1961), with rich tactile surfaces that suggest "the infinity that belongs to the free mind of man."[5]

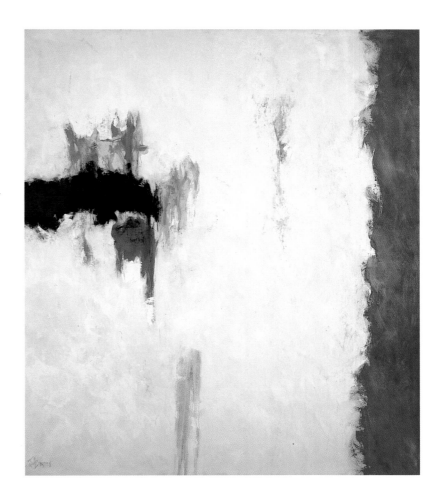

[1] Barbara Cavaliere, "Theodoros Stamos, the Early Years," in *Theodoros Stamos, Allegories of Nature: Organic Abstractions, 1945–1949* (New York: Michael Rosenfeld Gallery, 2001), 10. The biographical information is drawn from this essay and others by Stamos's friend, art historian Barbara Cavaliere.

[2] The painting was transferred, along with Attilio Salemme's *Enigma of Joy*, to the Smithsonian American Art Museum a year after the SS *Argentina* was decommissioned in 1958.

[3] Quoted in Cavaliere, "The Early Years," 7–8.

[4] Barbara Cavaliere, *Theodoros Stamos: An Overview* (New York: ACA Galleries, 1991), 5.

[5] Cavaliere, *An Overview*, 6.

◂ **SEA IMAGES**
1947, oil on fiberboard, 60 × 36 in.
Gift of the U.S. Maritime Administration

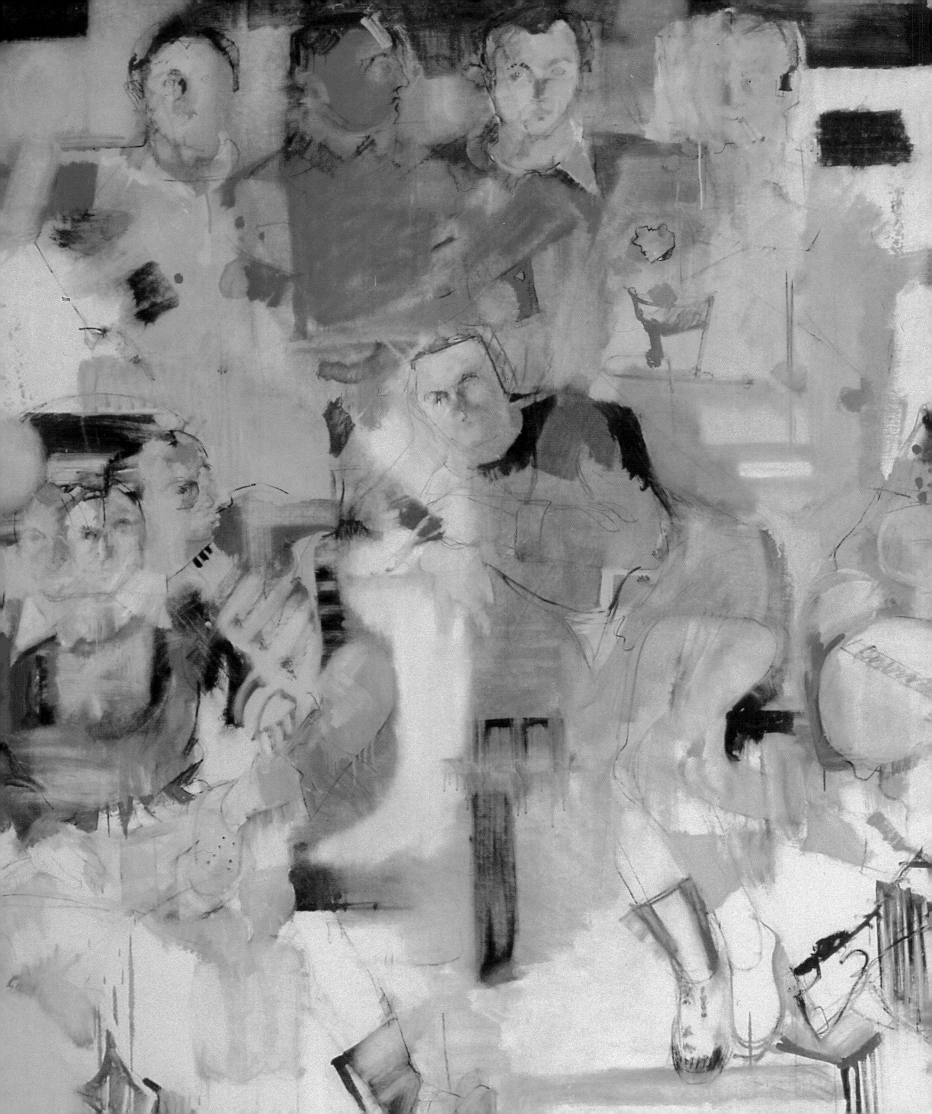

NEW IMAGES OF MAN

In 1959, the Museum of Modern Art and the Baltimore Museum of Art jointly organized an exhibition entitled *New Images of Man* to counter the notion that geometric abstraction and abstract expressionism were the reigning modes of art making. The show featured paintings and sculpture by American and European artists who used the human form to reflect disillusionment, isolation, and anxiety in the years after World War II.

Works in the show could claim a distinguished lineage. In the late nineteenth and early twentieth centuries, Vincent van Gogh, Paul Cézanne, Pablo Picasso, Henri Matisse, and other avant-garde artists were considered radical not because they rejected the figure, but because their distortions transgressed the appearance of the natural world. For postwar artists the figure offered an entrée for reflecting on the nature of man in the atomic age and served as the vehicle for a new humanism built on memory, community, and heritage.

From the early 1950s on, Nathan Oliveira, David Park, and Paul Wonner in California; Romare Bearden, Emilio Cruz, Jim Dine, Seymour Lipton, and Larry Rivers in New York; David Driskell in Tennessee; Grace Hartigan in Baltimore; and many others searched their surroundings and personal lives for vignettes emblematic of larger, universal concerns. Lipton and Cruz addressed man's struggle against oppression. Family members and friends provided motifs for Rivers and Oliveira. A car crash painting inspired by the death of a college roommate became for Dine a reminder that tragedy can strike anywhere at any time. Hartigan's painted array of motorcycle parts wittily reflects the age-old quest for communication among individuals of different generations. Appropriating pictures from a *Look* magazine article, Driskell linked his mother's pieced quilts with their African American origins and raised questions about race relations in contemporary America. Bearden used traditional religious iconography and images from the popular press to make collages that addressed spirituality and community. Park and Wonner truncated figures and flattened space to question the relationship between visual and psychological perception. Each of these artists fused abstraction and figuration, reconfiguring the human form in terms that were relevant in the postwar world.

Larry Rivers, *The Athlete's Dream* (detail)
See page 238

All painting is a kind of talking about life.[1]

ROMARE bearden

1912 | 1988

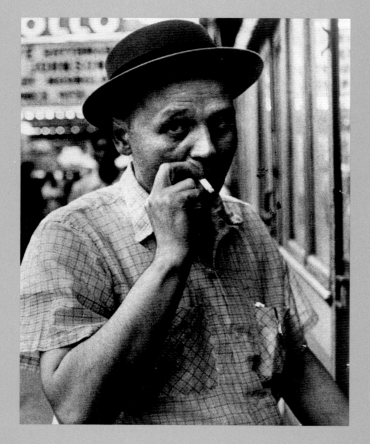

Jazz, Christianity, the streets of Harlem and Pittsburgh, recollections of summers with his grandparents in rural North Carolina—the recurring themes of Bearden's art present multiple realities of time and place. Each is a conceptual and actual assemblage that draws on the fertile intellectual climate of his parents' home in Harlem and his own deep feelings about myth, history, and life in black America. Images clipped from *Life*, *Ebony*, and other mass circulation magazines abut shards of cut and torn paper. Viewpoint, scale, and color are discontinuous. In writer Ralph Ellison's words, their "sharp breaks, leaps in consciousness, distortions, paradoxes, reversals, telescoping of time and Surreal blending of styles, values, hopes and dreams characterize much of Negro American history."[2]

Bearden's first exhibition at a mainstream gallery, in 1945 at Sam Kootz's newly opened space, featured oil versions of *Golgotha* (about 1945) and a dozen other watercolors from a series called "The Passion of Christ." The pathos of this crucifixion is made powerful by the stark simplicity of the figures. The dramatic arms of the cross and body fill the space; the slumped figure of Mary, echoing

ROMARE BEARDEN, about 1950
Courtesy of the Romare Bearden papers,
1937–1982, Archives of American Art,
Smithsonian Institution

the sinuous forms of medieval sculpture, provided a distinctly modern way to convey the desolation of loss. On seeing the passion series, *Art Digest* critic Ben Wolf declared, "I am now going overboard by flatly stating that Romare Bearden is one of the most exciting creative artists I have viewed for a very long time."[3]

Six months later, Bearden's second show at Kootz featured paintings inspired by Spanish writer Federico García Lorca's poem "Lament for Ignacio Sánchez Mejías." The exhibition sold out in the first two weeks. The enthusiastic Wolf applauded Bearden's simplified forms and well-integrated compositions and called the paintings a "stirring series" that supported the "promise" apparent in Bearden's first exhibition.[4]

In spite of this auspicious beginning, the 1950s brought a period of soul searching for Bearden. By that time, the artist had already forged an unusual career. He had graduated from New York University in 1935 with a B.S. degree in education that included courses in art and art history.[5] After graduation he took a position as a case worker for the New York City Department of Social Services,

painted social realist canvases at night and on weekends, and contributed politically charged illustrations to *The Crisis*, the magazine of the National Association for the Advancement of Colored People, and the *Baltimore Afro-American*, one of the country's leading black newspapers. After three years in the army during World War II, he went back to his job with the city, but felt increasingly alienated, and in 1950, took a leave of absence from work. He went to Paris on the G.I. bill, where he studied philosophy at the Sorbonne; met Picasso, Matisse, Wifredo Lam, and other leading lights of the Parisian art world; and spent time with American painter Herbert Gentry and writers James Baldwin and Albert Murray. During his seven months abroad, he looked at art in France, Italy, and Spain, but made little or none.[6] Later in the 1950s, Bearden briefly gave up painting to write song lyrics, then returned to art making by copying photostatic blowups of old masters, and by the end of the decade painted expressionistic abstract canvases.

In July 1963, a month before Martin Luther King's historic march on Washington, Bearden and eleven other artists met to "examine the plight of

the Black American artist in America." They formed a group called Spiral to discuss how as artists they could contribute to the civil rights movement.[7] The moment was cathartic. Bearden abandoned abstraction and began making the collages drawn from memories of black life in Pittsburgh, the rural south, and Harlem that became the hallmarks of his career. He needed, he said, "to redefine the image of man in the terms of the Negro experience."[8]

Spring Way (1964) is one of the first collages that marked Bearden's choice of black life as subject matter. The small image is complex and edgy. Brick and clapboard façades, doors, and windows blocked off by rectangles of crudely cut black paper fill the space. Scraps of pink punctuate the otherwise monochromatic composition. A shadowy figure descending a steep exterior stairway at right is a silhouette without features; the strength and grace of the body are defined solely in terms of shape. A face looking out from a window at the lower center, proportionally larger than the collage's other elements, seems remote, trapped within an unforgiving environment. The collage, titled after an alley near the Pittsburgh boardinghouse owned by Bearden's grandmother, is jumbled and disturbing—a projection of urban decay and hopelessness. The social conscience that inflected his paintings of the 1930s takes on an urgency made potent by the dense layering and the jump cuts in size and scale.

In the fall of 1964, Cordier & Ekstrom, a Manhattan gallery Bearden had joined several years earlier, opened a show called *Projections*. The exhibition featured enlarged black-and-white photostats of Bearden's new collages. The show sold out. A year later, twenty-two photostats and five of the original collages, including *Spring Way*, were shown at the Corcoran Gallery of Art in Washington, D.C. It was Bearden's first museum exhibition.

In the genre scenes, landscapes, and jazz and blues images that followed, Bearden transformed contemporary and recollected moments, people, and landscapes into archetypes that transcend generation and culture. *Village Square* (1969), populated by a woman with shopping basket, a child holding a treasured object, and a street musician, is both nowhere and everywhere. The face of the musician is simultaneously real and masklike, a contemporary figure with actual and cultural roots in Africa.

Throughout his life, Bearden studied the structure and spatial relationships of earlier art. "I . . . want my language to be strict and classical," he said, "in the tradition of most all the great exponents of flat painting."[9] *Mother and Child* (1971) is a Renaissance

Madonna reconfigured in African terms. The surfaces of multiple papers have been painted, stained, and scrubbed down, giving texture and physicality to the figures. The mother has two faces. She is a contemporary woman who looks up and out, and also the evocation of an Ife mask—linking the Christian iconography with beliefs of the Yoruba people, for whom Ife was the holiest city and the birthplace of the human race. The image is archetypal and human.

Family (1986) was created as the presentation model when Bearden was invited by the U.S. government to do a ceramic tile mural for the Joseph P. Addabbo Federal Building in Jamaica, New York. Here, too, he drew on his deep knowledge of art history. With a compositional starting point in Renaissance and baroque paintings of the holy family, Bearden located meaning within the connectedness of family. Each figure touches another. The grandmother and parents, dressed in working-class clothes, look to the child. The grandfather gazes meaningfully outward, connecting audience with scene. *Family* conveys a sense of stability and hope that reflects Bearden's belief that "an artist and his

creations are enhanced if he has the...'vision' of his particular society working with him."[10]

In the 1970s, jazz and blues, which had been part of Bearden's life since childhood, became significant elements in his thematic lexicon. His parents had been influential figures in Harlem in the 1920s and 1930s, and their home something of a salon where W. E. B. Du Bois, Paul Robeson, Langston Hughes, Aaron Douglas, Fats Waller, Duke Ellington, and other leading figures of the Harlem Renaissance congregated.[11] Encouraged by painter Stuart Davis, a close friend and jazz enthusiast, Bearden began thinking in terms of the visual corollaries to the intervals and silences of jazz. He came to see collage as the visual equivalent of musical improvisation.[12] After listening for hours to records of Earl Hines at the piano, Bearden said, "I was [finally] able to block out the melody and concentrate on the silences between the notes."[13]

Empress of the Blues (1974) captures the larger-than-life presence of singer and songwriter Bessie Smith in a space of syncopated color and line. The densely packed musicians and repeating shapes of

their instruments at the right form a high-energy counterpoint to the columnar figure of Smith, whose upraised arm anchors the composition. The image speaks of counterpoint, interval, energy, and silence, and to the power of color as an improvisational artistic device. The monotype *Vampin' (Piney Brown Blues)* (about 1976) shows a jazz pianist improvising at the Sunset, a Kansas City nightclub that was managed in the 1930s by Piney Brown, who was celebrated in a 1940 song by Joe Turner. The musician is formed of opaque paint laid down to give shape to his body; in the surrounding space puddles of muted grays bleed concentrically out like swelling sounds that fill the smoky atmosphere.[14]

With his decision in 1964 to emotionally situate his work within his own experience, Bearden found his voice. The *Projections* show and each exhibition that followed sold out, and in 1966, at age fifty-five, he retired from full-time work. Although his day job had consumed time he might otherwise have spent making art, Bearden said, "there is a richness in this social work, a storehouse of things seen that I draw upon in my painting."[15]

VAMPIN' (PINEY BROWN BLUES)
about 1976, monotype with watercolor
additions on paper, 29 ½ × 41 ¼ in.
Museum purchase

[1] Sharon F. Patton, "Memory and Metaphor: The Art of Romare Bearden, 1940–1987," in Sharon F. Patton, *Memory and Metaphor: The Art of Romare Bearden* (New York: The Studio Museum in Harlem and Oxford University Press, 1991), 70.

[2] Mary Schmidt Campbell, "History and the Art of Romare Bearden," in Patton, *Memory and Metaphor*, 9.

[3] Ben Wolf, "Bearden—He Wrestles with Angels," *Art Digest* 20, no. 1 (Oct. 1, 1945): 16.

[4] Ben Wolf, "Bearden Abstracts Drama of the Bull-Ring," *Art Digest* 20, no. 13 (Apr. 1, 1946): 13.

[5] Although Bearden always claimed to have received a degree in mathematics, his actual course of study, which included classes in art and art history, is described in Ruth Fine, "Romare Bearden: The Spaces Between," in Ruth Fine, *The Art of Romare Bearden* (Washington, DC: National Gallery of Art in assoc. with Abrams, 2003), 7.

[6] On his return to the United States Bearden's painting *Woman with Bird* was included in *American Painting Today*, the show that prompted the "Irascibles" protest against the Metropolitan Museum (see essay, page 40). The same artwork was included in one of the Whitney Museum annuals. For a chronology of Bearden's exhibitions, see Rocío Aranda-Alvarado, Sarah Kennel, and Carmenita Higginbotham, "Romare Bearden: A Chronology," in Fine, *The Art of Romare Bearden*, 212–46.

[7] Bearden invited Hale Woodruff, Charles Alston, Normal Lewis, Merton Simpson, and several other artists to his studio in July 1963, a month before Martin Luther King's historic march on Washington, to talk about how they could contribute to the struggle for civil rights. Woodruff suggested they call the group Spiral after the Archimedean form that signified positive energy. See Fine, *The Art of Romare Bearden*, 28, and Campbell, in Patton, *Memory and Metaphor*, 15. In the mid-1930s, Bearden had been involved with the formation of the Harlem Artists Guild and had collaborated with Langston Hughes, Claude McKay, Carl Van Vechten, Ralph Ellison, Jacob Lawrence, Augusta Savage, Aaron Douglas and others to organize the "306 Group," an informal group of black painters, writers, and musicians. See Patton, *Memory and Metaphor*, 21, and Aranda-Alvarado, Kennel, and Higginbotham, "Romare Bearden: A Chronology," in Fine, *The Art of Romare Bearden*, 222–23.

[8] Patton, *Memory and Metaphor*, 38.

[9] Fine, "Romare Bearden: The Spaces Between," *The Art of Romare Bearden*, 49–50.

[10] Campbell, in Patton, *Memory and Metaphor*, 14.

[11] Ibid., 11–12.

[12] Ibid., 15.

[13] Fine, "Romare Bearden: The Spaces Between," *The Art of Romare Bearden*, 65.

[14] See Joann Moser, *Singular Impressions: The Monotype in America* (Washington, DC, Smithsonian Institution Press for the National Museum of American Art, 1997), 149.

[15] Fine, "Romare Bearden: The Spaces Between," *The Art of Romare Bearden*, 21.

I try to give paint the freedom I desire for myself. I use any tool able to make a mark— paint rollers, hair combs, tooth brushes, squeeze bottles—tools that allow for a quick response to a stimulus; color is my catalyst.[1]

EMILIO Cruz

1938 | 2004

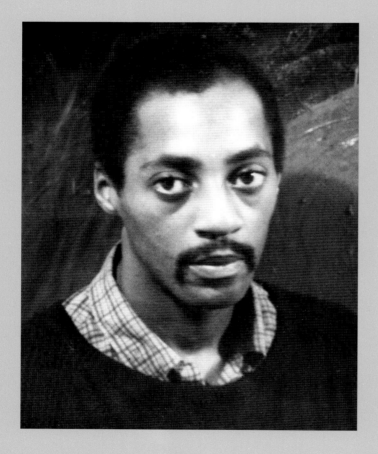

Angola's Dreams Grasp Finger Tips (1973) is a perplexing title for a diamond-shaped passage of pure paint. Cruz explained his motivation with these words:

> The title owes itself to my sympathy to the freedom struggle that existed many years in the country Angola and to two gentlemen I met in Rome from Angola. These two bedraggled spirits were perhaps the most intense individuals I have ever met. Neither one could speak English so we communicated with Spanish mixed with Italian, perhaps at times assimilating Portuguese....Our souls touched and I understood the life that blooms when one has dedicated their lives to what they believe to be a just cause. From this you can see the title is very important to me, though the painting was made many years later.[2]

Cruz was in Italy on a John Hay Whitney Fellowship in 1964, when he encountered the individuals whose cause gave rise, nine years later, to *Angola's Dreams*. Cruz was just twenty-six but was already recognized as a talented young painter. He

EMILIO CRUZ, 1966
Geoffrey Clements, photographer,
Courtesy of the American Federation
of Arts records, 1895–1993, Archives of
American Art, Smithsonian Institution

had grown up in Harlem and the Bronx. After high school he signed on for night classes with George Grosz and Edwin Dickinson at the Art Students League while working as a commercial artist. Two years later he was in Provincetown, where he met Red Grooms, Franz Kline, and Bob Thompson, another promising, young African American artist. Cruz had his first solo exhibition in 1959, at Sun Gallery in Provincetown where Grooms, Lester Johnson, Alex Katz, and Claes Oldenburg also showed work. By 1962, he was showing with Virginia Zabriskie, one of New York's leading dealers, who specialized in the "new figuration" artists.

The 1964 trip was Cruz's first visit to Europe. Based in Rome, he went to London, Paris, and Amsterdam, and made frequent trips to Florence to study Renaissance masters. His paintings during these years were simultaneously figurative and abstract. In *Figurative Composition #7* (1965), brightly colored nudes cavort in a landscape of pathways, hillsides, and trees defined by their essential geometries. It is a postmodern *fête champêtre* reminiscent of canvases by Giorgione, Titian, Manet, and Cézanne that Cruz saw and admired abroad. It was not a mode of painting he would long sustain.

Cruz's work took a more serious turn after spending 1968 and 1969 as an artist-in-residence with the "Camelot" project, a program funded by the Rockefeller and Danforth Foundations and the National Endowment for the Humanities. The program was intended to bring art, and a sense of possibility, to youth in the black ghettos of St. Louis in the aftermath of the assassinations of Dr. Martin Luther King Jr. and Malcolm X. Faced with extreme poverty and despair, and a deep sense of loss at the untimely death of his friend Bob Thompson, Cruz reconsidered meaning, life, and his own art. He spent many hours with the Oceanic and African art collections at Washington University and studied non-Western philosophy. Looking to his own heritage, he began introducing elements of African art into his work and began developing a cosmology in which he questioned humanity and the nature of existence.[3] Between 1970 and 1983, as a professor at the School of the Art Institute of Chicago, he refined his increasingly potent observations about man's place in the universe.

FIGURATIVE COMPOSITION #7
1965, oil on canvas, 59¼ × 67 in.
Gift of Mr. and Mrs. David K. Anderson,
Martha Jackson Memorial Collection

Angola's Dreams, an allusion to a chance meeting filtered through memory and intervening experience, was painted at this time. The cue that prompted him to recall the meeting in Rome nine years earlier is not recorded. It may have been press reports of the ongoing war there or news that American companies had signed agreements to develop the country's huge oil reserves. Whatever the immediate spark, Cruz's sympathy resurfaced for the people of Angola, who by then had suffered through twelve years of war for independence from Portugal.

He turned an almost square canvas into a diamond-shaped mandala—in Asian philosophy a schematized representation of the cosmos characterized by concentric geometric shapes that, according to Jungian psychology, represent the effort to unify the self. The central portion of the painting is a swirling mass of color. Thin calligraphic lines that dance across the surface seem the next elements to be sucked into a central soup of creation. It is a painting of opposites: stasis and motion, stability and energy; in theme it prefigures ideas Cruz explored after giving up abstraction in the mid-1970s. He came to believe in the duality of existence. Susan

Fleminger wrote of Cruz's philosophy during this period, "Life is a constant contradiction in which the opposite is also always true—Destruction is part of creation. Both are energizing cyclical forces."[4] The powerful canvases of his later "Homo Sapiens" paintings—a series of tall, thin canvases executed in a mixture of oil and beeswax—are haunting, compelling images that, in the words of critic Eleanor Heartney, celebrate "the tattered but still potent relics of our common humanity."[5]

[1] Elsa Fine, *The Afro-American Artist; a Search for Identity* (New York: Holt, Rinehart and Winston, 1973), 242.

[2] Emilio Cruz, letter to Harry Rand, June 1981, curatorial files, Smithsonian American Art Museum.

[3] Susan Fleminger, *Emilio Cruz: Spilled Nightmares, Revelations, and Reflections* (New York: The Studio Museum in Harlem, 1987), 7, 67.

[4] Ibid., 10.

[5] Eleanor Heartney, "Emilio Cruz at Steinbaum Kraus–New York, New York," *Art in America* 86, no.2 (Feb. 1998): 108.

◄ **ANGOLA'S DREAMS GRASP FINGER TIPS**
1973, acrylic on canvas, 84⅛ × 84 in.
Gift of Mr. and Mrs. David K. Anderson,
Martha Jackson Memorial Collection

JIM dine

born 1935

The familiar motifs in Jim Dine's art—hearts, bathrobes, neckties, oversized Venus de Milo sculptures—are rooted in the experiences of his life. *The Valiant Red Car* (1960) is one of the most personal, and earliest, of the many self-portraits that he has painted over a career of more than forty years. In this emotionally charged painting, a field of crosses dripping paint surrounds a glaring red taillight; a fragment of frayed wire (a spark plug wire?), like roadside debris found after an accident, dangles above. The phrase *The Valiant Red Car* is scrawled graffiti-style across the surface like an epitaph. At roughly four-and-a-half by eleven feet, the sheer physical size of the painting envelopes the viewer and engages peripheral vision. Insistent and repetitive, the crosses and the flashing lights of emergency vehicles reflected on rain-slicked streets give *The Valiant Red Car* the urgency of a cathartic statement in which image and paint flowed unchecked onto the canvas. It is a declaration of loss and a powerful metaphor for the omnipresent specter of untimely tragedy.

Dine had spent the summer of 1957 in a cabin in rural Kentucky with his wife. "I had a Morris

JIM DINE, 1977
Hans Namuth, photographer, © Hans Namuth Ltd., Courtesy National Portrait Gallery, Smithsonian Institution; this acquisition was made possible by a generous contribution from the James Smithson Society

Minor," he said, "and I went up this little road by myself to get the newspapers and...the radio came on and said 'Harvey Loeb of Cincinnati, Ohio, has been killed...in a car crash. At the same time that I heard this—Harvey Loeb had been my roommate in college, and we'd been friends since I was in high school—a bee came and stung me and I went through the windshield."[2] Between 1959 and 1962, Dine memorialized the tragedy in a series of drawings, paintings, and prints and in a 1960 Happening called *The Car Crash* for which *The Valiant Red Car* served as a backdrop. (See page 59.) The painting is also an erstwhile homage to art dealer Martha Jackson, who offered Dine $4,000 a year (the salary he earned working in an elementary school) to stop teaching. "I remember her fondly as an eccentric woman who loved art. *The Valiant Red Car* was a celebration of her red *Valiant*. It was a way for me to depict our relationship without giving up my own iconography."[3]

The emotional impact of *The Valiant Red Car* is distinctly different from the paintings of tools, bathrobes, neckties, and hearts that catapulted Dine to early fame. He was featured in 1962,

along with Roy Lichtenstein, Claes Oldenburg, Andy Warhol, James Rosenquist, and twenty-four others in a show called *New Realists* at Sidney Janis's gallery, which, in the words of critic Harold Rosenberg, "hit the New York art world with the force of an earthquake."[4] Dine's use of commercial imagery and objects—a shower head attached to a painting of a bathroom, or a lawnmower on a pedestal in front of a canvas covered with painted rays of sunshine and grass clippings—identified him as a pop artist. But, Dine insisted, his aims were different from theirs. Instead of neutral subjects painted with deadpan detachment, Dine said, "those tools or those objects, or that bathrobe," (see *A Robe Colored with 13 Kinds of Oil Paint,* 1976), like *The Valiant Red Car*, "were metaphors for me and my condition....It was me painting out my history."[5] He also liked the physicality of paint and the autographic nature of touch and gesture, and so felt a greater kinship with the work of Willem de Kooning, Robert Motherwell, and other abstract expressionists who were featured in the issues of *ARTnews* he had pored over while an art student at Ohio University.

THE VALIANT RED CAR
1960, oil on canvas, 52⅛ × 129⅞ in.
Gift of Mr. and Mrs. David K. Anderson,
Martha Jackson Memorial Collection

A ROBE COLORED WITH 13 KINDS OF OIL PAINT
1976, color etching and softground on paper
35¾ × 23 ⅝ in.
Museum purchase

By 1967, Dine needed an escape from the hectic New York art world and moved to London with his young family. "I experienced a kind of new freedom there, formally and emotionally," he said.[6] "[London has] made me understand that there are other things more important than paintings—like day-to-day life."[7] The three years Dine spent in London marked a critical juncture. He distanced himself from the avant-garde and returned to the figure, training himself in life drawing and turning to nature and other time-honored motifs for subject matter. Since then, beautifully worked still lifes, trees, birds, and figure drawings assert a lineage in the traditions of art. Their rich, scumbled surfaces and personal associations have their origin in the tactile brushiness and dripping paint of *The Valiant Red Car.*

[1] Grace Glueck, "Jim Dine, Expatriate, Returns for Retrospective," *New York Times,* Feb. 18, 1970, 24.

[2] Marco Livingstone, conversation with Jim Dine, Dec. 1, 1995, quoted in Marco Livingstone, *Jim Dine, The Alchemy of Images* (New York: The Monacelli Press, 1998), 81.

[3] Jim Dine, letter to Harry Rand, May 12, 1981, curatorial files, Smithsonian American Art Museum.

[4] Harold Rosenberg, "The Game of Illusion: Pop and Gag," reprinted in Rosenberg, *The Anxious Object: Art Today and Its Audience* (New York: Horizon Press, 1964), 63.

[5] Livingstone, conversation with Dine, Dec. 2, 1995, quoted in Livingstone, *The Alchemy of Images,* 20.

[6] Cyril Barrett, "Jim Dine's London," *Studio International* 172 (Sep. 1966): 122.

[7] Glueck.

I have turned my attention to images that reflect the exciting expression that is based in the iconography of African art. In doing so, I am not attempting to create African art, instead, I am interested in keeping alive some of the potent symbols that have significant meaning for me as a person of African descent.[1]

DAVID driskell

born 1931

Dancing Angel (1974) resonates with allusions to ancient, classical, and African art, and to personal history, filtered through the language of cubism and abstract expressionism. The body of the angel is crafted with oil paint, fabric, pieces of Driskell's own prints, and clippings from a 1969 *Look* magazine article entitled "The Blacks and the Whites: Can We Bridge the Gap?" The head is split, signaling the dual nature of its psychological heritage. One half is modern; the other resembles the eleventh- and twelfth-century terracotta heads and face masks of the Ife and later Benin bronzes Driskell saw on his first trip to Nigeria.[2] Areas of spattered paint speak to the spontaneity of abstract expressionism, and colorful circles at left summon thoughts of French synchromist Robert Delaunay. The striped ceremonial cloth across the angel's chest, appropriated from an illustration of Benin fabric, is also a sidelong reference to the banded quilts Driskell's mother made when he was a boy. The angel alludes to Driskell's father, a Baptist minister who talked about angels in sermons and drew small pictures of angels hovering over churches. *Dancing Angel* thus pays homage to Reverend Driskell, who

DAVID DRISKELL, 1966
Driskell in his studio, Fisk University,
Courtesy personal archives of David C. Driskell

passed away the year before Driskell created this complex, symbol-laden tribute to his immediate family and to the multiple sources in Africa that infused black life in the American south.[3]

The collage technique Driskell used for *Dancing Angel* and other works from the early and mid-1970s is fundamental to his meaning as well as to the creative process and acknowledges the work of Romare Bearden, whom he met in 1973. Driskell had invited Bearden to come to Fisk, where Driskell was teaching, as part of the Scholars and Artists in Residence Program. "You have to remember that I was always in awe of Bearden. I was always pondering what I would say to him...would often think, 'Here I am in the presence of this great American master.' And yet he always treated me as an equal," Driskell recalled.[4]

During the late 1950s and 1960s, Driskell traveled extensively in Europe and Africa at the invitation of the U.S. Department of State. Seeing life in Africa firsthand made him realize that the African American experience represented a unique culture with its own sensibility and identity that had grown from multiple sources. He incorporated mask forms in his work that served, initially, as symbolic indications of cultural associations, and, increasingly, as a way to introduce fragments of black cultures from around the world.

Driskell had grown up in the mountains of western North Carolina. At Howard University, where he studied with James Porter, Lois Jones, Morris Louis, and James Wells in the early 1950s, Driskell began searching, he said, "for those heritable sensibilities that help to establish our roots in more than one culture."[5] He talked with Bearden about the importance of memory and credited Porter and Jones with reinforcing the importance of understanding the relationship between African culture and contemporary African American life. After graduation in 1955, he accepted a teaching position at Talladega College in Georgia, completed an M.F.A. degree at Catholic University, and became acting chair of the Department of Art at Howard University. In 1966, he joined the faculty at Fisk. Living in the Deep South prompted Driskell to confront America's complicated racial situation. *Behold Thy Son*, a crucifixion scene based on the lynching of a teenager in Mississippi, was followed

DANCING ANGEL
1974, oil, fabric, and collage on canvas, 60 × 40 in.
Gift of Cynthia Shoats and museum purchase

by paintings that confronted the tragic events of the civil rights movement.

Increasingly, Driskell earned recognition not only as an artist, but as a scholar and one of the country's leading curators. He organized *Amistad II: Afro-American Art*, an exhibition at Fisk in 1975; *Two Centuries of Black American Art*, the Los Angeles County Museum of Art's bicentennial exhibition, followed in 1976. By this time, Driskell had pushed beyond references to specific events to probe universal human themes. *Dancing Angel* came at this time. Fusing art historical and spiritual sources, archaic and modern visual motifs, and American and African references, *Dancing Angel* suggests the passage of humanity across cultures and through time.

[1] David Driskell, "Statement by the Artist," *The Recent Work of David Driskell* (Atlanta: Coordinated Art Program of the Atlanta University Center, 1974), n.p., quoted in Julie L. McGee, *David C. Driskell, Artist and Scholar* (Petaluma, CA: Pomegranate Communications, 2006), 100.

[2] McGee, 98.

[3] Ibid.

[4] David Driskell, et al., *Reminiscences of Charlotte's Own Romare Bearden* (Charlotte, NC: Mint Museum of Art, 2002), 18–19, quoted in McGee, 96.

[5] Leslie King-Hammond, "David Driskell: Memoir of a Painter cum Scholar," *The International Review of African American Art* 14, no. 1 (1997): 4.

*I perceive the world in fragments. It's some-
what like being on a very fast train and
getting glimpses of things . . . as you pass
by. . . . Somehow, in a painting, I try to make
some logic out of the world that has been
given to me in chaos.*[1]

GRACE hartigan

born 1922

Standing in front of a Grace Hartigan painting,
especially one from the 1960s, it is hard not to play
the game of "that looks like a __;" "do you think
that red thing is a __?" Hartigan herself selected the
fragments that prompt the urge to guess, or second-
guess, what her pictures actually show. Clues in the
titles are sometimes helpful, although they often
suggest double meanings that confound even as they
illuminate.

 Motorcycle parts are spread across the canvas
of *Modern Cycle* (1967) like prizes to be discovered
in a maze. Engine parts, a headlight, gas tank, and
handle bars freely mingle with a zippered motorcycle
jacket sleeve, a rider, women's legs, and other less
easily identified forms. Hartigan chose these items
partly in self-defense. She had begun teaching at
the Maryland Institute College of Art in Baltimore.
"My male students at the time were obsessed with
motorcycles—one even kept his in his studio," she
said, "and out of sheer self-preservation I bought a
poster of Brando on a bike and Peter Fonda, some
cycle magazines, pinned them on my painting wall
and *Modern Cycle* was the result. It is, incidentally,
one of my favorite paintings."[2] Although the subject

is drawn from pop culture, the lively surface and conceptual allusion to fortune's cycles of fame and obscurity are Hartigan's own.

She had come to this blending of recognizable objects embedded in abstract shapes via abstract expressionism. Young and newly resolved to be a painter, she had come to New York in 1946, and immediately sought out Jackson Pollock and Willem de Kooning. Hartigan was quickly accepted into the ranks of the habitués at the Cedar Street Tavern, and within five years had her first show at the newly established Tibor de Nagy Gallery. But after her second show she had a "bout of conscience," about her own originality, she later said. "I thought I was a robber, that I had taken from [other] people . . . [so] I started to paint through art history."[3] Hartigan studied old masters and Matisse and turned, like a modern-day Ashcan artist, to the street life around her New York studio and to mythical subjects and universal concerns, retaining, nonetheless, the expressionist energy of her earlier paintings.

In 1959, Hartigan married a Johns Hopkins University medical researcher and arts patron and moved to Baltimore. She missed the lively street life of Manhattan; the only equivalent she found was in hobby shops in area shopping malls. She discovered "assemble a family" kits "where you get Ma and Pa and the kids . . . and paper-doll books of our society—the bride, the groom, movie stars. So I thought, this is my substitute for the Lower East Side of New York. . . . I battled my way through those subjects."[4]

Although she continued to show in New York, Minneapolis, Chicago, and Baltimore, and was invited in 1967 to serve as director of the newly founded Hoffberger School of Painting at the Maryland Institute, she felt invisible. Hartigan mourned the loss of her friend Frank O'Hara (*Frank O'Hara, 1926–1966*, 1966), and missed the camaraderie of the early days of The Club. The death of her husband in 1981 exacerbated her isolation and loneliness. When she emerged from these difficult years, it was with a new sense of energy and connectedness with the long traditions and masters of art. Bright canvases with spattered paint and thinly painted figures formed by long, looping lines bear titles linking them with Raphael, Ingres, Bosch, Shakespeare, and famous and infamous women in history (Portia, Mata Hari,

Empress Josephine). Hartigan has circled round, encompassing and broadening her scope, as though fulfilling words written in 1962, almost as a promise to herself, "I wish not only to endure but prevail."[5]

[1] Allen Barber, "Making Some Marks," *Arts Magazine* 48, no. 9 (June 1974): 50

[2] Hartigan, letter to Harry Rand, Sep. 14, 1981, curatorial files, Smithsonian American Art Museum.

[3] Joseph D. Ketner II, "The Continuing Search of Grace Hartigan," *ARTnews* 80, no. 2 (Feb. 1981): 129.

[4] Mary Gabriel, "Amazing Grace," *Museum and Arts Washington* (Nov. – Dec. 1990): 67.

[5] Robert Saltonstall Mattisen, *Grace Hartigan, A Painter's World* (New York: Hudson Hills, 1990), 107.

My work grows... from the web of my experience. The dynamics of historical flow, the ironies of peace and conflict, a better way of life for men—these things absorb me.... Meeting the challenge of contemporary art and life, [my work] must in the main be provocative, searching, harsh, and tragic.[1]

SEYMOUR lipton

1903 | 1986

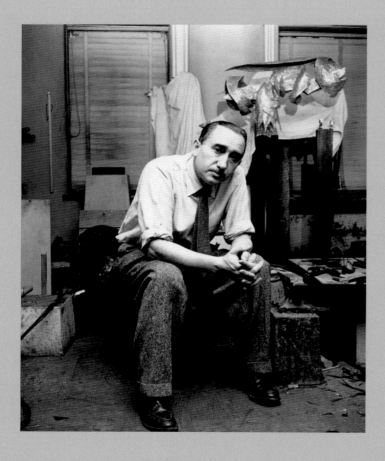

Seymour Lipton was one of the most articulate artists of his generation. In private writings, published articles, and interviews for national magazines, he described the meaning behind the sometimes dark, sometimes exultant impulse that drove him to make sculpture. Each passage is probing, as Lipton constantly worked to penetrate the mysteries that shape human actions.

A profound humanism impelled his sculpture from the beginning. His early work, like that of other social realists during the Depression years of the 1930s, coaxed the anguish of poverty, racism, child labor, and class struggle from the obdurate materials of wood and stone. With the outbreak of World War II, his themes grew darker; conflict and the bestial aspect of human nature became compelling subjects. Lipton became interested, he said, in Mayan and Aztec death ritual sculpture that exemplified "the hidden destructive forces below the surface in man."[2] He began making sculptures that resemble primordial creatures and birds of prey with jagged beaks and claws (stand-ins for the warplanes that wrought destruction on Guernica and Nagasaki) that forced awareness of the unnamed menaces that plague human existence.

With the 1950s came new possibilities. Lipton left social comment behind in favor of timeless and mythic themes that reflected the oppositions he had come to believe were inherent in life: bestiality was countered by beauty, strength by vulnerability, threat by protectiveness. "Tragic horror had reached a point of no return," Lipton said. Instead, he wanted to reveal the "new hope" that comes with the cycles of life. Sculptures based on buds, seed pods, cocoons, and other living forms evoked regenerative cycles of life, death, and rebirth.[3] "I've been preoccupied with the life cycle and its renewal—with birth, struggle, death, and rebirth in an evolving process of reality," Lipton maintained. "The dark inside of things, germination, the seed, the womb,...the winter earth, etc.... have suggested forms with unfolding layers, with sharp cleavages, with struggling emergent forces."[4]

These new themes were executed in new materials. In the late 1940s, Lipton began working with sheet steel. In 1955, he shifted to Monel, cutting shapes that he welded together, and dripping silver nickel or bronze melted with an oxyacetylene torch to create soft, luminous surfaces. He worked out his ideas

by drawing and made small maquettes (*Manuscript*, 1960) before creating full-sized work. These multiple steps allowed him to freely explore before committing to unchangeable decisions in a medium that, by nature, precluded spontaneity.

The Defender (1962), which, at almost seven feet, dominates surrounding space, brings to fruition Lipton's commitment to finding optimism in opposition. The large, hooded figure clad in armor-like plate represents a duality. The artist intended it to evoke the ancient sculptures of winged monsters that symbolically defended the walls of Mesopotamian palaces. Its menacing demeanor is countered by the armor's role in protecting the vulnerable physical and psychological core within. *The Defender* is one in a group of sculptures (*Pioneer, Sentinel,* and *Archangel* are others) that Lipton called "Heroes with Many Faces." The idea was prompted by Joseph Campbell's 1949 book *The Hero with a Thousand Faces*, in which Campbell presents the hero as an archetype. Lipton, who described the hero as "the force in man of courage, of the effort to not succumb to the adversaries of life but to struggle and fight them," locates the concept of

MANUSCRIPT
1960, iron/brazed with nickel-silver on
limestone base, 11 ⅞ × 15½ × 6⅞ in.
Gift of Mr. Seymour Lipton

hero in everyone.[5] "Each human being," he said,
"is struggling in some way to encompass and tran-
scend his own limitations."[6]

New York was the arena in which Lipton
lived and worked out his artistic credo. He had the
opportunity to pursue a bohemian life, interact-
ing with émigré surrealists whose ideas and antics
captivated the press in the 1940s, and spending hours
at the Cedar Street Tavern arguing philosophy,
Jungian psychology, and the source of myth and
archetype with William Baziotes, Adolph Gottlieb,
Mark Rothko, and others. But Lipton chose a more
quotidian path. A graduate of Columbia University
dental school in 1927, he married in 1930, practiced
dentistry, and raised his children. He began exhibit-
ing in the early 1930s, affiliated with Betty Parsons
Gallery in 1948, and from 1940 to 1965, taught
sculpture at the New School for Social Research.
Throughout his life, he aimed to characterize the
dignity, suffering, and ultimately the "exultant
triumph" of human existence.[7]

[1] Seymour Lipton, "Some Notes on
My Work," *Magazine of Art* 40
(Nov. 1947): 264.

[2] Albert Elsen, *Seymour Lipton*
(New York: Abrams, 1970), 27.

[3] Ibid., 30.

[4] Seymour Lipton, "Metaphor
in Sculpture," Lipton papers,
Archives of American Art,
quoted in Lori Verderame, *An
American Sculptor: Seymour
Lipton* (State College, PA:
Palmer Museum of Art, 1999), 31.

[5] Ibid., 46, n.11.

[6] Ibid., 45, n. 6.

[7] Seymour Lipton, letter to Harry
Rand, Mar. 20, 1978, curatorial
files, Smithsonian American Art
Museum.

◄ **THE DEFENDER**
1962, nickel silver on Monel metal
79 ¾ × 38 ⅞ × 32 ⅛ in.
Museum purchase

I am an abstract painter who finds these figures.[1]

NATHAN oliveira

born 1928

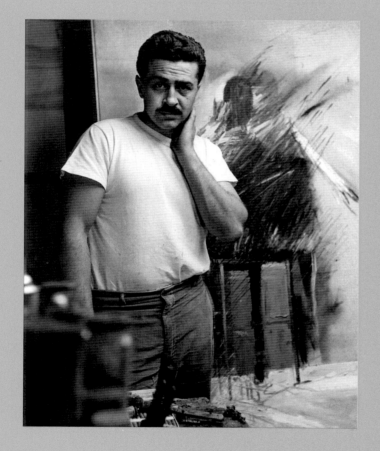

Nathan Oliveira's enigmatic portraits ensnare viewers with their barely recognizable features and obscure settings. Evoking half-remembered dreams, or characters from movies or plays, the figures capture the imagination. The eye then becomes entranced by Oliveira's unusual colors that create dramatic moods. His dexterity with paint itself is yet another source of intrigue. Textures created by scumbling, incising, and painting wet-on-wet seem magically to coalesce to form miragelike figures from the collective subconscious. These characters often have a disturbing effect.

The painting *Nineteen Twenty-Nine* (1961) is a somber depiction of Oliveira's mother drawn from memory. Its composition and alternating colors create an unsettling sense of teetering ahead of the stock market crash, which devastated his immigrant Portuguese family when he was less than one year old. The lone figure, seated at an oblique angle, balances precariously on a one-legged stool while her lower leg seems to dangle above the ambiguous floor. Sporting fashionable garters, hat, and stole, she has an aloof air. Her position, with arms and legs crossed, makes her seem even more vulnerable

to turbulence. The alternating cool and warm colors enhance the drama and sense of impending doom. The eye rocks back and forth from the warm wall to the cool floor, from the green hat to the red eye, from the green stole and blue arm to the red belt, and finally from the outstretched blue shoe to the energetic red brushstrokes surrounding it. By scratching the date in the lower right corner, Oliveira seals her fate—and commemorates his family's suffering.

In contrast, the figure in *Man with a Hat, Cane and Glove* (1961) stands frontally. His open, formal pose arrests the viewer with his direct attention. He looks as if he will introduce himself at any moment. The vague setting conjures an archetypal character, one of stiff formality humanized by an air of anticipation. Yet subtle details suggest that this person is caught in a moment. The crooked tie, a charming imperfection in his otherwise dapper suit, implies that he might be surveying himself in a mirror, preparing for an outing. Perhaps he is readying to enter a room of business associates, or maybe he is going to ask his true love to marry him. In the indiscernible eyes, viewers can read whatever they like.

In describing his process of completing a painting, Oliveira said, "When I reach that point, where the painting comes alive, then I step away. It reaches out and starts touching people; it's up to them to deal with it."[2]

Given these works, it might be surprising that Nathan Oliveira went to art school enamored with Rembrandt. From the beginning, Oliveira wanted to paint portraits. However, the crucible of formal art instruction from 1947 to 1952, when abstract expressionism was gaining momentum, influenced his style if not his subject matter. In speaking of his early career in the 1950s, Oliveira reflected, "My concern was to use the language of the abstract expressionists, the gesture of the pigment, and somehow put it together to represent the human figure, to restate classical subjects. I built figures out of the pigment gestures themselves."[3]

As a summer student of German artist Max Beckmann in 1950, he witnessed that artist's melding of figural subjects with painterly expression, a formative experience in his artistic development. Around the same time, Oliveira saw works by Edvard Munch and Oskar Kokoschka at the de Young Museum

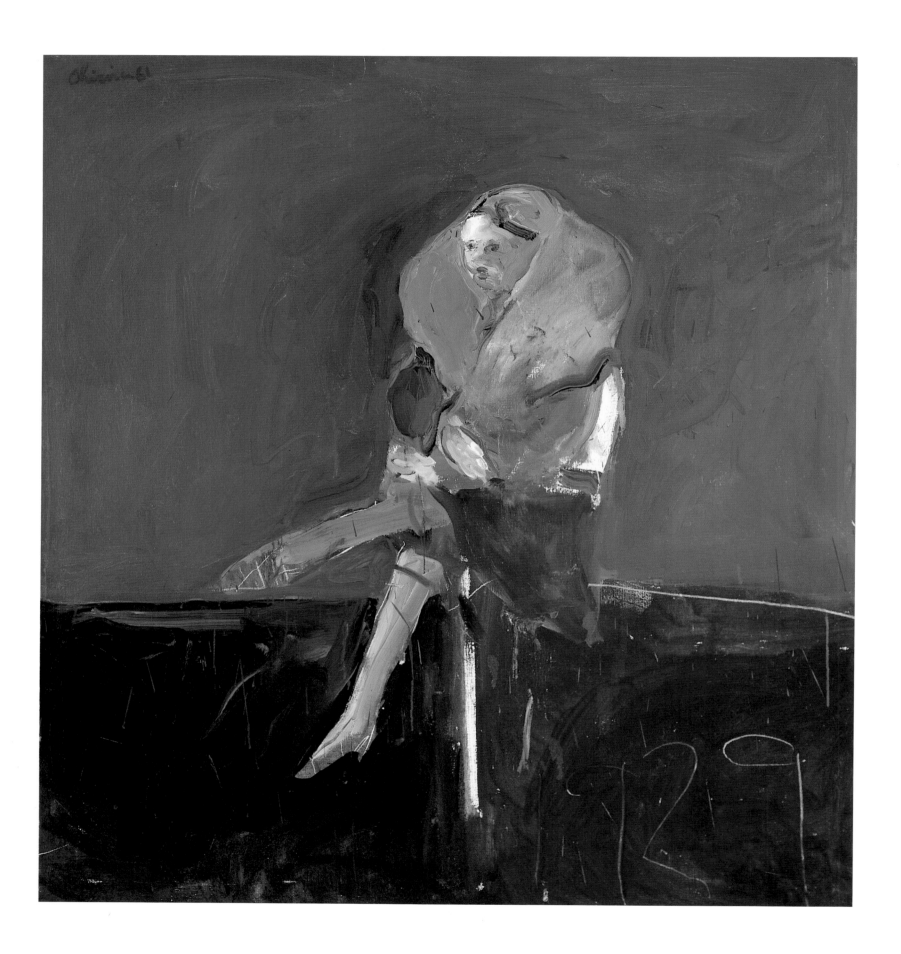

NINETEEN TWENTY-NINE
1961, oil on canvas, 54⅛ × 50⅛ in.
Gift of S. C. Johnson & Son, Inc.

in San Francisco. He later said of these European artists, "They were my spiritual fathers in a way, because they had all the expressive qualities, presence, the manipulation of this wonderful paint, and they tied it all together with figures."[4]

In 1959, just seven years after earning his M.F.A. from the California College of Arts and Crafts (now known as the California College of the Arts) in Oakland, he was included in the seminal, and at that time highly controversial, exhibition *New Images of Man* at the Museum of Modern Art in New York. There his works were shown alongside those by Willem de Kooning, Richard Diebenkorn, Jackson Pollock, Francis Bacon, Alberto Giacometti, and others.

Despite his growing reputation in New York, Oliveira continued his teaching career, mostly in his native California. To support his wife and young family, he had begun as an instructor at his alma mater and at the California School of Fine Arts. At the latter, he worked with Elmer Bischoff and Richard Diebenkorn. Oliveira claimed that he honed his artistic ideas through arguments with older colleagues Bischoff, Diebenkorn, and David

Park, who had earlier taught at CSFA. This loose association of artists would become known as the Bay Area figurative school, though they rejected any notion of consciously forming a group. Oliveira ultimately accepted a permanent faculty position at Stanford University in 1964, where he continued to teach painting and printmaking until he retired in 1996.

Although Oliveira's recent paintings have included pure abstractions, he remains energized by portraiture. In 2002, he was quoted as saying, "Even today, whenever I go to New York, I go to the Frick and stand in front of the Rembrandt self-portrait there and see a human, living presence and an energy that touches me. It's that presence that keeps me painting."[5] [TDF]

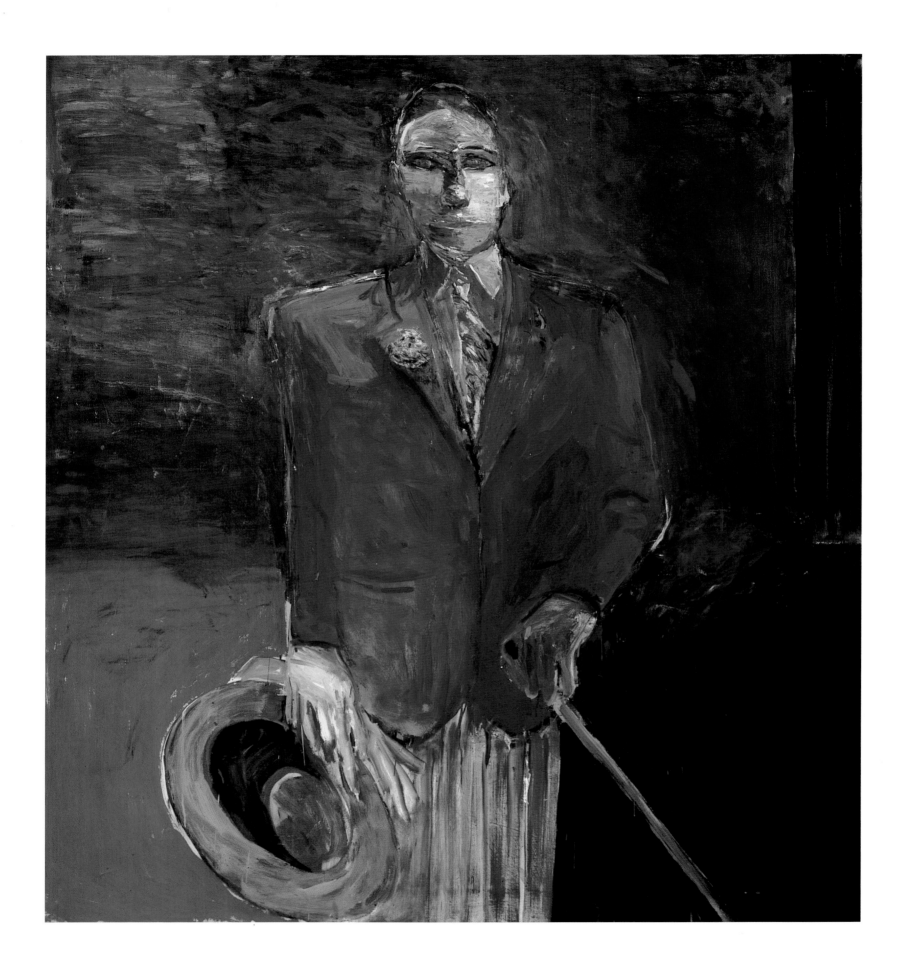

MAN WITH A HAT, CANE AND GLOVE
1961, oil on canvas, 60 × 40 in.
Bequest of Edith S. and Arthur J. Levin

[1] Dore Ashton, *Nathan Oliveira* (New York: DC Moore Gallery, 2005), 11.

[2] Dorothy Burkhart, "Nathan Oliveira's Separate Reality," *San Jose Mercury News*, Sep. 2, 1984.

[3] Donald Stokes, "Oliveira Describes Ordeal of 'Artist's Block' That Lasted Three Lonely Years," *Campus Report* (Stanford University), Dec. 14, 1983.

[4] Burkhart, "Nathan Oliveira's Separate Reality."

[5] Diane Rogers, "The Color of His Dreams: Master Artist Nathan Oliveira Contemplates Creation, Imagination, and the Big Picture," *Stanford Magazine*, Nov./Dec. 2002. Available online at http://www.stanfordalumni. org/news/magazine/2002/ novdec/features/oliveira.html

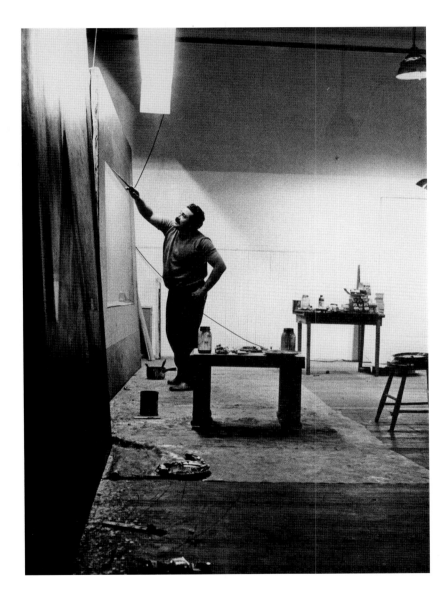

Nathan Oliveira, Leo Holub, photographer, Courtesy of Nathan Oliveira's personal archives

Art ought to be a troublesome thing, and one of my reasons for painting representationally is that this makes for much more troublesome pictures. [1]

DAVID park

1911 | 1960

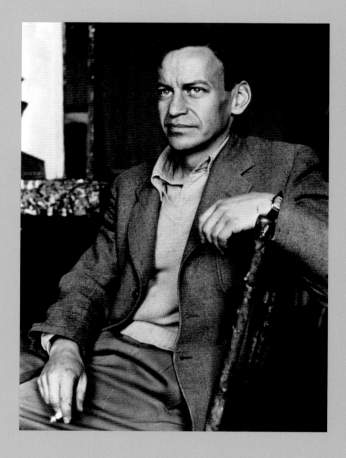

In *Beach Profile* (1953), David Park takes a traditional leisure subject, people visiting the seaside, and turns it ninety degrees in this boldly composed painting. Instead of the typical horizontal orientation, the canvas, sea, and sand are all arranged vertically. The absence of a sky and horizon line further disorients the viewer. The figures and their exaggerated perspective also create tension. The viewer appears to be uncomfortably close to the near figure, whose size seems too large in relation to the figure in the distance. Are we encroaching on her personal space? She covers two-thirds of the canvas, yet we see very little of her face. Her neck and cheek retreat in shadow, and her eye, the most revealing feature, is tightly cropped between the top of the canvas and the rim of the hat. Her gaze leads into the constrained area along a ribbon of sand—where one would normally expect to find an expansive sea. Without a facial expression to interpret, viewers are left in curiosity. Is she awaiting the figure in the distance? Is she sizing up a stranger? Or is she merely gazing out to the ocean?

But then, the smaller figure is disturbing, too. He is even less defined, and his head is also slightly

cropped at the top of the canvas. His face appears directly at the woman's eye level. Is he looking back at her? At this point, the bright highlights along the edge of the woman's face come into view and create a sense of the sun's heat. Judging by the lengthening shadow cast by the smaller figure, the time appears to be evening. That shadow touches the woman's shoulder, again implying some connection between the two. Along with her gaze, the shadow's strong diagonal gives a sense of spatial depth that is at odds with the flat appearance of the vertical shoreline and the painterly surface itself.

The preponderance of warm colors and the vigorously worked surface—especially the texture evoked in the sand—combine to suggest an intense heat. They also inspire a thirst for cool colors. Yet the sea's refreshing clarity is given precious little space in this picture. Perhaps the painting is a pæan to desire itself—for the ambiguous relationship between the figures, the seaward gaze, the obscured faces, and the truncated seascape commingle both to whet and confound the viewer's fascination with the unknown.

Park himself understood the allure and frustration of the unknown. In 1949, about four years before he painted *Beach Profile*, he dove headlong into creating a new art style. According to a story told by Park's aunt, the artist took virtually all of his abstract expressionist paintings to a dump in Berkeley, California, and destroyed them. In this dramatic artistic turnabout, he rejected several years' worth of work because, as he said, "[those] paintings practically never, even vaguely, approximated any achievement of my aims. Quite the opposite; what the paintings told me was that I was a hard-working guy who was trying to be important."[2] At that time, Park believed that abstract expressionism had become largely decorative and lacked meaning. In 1952, he explained some of the rationale behind his shift. "I believe the best painting America has produced is in the current non-objective direction. However, I often miss the sting that I believe a more descriptive reference to some fixed subject can make. Quite often, even the very fine non-objective canvases seem to me to be so visually beautiful that I find them insufficiently troublesome, not personal enough."[3] His interior, frontal portrait *Woman with Red Mouth* (1954–55) is a cool contrast to *Beach Profile*, though no less disturbing.

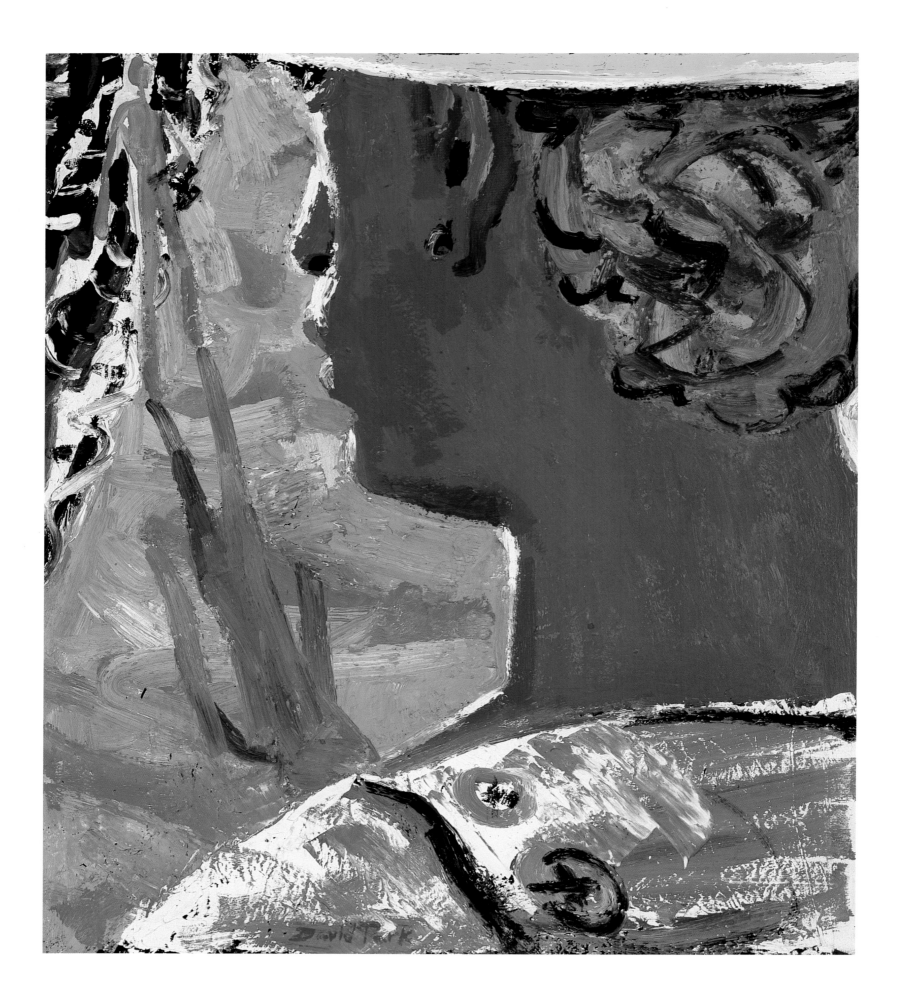

WOMAN WITH RED MOUTH
1954–55, oil on canvas
28¼ × 24⅛ in.
Bequest of Edith S. and Arthur J. Levin

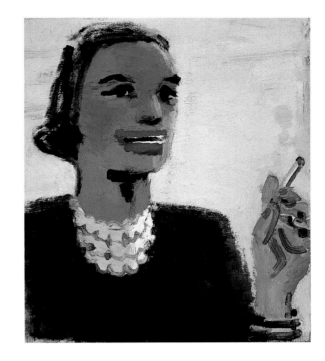

Park's courage in rejecting what was the preferred style of the New York art world—and even that of San Francisco, the city in which he worked—should not be underestimated. Indeed, abstract expressionism had by then become the cultural symbol for the avant-garde.[4] Park's change in direction drew attention in 1951, when his 1950 painting *Kids on Bikes* won a major prize in an exhibition of the San Francisco Art Association. The figural canvas caused a stir among his colleagues, who were also working in the abstract expressionist mode.[5]

At that time, David Park was a teacher at the California School of Fine Arts (now the San Francisco Art Institute), where he worked from about 1943 to 1952. Despite their shock at Park's new figural work, several of his friends, including Richard Diebenkorn and Elmer Bischoff, ultimately chose to abandon abstraction and paint representational subjects. This movement was formally acknowledged by a 1957 exhibition at the Oakland Art Museum, *Contemporary Bay Area Figurative Painting*. The curator of that exhibition, Paul Mills, cited Park as the founder.

From 1955 onward, David Park taught art at the University of California at Berkeley, where

he enjoyed artistic freedom and influenced many students. He continued to paint figures until his untimely death at the age of forty-nine, though he had long before claimed to separate his work from his ego: "A man's work should be quite independent of him and possibly much more wonderful."[6]

[TDF]

[1] Paul Mills, *Contemporary Bay Area Figurative Painting* (exhibition brochure) (Oakland, CA: Oakland Art Museum, 1957), 7.

[2] Paul Mills, *The New Figurative Art of David Park* (Santa Barbara, CA: Capra Press, 1988), 35.

[3] David Park's artist statement, *Contemporary American Painting* (Urbana: University of Illinois, 1952), 220.

[4] Christopher Knight, *The Figurative Mode: Bay Area Painting, 1956–1966* (New York: Grey Art Gallery and Study Center, New York University, 1984), 8, 12–14. In these pages Knight describes Park's realization that abstraction "had become the authoritative value" and that abstract expressionism "had become a fixed cultural symbol for, rather than a dialectical embodiment of, an avant-garde art."

[5] Caroline A. Jones, *Bay Area Figurative Art 1950–1965* (Berkeley and Los Angeles: University of California Press with the San Francisco Museum of Modern Art, 1990), 15–17.

[6] Mills, *The New Figurative Art of David Park*, 36.

◄ **BEACH PROFILE**
1953, oil on canvas, 34 × 30 in.
Bequest of Edith S. and Arthur J. Levin

There are four elements that ultimately deter-
mine quality and meaning in painting.... One,
the colour you choose and how much; two,
where you put it; three, in what manner. The
fourth is outside of you... and that is life.[1]

LARRY rivers

1923 | 2002

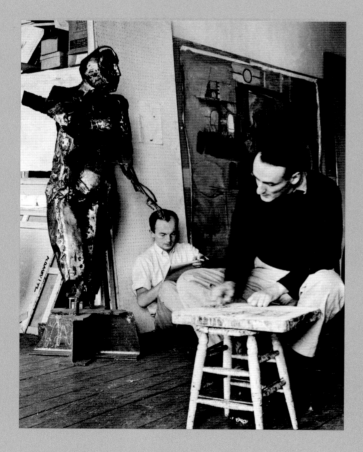

In 1965, Larry Rivers designed a poster for his
retrospective exhibition at the Jewish Museum in
New York that prompted him to review his fifteen-
year career. He selected fragments of four paintings
to signal milestones in his life and art.[2] One of the
images featured segments of *The Athlete's Dream*
(1956). It was a stand-in for portraits of family and
friends that he painted while living in Southampton
from 1953 to 1957. The sketchy heads and multiple,
fractured body parts of *The Athlete's Dream* are
personal, even autobiographical notations about his
identity as an individual and a painter.

Rivers had come to art via a circuitous route.
After high school, he worked as a jazz musician
and played saxophone with a U.S. Army Air Corps
band. Following his discharge from the military in
1943 (he was mistakenly diagnosed with multiple
sclerosis), Rivers studied music composition at the
Juilliard School in New York, met Miles Davis and
Charlie Parker, and earned his living playing clubs
in and around New York. He took his first painting
lessons from Jane Freilicher, whom he met during a
summer gig in Maine in 1945. Through her he met
other New York artists, among them Nell Blaine,

LARRY RIVERS (right) AND FRANK O'HARA, 1958
Hans Namuth, photographer, © Hans Namuth Ltd.,
Courtesy National Portrait Gallery, Smithsonian
Institution; gift of the Estate of Hans Namuth

who suggested he study with Hans Hofmann. From January 1947 through the summer of 1948, Rivers attended Hofmann's New York and Provincetown schools, painting during the day and playing in jazz clubs at night. But, Rivers said, hearing Hofmann talk about 'push and pull' made him "frantic to draw the figure."[3]

A large retrospective of Pierre Bonnard's brushy, impressionistic paintings at the Museum of Modern Art in 1948 reinforced this inclination and, with support from the G.I. Bill, he went to Paris in 1950. There Gustave Courbet, Edouard Manet, and Bonnard joined Rivers's pantheon of artistic heroes. After eight months abroad, he returned to New York, where he met Helen Frankenthaler, Grace Hartigan, Philip Guston, Franz Kline, Frank O'Hara, and other avant-garde painters, poets, and filmmakers. At that time, Rivers was selected for the *Talent 1950* show, which Meyer Schapiro and Clement Greenberg organized at Sam Kootz's gallery. The following year, 1951, Rivers painted his first major canvas, *The Burial*, inspired by Courbet's famous *A Burial at Ornans*. In December, he had his first major solo exhibition with Tibor de Nagy, a gallery established to exhibit new work by promising young artists that included Frankenthaler and Hartigan.[4] Critical response to this show and two that followed in 1952 and 1953 was distinctly mixed. Rivers was simultaneously lambasted as artistically *retardataire* and celebrated for his independent if contrary attitude for painting figures and three-dimensional space just as many of his avant-garde contemporaries were banishing the last traces of representation from their canvases. In 1953, stressed by the pressures of the Manhattan art scene and needing escape from a lifestyle that by his own admission involved drugs, alcohol, and unconventional sex, Rivers decided to leave New York for Southampton. "I wanted to get away from it all. To do my paintings more seriously without any of the interruptions of the city."[5]

Between 1953, when Rivers moved to Long Island, and 1957, he focused on portraits. Friends posed, as did his two sons, elderly mother-in-law Berdie Berger, and close friend and sometime lover Frank O'Hara. Sitters are easily recognized, as are backgrounds that show the spaces and furnishings of Rivers's house and studio. If not precisely realistic,

THE ATHLETE'S DREAM
1956, oil on canvas, 82⅛ × 118⅞ in.
Gift of S. C. Johnson & Son, Inc.

these likenesses of the mid-1950s represent a traditional approach in which space is relatively three-dimensional and figures possess weight and volume.

In *The Athlete's Dream,* Rivers leaves conventional portraiture behind. The painting is a composite of heads and fragments of bodies that captures multiple moments in time, as though Rivers has transcribed sitters shifting position during long sessions of posing. Four images of red-shirted Frank O'Hara stand at the upper left above several versions of Rivers seated below. The right half of the canvas is devoted to profile, reclining, and half-seated images of Berdie, who lived with him and took care of his two sons. The dimensional space he used as background in the earlier portraits has given way to sweeping areas of unpainted canvas that barely indicate floor and to a background "wall" of wide strokes of diluted pigment that link the otherwise disconnected quadrants of the composition. Blurry erasures, smears, and scrubbed areas of paint suggest figures in motion, psychological fragmentation, and the temporal and spatial shifts of dreams.[6] Although Rivers normally made drawings in advance of painting, the surface of *The Athlete's Dream* has an improvisational, random quality that connects the canvas with the artist's origins as a jazz saxophonist.

When Rivers moved back to New York after Berdie's death in 1957, he was widely acclaimed as a major figure on the New York art scene. The Gloria Vanderbilt Foundation and the Museum of Modern Art had acquired paintings, and he was one of twelve artists selected to represent the United States in the 1956 São Paulo biennial. Although he insistently pursued figuration, he expanded his thematic repertoire beyond close friends and family to engage history, politics, troubling social issues, and subjects drawn from popular culture. Cigar and cigarette packaging, Hollywood, American flags, and the civil rights movement provided motifs for wry, sometimes devastating commentaries on contemporary life. *Identification Manual* (1964), for example, presents images of civil rights leaders and a beautiful black woman juxtaposed alongside products designed to bleach dark skin in a triptych format that resembles a Renaissance altarpiece. *Identification Manual* is an assertive and provocative image in which Rivers questions the values of a society that allows personal identity to be formulated in terms of race and commercial products.

IDENTIFICATION MANUAL
1964, mixed media and collage on
fiberboard, 73⅝ × 84⅝ × 19 in.
Gift of Container Corporation of America

In other paintings of the late 1950s and 1960s, Rivers reconceived the grand historical genres of narrative and portraiture and French romantic epics in modern terms. He riffed on compositions by Picasso and Miró, and his *History of the Russian Revolution*, which was shown in the retrospective at the Jewish Museum in the fall of 1965, was reproduced in a double-page spread in *Time* magazine.

Yet Rivers's own artistic identity, and his insistence on life as a fundamental-theme, coalesced in the portrait images of the mid-1950s. In *The Athlete's Dream*, Rivers lays out his personal life for public inspection, and reviews, questions, and assimilates the conflicting impulses of his public and private selves.

[1] Larry Rivers, "A Self-Portrait, Part I," *The Listener*, Jan. 11, 1962, 70.

[2] Of the other paintings reproduced in the poster, one was *Washington Crossing the Delaware* (1953), the painting that catapulted the thirty-year-old Rivers into the center of contemporary debate about the "death" of figurative painting. Another, a likeness of Daniel Webster borrowed from the cover of a cigar box, signaled Rivers's appropriation of images from pop culture. A third reprised a portion of his notorious reinvention of Jacques Louis David's portrait of Napoleon that Rivers called *The Second Greatest Homosexual* (1965).

[3] Larry Rivers, "A Self-Portrait, Part II," *The Listener*, Jan. 18, 1962, 125–26.

[4] Biographical information is drawn from "Larry Rivers Chronology," in David C. Levy, Barbara Rose, and Jacquelyn Days Serwer, *Larry Rivers, Art and the Artist* (Boston: Bullfinch Press in assoc. with the Corcoran Gallery of Art, 2002), 172–81.

[5] Larry Rivers with Arnold Weinstein, *What Did I Do? The Unauthorized Autobiography* (New York: HarperCollins, 1992), quoted in *Larry Rivers, Art and the Artist*, 174.

[6] Lynda Roscoe Hartigan, text for unpublished catalogue entry, about 1980, Larry Rivers curatorial file, Smithsonian American Art Museum.

PAUL wonner

born 1920

Girl in Swing (1957) pulses with the pleasure of paint. One can imagine the artist creating the composition with a loaded brush and quick, expert strokes that are clearly visible in the surface itself. Art historian James Ackerman wrote, "I marvel that a person as profound and as intense as Wonner can paint with such simplicity and ease; he never makes a labored stroke. The drips that fall here and there from his brush not only testify to the vigor and immediacy of his movement, but become integral features of the composition, like punctuation marks in a poem."[2] The cool palette of blues, greens, and bright whites are typical of Wonner's figural works from the 1950s and 1960s. The bold contrasts create a jarring luminosity, the artist's signature style that captured his sense of California sunlight.

Despite the immediacy evident in his paint handling, Wonner sketched this carefully structured composition in advance. The beauty of the curvaceous shoreline draws the viewer into this seductive painting with a strong diagonal. Yet the oblique view of the figure, with her face obscured by shadows and her limbs severed in the tight cropping, is unsettling. Despite the expansive seascape,

PAUL WONNER, about 1958
Courtesy of the Paul Wonner papers, about 1956–2005,
Archives of American Art, Smithsonian Institution

hillside, and sky at the right, the figure is cramped within the claustrophobic architecture of the swing and the canvas edge. Even in other figural paintings, Wonner rarely presented facial features in detail. In *Model Drinking Coffee* (1964), for example, the face is not obscured by shadow or awning, but neither are its features tightly focused.

The unusual rendering of shoreline leisure in *Girl in Swing* is reminiscent of David Park's *Beach Profile* of 1953 (see page 234) in its odd cropping and ambiguous face. In these works, figures are portrayed in tantalizing, recognizable ways that are nonetheless disturbing. This similarity hints at the influence of a group of artists who worked together and shared ideas in the 1950s in the San Francisco Bay area.

Paul Wonner, a native westerner, was born in Tucson and raised in California. His supportive family helped jump-start his career by hiring an art tutor during high school. Wonner went on to study at the California College of Arts and Crafts in Oakland, where he received his degree in 1941. After serving in the U.S. Army during World War II, he settled in New York City during the heyday of abstract expressionism. While working as a commercial designer, Wonner took classes at the Art Students League and attended lectures at the studio of Robert Motherwell, pursuits that enabled him to share ideas with leading critics and artists of the New York school.

In 1950, Wonner decided to return to California and enrolled at the University of California, Berkeley, from which he earned a master's degree in 1953. Back on his native West Coast, Wonner immersed himself in the Bay Area's vibrant art scene. At Berkeley, Wonner met William Theophilus Brown, who became a longtime friend and colleague, and they both rented studio space in a Berkeley building also used by Richard Diebenkorn. There the three painters held life-drawing sessions, which also included Elmer Bischoff, David Park, James Weeks, and Nathan Oliveira.[3] Influenced by this loose association of artists, Wonner became known as one of the Bay Area figurative painters, and his work *The Glider* was included in the seminal 1957 exhibition at the Oakland Museum that dubbed the group a "school." *Girl in Swing*, notable because Wonner painted it in the same year as this

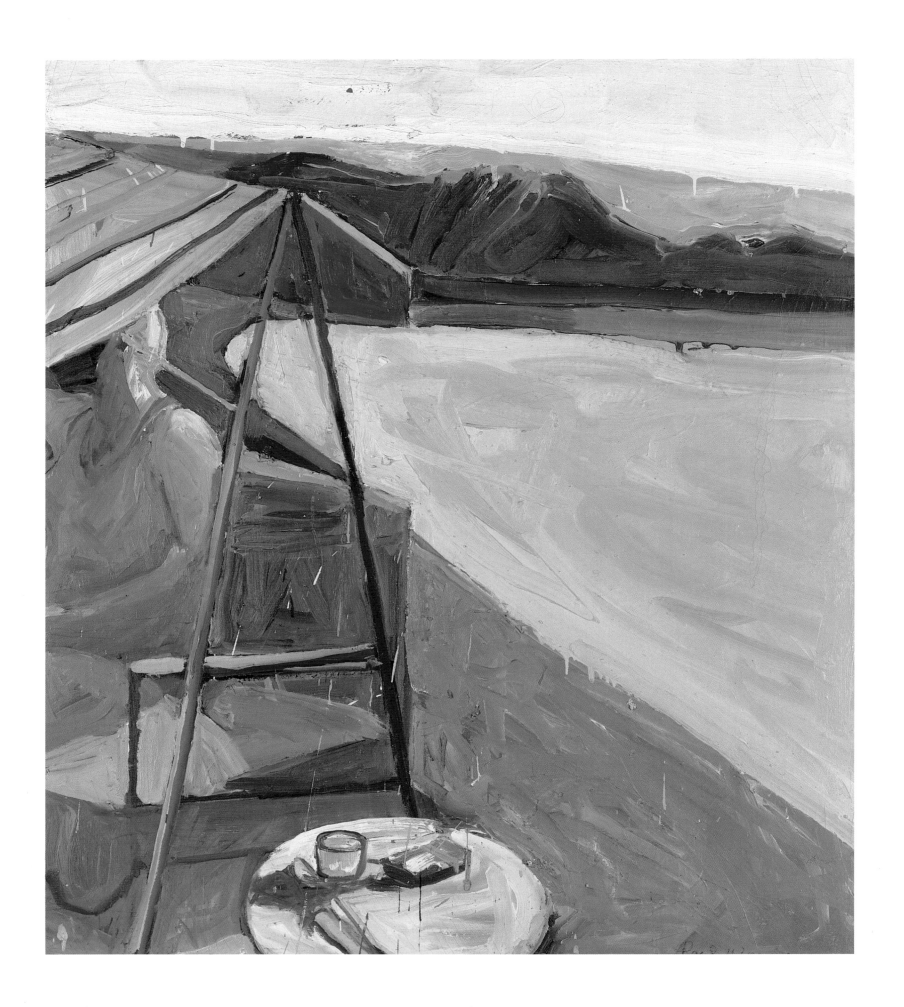

exhibition, is similar in subject and composition to *The Glider.*

Wonner's paint handling techniques of this period owe a debt to the abstract expressionists. Even though he consciously chose to paint representational subjects, his gestural brushwork leaves a thick, impasto surface. The intensity of Wonner's brilliant colors and the sense of immediacy in his brushwork lend a psychological component to the scene, despite the ambiguity of facial or geographic features. *Girl in Swing* is no exception. In 1957, the same year *Girl in Swing* was executed, Wonner gave some insight into his philosophy of art. He said, "I think a painting has to be some kind of translation of psychological experience."[4] [TDF]

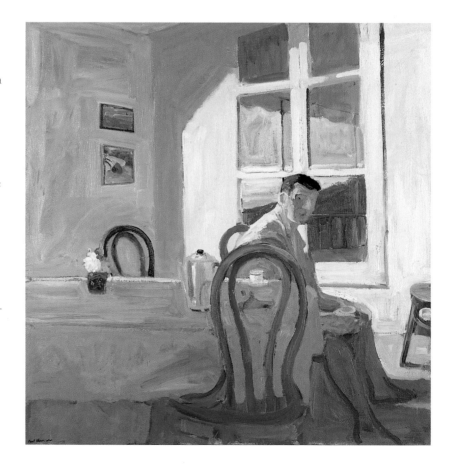

[1] Paul Wonner, artist's statement in *Paul Wonner* (exhibition brochure) (San Francisco: California School of Fine Arts, SFAA Gallery, 1956).

[2] James Ackerman, *Paul Wonner, Recent Painting, April 18-May 7, 1960* (exhibition brochure) (Los Angeles: Felix Landau Gallery, 1960).

[3] Caroline A. Jones, *Bay Area Figurative Art 1950–1965* (Berkeley and Los Angeles: University of California Press with the San Francisco Museum of Modern Art, 1990), 87.

[4] Paul Mills, *Contemporary Bay Area Figurative Painting* (exhibition brochure) (Oakland, CA: The Oakland Art Museum, 1957), 17.

◄ **GIRL IN SWING**
1957, oil on canvas, 52⅝ × 46¼ in.
Gift of Ruth J. Chase in memory of
Dr. William Chase

FOR FURTHER READING

Thousands of books and articles have been written about postwar abstraction in the United States. It would be a hopeless task to try to compile a list even of the most significant. The items indicated below were selected in part because most will be easily available to readers and because I found them useful, and very readable, accounts of the artists' lives and work and of events surrounding their careers.

I would especially like to direct readers to the extensive original materials available on the Web site of the Archives of American Art. Transcripts of dozens of interviews conducted over almost fifty years as well as other materials related to American artists, critics, dealers, and art historians can be found at www.aaa.si.edu.

SELECTED EXHIBITIONS, 1940–1962

American Abstract Expressionists and Imagists. New York: Solomon R. Guggenheim Museum, 1961.

American Painting Today, 1950: A National Competitive Exhibition. New York: Metropolitan Museum of Art, 1950.

Arnason, H. H. *Vanguard American Painting.* New York: Solomon R.Guggenheim Museum, 1962.

Baur, John I. H. *Nature in Abstraction: The Relation of Abstract Painting and Sculpture to Nature in Twentieth-Century American Art.* With contributions by Rosalind Irvine. New York: Whitney Museum of American Art, 1958.

Geometric Abstraction in America. New York: Whitney Museum of American Art, 1962.

International Exhibition of the New Realists. New York: Sidney Janis Gallery, 1962.

Langsner, Jules. *Four Abstract Classicists.* San Francisco: San Francisco Museum of Art; Los Angeles: Los Angeles County Museum, 1959.

Miller, Dorothy C., ed. *Americans 1942–1963: Six Group Exhibitions.* New York: Museum of Modern Art, 1972.

Mills, Paul. *Contemporary Bay Area Figurative Painting.* Oakland, CA: Oakland Museum, 1957.

The New American Painting: As Shown in Eight European Countries, 1958–1959. New York: Museum of Modern Art, 1959.

The New Decade: 35 American Painters and Sculptors. New York: Whitney Museum of American Art, 1955.

New Forms—New Media. New York: Martha Jackson Gallery, 1960.

Pioneers of Modern Art in America. New York: Whitney Museum of American Art, 1946.

Ritchie, Andrew Carnduff. *Abstract Painting and Sculpture in America.* New York: Museum of Modern Art, 1951.

Selz, Peter. *New Images of Man.* New York: Museum of Modern Art, 1959.

CONTEMPORARY THEORY AND CRITICISM

Greenberg, Clement. *Art and Culture: Critical Essays.* Boston: Beacon Press, 1971.

———. *The Collected Essays and Criticism.* Edited by John O'Brian. Chicago: University of Chicago Press, 1986.

———. *Late Writings.* Edited by Robert C. Morgan. Minneapolis: University of Minnesota Press, 2007.

Hess, Thomas B. *Abstract Painting: Background and American Phase.* New York: Viking, 1951.

Janis, Harriet, and Sidney Janis. *Picasso: The Recent Years, 1939–46.* Garden City, NY: Doubleday, 1946.

Janis, Sidney. *Abstract and Surrealist Art in America.* New York: Reynal & Hitchcock, 1944.

Kootz, Samuel M. *Modern American Painters.* New York: Brewer & Warren, 1930.

———. *New Frontiers in American Painting.* New York: Hastings House, 1943.

Rosenberg, Harold. "The American Action Painters," *ARTnews* 51, no. 8 (Dec. 1952): 22–23, 48–50.

———. *The Anxious Object: Art Today and its Audience.* New York: Horizon, 1964.

———. *The De-Definition of Art: Action Art to Pop to Earthworks.* New York: Horizon, 1972.

———. *Discovering the Present: Three Decades in Art, Culture, and Politics.* Chicago: University of Chicago Press, 1973.

———. *The Tradition of the New.* New York: Horizon, 1959.

Schapiro, Meyer. "Abstract Art." In *Modern Art: 19th and 20th Centuries, Selected Papers.* New York: George Braziller, 1978.

Steinberg, Leo. *Other Criteria: Confrontations with Twentieth-Century Art.* New York: Oxford University Press, 1972.

INTERPRETIVE HISTORIES

Alloway, Lawrence. *The Venice Biennale, 1895–1968: From Salon to Goldfish Bowl.* Greenwich, CT: New York Graphic Society, 1968.

Altshuler, Bruce. *The Avant-Garde in Exhibition: New Art in the 20th Century.* New York: Abrams, 1994.

Ashton, Dore. *The New York School: A Cultural Reckoning.* New York: Viking, 1973.

Auping, Michael. *Abstraction, Geometry, Painting: Selected Geometric Abstract Painting in America Since 1945.* New York: Abrams in assoc. with Albright-Knox Art Gallery, 1989.

Crow, Thomas. *The Rise of the Sixties: American and European Art in the Era of Dissent.* New York: Abrams, 1996.

Davidson, Susan, and Philip Rylands, eds. *Peggy Guggenheim and Frederick Kiesler: The Story of Art of This Century.* New York: Guggenheim Museum Publications, 2004.

De Coppet, Laura, and Alan Jones. *The Art Dealers: The Powers Behind the Scene Tell How the Art World Really Works.* New York: C. N. Potter, 1984.

Elderfield, John, and John Szarkowski, eds. *The Museum of Modern Art at Mid-Century: At Home and Abroad*. New York: Museum of Modern Art, 1994.

Fineberg, Jonathan. *Art Since 1940: Strategies of Being*. 2nd ed. New York: Abrams, 2000.

Frascina, Francis, ed. *Pollock and After: The Critical Debate*. New York: Harper & Row, 1985.

Gibson, Ann Eden. *Abstract Expressionism: Other Politics*. New Haven: Yale University Press, 1997.

Guilbaut, Serge. *How New York Stole the Idea of Modern Art: Abstract Expressionism, Freedom, and the Cold War*. Translated by Arthur Goldhammer. Chicago: University of Chicago Press, 1983.

Hall, Lee. *Betty Parsons: Artist, Dealer, Collector*. New York: Abrams, 1991.

Herskovic, Marika, ed. *New York School Abstract Expressionists: Artists Choice by Artists, A Complete Documentation of the New York Painting and Sculpture Annuals, 1951–1957*. Franklin Lakes, NJ: New York School Press, 2000

———. *American Abstract Expressionism of the 1950s: An Illustrated Survey, With Artists' Statements, Artwork, and Biographies*. New York: New York School Press, 2003.

Hess, Thomas B. *Willem de Kooning*. New York: Museum of Modern Art, 1968.

Hobbs, Robert C., and Gail Levin. *Abstract Expressionism: The Formative Years*. New York: Whitney Museum of American Art, 1978.

Huyssen, Andreas. *After the Great Divide: Modernism, Mass Culture, Postmodernism*. Bloomington: Indiana University Press, 1986.

Kingsley, April. *The Turning Point: The Abstract Expressionists and the Transformation of American Art*. New York: Simon & Schuster, 1992.

Landau, Ellen G. *Jackson Pollock*. New York: Abrams, 1989.

Larson, Gary O. *The Reluctant Patron: The United States Government and the Arts, 1943–1965*. Philadelphia: University of Pennsylvania Press, 1983.

Leja, Michael. *Reframing Abstract Expressionism: Subjectivity and Painting in the 1940s*. New Haven: Yale University Press, 1993.

Lynes, Russell. *Good Old Modern: An Intimate Portrait of the Museum of Modern Art*. New York: Atheneum, 1973.

Phillips, Lisa. *The Third Dimension: Sculpture of the New York School*. New York: Whitney Museum of American Art, 1984.

———. *Beat Culture and the New America, 1950–1965*. New York: Whitney Museum of American Art, 1995.

Powell, Richard. *Black Art and Culture in the 20th Century*. New York: Thames and Hudson, 1997.

Rand, Harry. *The Martha Jackson Memorial Collection*. Washington, DC: Smithsonian Institution Press for the National Museum of American Art, 1985.

Rodman, Selden. *Conversations with Artists*. New York: Devin-Adair, 1957.

Ross, Clifford, ed. *Abstract Expressionism: Creators and Critics*. New York: Abrams, 1990.

Sandler, Irving. *The New York School: The Painters and Sculptors of the Fifties*. New York: Harper & Row, 1978.

———. *The Triumph of American Painting: A History of Abstract Expressionism*. New York: Praeger, 1970.

Schimmel, Paul, and Judith E. Stein. *The Figurative Fifties: New York Figurative Expressionism*. Newport Beach, CA: Newport Harbor Art Museum, 1988.

Schimmel, Paul. *The Interpretive Link: Abstract Surrealism into Abstract Expressionism: Works on Paper, 1938–48*. Newport Beach, CA: Newport Harbor Art Museum, 1986.

Warren, Lynne. *Art in Chicago: 1945–1995*. Chicago: Museum of Contemporary Art, 1996.

Wechsler, Jeffrey, Sam Hunter, and Irving Sandler. *Abstract Expressionism: Other Dimensions: An Introduction to Small Scale Painterly Abstraction in America, 1940–1965*. New Brunswick, NJ: Jane Voorhees Zimmerli Art Museum, Rutgers, 1989.

Wood, Paul, Francis Frascina, Jonathan Harris, and Charles Harrison. *Modernism in Dispute: Art since the Forties*. New Haven: Yale University Press, 1993.

ART IN CALIFORNIA

Albright, Thomas. *Art in the San Francisco Bay Area, 1945–1980*. Berkeley: University of California Press, 1985.

Jones, Caroline A. *Bay Area Figurative Art, 1950–1965*. Berkeley: University of California Press; San Francisco: San Francisco Museum of Modern Art, 1989.

Landauer, Susan. *The San Francisco School of Abstract Expressionism*. Berkeley: University of California Press; Laguna Beach, CA: Laguna Art Museum, 1996.

ARTISTS

JOSEF ALBERS

Albers, Josef. *Interaction of Color*. New Haven: Yale University Press, 1971.

Haas, Karen E. *Josef Albers in Black and White*. Seattle: University of Washington Press in assoc. with Boston University Art Gallery, 2000.

Waldman, Diane. *Josef Albers: A Retrospective*. New York: Solomon R. Guggenheim Foundation, 1988.

Weber, Nicholas Fox. *Josef Albers: His Art and His Influence*. Montclair, NJ: Montclair Art Museum, 1981.

ROMARE BEARDEN

Bearden, Romare, and Harry Henderson. *A History of African-American Artists from 1792 to the Present*. New York: Pantheon, 1993.

Campbell, Mary Schmidt, and Sharon F. Patton. *Memory and Metaphor: The Art of Romare Bearden, 1940–1987*. Introduction by Kinshasha Holman Conwill. New York: Studio Museum in Harlem, 1991.

Fine, Ruth. *The Art of Romare Bearden*. Washington, DC: National Gallery of Art, 2003.

ILYA BOLOTOWSKY

Geldzahler, Henry. "Adventures with Bolotowsky," *Archives of American Art Journal* 22, no. 1 (1982): 8–30.

Lane, John R., and Susan C. Larsen, eds. *Abstract Painting and Sculpture in America, 1927–1944*. Pittsburgh: Museum of Art, Carnegie Institute, 1984.

Svendsen, Louise Averill, and Mimi Poser. *Ilya Bolotowsky*. New York: Solomon R. Guggenheim Foundation, 1974.

EMILIO CRUZ

Emilio Cruz. Homo Sapiens. Philadelphia: Pennsylvania Academy of the Fine Arts, 1997.

Fleminger, Susan. *Emilio Cruz: Spilled Nightmares, Revelations, and Reflections*. New York: Studio Museum in Harlem, 1987.

Rand, Harry. *Emilio Cruz: Recent Paintings and Drawings*. New York: The Alternative Museum, 1984.

Staiti, Paul. "Emilio Cruz's Life on Earth," *Black Renaissance/Renaissance Noire* 6, no. 2 (Spring 2005): 128–37.

RICHARD DIEBENKORN

Elderfield, John. *Richard Diebenkorn*. London: Whitechapel Art Gallery, 1991.

Livingston, Jane. *The Art of Richard Diebenkorn*. Berkeley: University of California Press in assoc. with the Whitney Museum of American Art, 1997.

Nordland, Gerald. *Richard Diebenkorn*. 2nd ed. New York: Rizzoli, 2001.

JIM DINE

Beal, Graham W. J. *Jim Dine: Five Themes*. Minneapolis: Walker Art Center, 1984.

Dine, Jim, Ruth Fine, and Stephen Fleischman. *Jim Dine: Drawing from the Glyptothek*. New York: Hudson Hills in assoc. with the Madison Art Center, 1993.

Feinberg, Jean E. *Jim Dine*. New York: Abbeville, 1995.

Livingstone, Marco. *Jim Dine: The Alchemy of Images*. New York: Monacelli, 1998.

DAVID DRISKELL

Brown, Bruce, and Lowery Stokes Sims. *David Driskell: Painting Across the Decade, 1996–2006*. New York: DC Moore Gallery, 2006.

McGee, Julie L. *David C. Driskell: Artist and Scholar*. San Francisco: Pomegranate, 2006.

SAM FRANCIS

Agee, William C. *Sam Francis: Paintings 1947–1990*. Los Angeles: Museum of Contemporary Art, 1999.

Hultén, Pontus. *Sam Francis*. Stuttgart: Edition Cantz in assoc. with Kunst- und Ausstellungshalle der Bundesrepublik Deutschland, 1993.

Sam Francis: Paintings, 1947–1972. Buffalo: Albright-Knox Art Gallery, 1972.

Selz, Peter. *Sam Francis*. Rev. ed. New York: Abrams, 1982.

HELEN FRANKENTHALER

Carmean, E. A., Jr. *Helen Frankenthaler: A Paintings Retrospective*. New York: Abrams, 1989.

Elderfield, John. *Frankenthaler*. New York: Abrams, 1989.

Rose, Barbara. *Frankenthaler*. New York: Abrams, 1971.

Schumacher, Bett. "Helen Frankenthaler's Modernism: Embodiment and Pictorial Ambiguity, 1950–1965." PhD diss., Johns Hopkins University, 2004.

MICHAEL GOLDBERG

Acton, David. *The Stamp of Impulse, Abstract Expressionist Prints*. Worcester, MA: Worcester Art Museum, 2001.

Doe, Donald Bartlett. "Reckoning with Michael Goldberg." *Sheldon Memorial Art Gallery Resource and Response*, vol. 1, no. 2.

Kalina, Richard. *Michael Goldberg*. Omaha, NE: Joslyn Art Museum, 2003.

Klein, Ellen Lee. "All Kinds of Rational Questions: An Interview with Michael Goldberg." *Arts* 59, no. 6 (Feb. 1985): 80–84.

MAURICE GOLUBOV

Cameron, Daniel J., ed. *Maurice Golubov: Paintings 1925–1980*. Charlotte, NC: Mint Museum, 1980.

Mecklenburg, Virginia M. *American Abstraction 1930–1945: The Patricia and Phillip Frost Collection*. Washington, DC: Smithsonian Institution Press for the National Museum of American Art, 1989.

ADOLPH GOTTLIEB

Adolph Gottlieb, Una Retrospectiva/A Survey Exhibition. Valencia, Spain: IVAM Centro Julio Gonzalez, 2001.

Alloway, Lawrence. *The Pictographs of Adolph Gottlieb*. New York: Hudson Hills, 1994.

Alloway, Lawrence, and Mary Davis MacNaughton. *Adolph Gottlieb: A Retrospective*. New York: The Arts Publisher in assoc. with the Adolph and Esther Gottlieb Foundation, 1981.

Doty, Robert, and Diane Waldman. *Adolph Gottlieb*. New York: Praeger in assoc. with the Whitney Museum of American Art and the Solomon R. Guggenheim Museum, 1968.

PHILIP GUSTON

Auping, Michael. *Philip Guston Retrospective*. Fort Worth, TX: Modern Art Museum of Fort Worth, 2003.

Hopkins, Henry T. *Philip Guston*. San Francisco: San Francisco Museum of Modern Art, 1980.

Mayer, Musa. *Night Studio: A Memoir of Philip Guston*. New York: Knopf, 1988.

Serota, Nicholas, ed. *Philip Guston: Paintings 1969–1980*. London: Whitechapel Art Gallery, 1982.

Storr, Robert. *Philip Guston*. New York: Abbeville, 1986.

GRACE HARTIGAN

Hirsh, Sharon L. *Grace Hartigan: Painting Art History*. Carlisle, PA: Trout Gallery, Dickinson College, 2003.

Mattison, Robert Saltonstall. *Grace Hartigan: A Painter's World*. New York: Hudson Hills, 1990.

HANS HOFFMAN

Goodman, Cynthia. *Hans Hofmann*. New York: Whitney Museum of American Art, 1990.

Seitz, William. *Hans Hofmann*. New York: Museum of Modern Art, 1963.

Yohe, James, ed. *Hans Hofmann*. New York: Rizzoli, 2002.

FRANZ KLINE

Christov-Bakargiev, Carolyn, ed. *Franz Kline 1910–1962*. Translated by Isabella Varea. Milan, Italy: Skira, 2004.

Franz Kline: Art and the Structure of Identity. London: Whitechapel Art Gallery, 1994.

Gaugh, Harry F. *The Vital Gesture: Franz Kline*. New York: Abbeville, 1985.

IBRAM LASSAW

Heller, Nancy Gale. "The Sculpture of Ibram Lassaw." PhD diss., Rutgers University, 1982.

Ibram Lassaw:, Space Explorations, A Retrospective Survey, 1929–1988. East Hampton, NY: Guild Hall Museum, 1988.

Jones, Arthur F., and Denise Lassaw. *Ibram Lassaw: Deep Space and Beyond*. Radford, VA: Radford University Foundation Press, 2002.

SEYMOUR LIPTON

Elsen, Albert. *Seymour Lipton*. New York: Abrams, 1970.

Rand, Harry. *Seymour Lipton: Aspects of Sculpture*. Washington, DC: Smithsonian Institution Press for the National Collection of Fine Arts, 1979.

Verderame, Lori. *An American Sculptor: Seymour Lipton*. University Park, PA: Palmer Museum of Art, Pennsylvania State University, 1999.

JOHN MCLAUGHLIN

Barron, Stephanie, ed. *California: Five Footnotes to Modern Art History*. Los Angeles: Los Angeles County Museum, 1977.

Figoten, Sheldon. "An Appreciation of John McLaughlin." *Archives of American Art Journal* 20, no. 4 (1980): 12–16.

Larsen, Susan C., and Peter Selz. *John McLaughlin, Western Modernism, Eastern Thought*. Laguna Beach, CA: Laguna Art Museum, 1996.

JOAN MITCHELL

Bernstock, Judith E. *Joan Mitchell*. New York: Hudson Hills in assoc. with the Herbert F. Johnson Museum of Art, Cornell University, 1988.

Livingston, Jane. *The Paintings of Joan Mitchell*. New York: Whitney Museum of American Art, 2002.

ROBERT MOTHERWELL

Arnason, H. H. *Robert Motherwell*. 2nd ed. New York: Abrams, 1982.

Ashton, Dore, and Jack Flam. *Robert Motherwell*. New York: Abbeville Press in assoc. with Albright-Knox Art Gallery, 1983.

Ashton, Dore, and Joan Banach, eds. *The Writings of Robert Motherwell*. Berkeley: University of California Press, 2007.

Carmean, E. A., Jr. *The Collages of Robert Motherwell: A Retrospective Exhibition*. Houston: Museum of Fine Arts, 1972.

Mattison, Robert Saltonstall. *Robert Motherwell: The Formative Years*. Ann Arbor, MI: UMI Research Press, 1987.

LOUISE NEVELSON

Glimcher, Arnold B. *Louise Nevelson*. 2nd ed. New York: Dutton, 1976.

Lipman, Jean. *Nevelson's World*. New York: Whitney Museum of American Art, 1983.

Nevelson, Louise. *Dawns + Dusks: Taped Conversations with Diana MacKown*. New York: Charles Scribner's Sons, 1976.

Whitney Museum of Art. *Louise Nevelson: Atmospheres and Environments*. New York: C. N. Potter, 1980.

NATHAN OLIVEIRA

Ashton, Dore. *Nathan Oliveira*. New York: DC Moore Gallery, 2005.

Selz, Peter. *Nathan Oliveira*. Berkeley: University of California Press, 2002.

DAVID PARK

Armstrong, Richard. *David Park*. New York: Whitney Museum of American Art, 1988.

Di Piero, W. S., and Helen Park Bigelow. *David Park: A Singular Humanity*. San Francisco: Hackett-Freedman Gallery, 2003.

Mills, Paul. *The New Figurative Art of David Park*. Santa Barbara, CA: Capra, 1988.

AD REINHARDT

Ad Reinhardt. New York: Rizzoli in assoc. with the Museum of Contemporary Art, Los Angeles, and the Museum of Modern Art, 1991.

Hess, Thomas B. "The Art Comics of Ad Reinhardt." *Artforum* 12 (April 1974): 46–51.

Inboden, Gudrun, and Thomas Kellein. *Ad Reinhardt*. Stuttgart, Germany: Staatsgalerie Stuttgart, 1985.

Reinhardt, Ad. *Art-as-Art: The Selected Writings of Ad Reinhardt*. Edited by Barbara Rose. New York: Viking, 1975.

LARRY RIVERS

Hunter, Sam. *Larry Rivers*. New York: Rizzoli, 1989.

Rivers, Larry. *What Did I Do?: The Unauthorized Autobiography*. New York: HarperCollins, 1992.

Roce, Barbara, and Jacquelyn Days Serwer. *Larry Rivers: Art and the Artist*. Boston: Little, Brown & Co. in assoc. with the Corcoran Gallery of Art, 2002.

THEODORE ROSZAK

Dreishpoon, Douglas S. "Theodore J. Roszak (1907–1981): Painting and Sculpture." PhD diss., City University of New York, 1993.

———. *Between Transcendence and Brutality: American Sculptural Drawings from the 1940s and 1950s*. Tampa, FL: Tampa Museum of Art, 1994.

Seeman, Joan French. "The Sculpture of Theodore Roszak: 1932–1952." PhD diss., Stanford University, 1979.

THEODOROS STAMOS

Cavaliere, Barbara. *Theodoros Stamos: Allegories of Nature: Organic Abstractions, 1945–1949*. New York: Michael Rosenfeld Gallery, 2001.

Pomeroy, Ralph. *Stamos*. New York: Abrams, 1974.

ANNE TRUITT

Hileman, Kristen. *Anne Truitt: Perception and Reflection*. Washington, DC: Hirshhorn Museum and Sculpture Garden, Smithsonian Institution, forthcoming.

Hopps, Walter. *Anne Truitt: Sculpture and Drawings 1961–1973*. Washington, DC: Corcoran Gallery of Art, 1974.

Truitt, Anne. *Daybook: The Journal of an Artist*. New York: Pantheon Books, 1982.

ESTEBAN VICENTE

Frank, Elizabeth. *Esteban Vicente*. New York: Hudson Hills, 1995.

Lucie-Smith, Edward. *Esteban Vicente, A Retrospective View: 1951–2000*. Scottsdale, AZ: Riva Yares Gallery, 2002.

Vicente, Esteban. *El Color Es La Luz*. Segovia, Spain: Museo de Arte Contemporáneo Esteban Vicente, 2001.

PAUL WONNER

Arthur, John. *Paul Wonner: Recent Work*. San Francisco: John Berggruen Gallery, 1998.

Grimes, Nancy. *Paul Wonner*. New York: DC Moore Gallery, 1999.

Paul Wonner: Abstract Realist. Los Angeles: Fellows of Contemporary Art, 1981.

INDEX